GARDNER'S

FRED S. KLEINER

through the

A GLOBAL HISTORY

FOURTEENTH EDITION

Gardner's Art through the Ages: A Global History, Fourteenth Edition Non-Western Art Since 1300, Book F Fred S. Kleiner

Publisher: Clark Baxter

Senior Development Editor: Sharon Adams Poore

Assistant Editor: Ashley Bargende Editorial Assistant: Elizabeth Newell

Associate Media Editor: Kimberly Apfelbaum

Senior Marketing Manager: Jeanne Heston Marketing Coordinator: Klaira Markenzon

Senior Marketing Communications Manager: Heather Baxley

Senior Content Project Manager: Lianne Ames

Senior Art Director: Cate Rickard Barr Senior Print Buyer: Mary Beth Hennebury

Rights Acquisition Specialist, Images: Mandy Groszko

Production Service & Layout: Joan Keyes, Dovetail

Publishing Services

Text Designer: tani hasegawa Cover Designer: tani hasegawa

Cover Image: © Giraudon/The Bridgeman Art Library

Compositor: Thompson Type, Inc.

© 2013, 2009, 2005 Wadsworth, Cengage Learning

ALL RIGHTS RESERVED. No part of this work covered by the copyright herein may be reproduced, transmitted, stored, or used in any form or by any means graphic, electronic, or mechanical, including but not limited to photocopying, recording, scanning, digitizing, taping, Web distribution, information networks, or information storage and retrieval systems, except as permitted under Section 107 or 108 of the 1976 United States Copyright Act, without the prior written permission of the publisher.

For product information and technology assistance, contact us at Cengage Learning Customer & Sales Support, 1-800-354-9706

For permission to use material from this text or product, submit all requests online at www.cengage.com/permissions.

Further permissions questions can be emailed to permissionrequest@cengage.com.

Library of Congress Control Number: 2011931848 ISBN-13: 978-0-8400-3059-7 ISBN-10: 0-8400-3059-2

Wadsworth

20 Channel Center Street Boston, MA 02210 USA

Cengage Learning is a leading provider of customized learning solutions with office locations around the globe, including Singapore, the United Kingdom, Australia, Mexico, Brazil and Japan. Locate your local office at international.cengage.com/region

Cengage Learning products are represented in Canada by Nelson Education, Ltd.

For your course and learning solutions, visit **www.cengage.com**. Purchase any of our products at your local college store or at our preferred online store **www.cengagebrain.com**.

Instructors: Please visit **login.cengage.com** and log in to access instructor-specific resources.

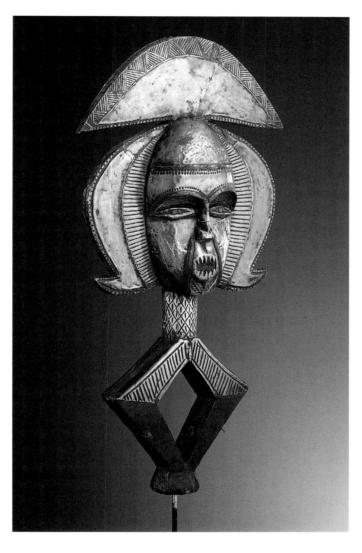

Reliquary guardian figure (mbulu ngulu), Kota, Gabon, 19th or early 20th century. Wood, copper, iron, and brass, 1' $9\frac{1}{16}''$ high. Musée Barbier-Mueller, Geneva.

Throughout the continent, Africans venerate ancestors for the continuing aid they believe they provide the living, including help in maintaining the productivity of the earth for ensuring bountiful crop production and successful hunts. In some African societies, for example the Kota of Gabon and several other migratory peoples just south of the equator, people place the bones of their ancestors in containers guarded by sculptured figures in order to protect these treasured relics from theft or harm.

These portable reliquaries were ideal for African nomadic population groups such as the Kota. The name for the Kota reliquary figures is *mbulu ngulu*, and they differ markedly from those of neighboring population groups. The mbulu ngulu have severely stylized bodies in the form of an open diamond below a wood head. The sculptors of these reliquary guardians covered both the head and the abstract body with strips and sheets of polished copper and brass. The Kota believe the gleaming surfaces repel evil. The simplified heads have hairstyles flattened out laterally above and beside the face. Geometric ridges, borders, and subdivisions add a textured elegance to the shiny forms. The copper alloy on most of these images is reworked sheet brass (or copper wire) taken from brass basins originating in Europe and traded into equatorial Africa in the 18th and 19th centuries.

The identity of the sculptor of this Kota reliquary figure is unknown, but that is the norm in African art—and indeed in most Western art before the Renaissance, when the modern notion of individual artistic genius took root. *Art through the Ages* surveys the art of all periods from prehistory to the present, and worldwide, and examines how artworks of all kinds have always reflected the historical contexts in which they were created.

BRIEF CONTENTS

PREFACE viii

CHAPTER 32

SOUTH AND SOUTHEAST ASIA, 1200 TO 1980 974

CHAPTER 33

CHINA AND KOREA, 1279 TO 1980 988

CHAPTER 34

JAPAN, 1336 TO 1980 1004

CHAPTER 35

NATIVE ARTS OF THE AMERICAS, 1300 TO 1980 1022

CHAPTER 36

OCEANIA BEFORE 1980 1042

CHAPTER 37

AFRICA, 1800 TO 1980 1060

CHAPTER 31

CONTEMPORARY ART WORLDWIDE 940

NOTES 1080

GLOSSARY 1081

BIBLIOGRAPHY 1085

CREDITS 1089

MUSEUM INDEX 1091

SUBJECT INDEX 1093

CONTENTS

PREFACE viii

CHAPTER 32

SOUTH AND SOUTHEAST ASIA, 1200 TO 1980 974

FRAMING THE ERA | Painting at the Mughal Imperial Court 975

TIMELINE 976

India 976

Southeast Asia 984

■ MATERIALS AND TECHNIQUES: Indian Miniature Painting 979

MAP 32-1 South and Southeast Asia, 1200 to 1980 976

THE BIG PICTURE 987

CHAPTER 33

CHINA AND KOREA, 1279 TO 1980 988

FRAMING THE ERA | The Forbidden City 989

TIMELINE 990

China 990

Korea 1001

- MATERIALS AND TECHNIQUES: Chinese Porcelain 992
- MATERIALS AND TECHNIQUES: Lacquered Wood 995
- MATERIALS AND TECHNIQUES: Calligraphy and Inscriptions on Chinese Paintings 997

MAP 33-1 China during the Ming dynasty 993

THE BIG PICTURE 1003

CHAPTER 34

JAPAN, 1336 TO 1980 1004

FRAMING THE ERA | Famous Views of Edo 1005

TIMELINE 1006

Muromachi 1006

Momoyama 1009

Edo 1012

Meiji and Showa 1017

- RELIGION AND MYTHOLOGY: Zen Buddhism 1007
- ART AND SOCIETY: The Japanese Tea Ceremony 1012
- MATERIALS AND TECHNIQUES: Japanese Woodblock Prints 1016

MAP 34-1 Modern Japan 1006

THE BIG PICTURE 1021

CHAPTER 35

NATIVE ARTS OF THE AMERICAS, 1300 TO 1980 1022

FRAMING THE ERA | The Founding of Tenochtitlán 1023

TIMELINE 1024

Mesoamerica 1024

South America 1029

North America 1032

- RELIGION AND MYTHOLOGY: Aztec Religion 1027
- MATERIALS AND TECHNIQUES: Inka Technology 1030
- ART AND SOCIETY: Gender Roles in Native American Art 1035

MAP 35-1 Mixteca-Puebla and Aztec sites in Mesoamerica 1024

MAP 35-2 Inka sites in Andean South America 1029

MAP 35-3 Later Native American sites in North America 1032

THE BIG PICTURE 1041

CHAPTER 36

OCEANIA BEFORE 1980 1042

FRAMING THE ERA | Maori Men's | Meetinghouses 1043

TIMELINE 1044

Island Cultures of the South Pacific 1044

Australia and Melanesia 1045

Micronesia 1050

Polynesia 1052

- ART AND SOCIETY: Women's Roles in Oceania 1051
- MATERIALS AND TECHNIQUES: Tongan Barkcloth 1053
- ART AND SOCIETY: Tattoo in Polynesia 1055

MAP 36-1 Oceania 1044

THE BIG PICTURE 1059

CHAPTER 37

AFRICA, 1800 TO 1980 1060

FRAMING THE ERA | Kalabari Ijaw Ancestral | Screens | 1061

NOTES 1080

GLOSSARY 1081

BIBLIOGRAPHY 1085

CREDITS 1089

MUSEUM INDEX 1091

SUBJECT INDEX 1093

CHAPTER 31

CONTEMPORARY ART WORLDWIDE 940

FRAMING THE ERA | Art as Sociopolitical Message 941

TIMELINE 942

Social and Political Art 942

Other Movements and Themes 954

Architecture and Site-Specific Art 960

New Media 969

- ART AND SOCIETY: Public Funding of Controversial Art 944
- ARTISTS ON ART: Frank Gehry on Architectural Design and Materials 963
- ART AND SOCIETY: Maya Lin's Vietnam Veterans Memorial 965
- ART AND SOCIETY: Richard Serra's Tilted Arc 967

THE BIG PICTURE 973

PREFACE

THE GARDNER LEGACY IN THE 21ST CENTURY

I take great pleasure in introducing the extensively revised and expanded 14th edition of *Gardner's Art through the Ages: A Global History*, which, like the enhanced 13th edition, is a hybrid art history textbook—the first, and still the only, introductory survey of the history of art of its kind. This innovative new kind of "Gardner" retains all of the best features of traditional books on paper while harnessing 21st-century technology to increase by 25% the number of works examined—without increasing the size or weight of the book itself and at very low additional cost to students compared to a larger book.

When Helen Gardner published the first edition of *Art through the Ages* in 1926, she could not have imagined that more than 85 years later instructors all over the world would still be using her textbook in their classrooms. Indeed, if she were alive today, she would not recognize the book that, even in its traditional form, long ago became—and remains—the most widely read introduction to the history of art and architecture in the English language. During the past half-century, successive authors have constantly reinvented Helen Gardner's groundbreaking global survey, always keeping it fresh and current, and setting an ever-higher standard with each new edition. I am deeply gratified that both professors and students seem to agree that the 13th edition, released in 2008, lived up to that venerable tradition, for they made it the number-one choice for art history survey courses. I hope they will find the 14th edition of this best-selling book exceeds their high expectations.

In addition to the host of new features (enumerated below) in the book proper, the 14th edition follows the enhanced 13th edition in incorporating an innovative new online component. All new copies of the 14th edition are packaged with an access code to a web site with bonus essays and bonus images (with zoom capability) of more than 300 additional important paintings, sculptures, buildings, and other art forms of all eras, from prehistory to the present and worldwide. The selection includes virtually all of the works professors have told me they wished had been in the 13th edition, but were not included for lack of space. I am extremely grateful to Cengage Learning/Wadsworth for the considerable investment of time and resources that has made this remarkable hybrid text-book possible.

In contrast to the enhanced 13th edition, the online component is now fully integrated into the 14th edition. Every one of the

more than 300 bonus images is cited in the text of the traditional book and a thumbnail image of each work, with abbreviated caption, is inset into the text column where the work is mentioned. The integration extends also to the maps, index, glossary, and chapter summaries, which seamlessly merge the printed and online information. The 14th edition is in every way a unified, comprehensive history of art and architecture, even though the text is divided into paper and digital components.

KEY FEATURES OF THE 14TH EDITION

In this new edition, I have added several important features while retaining the basic format and scope of the previous edition. Once again, the hybrid Gardner boasts roughly 1,700 photographs, plans, and drawings, nearly all in color and reproduced according to the highest standards of clarity and color fidelity, including hundreds of new images, among them a new series of superb photos taken by Jonathan Poore exclusively for Art through the Ages during three photographic campaigns in France and Italy in 2009, 2010, and 2011. The online component also includes custom videos made at each site by Sharon Adams Poore. This extraordinary new archive of visual material ranges from ancient Roman ruins in southern France to Romanesque and Gothic churches in France and Tuscany to Le Corbusier's modernist chapel at Ronchamp and the postmodern Pompidou Center and the Louvre Pyramide in Paris. The 14th edition also features the highly acclaimed architectural drawings of John Burge. Together, these exclusive photographs, videos, and drawings provide readers with a visual feast unavailable anywhere else.

The captions accompanying those illustrations contain, as before, a wealth of information, including the name of the artist or architect, if known; the formal title (printed in italics), if assigned, description of the work, or name of the building; the provenance or place of production of the object or location of the building; the date; the material(s) used; the size; and the present location if the work is in a museum or private collection. Scales accompany not only all architectural plans, as is the norm, but also appear next to each photograph of a painting, statue, or other artwork—another unique feature of the Gardner text. The works discussed in the 14th edition of *Art through the Ages* vary enormously in size, from colossal sculptures carved into mountain cliffs and paintings that cover

entire walls or ceilings to tiny figurines, coins, and jewelry that one can hold in the hand. Although the captions contain the pertinent dimensions, it is difficult for students who have never seen the paintings or statues in person to translate those dimensions into an appreciation of the real size of the objects. The scales provide an effective and direct way to visualize how big or how small a given artwork is and its relative size compared with other objects in the same chapter and throughout the book.

Also retained in this edition are the Quick-Review Captions introduced in the 13th edition. Students have overwhelmingly reported that they found these brief synopses of the most significant aspects of each artwork or building illustrated invaluable when preparing for examinations. These extended captions accompany not only every image in the printed book but also all the digital images in the online supplement. Another popular tool introduced in the 13th edition to aid students in reviewing and mastering the material reappears in the 14th edition. Each chapter ends with a full-page feature called The Big Picture, which sets forth in bulletpoint format the most important characteristics of each period or artistic movement discussed in the chapter. Small illustrations of characteristic works accompany the summary of major points. The 14th edition, however, introduces two new features in every chapter: a timeline summarizing the major developments during the era treated (again in bullet-point format for easy review) and a chapteropening essay on a characteristic painting, sculpture, or building. Called *Framing the Era*, these in-depth essays are accompanied by a general view and four enlarged details of the work discussed.

The 14th edition of Art through the Ages is available in several different traditional paper formats—a single hardcover volume; two paperback volumes designed for use in the fall and spring semesters of a yearlong survey course; a six-volume "backpack" set; and an interactive e-book version. Another pedagogical tool not found in any other introductory art history textbook is the Before 1300 section that appears at the beginning of the second volume of the paperbound version of the book and at the beginning of Book D of the backpack edition. Because many students taking the second half of a survey course will not have access to Volume I or to Books A, B, and C, I have provided a special set of concise primers on architectural terminology and construction methods in the ancient and medieval worlds, and on mythology and religion—information that is essential for understanding the history of art after 1300, both in the West and the East. The subjects of these special boxes are Greco-Roman Temple Design and the Classical Orders; Arches and Vaults; Basilican Churches; Central-Plan Churches; The Gods and Goddesses of Mount Olympus; The Life of Jesus in Art; Buddhism and Buddhist Iconography; and Hinduism and Hindu Iconography.

Boxed essays once again appear throughout the book as well. This popular feature first appeared in the 11th edition of *Art through the Ages*, which in 2001 won both the Texty and McGuffey Prizes of the Text and Academic Authors Association for a college textbook in the humanities and social sciences. In this edition the essays are more closely tied to the main text than ever before. Consistent with that greater integration, almost all boxes now incorporate photographs of important artworks discussed in the text proper that also illustrate the theme treated in the boxed essays. These essays fall under six broad categories:

Architectural Basics boxes provide students with a sound foundation for the understanding of architecture. These discussions are concise explanations, with drawings and diagrams, of the major aspects of design and construction. The information included

is essential to an understanding of architectural technology and terminology. The boxes address questions of how and why various forms developed, the problems architects confronted, and the solutions they used to resolve them. Topics discussed include how the Egyptians built the pyramids; the orders of classical architecture; Roman concrete construction; and the design and terminology of mosques, stupas, and Gothic cathedrals.

Materials and Techniques essays explain the various media artists employed from prehistoric to modern times. Since materials and techniques often influence the character of artworks, these discussions contain essential information on why many monuments appear as they do. Hollow-casting bronze statues; fresco painting; Chinese silk; Andean weaving; Islamic tilework; embroidery and tapestry; engraving, etching, and lithography; and daguerreotype and calotype photography are among the many subjects treated.

Religion and Mythology boxes introduce students to the principal elements of the world's great religions, past and present, and to the representation of religious and mythological themes in painting and sculpture of all periods and places. These discussions of belief systems and iconography give readers a richer understanding of some of the greatest artworks ever created. The topics include the gods and goddesses of Egypt, Mesopotamia, Greece, and Rome; the life of Jesus in art; Buddha and Buddhism; Muhammad and Islam; and Aztec religion.

Art and Society essays treat the historical, social, political, cultural, and religious context of art and architecture. In some instances, specific monuments are the basis for a discussion of broader themes, as when the Hegeso stele serves as the springboard for an exploration of the role of women in ancient Greek society. Another essay discusses how people's evaluation today of artworks can differ from those of the society that produced them by examining the problems created by the contemporary market for undocumented archaeological finds. Other subjects include Egyptian mummification; Etruscan women; Byzantine icons and iconoclasm; artistic training in Renaissance Italy; 19th-century academic salons and independent art exhibitions; the Mesoamerican ball game; Japanese court culture; and art and leadership in Africa.

Written Sources present and discuss key historical documents illuminating important monuments of art and architecture throughout the world. The passages quoted permit voices from the past to speak directly to the reader, providing vivid and unique insights into the creation of artworks in all media. Examples include Bernard of Clairvaux's treatise on sculpture in medieval churches; Giovanni Pietro Bellori's biographies of Annibale Carracci and Caravaggio; Jean François Marmontel's account of 18th-century salon culture; as well as texts that bring the past to life, such as eyewitness accounts of the volcanic eruption that buried Roman Pompeii and of the fire that destroyed Canterbury Cathedral in medieval England.

Finally, in the *Artists on Art* boxes, artists and architects throughout history discuss both their theories and individual works. Examples include Sinan the Great discussing the mosque he designed for Selim II; Leonardo da Vinci and Michelangelo debating the relative merits of painting and sculpture; Artemisia Gentileschi talking about the special problems she confronted as a woman artist; Jacques-Louis David on Neoclassicism; Gustave Courbet on Realism; Henri Matisse on color; Pablo Picasso on Cubism; Diego Rivera on art for the people; and Judy Chicago on her seminal work *The Dinner Party*.

For every new edition of *Art through the Ages*, I also reevaluate the basic organization of the book. In the 14th edition, the un-

folding narrative of the history of art in Europe and America is no longer interrupted with "excursions" to Asia, Africa, and Oceania. Those chapters are now grouped together at the end of Volumes I and II and in backpack Books D and F. And the treatment of the art of the later 20th century and the opening decade of the 21st century has been significantly reconfigured. There are now separate chapters on the art and architecture of the period from 1945 to 1980 and from 1980 to the present. Moreover, the second chapter (Chapter 31, "Contemporary Art Worldwide") is no longer confined to Western art but presents the art and architecture of the past three decades as a multifaceted global phenomenon. Furthermore, some chapters now appear in more than one of the paperbound versions of the book in order to provide enhanced flexibility to instructors who divide the global history of art into two or three semester-long courses. Chapter 14—on Italian art from 1200 to 1400—appears in both Volumes I and II and in backpack Books B and D. The Islamic and contemporary art chapters appear in both the Western and non-Western backpack subdivisions of the full global text.

Rounding out the features in the book itself is a greatly expanded Bibliography of books in English with several hundred new entries, including both general works and a chapter-by-chapter list of more focused studies; a Glossary containing definitions of all italicized terms introduced in both the printed and online texts; and, for the first time, a complete museum index listing all illustrated artworks by their present location .

The 14th edition of *Art through the Ages* also features a host of state-of-the-art online resources (enumerated on page xiii).

WRITING AND TEACHING THE HISTORY OF ART

Nonetheless, some things have not changed in this new edition, including the fundamental belief that guided Helen Gardner so many years ago-that the primary goal of an introductory art history textbook should be to foster an appreciation and understanding of historically significant works of art of all kinds from all periods and from all parts of the globe. Because of the longevity and diversity of the history of art, it is tempting to assign responsibility for telling its story to a large team of specialists. The original publisher of Art through the Ages took this approach for the first edition prepared after Helen Gardner's death, and it has now become the norm for introductory art history surveys. But students overwhelmingly say the very complexity of the global history of art makes it all the more important for the story to be told with a consistent voice if they are to master so much diverse material. I think Helen Gardner would be pleased to know that Art through the Ages once again has a single storyteller—aided in no small part by invaluable advice from well over a hundred reviewers and other consultants whose assistance I gladly acknowledge at the end of this Preface.

I continue to believe that the most effective way to tell the story of art through the ages, especially to anyone studying art history for the first time, is to organize the vast array of artistic monuments according to the civilizations that produced them and to consider each work in roughly chronological order. This approach has not merely stood the test of time. It is the most appropriate way to narrate the *history* of art. The principle underlying my approach to every period of art history is that the enormous variation in the form and meaning of the paintings, sculptures, buildings, and other artworks men and women have produced over the past 30,000 years is largely the result of the constantly changing contexts in which

artists and architects worked. A historically based narrative is therefore best suited for a global history of art because it enables the author to situate each work discussed in its historical, social, economic, religious, and cultural context. That is, after all, what distinguishes art history from art appreciation.

In the 1926 edition of Art through the Ages, Helen Gardner discussed Henri Matisse and Pablo Picasso in a chapter entitled "Contemporary Art in Europe and America." Since then many other artists have emerged on the international scene, and the story of art through the ages has grown longer and even more complex. As already noted, that is reflected in the addition of a new chapter at the end of the book on contemporary art in which developments on all continents are treated together for the first time. Perhaps even more important than the new directions artists and architects have taken during the past several decades is that the discipline of art history has also changed markedly—and so too has Helen Gardner's book. The 14th edition fully reflects the latest art historical research emphases while maintaining the traditional strengths that have made previous editions of Art through the Ages so popular. While sustaining attention to style, chronology, iconography, and technique, I also ensure that issues of patronage, function, and context loom large in every chapter. I treat artworks not as isolated objects in sterile 21st-century museum settings but with a view toward their purpose and meaning in the society that produced them at the time they were produced. I examine not only the role of the artist or architect in the creation of a work of art or a building, but also the role of the individuals or groups who paid the artists and influenced the shape the monuments took. Further, in this expanded hybrid edition, I devote more space than ever before to the role of women and women artists in societies worldwide over time. In every chapter, I have tried to choose artworks and buildings that reflect the increasingly wide range of interests of scholars today, while not rejecting the traditional list of "great" works or the very notion of a "canon." Indeed, the expanded hybrid nature of the 14th edition has made it possible to illustrate and discuss scores of works not traditionally treated in art history survey texts without reducing the space devoted to canonical works.

CHAPTER-BY-CHAPTER CHANGES IN THE 14TH EDITION

All chapters feature many new photographs, revised maps, revised Big Picture chapter-ending summaries, and changes to the text reflecting new research and discoveries.

31: Contemporary Art Worldwide. Former 1945–Present chapter significantly expanded and divided into two chapters. This chapter also now includes contemporary non-Western art. New Framing the Era essay "Art as Socio-Political Message" and new timeline. Robert Mapplethorpe, Shahzia Sikander, Carrie Mae Weems, Jean-Michel Basquiat, Kehinde Wiley, Shirin Neshat, Edward Burtynksy, Wu Guanzhong, Emily Kame Kngwarreye, Tara Donovan, Jenny Saville, Marisol, Rachel Whiteread, Andy Goldsworthy, Keith Haring, Andreas Gursky, Zaha Hadid, I.M. Pei, Daniel Libeskind, and green architecture added.

32: South and Southeast Asia, 1200 to 1980. New Framing the Era essay "Painting at the Mughal Imperial Court" and new timeline. Sahifa Banu, Abdul Hasan, and Manohar added.

33: China and Korea, 1279 to 1980. New Framing the Era essay "The Forbidden City" and new timeline. Zhao Mengfu and Ni Zan added.

34: Japan, 1336 to 1980. New Framing the Era essay "Famous Views of Edo" and new timeline. White Heron Castle, Tawaraya Sotatsu, Ando Hiroshige, Kitagawa Utamaro, and Kano Hogai added.

35: Native Arts of the Americas, 1300 to 1980. New Framing the Era essay "The Founding of Tenochtitlán" and new timeline. Expanded discussion of Aztec religion and of the Templo Mayor in Mexico City with recently discovered relief of Tlaltecuhtli. New box on Inka technology. *Codex Mendoza* and Mandan buffalo-hide robe added.

36: Oceania before 1980. New Framing the Era essay "Maori Men's Meetinghouses" and new timeline. *Ambum Stone* and Austral Islands Rurutu added. Expanded discussion of Hawaiian art with new illustrations.

37: Africa, 1800 to 1980. New Framing the Era essay "Kalabari Ijaw Ancestral Screens" and new timeline. Chokwe art and Olowe of Ise's Ikere palace doors added.

Go to the online instructor companion site or PowerLecture for a more detailed list of chapter-by-chapter changes and the figure number transition guide.

ACKNOWLEDGMENTS

A work as extensive as a global history of art could not be undertaken or completed without the counsel of experts in all areas of world art. As with previous editions, Cengage Learning/Wadsworth has enlisted more than a hundred art historians to review every chapter of Art through the Ages in order to ensure that the text lives up to the Gardner reputation for accuracy as well as readability. I take great pleasure in acknowledging here the important contributions to the 14th edition made by the following: Michael Jay Adamek, Ozarks Technical Community College; Charles M. Adelman, University of Northern Iowa; Christine Zitrides Atiyeh, Kutztown University; Gisele Atterberry, Joliet Junior College; Roann Barris, Radford University; Philip Betancourt, Temple University; Karen Blough, SUNY Plattsburgh; Elena N. Boeck, DePaul University; Betty Ann Brown, California State University Northridge; Alexandra A. Carpino, Northern Arizona University; Anne Walke Cassidy, Carthage College; Harold D. Cole, Baldwin Wallace College; Sarah Cormack, Webster University, Vienna; Jodi Cranston, Boston University; Nancy de Grummond, Florida State University; Kelley Helmstutler Di Dio, University of Vermont; Owen Doonan, California State University Northridge; Marilyn Dunn, Loyola University Chicago; Tom Estlack, Pittsburgh Cultural Trust; Lois Fichner-Rathus, The College of New Jersey; Arne R. Flaten, Coastal Carolina University; Ken Friedman, Swinburne University of Technology; Rosemary Gallick, Northern Virginia Community College; William V. Ganis, Wells College; Marc Gerstein, University of Toledo; Clive F. Getty, Miami University; Michael Grillo, University of Maine; Amanda Hamilton, Northwest Nazarene University; Martina Hesser, Heather Jensen, Brigham Young University; Grossmont College; Mark Johnson, Brigham Young University; Jacqueline E. Jung, Yale University; John F. Kenfield, Rutgers University; Asen Kirin, University of Georgia; Joanne Klein, Boise State University; Yu Bong Ko, Tappan Zee High School; Rob Leith, Buckingham Browne & Nichols School; Adele H.

Lewis, Arizona State University; Kate Alexandra Lingley, University of Hawaii-Manoa; Ellen Longsworth, Merrimack College; Matthew Looper, California State University-Chico; Nuria Lledó Tarradell, Universidad Complutense, Madrid; Anne McClanan, Portland State University; Mark Magleby, Brigham Young University; Gina Miceli-Hoffman, Moraine Valley Community College; William Mierse, University of Vermont; Amy Morris, Southeastern Louisiana University; Charles R. Morscheck, Drexel University; Johanna D. Movassat, San Jose State University; Carola Naumer, Truckee Meadows Community College; Irene Nero, Southeastern Louisiana University; Robin O'Bryan, Harrisburg Area Community College; Laurent Odde, Kutztown University of Pennsylvania; E. Suzanne Owens, Lorain County Community College; Catherine Pagani, The University of Alabama; Martha Peacock, Brigham Young University; Mabi Ponce de Leon, Bexley High School; Curtis Runnels, Boston University; Malia E. F. Serrano, Grossmont College; Molly Skjei, Normandale Community College; James Swensen, Brigham Young University; John Szostak, University of Hawaii-Manoa; Fred T. Smith, Kent State University; Thomas F. Strasser, Providence College; Katherine H. Tachau, University of Iowa; Debra Thompson, Glendale Community College; Alice Y. Tseng, Boston University; Carol Ventura, Tennessee Technological University; Marc Vincent, Baldwin Wallace College; Deborah Waite, University of Hawaii-Manoa; Lawrence Waldron, Saint John's University; Victoria Weaver, Millersville University; and Margaret Ann Zaho, University of Central Florida.

I am especially indebted to the following for creating the instructor and student materials for the 14th edition: William J. Allen, Arkansas State University; Ivy Cooper, Southern Illinois University Edwardsville; Patricia D. Cosper, The University of Alabama at Birmingham; Anne McClanan, Portland State University; and Amy M. Morris, Southeastern Louisiana University. I also thank the members of the Wadsworth Media Advisory Board for their input: Frances Altvater, University of Hartford; Roann Barris, Radford University; Bill Christy, Ohio University-Zanesville; Annette Cohen, Great Bay Community College; Jeff Davis, The Art Institute of Pittsburgh–Online Division; Owen Doonan, California State University-Northridge; Arne R. Flaten, Coastal Carolina University; Carol Heft, Muhlenberg College; William Mierse, University of Vermont; Eleanor F. Moseman, Colorado State University; and Malia E. F. Serrano, Grossmont College.

I am also happy to have this opportunity to express my gratitude to the extraordinary group of people at Cengage Learning/ Wadsworth involved with the editing, production, and distribution of Art through the Ages. Some of them I have now worked with on various projects for nearly two decades and feel privileged to count among my friends. The success of the Gardner series in all of its various permutations depends in no small part on the expertise and unflagging commitment of these dedicated professionals, especially Clark Baxter, publisher; Sharon Adams Poore, senior development editor (as well as videographer extraordinaire); Lianne Ames, senior content project manager; Mandy Groszko, rights acquisitions specialist; Kimberly Apfelbaum, associate media editor; Robert White, product manager; Ashley Bargende, assistant editor; Elizabeth Newell, editorial assistant; Amy Bither and Jessica Jackson, editorial interns; Cate Rickard Barr, senior art director; Jeanne M. Heston, senior marketing manager, Heather Baxley, senior marketing communications manager, and the incomparable group of local sales representatives who have passed on to me the welcome advice offered by the hundreds of instructors they speak to daily during their visits to college campuses throughout North America.

I am also deeply grateful to the following out-of-house contributors to the 14th edition: the peerless and tireless Joan Keyes, Dovetail Publishing Services; Helen Triller-Yambert, development editor; Ida May Norton, copy editor; Do Mi Stauber and Michael Brackney, indexers; Susan Gall, proofreader; tani hasegawa, designer; Catherine Schnurr, Mary-Lise Nazaire, Lauren McFalls, and Corey Geissler, PreMediaGlobal, photo researchers; Alma Bell, Scott Paul, John Pierce, and Lori Shranko, Thompson Type; Jay and John Crowley, Jay's Publishing Services; Mary Ann Lidrbauch, art manuscript preparer; and, of course, Jonathan Poore and John Burge, for their superb photos and architectural drawings.

Finally, I owe thanks to my former co-author, Christin J. Mamiya of the University of Nebraska–Lincoln, for her friendship and advice, especially with regard to the expanded contemporary art section of the 14th edition, as well as to my colleagues at Boston University and to the thousands of students and the scores of teaching fellows in my art history courses since I began teaching in 1975. From them I have learned much that has helped determine the form and content of *Art through the Ages* and made it a much better book than it otherwise might have been.

Fred S. Kleiner

FRED S. KLEINER (Ph.D., Columbia University) is the author or coauthor of the 10th, 11th, 12th, and 13th editions of *Art through the Ages: A Global History*, as well as the 1st, 2nd, and 3rd editions of *Art through the Ages: A Concise History*, and more than a hundred publications on Greek and Roman art and architecture, including *A History of Roman Art*, also published by Wadsworth, a part of Cengage Learning. He has taught the art history survey course for more than three decades, first at the University of Virginia and, since 1978, at Boston University, where he is currently Professor of Art History and Archaeology and Chair of the Department of History of Art and Architecture. From 1985 to 1998, he was Editor-in-Chief of the *American Journal of Archaeology*. Long acclaimed for his inspiring lectures and dedication to students, Professor Kleiner

won Boston University's Metcalf Award for Excellence in Teaching as well as the College Prize for Undergraduate Advising in the Humanities in 2002, and he is a two-time winner of the Distinguished Teaching Prize in the College of Arts and Sciences Honors Program. In 2007, he was elected a Fellow of the Society of Antiquaries of London, and, in 2009, in recognition of lifetime achievement in publication and teaching, a Fellow of the Text and Academic Authors Association.

Also by Fred Kleiner: A History of Roman Art, Enhanced Edition (Wadsworth 2010; ISBN 9780495909873), winner of the 2007 Texty Prize for a new college textbook in the humanities and social sciences. In this authoritative and lavishly illustrated volume, Professor Kleiner traces the development of Roman art and architecture from Romulus's foundation of Rome in the eighth century BCE to the death of Constantine in the fourth century CE, with special chapters devoted to Pompeii and Herculaneum, Ostia, funerary and provincial art and architecture, and the earliest Christian art. The enhanced edition also includes a new introductory chapter on the art and architecture of the Etruscans and of the Greeks of South Italy and Sicily.

RESOURCES

FOR FACULTY

PowerLecture with Digital Image Library

This flashdrive is an all-in-one lecture and class presentation tool that makes it easy to assemble, edit, and present customized lectures for your course using Microsoft® PowerPoint®. The Digital Image Library provides high-resolution images (maps, diagrams, and most of the fine art images from the text, including the over 300 new images) for lecture presentations, either in PowerPoint format, or in individual file formats compatible with other image-viewing software. A zoom feature allows you to magnify selected portions of an image for more detailed display in class, or you can display images side by side for comparison. You can easily add your own images to those from the text. The Google Earth™ application allows you to zoom in on an entire city, as well as key monuments and buildings. There are links to specific figures for every chapter in the book. PowerLecture also includes an Image Transition Guide, an electronic Instructor's Manual and a Test Bank with multiplechoice, matching, short-answer, and essay questions in ExamView® computerized format. The text-specific Microsoft® PowerPoint® slides are created for use with JoinIn™, software for classroom personal response systems (clickers).

WebTutor™ with eBook on WebCT® and Blackboard®

WebTutor™ enables you to assign preformatted, text-specific content that is available as soon as you log on. You can also customize the WebTutor™ environment in any way you choose. Content includes the Interactive ebook, Test Bank, Practice Quizzes, Video Study Tools, and CourseMate™.

To order, contact your Cengage Learning representative.

FOR STUDENTS

CourseMateTM with eBook

Make the most of your study time by accessing everything you need to succeed in one place. Open the interactive eBook, take notes, review image and audio flashcards, watch videos, and take practice quizzes online with CourseMate™. You will find hundreds of zoomable, high-resolution bonus images (represented by thumbnail images in the text) along with discussion of the images, videos created specifically to enhanced your reading comprehension, audio chapter summaries, compare-and-contrast activities, Guide to Studying, and more.

Slide Guides

The Slide Guide is a lecture companion that allows you to take notes alongside thumbnails of the same art images that are shown in class. This handy booklet includes reproductions of the images from the book with full captions, page numbers, and space for note taking. It also includes Google Earth™ exercises for key cities, monuments, and buildings that will take you to these locations to better understand the works you are studying.

To order, go to www.cengagebrain.com

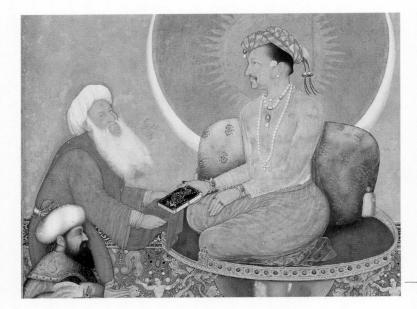

In this allegorical portrait of Emperor Jahangir on an hourglass throne, the Mughal ruler appears with a radiant halo behind him and sits above time, favoring spiritual power over worldly power.

Bichitr included a copy of a portrait of King James I to underscore that the Mughal emperor Jahangir preferred the wisdom of an elder Sufi mystic saint to the counsel of the British monarch.

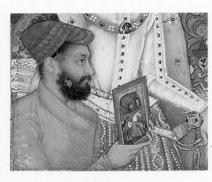

The artist not only signed this painting but inserted a self-portrait. Bichitr bows before Jahangir and holds a painting of two horses and an elephant, costly gifts to the painter from the emperor.

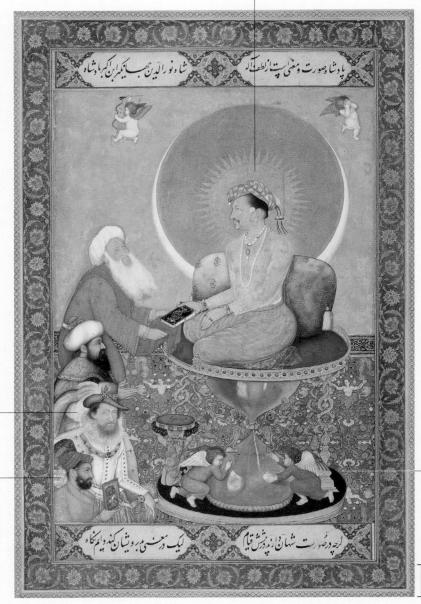

32-1 BICHITR, Jahangir Preferring a Sufi Shaykh to Kings, ca. 1615–1618. Opaque watercolor on paper, $1' 6\frac{7}{8}'' \times 1' 1''$. Freer Gallery of Art, Washington, D.C.

1 in

32

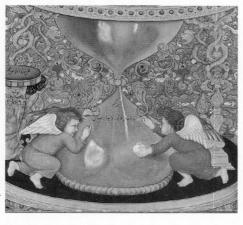

As the sands of time run out, two cupids (clothed, unlike their European prototypes) inscribe Jahangir's hourglass throne with a wish for the Mughal emperor to live a thousand years.

SOUTH AND SOUTHEAST ASIA, 1200 TO 1980

PAINTING AT THE MUGHAL IMPERIAL COURT

From the 16th to the 19th century, the most powerful rulers in South Asia were the Mughal emperors. *Mughal*, originally a Western term, means "descended from the Mongols," although the Mughals considered themselves descendants of Timur (r. 1370–1405), the Muslim conqueror whose capital was at Samarkand in Uzbekistan. The Mughal dynasty presided over a cosmopolitan court with refined tastes. British ambassadors and merchants were frequent visitors, and the Mughal emperors acquired many European luxury goods. They were also great admirers of Persian art and maintained an imperial workshop of painters who, in sharp contrast to pre-Mughal artists in India, often signed their works.

The influence of European as well as Persian styles on Mughal painting is evident in the allegorical portrait (FIG. 32-1) BICHITR painted of Jahangir (r. 1605–1627), the great-grandson of the founder of the Mughal Empire. The emperor sits on an hourglass throne. As the sands of time run out, two cupids (clothed, unlike their European models more closely copied at the top of the painting) inscribe the throne with the wish that Jahangir would live a thousand years. Bichitr portrayed his patron as an emperor above time and placed behind Jahangir's head a radiant halo combining a golden sun and a white crescent moon, indicating Jahangir is the center of the universe and its light source. One of the inscriptions on the painting gives the emperor's title as "Light of the Faith."

At the left are four figures. The lowest, both spatially and in the social hierarchy, is the Hindu painter Bichitr himself, wearing a red turban. He holds a painting representing two horses and an elephant, costly gifts to him from Jahangir, and another self-portrait. In the painting-within-the-painting, Bichitr bows deeply before the emperor. In the larger painting, the artist signed his name across the top of the footstool Jahangir uses to step up to his hourglass throne. Thus, the ruler steps on Bichitr's name, further indicating the painter's inferior status.

Above Bichitr is a portrait in full European style (compare FIGS. 23-11, 23-11A, and 23-12) of King James I of England (r. 1603–1625), copied from a painting by John de Critz (ca. 1552–1642) that the English ambassador to the Mughal court had given as a gift to Jahangir. Above the king is a Turkish sultan, a convincing study of physiognomy but probably not a specific portrait. The highest member of the foursome is an elderly Muslim Sufi *shaykh* (mystic saint). Jahangir's father, Akbar, had gone to the mystic to pray for an heir. The current emperor, the answer to Akbar's prayers, presents the holy man with a sumptuous book as a gift. An inscription explains that "although to all appearances kings stand before him, Jahangir looks inwardly toward the dervishes [Islamic holy men]" for guidance. Bichitr's allegorical painting portrays his emperor in both words and pictures as favoring spiritual over worldly power.

INDIA

Arab armies first appeared in South Asia (MAP 32-1)—at Sindh in present-day Pakistan—in 712, more than 800 years before the founding of the Mughal Empire. With the Arabs came Islam, the new religion that had already spread with astonishing speed from the Arabian peninsula to Syria, Iraq, Iran, Egypt, North Africa, and even southern Spain (see Chapter 10). At first, the Muslims (see "Muhammad and Islam," Chapter 10, page 285) established trading settlements in South Asia but did not press deeper into the subcontinent. At the Battle of Tarain in 1192, however,

Muhammad of Ghor (Afghanistan) defeated the armies of a confederation of independent states. The Ghorids and other Islamic rulers gradually transformed South Asian society, religion, art, and architecture.

Sultanate of Delhi

In 1206, Qutb al-Din Aybak, Muhammad of Ghor's general, established the Sultanate of Delhi (1206–1526). On his death in 1211, he passed power to his son Iltutmish (r. 1211–1236), who extended Ghorid rule across northern India.

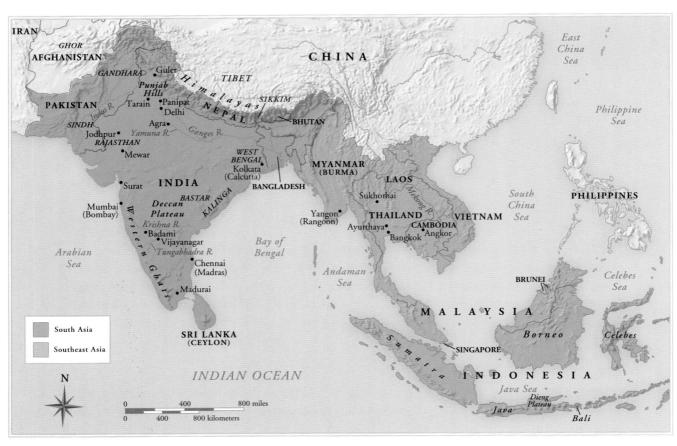

MAP 32-1 South and Southeast Asia, 1200 to 1980.

1200

SOUTH AND SOUTHEAST ASIA, 1200 TO 1980

1600

I Arabs establish the Muslim Sultanate of Delhi (1206–1526) and introduce Islamic art and architecture to northern India

In the south, Hindu kings rule the Vijayanagar Empire (1336–1565) and construct buildings mixing elements of both Hindu and Islamic architecture

- Miniature painting flourishes in the Mughal Empire (1526–1857)
- Muslim builders construct the Taj Mahal at Agra
- Rajput painters in northwestern India produce vividly colored miniature paintings with Hindu subjects
- The southern Nayak dynasty (1529–1736) builds towering Hindu temple precinct gateways decorated with painted stucco
- Buddhism and Buddhist art and architecture dominate Southeast Asia
- Queen Victoria I of England becomes Empress of India in 1877. Europeaninspired art and architecture accompany colonial rule

1980

1900

I India and Pakistan achieve independence in 1947. Post-World War II art in South and Southeast Asia is a mix of traditional and Western modernist styles

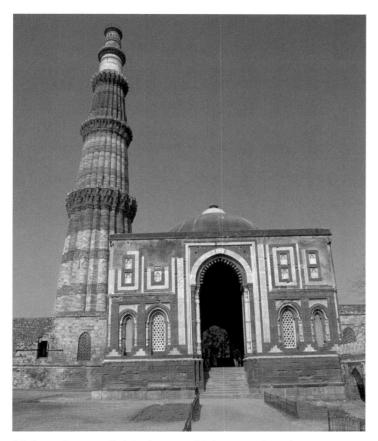

32-2 Qutb Minar (*left*, looking north), begun early 13th century, and Alai Darvaza (*right*), 1311, Delhi, India. ■◀

Qutb al-Din Aybak established the Sultanate of Delhi in 1206 and built the city's first mosque to mark the triumph of Islam in northern India. The 238-foot-high Qutb Minar is the world's tallest minaret.

QUTB MINAR To mark the triumph of Islam, Qutb al-Din Aybak built a great *congregational mosque* (see "The Mosque," Chapter 10, page 288) at Delhi, in part with pillars taken from Hindu and other temples. He named Delhi's first mosque the Quwwat al-Islam

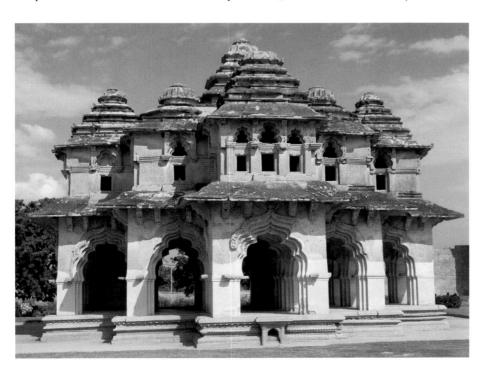

(Might of Islam) Mosque. During the course of the next century, as the Islamic population of Delhi grew, the *sultans* (Muslim rulers) enlarged the mosque to more than triple its original size. Iltumish erected the mosque's 238-foot tapering sandstone *minaret*, the Qutb Minar (FIG. **32-2**, *left*)—the tallest extant mosque tower in the world. It is too tall, in fact, to serve the principal function of a minaret—to provide a platform from which to call the Islamic faithful to prayer. Rather, it is a soaring monument to the victory of Islam, engraved with inscriptions in Arabic and Persian proclaiming the minaret casts the shadow of Allah (God) over the conquered Hindu city. Added in 1311, the Alai Darvaza, the entrance pavilion (FIG. 32-2, *right*), is a mix of architectural traditions, combining Islamic *pointed arches*, decorative grills over the windows, and a hemispherical *dome*, with a crowning *finial* recalling the motifs at the top of many Hindu temple towers (see Chapter 15).

Vijayanagar Empire

While Muslim sultans from Central Asia ruled much of northern India from Delhi, Hindu kings controlled most of central and southern India. The most powerful Hindu dynasty of the era was the Vijayanagar. Established in 1336 by Harihara, a local king, the Vijayanagar Empire (1336–1565) takes its name from Vijayanagara (City of Victory) on the Tungabhadra River. Under the patronage of the royal family, Vijayanagara, located at the junction of several trade routes through Asia, became one of the most magnificent cities in the East. Although the capital lies in ruins today, at its peak ambassadors and travelers from as far away as Italy and Portugal marveled at Vijayanagara's riches. Under its greatest king, Krishnadevaraya (r. 1509–1529), who was also a renowned poet, the Vijayanagar kingdom was a magnet for the learned and cultured from all corners of India.

LOTUS MAHAL Vijayanagara's sacred center, built up over two centuries, boasts imposing temples to the Hindu gods in the style of southern India with tall pyramidal *vimanas* (towers) over the *garbha griha*, "the inner sanctuary" (see "Hindu Temples," Chapter 15, page 439). The buildings of the so-called Royal Enclave are more eclectic in character. One example in this prosperous royal city is the two-story monument of uncertain function known as

the Lotus Mahal (FIG. 32-3). The stepped towers crowning the vaulted second-story rooms resemble the pyramidal roofs of southern Indian temple vimanas (FIG. 15-23). But the windows of the upper level as well as the arches of the ground-floor piers have the distinctive multilobed contours of Islamic architecture (FIGS. 10-10 and 10-11). The Lotus Mahal, like the entrance pavilion of Delhi's first mosque (FIG. 32-2, *right*), exemplifies the stylistic crosscurrents typical of much of South Asian art and architecture of the second millennium.

32-3 Lotus Mahal (looking southwest), Vijayanagara, India, 15th or early 16th century.

The Vijayanagar Empire was the most powerful Hindu kingdom in southern India during the 14th to 16th centuries. The Lotus Mahal is an eclectic mix of Hindu and Islamic architectural elements.

Mughal Empire

The 16th century was a time of upheaval in South Asia. In 1565, only a generation after Krishnadevaraya, a confederacy of sultanates in the Deccan plateau of central India brought the Vijayanagar Empire of the south to an end. Even earlier, a Muslim prince named Babur had defeated the last of the Ghorid sultans of northern India at the Battle of Panipat. Declaring himself the ruler of India, Babur established the Mughal Empire (1526–1857) at Delhi. In 1527, Babur vanquished the Rajput Hindu kings of Mewar (see page 980). By the time of his death in 1530, Babur headed a vast new empire in India.

HUMAYUN The emperor who succeeded Babur was Humayun (r. 1530–1556), but in 1543 the sultan of Gujarat temporarily wrested control of the Mughal Empire. Humayun sought sanctuary in Iran at the court of the Safavid ruler Shah Tahmasp (r. 1524–1576; FIG. 32-5) and remained in exile until 1555. During his years at the Safavid court, the Mughal emperor acquired a taste for Persian illustrated books. Upon his return to power, Humayun brought with him to Delhi two Safavid master painters. Pupils of the renowned Bihzad (FIG. 10-29), they in turn trained a generation of Mughal artists.

AKBAR THE GREAT The first great flowering of Mughal art and architecture occurred during the long reign of Humayun's son, Akbar (r. 1556–1605), called the Great, who ascended the throne at age 14. Like his father, Akbar was a great admirer of the narrative paintings (FIG. 10-29) produced at the Safavid court. The young ruler enlarged the number of painters in Humayun's imperial workshop to about a hundred and kept them busy working on a series of ambitious projects. One of these was to illustrate the text of the *Hamzanama*—the story of Hamza, Muhammad's uncle—in some 1,400 large paintings on cloth. The assignment took 15 years to complete.

The illustrated books and engravings that traders, diplomats, and Christian missionaries brought from Europe to India also fascinated Akbar. In 1580, Portuguese Jesuits brought one particularly important source, the eight-volume *Royal Polyglot Bible*, as a gift to Akbar. This massive set of books, printed in Antwerp, contained engravings by several Flemish artists. Akbar immediately set his painters to copying the illustrations.

AKBARNAMA Akbar also commissioned Abul Fazl (1551–1602), a member of his court and close friend, to chronicle his life in a great biography, the Akbarnama (History of Akbar), which the emperor's painters illustrated. One of the full-page illustrations, or so-called miniatures (see "Indian Miniature Painting," page 979), in the emperor's personal copy of the Akbarnama was a collaborative effort between the painter BASAWAN, who designed and drew the composition, and Chatar Muni, who colored it. The painting (FIG. 32-4) depicts the episode of Akbar and Hawai, a wild elephant the 19-year-old ruler mounted and pitted against another ferocious elephant. When the second animal fled in defeat, Hawai, still carrying Akbar, chased it to a pontoon bridge. The enormous weight of the elephants capsized the boats, but Akbar managed to bring Hawai under control and dismount safely. The young ruler viewed the episode as an allegory of his ability to govern—that is, to take charge of an unruly state.

For his pictorial record of that frightening day, Basawan chose the moment of maximum chaos and danger—when the elephants crossed the pontoon bridge, sending boatmen flying into the water. The composition is a bold one, with a very high horizon and two strong diagonal lines formed by the bridge and the shore. Together

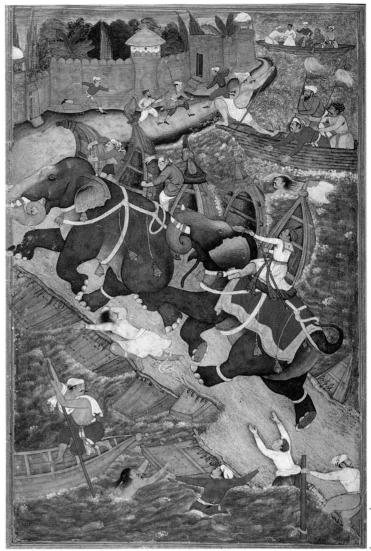

32-4 Basawan and Chatar Muni, *Akbar and the Elephant Hawai*, folio 22 from the *Akbarnama* (*History of Akbar*) by Abul Fazl, ca. 1590. Opaque watercolor on paper, $1' 1\frac{7''}{8} \times 8\frac{3''}{4}$. Victoria & Albert Museum, London.

For this miniature portraying the young emperor Akbar bringing an elephant under control, Basawan chose the moment of maximum danger. The episode is an allegory of Akbar's ability to rule.

these devices tend to flatten out the vista, yet at the same time Basawan created a sense of depth by diminishing the size of the figures in the background. He was also a master of vivid gestures and anecdotal detail. Note especially the bare-chested figure in the foreground clinging to the end of a boat, the figure near the lower right corner with outstretched arms sliding into the water as the bridge sinks, and the oarsman just beyond the bridge who strains to steady his vessel while his three passengers stand up or lean overboard in reaction to the surrounding commotion.

SAHIFA BANU Another Mughal miniaturist whose name is known is Sahifa Banu (active early 17th century), a princess in the court of Jahangir (FIGS. 32-1 and 32-5A) and the most renowned female artist of the Mughal Empire. In one of her miniatures (FIG. 32-5), she paid tribute to Shah Tahmasp of Iran, the great patron of Safavid painting who sent two of his masters to Delhi to train the

Indian Miniature Painting

lthough India had a tradition of mural painting going back to ancient times (see "The Painted Caves of Ajanta," Chapter 15, page 433, and FIG. 15-15), the most popular form of painting under the Mughal emperors (FIGS. 32-1, 32-4, 32-5, and 32-5A) and Rajput kings (FIGS. 32-7 and 32-7A) was miniature painting. Art historians usually call these paintings miniatures because of their small size (about the size of a page in this book) compared with paintings on walls, wood panels, or canvas, but the original terminology derives from the red lead (miniatum) used as a pigment. The artists who painted

32-5 Sahifa Banu, Shah Tahmasp Meditating, early 17th century. Opaque watercolor on paper, figure panel $6'' \times 3\frac{5}{8}''$. Victoria & Albert Museum, London.

This miniature by one of the few known Mughal women artists depicts the Persian emperor Shah Tahmasp. Two of his court painters went to India to train Mughal imperial book illustrators.

the Indian miniatures designed them to be held in the hands, either as illustrations in books or as loose-leaf pages in albums. Owners did not place Indian miniatures in frames and only very rarely hung them on walls.

Indian artists used opaque watercolors and paper (occasionally cotton cloth) to produce their miniatures. The manufacturing and painting of miniatures was a complicated process and required years of training as an apprentice in a workshop. The painters' assistants created pigments by grinding natural materials—minerals such as malachite for green and lapis lazuli for blue; earth ochers for red and yellow; and metallic foil for gold, silver, and copper. They fashioned brushes from bird quills and kitten or baby squirrel hairs. For minute details, the painters used brushes with a single hair.

The artist began the painting process by making a full-size sketch of the composition. The next step was to transfer the sketch onto paper by *pouncing*, or tracing, using thin, transparent gazelle skin placed on top of the drawing and pricking the contours of the design with a pin. Then, with the skin laid on a fresh sheet of fine paper, the painter forced black pigment through the tiny holes, reproducing the outlines of the composition. Painting proper started with the darkening of the outlines with black or reddish brown ink. Painters of miniatures sat on the ground, resting their painting boards on one raised knee. Each pigment color was in a separate half seashell. The paintings usually required several

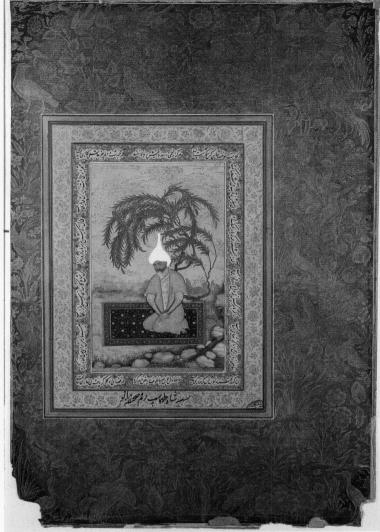

layers of color, with gold always applied last. The final step was to burnish the painted surface. The artists accomplished this by placing the miniature, painted side down, on a hard, smooth surface and stroking the paper with polished agate or crystal.

early Mughal miniaturists at the court of Humayun. The Safavid ruler sits in meditation on a magnificent Persian carpet at the edge of a stream underneath the windblown branches of a tree. As in other Mughal paintings (FIGS. 32-1, 32-4, and 32-5A)—in sharp contrast to the almost obsessive interest in linear perspective in contemporaneous Eu-

32-5A ABDUL HASAN and MANOHAR, *Darbar of Jahangir*, ca. 1620.

ropean painting—the Indian artist combined different viewpoints in the same frame, depicting the shah and the tree seen from eye level, and the carpet, ground, and stream seen from above. This composition enabled the princess to reproduce the intricate design of the woven carpet (compare FIG. 10-27) with pristine clarity and without the distortion that would have resulted from foreshortening the textile patterns. In fact, the miniature itself, with its decorative border, has a textilelike quality and resembles Tahmasp's carpet in both format and proportions. The frame around Banu's portrait of Tahmasp also features elegant calligraphy. Although female painters were rare during the Mughal Empire, many court women were accomplished calligraphers.

32-6 Taj Mahal (looking north), Agra, India, 1632-1647. ■

This Mughal mausoleum seems to float magically over reflecting pools in a vast garden. The tomb may have been conceived as the throne of God perched above the gardens of Paradise on judgment day.

TAJ MAHAL Monumental tombs were not part of either the Hindu or Buddhist traditions but had a long history in Islamic architecture. The Delhi sultans had erected tombs in India, but none could compare in grandeur to the fabled Taj Mahal (FIG. 32-6) at Agra. Shah Jahan (r. 1628-1658), Jahangir's son, built the immense mausoleum as a memorial to his favorite wife, Mumtaz Mahal (1593-1631), although it eventually became the ruler's tomb as well. The dome-oncube shape of the central block has antecedents in earlier Islamic mausoleums (FIGS. 10-8 and 10-22) and other Islamic buildings such as the Alai Darvaza (FIG. 32-2, right) at Delhi, but modifications and refinements in the design of the Agra tomb converted the earlier massive structures into an almost weightless vision of glistening white marble. The Agra mausoleum seems to float magically above the tree-lined reflecting pools punctuating the garden leading to it. Reinforcing the illusion of the marble tomb being suspended above water is the absence of any visible means of ascent to the upper platform. A stairway does exist, but the architect intentionally hid it from the view of anyone approaching the memorial.

The Taj Mahal follows the plan of Iranian garden pavilions, except the building stands at one end rather than in the center of the formal garden. The tomb is octagonal in plan and has typically Iranian arcuated niches (FIG. 10-26) on each side. The interplay of shadowy voids with light-reflecting marble walls that seem paper-thin creates an impression of translucency. The pointed arches lead the eye in a sweeping upward movement toward the climactic dome, shaped like a crown (*taj*). Four carefully related minarets and two flanking triple-domed pavilions (not visible in FIG. 32-6) enhance and stabilize the soaring form of the mausoleum. The architect achieved this delicate balance between verticality and horizontality by strictly applying an all-encompassing system of proportions. The Taj Mahal (excluding the minarets) is exactly as wide as it is tall, and the height of its dome is equal to the height of the facade.

Abd al-Hamid Lahori (d. 1654), a court historian who witnessed the construction of the Taj Mahal, compared its minarets with ladders reaching toward Heaven and the surrounding gardens to Paradise. In fact, inscribed on the gateway to the gardens and the walls of the mausoleum are carefully selected excerpts from the Koran confirming the historian's interpretation of the tomb's symbolism. The designer of the Taj Mahal may have conceived the mausoleum as the throne of God perched above the gardens of Paradise on judgment day. The minarets hold up the canopy of that throne. In Islam, the most revered place of burial is beneath the throne of God.

Hindu Rajput Kingdoms

The Mughal emperors ruled vast territories, but much of north-western India (present-day Rajasthan) remained under the control of Hindu Rajput (sons of kings) rulers. These small kingdoms, some claiming to have originated well before 1500, had stubbornly resisted Mughal expansion, but even the strongest of them—Mewar—eventually submitted to the Mughal emperors. When Jahangir defeated the Mewari forces in 1615, the Mewari maharana

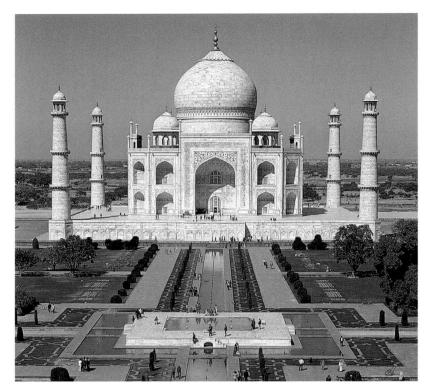

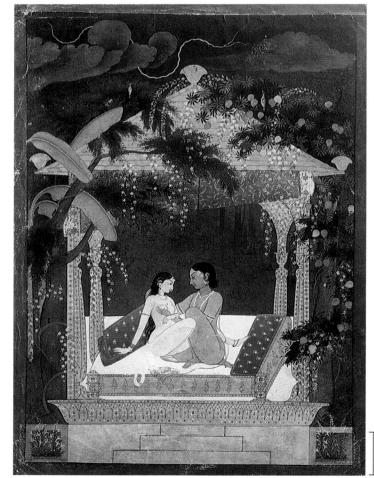

32-7 Krishna and Radha in a Pavilion, ca. 1760. Opaque watercolor on paper, $11\frac{1}{3}^{"} \times 7\frac{3}{4}^{"}$. National Museum, New Delhi.

The love of Krishna, the "Blue God," for Radha is the subject of this colorful, lyrical, and sensual Pahari watercolor. Krishna's love was a model of the devotion paid to the Hindu god Vishnu.

1 ir

(great king), like the other Rajput rulers, maintained a degree of independence but had to pay tribute to the Mughal treasury until the demise of the Mughal Empire in 1857.

Rajput painting resembles Mughal (and Persian) painting in format and material, but it differs sharply in other respects. Most Rajput artists, for example, worked in anonymity, never inserting self-portraits into their paintings as the Mughal painter Bichitr did in his miniature (FIG. 32-1) of Jahangir sitting on an hourglass throne

KRISHNA AND RADHA One of the most popular subjects for Rajput paintings was the amorous adventures of Krishna, the "Blue God," the most popular of the *avatars*, or incarnations, of the Hindu god Vishnu, who descends to earth to aid mortals (see "Hinduism," Chapter 15, page 435, or page xxxiii in Volume II and Book D). Krishna was a herdsman who spent an idyllic existence tending his cows, playing the flute, and sporting with beautiful herdswomen. His favorite lover was Radha. The 12th-century poet Jayadeva re-

32-7A Krishna and the Gopis ca. 1550.

lated the story of Krishna and Radha in the *Gita Govinda* (*Song of the Cowherd*). Their love was a model of the devotion, or *bhakti*, paid to Vishnu. Jayadeva's poem was the source for hundreds of later paintings, including *Krishna and Radha in a Pavilion* (FIG. **32-7**) and *Krishna and the Gopis* (FIG. **32-7**A).

Krishna and Radha in a Pavilion was the work of an artist in the Punjab Hills, probably in the employ of Raja Govardhan Chand

of Guler (r. 1741–1773). The artists producing paintings for the rulers of the Punjab Hill states—referred to collectively as the Pahari School—had a distinctive style. Although Pahari painting owed much to Mughal drawing style, its coloration, lyricism, and sensuality are readily recognizable. In the Krishna and Radha miniature, the lovers sit naked on a bed beneath a jeweled pavilion in a lush garden of ripe mangoes and flowering shrubs. Krishna gently touches Radha's breast while looking directly into her face. Radha shyly averts her gaze. It is night, the time of illicit trysts, and the dark monsoon sky momentarily lights up with a lightning flash indicating the moment's electric passion. Lightning is one of the standard symbols used in Rajput and Pahari miniatures to represent sexual excitement.

Nayak Dynasty

The Nayakas, governors under the Vijayanagar kings, declared their independence in 1529, and after their former overlords' defeat in 1565 at the hands of the Deccan sultanates, they continued Hindu rule in the far south of India for two centuries (1529–1736).

GREAT TEMPLE, MADURAI Construction of some of the largest temple complexes in India occurred under Nayak patronage. The most striking features of these huge complexes are their gateway towers called *gopuras* (FIG. 32-8), decorated from top to bottom with painted sculptures. After erecting the gopuras, the builders constructed walls to connect them and then built more gopuras, always expanding outward from the center. Each set of gopuras was taller than those of the previous wall circuit. The outermost towers reached colossal size, dwarfing the temples at the heart

of the complexes. The tallest gopuras of the Great Temple at Madurai, dedicated to Shiva (under his local name, Sundareshvara, the Handsome One) and his consort Minakshi (the Fish-eyed One), stand about 150 feet tall. Rising in a series of tiers of diminishing size, they culminate in a barrel-vaulted roof with finials. The ornamentation is extremely rich, consisting of row after row of brightly painted stucco sculptures representing the vast pantheon of Hindu deities and a host of attendant figures. Reconsecration of the temple occurs at 12-year intervals, at which time the gopura sculptures receive a new coat of paint, which accounts for the vibrancy of their colors today. The Madurai Nayak temple complex also contains large and numerous mandapas, as well

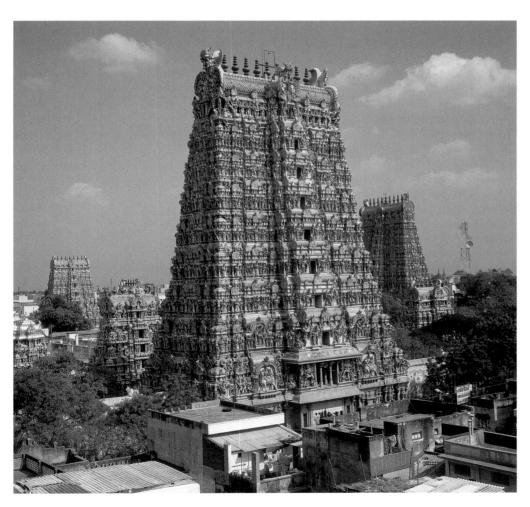

32-8 Outermost gopuras of the Great Temple (looking southeast), Madurai, India, completed 17th century.

The colossal gateway towers erected during the Nayak dynasty at the Great Temple at Madurai feature brightly painted stucco sculptures representing the vast pantheon of Hindu deities. as great water tanks worshipers use for ritual bathing. These temples were, and continue to be, almost independent cities, with thousands of pilgrims, merchants, and priests flocking from near and far to the many yearly festivals hosted by the temples.

The British in India

English merchants first arrived in India toward the end of the 16th century, attracted by the land's spices, gems, and other riches. On December 31, 1599, Queen Elizabeth I (r. 1558-1603) granted a charter to the East India Company, which sought to compete with the Portuguese and Dutch in the lucrative trade with South Asia. The company established a "factory" (trading post) at the port of Surat, approximately 150 miles from Mumbai (Bombay) in western India in 1613. After securing trade privileges with the Mughal emperor Jahangir, the British expanded their factories to Chennai (Madras), Kolkata (Calcutta), and Mumbai by 1661. These outposts gradually spread throughout India, especially after the British defeat of the ruler of Bengal in 1757. By the opening of the 19th century, the East India Company effectively ruled large portions of the subcontinent, and in 1835, the British declared English India's official language. A great rebellion in 1857 persuaded the British Parliament the East India Company could no longer be the agent of British rule. The next year Parliament abolished the company and replaced its governor-general with a viceroy of the

crown. Two decades later, in 1877, Queen Victoria (r. 1837–1901) assumed the title Empress of India with sovereignty over all the former Indian states.

VICTORIA TERMINUS The British brought the Industrial Revolution and railways to India. One of the most enduring monuments of British rule, still used by millions of travelers, is Victoria Terminus (FIG. 32-9) in Mumbai, named at the time of its construction for the first British empress of India (but now called Chhatrapati Shivaji Terminus). A British architect, Frederick W. Stevens (1847-1900), was the designer. Construction of the giant railway station began in 1878 and took a decade to complete. Although built of the same local sandstone used for temples and statues throughout India's long history, Victoria Terminus is a European transplant to the subcontinent, the architectural counterpart of colonial rule. Conceived as a cathedral to modernization, the terminus fittingly has an allegorical statue of Progress crowning its tallest dome. Nonetheless, the building's design looks backward, not forward. Inside, passengers gaze up at groin-vaulted ceilings and stainedglass windows, and the exterior of the station resembles a Western church with a gabled facade and flanking towers. Stevens modeled Victoria Terminus, with its tiers of screened windows, on the architecture of late medieval and Renaissance Venice (FIGS. 14-21 and 21-37A).

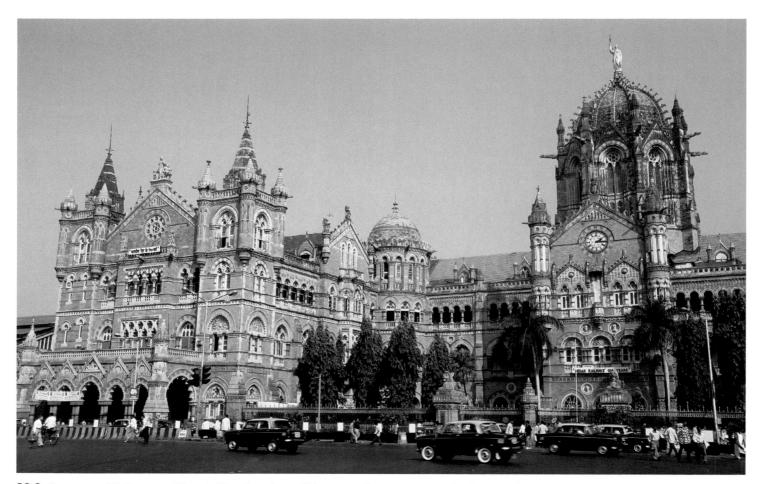

32-9 FREDERICK W. STEVENS, Victoria Terminus (now Chhatrapati Shivaji Terminus; looking northeast), Mumbai (Bombay), India, 1878–1887. Victoria Terminus, named after Queen Victoria of England, is a monument to colonial rule. Designed by a British architect, it is a European transplant to India, modeled on late medieval Venetian architecture.

JASWANT SINGH With British rulers and modern railways also came British or, more generally, European ideas, but Western culture and religion never supplanted India's own rich traditions. Many Indians, however, readily took on the trappings of European society. When Jaswant Singh, the ruler of Jodhpur (r. 1873-1895) in Rajasthan, sat for his portrait (FIG. 32-10) around 1880, he chose to sit in an ordinary chair, rather than on a throne, with his arm resting on a simple table with a bouquet and a book on it. In other words, he posed as if he were an ordinary British gentleman in his sitting room. Nevertheless, the painter, an anonymous local artist who had embraced Western style, left no question about Jaswant Singh's regal presence and pride. The ruler's powerful chest and arms, along with the sword and his leather riding boots, indicate his abilities as a warrior and hunter. The curled beard signified fierceness to Indians of that time. The unflinching gaze records the ruler's confidence. Perhaps the two necklaces Jaswant Singh wears best exemplify the combination of his two worlds. One necklace is a bib of huge emeralds and diamonds, the heritage of the wealth and splendor of his family's rule. The other, a wide gold band with a cameo, is the Order of the Star of India, a high honor his British overlords bestowed on him.

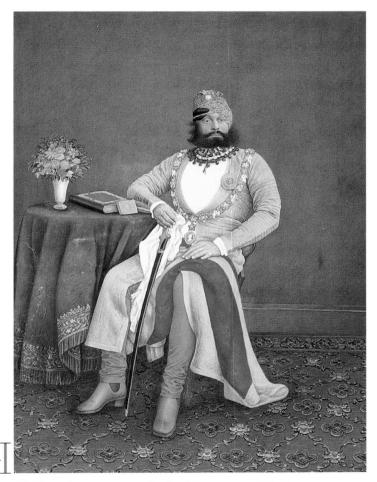

32-10 Maharaja Jaswant Singh of Marwar, ca. 1880. Opaque watercolor on paper, 1' $3\frac{1}{2}'' \times 11\frac{5}{8}''$. Brooklyn Museum, Brooklyn (gift of Mr. and Mrs. Robert L. Poster).

Jaswant Singh, the ruler of Jodhpur, had himself portrayed as a British gentleman in his sitting room, but the artist employed the same materials Indian miniature painters had used for centuries.

The painter of this portrait worked on the same scale and employed the same materials—opaque watercolor on paper—Indian miniature painters had used for centuries, but the artist copied the ruler's likeness from a photograph. This accounts in large part for the realism of the portrait. Indian artists sometimes even painted directly on top of photographs. Photography arrived in India at an early date. In 1840, just one year after its invention in Paris, the *daguerreotype* (FIG. 27-48) was introduced in Calcutta. Indian artists readily adopted the new medium, not just to produce portraits but also to record landscapes and monuments.

In 19th-century India, however, admiration of Western art and culture was by no means universal. At the end of the century, Abanindranath Tagore (1871–1951) founded a nationalistic art movement, and the opening decades of the 20th century brought ever-louder calls for Indian self-government. Under the leadership of Mahatma Gandhi (1869–1948) and others, India achieved independence in 1947—not, however, as a unified state but as the predominantly Hindu and Muslim nations of India and Pakistan respectively.

20th Century

Modern art in India is as multifaceted a phenomenon as modern art is elsewhere in the world. Many traditional artists work at the village level, making images of deities for local use out of inexpensive materials, such as clay, plaster, and papier-mâché. Some urban artists use these same materials to produce elaborate religious tableaux, such as depictions of the goddess Durga killing the buffalo demon for the annual 10-day Durga Festival in Calcutta. Participants in the festival often ornament the tableaux with thousands of colored electric lights. The most popular art form for religious imagery, however, is the brightly colored print, sold for only a few rupees each.

Many contemporary artists, in contrast, create works for the international market. Although many of them received their training in South or Southeast Asia or Japan, others attended schools in Europe or the United States, and some, for example, Shahzia Sikander (FIG. 31-5), now work outside their home countries. They face one of the fundamental quandaries of many contemporary Asian artists—how to identify themselves and situate their work between local and international, traditional and modern, and non-Western and Western cultures.

MEERA MUKHERJEE One Indian artist who successfully bridged these two poles of modern Asian artwas Meera Mukherjee (1923-1998). Mukherjee studied with European masters in Germany, but when she returned to India, she rejected much of what she had learned in favor of the techniques long employed by traditional sculptors of the Bastar tribe in central India. Mukherjee went to live with Bastar bronze-casters, who had perfected a variation on the classic lost-wax process (see "Hollow-Casting Life-Size Bronze Statues," Chapter 5, page 130). Beginning with a rough core of clay, the Bastar sculptors build up what will be the final shape of the statue by placing long threads of beeswax over the core. Then they apply a coat of clay paste to the beeswax and tie up the mold with metal wire. After heating the mold over a charcoal fire, which melts the wax away, they pour liquid bronze into the space once occupied by the wax threads. Large sculptures require many separate molds. The Bastar artists complete their statues by welding together the separately cast sections, usually leaving the seams visible.

32-11 MEERA MUKHERJEE, *Ashoka at Kalinga*, 1972. Bronze, $11' 6\frac{3''}{4}$ high. Maurya Sheraton Hotel, New Delhi.

Mukherjee combined the Bastar tribe's traditional bronze-casting techniques with the swelling forms of 20th-century European sculpture in this statue of King Ashoka—a pacifist's protest against violence.

Many scholars regard Ashoka at Kalinga (FIG. 32-11) as Mukherjee's greatest work. Twice life-size and assembled from 26 cast-bronze sections, the towering statue combines the intricate surface textures of traditional Bastar work with the expressively swelling abstract forms of some 20th-century European sculpture (FIG. 29-63). Mukherjee chose as her subject the third-century BCE Maurya emperor Ashoka standing on the battlefield at Kalinga. There, Ashoka witnessed more than 100,000 deaths and, shocked by the horrors of the war he had unleashed, rejected violence and adopted Buddhism as the official religion of his empire (see "Ashoka's Conversion to Buddhism," Chapter 15, page 428). Mukherjee conceived her statue as a pacifist protest against political violence in late-20th-century India. By reaching into India's remote history to make a contemporary political statement and by employing the bronze-casting methods of tribal sculptors while molding her forms in a modern idiom, she united her native land's past and present in a single work of great emotive power.

SOUTHEAST ASIA

India was not alone in experiencing major shifts in political power and religious preferences during the past 800 years. The Khmer of Angkor (see Chapter 15), after reaching the height of their power at the beginning of the 13th century, lost one of their outposts in northern Thailand to their Thai vassals at midcentury. The newly founded Thai kingdoms quickly replaced Angkor as the region's major power, while Theravada Buddhism (see "Buddhism and Buddhist Iconography," Chapter 15, page 427, or page xxxii in Volume II and Book D) became the religion of the entire mainland except Vietnam. The Vietnamese, restricted to the northern region of present-day Vietnam, gained independence in the 10th century after a thousand years of Chinese political and cultural domination. They pushed to the south, ultimately destroying the indigenous Cham culture, which had dominated there for more than a millennium. A similar Burmese drive southward in Myanmar matched the Thai and Vietnamese expansions. All these movements resulted in demographic changes during the second millennium that led to the cultural, political, and artistic transformation of mainland Southeast Asia. A religious shift also occurred in Indonesia. With Islam growing in importance, all of Indonesia except the island of Bali became predominantly Muslim by the 16th century.

Thailand

Southeast Asians practiced both Buddhism and Hinduism, but by the 13th century, in contrast to developments in India, Hinduism was in decline and Buddhism dominated much of the mainland. Two prominent Buddhist kingdoms came to power in Thailand during the 13th and early 14th centuries. Historians date the beginning of the Sukhothai kingdom to 1292, the year King Ramkhamhaeng (r. 1279–1299) erected a four-sided stele bearing the first inscription written in the Thai language. Sukhothai's political dominance proved to be short-lived, however. Ayuthaya, a city founded in central Thailand in 1350, quickly became the more powerful kingdom and warred sporadically with other states in Southeast Asia until the mid-18th century. Scholars nonetheless regard the Sukhothai period as the golden age of Thai art. In the inscription on his stele, Ramkhamhaeng (Rama the Strong) described Sukhothai as a city of monasteries and many images of the Buddha.

WALKING BUDDHA Theravada Buddhism came to Sukhothai from Sri Lanka (see Chapter 15). At the center of the city stood Wat Mahathat, Sukhothai's most important Buddhist monastery. Its stupa (mound-shaped Buddhist shrine; see "The Stupa," Chapter 15, page 430) housed a relic of the Buddha (Wat Mahathat means "Monastery of the Great Relic") and attracted large crowds of pilgrims. Sukhothai's crowning artistic achievement was the development of a type of walking-Buddha statue (FIG. 32-12) displaying a distinctively Thai approach to body form. The bronze Buddha has broad shoulders and a narrow waist and wears a clinging monk's robe. He strides forward, his right heel off the ground and his left arm raised with the hand held in the do-not-fear mudra (gesture) that encourages worshipers to come forward in reverence (see "Buddhism and Buddhist Iconography," Chapter 15, page 427, or page xxxii in Volume II or Book D). A flame leaps from the top of the Buddha's head, and a sharp nose projects from his rounded face. The right arm hangs loosely, seemingly without muscles or joints, and resembles an elephant's trunk. The Sukhothai artists intended the body type to suggest a supernatural being and to express the Buddha's beauty and perfection. Although images in

32-12 Walking Buddha, from Sukhothai, Thailand, 14th century. Bronze, $7' 2\frac{1}{2}''$ high. Wat Bechamabopit, Bangkok.

1 ft

Walking-Buddha statues are unique to Thailand and display a distinctive approach to human anatomy. The Buddha's body is soft and elastic, and the right arm hangs loosely, like an elephant trunk.

stone exist, the Sukhothai artists handled bronze best, a material well suited to their conception of the Buddha's body as elastic. The Sukhothai walking-Buddha statuary type is unique in Buddhist art.

EMERALD BUDDHA A second distinctive Buddha image from northern Thailand is the Emerald Buddha (FIG. 32-13), housed in the Emerald Temple on the royal palace grounds in Bangkok. The sculpture is small, only 30 inches tall, and conforms to the ancient type of the Buddha seated in meditation in a yogic posture with his legs crossed and his hands in his lap, palms upward (FIG. 15-11). It first appears in historical records in 1434 in northern Thailand, where Buddhist chronicles record its story. The chronicles describe the Buddha image as plaster-encased, and thus no one knew the statue was green stone. A lightning bolt caused

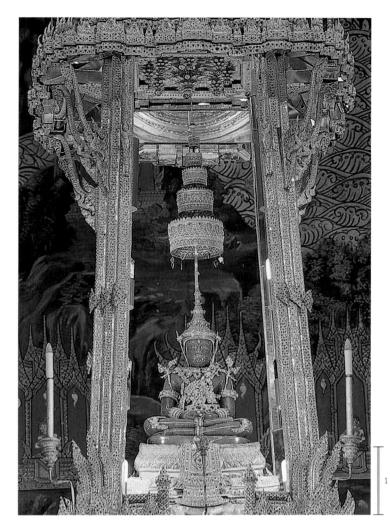

32-13 *Emerald Buddha*, Emerald Temple, Bangkok, Thailand, 15th century. Jade or jasper, 2′ 6″ high.

The Thai king dresses the *Emerald Buddha*, carved from green jade or jasper, in a monk's robe and a king's robe at different times of the year, underscoring the image's symbolic role as both Buddha and king.

some of the plaster to flake off, disclosing its gemlike nature. Taken by various rulers to a series of cities in northern Thailand and in Laos over the course of more than 300 years, the small image finally reached Bangkok in 1778 in the possession of the founder of the present Thai royal dynasty.

The *Emerald Buddha* is not, in fact, emerald but probably green jade. Nonetheless, its nature as a gemstone gives it a special aura. The Thai believe the gem enables the *chakravartin* (universal king) who possesses the statue to bring the rains. The historical Buddha renounced his secular destiny for the spiritual life, yet his likeness carved from the gem of a universal king enables fulfillment of the Buddha's royal destiny as well. The Buddha is also the universal king. Thus, the combination of the sacred and the secular in the small image explains its symbolic power. The Thai king dresses the *Emerald Buddha* at different times of the year in a monk's robe and a king's robe (in FIG. 32-13 the Buddha wears the royal garment), reflecting the image's dual nature and accentuating its symbolic role as both Buddha and king. The Thai king possessing the image therefore has both religious and secular authority.

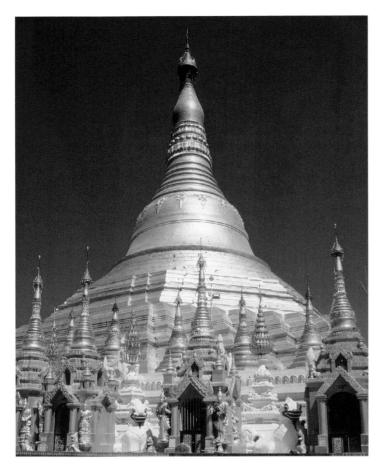

32-14 Schwedagon Pagoda (looking northeast), Rangoon (Yangon), Myanmar (Burma), 14th century or earlier (rebuilt several times).

The 344-foot-tall Schwedagon Pagoda houses two of the Buddha's hairs. Silver and jewels and 13,153 gold plates sheathe its exterior. The gold ball at the top is inlaid with 4,351 diamonds.

Myanmar

Myanmar, like Thailand, is overwhelmingly a Theravada Buddhist country today. Important Buddhist monasteries and monuments dot the countryside.

SCHWEDAGON PAGODA In Rangoon, an enormous complex of buildings, including shrines filled with Buddha images, has as its centerpiece one of the largest stupas in the world, the Schwedagon Pagoda (FIG. 32-14). (Pagoda derives from the Portuguese version of a word for stupa.) The Rangoon pagoda houses two of the Buddha's hairs, traditionally said to have been brought to Myanmar by merchants who received them from the Buddha himself. Rebuilt several times, this highly revered stupa is famous for the gold, silver, and jewels encrusting its surface. The Schwedagon Pagoda stands 344 feet high. Covering its upper part are 13,153 plates of gold, each about a foot square. At the very top is a seven-tiered umbrella crowned with a gold ball inlaid with 4,351 diamonds, one of which weighs 76 carats. This great wealth was a gift to the Buddha from the laypeople of Myanmar to earn merit on their path to enlightenment.

Vietnam

The history of Vietnam is particularly complex, as it reveals both an Indian-related art and culture, broadly similar to those of the rest of Southeast Asia, and a unique and intense relationship with China's art and culture. Vietnam's tradition of fine ceramics is of special interest. The oldest Vietnamese ceramics date to the Han period

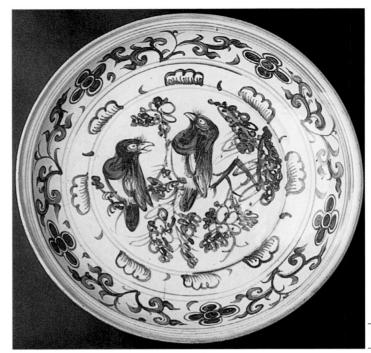

32-15 Dish with two mynah birds on flowering branch, from Vietnam, 16th century. Stoneware painted with underglaze-cobalt, $1' 2\frac{1}{2}''$ in diameter. Pacific Asia Museum, Pasadena.

Vietnamese ceramists exported underglaze pottery throughout Southeast Asia and beyond. The spontaneous depiction of mynah birds on this dish contrasts with the formality of Chinese porcelains.

(206 BCE–220 CE), when the Chinese began to govern the northern area of Vietnam. China directly controlled Vietnam for a thousand years, and early Vietnamese ceramics closely reflected Chinese wares. But during the Ly (1009–1225) and Tran (1225–1400) dynasties, when Vietnam had regained its independence, Vietnamese potters developed an array of ceramic shapes, designs, and *glazes* that brought their wares to the highest levels of quality and creativity.

UNDERGLAZE CERAMICS In the 14th century, the Vietnamese began exporting underglaze wares modeled on the blueand-white ceramics first produced in China (see "Chinese Porcelain," Chapter 33, page 992). During the 15th and 16th centuries, the ceramic industry in Vietnam had become the supplier of pottery of varied shapes to an international market extending throughout Southeast Asia and to the Middle East. A 16th-century Vietnamese dish (FIG. 32-15) with two mynah birds on a flowering branch reveals both the potter's debt to China and how the spontaneity, power, and playfulness of Vietnamese painting contrast with the formality of Chinese wares (FIG. 33-5). The artist suggested the foliage with curving and looped lines executed in almost one continuous movement of the brush over the surface. This technique—very different from the more deliberate Chinese habit of lifting the brush after painting a single motif in order to separate the shapes more sharply—facilitated rapid production. Combined with the painter's control, it allowed a fresh and unique design, making Vietnamese pottery attractive to a wide export market.

CONTEMPORARY ART In the Buddhist countries of Southeast Asia, some artists continue to produce traditional images of the Buddha, primarily in bronze, for worship in homes, businesses, and temples. But, as in South Asia, many contemporary artists work in an international modernist idiom (see Chapter 31).

SOUTH AND SOUTHEAST ASIA, 1200 TO 1980

SULTANATE OF DELHI

- After defeating a confederation of South Asian states, Qutb al-Din Aybak (r. 1206–1211) established the Sultanate of Delhi (1206–1526), bringing Muslim rule to northern India and transforming South Asian society, religion, art, and architecture.
- To mark the triumph of Islam, the new sultan built Delhi's first mosque—the Might of Islam Mosque—and its 238-foot Qutb Minar, the tallest minaret in the world.

Qutb Minar, Delhi, begun early 13th century

VIJAYANAGAR EMPIRE

- The most powerful Hindu kingdom in southern India when Muslim sultans ruled the north was the Vijayanagar Empire (1336–1565).
- Vijayanagar buildings, for example, the Lotus Mahal, display an eclectic mix of Islamic multilobed arches and crowning elements resembling Hindu temple vimanas.

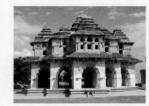

Lotus Mahal, Vijayanagara, 15th or early 16th century

MUGHAL EMPIRE

- Babur (r. 1526–1530) defeated the Delhi sultans in 1526 and established the Mughal Empire (1526–1857).
- The first great flowering of Mughal art and architecture occurred under Akbar the Great (r. 1556–1605).
 The imperial painting workshop continued to produce magnificent illustrated books under his son Jahangir (r. 1605–1627) and his successors. The names of many Mughal miniature painters are known.
- Shah Jahan (r. 1628–1658) built the Taj Mahal as a memorial to his favorite wife. The mausoleum may symbolize the throne of God above the gardens of Paradise.

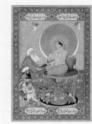

Bichitr, Jahangir Preferring a Sufi Shaykh to Kings, ca. 1615–1618

OTHER SOUTH AND SOUTHEAST ASIAN KINGDOMS

- During the Mughal Empire, Hindu Rajput kings ruled much of northwestern India. The coloration and sensuality of Rajput painting distinguish it from the contemporaneous Mughal style.
- Between 1529 and 1736, the Hindu Nayak dynasty controlled southern India and erected temple complexes with immense gateway towers (gopuras) decorated with painted stucco sculptures.
- In Thailand, Theravada Buddhism was the dominant religion. The Sukhothai walking-Buddha statuary type displays a unique approach to body form as seen, for example, in the Buddha's trunklike right arm.
- Myanmar's Schwedagon Pagoda in Rangoon, one of the largest stupas in the world, is encrusted with gold, silver, and jewels.

Walking Buddha, from Sikhothai, 14th century

BRITISH COLONIAL PERIOD TO 1980

- Queen Elizabeth I (r. 1558–1603) established the East India Company, which eventually effectively ruled large portions of the subcontinent. In 1877, Queen Victoria I (r. 1837–1901) assumed the title Empress of India. British colonial rule lasted from 1600 to 1947, and Victoria Terminus is its architectural symbol—a European transplant to India capped by an allegorical statue of Progress.
- Under the leadership of Mahatma Gandhi (1869–1948), India and Pakistan achieved independence from England in 1947. Post–World War II South Asian art ranges from the traditional to the modern and embraces both native and Western styles.

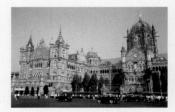

Stevens, Victoria Terminus, Mumbai, 1878–1887

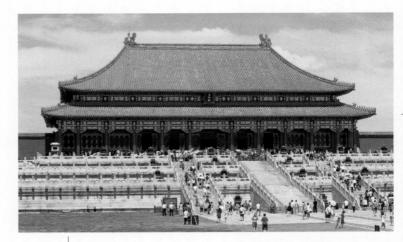

The Hall of Supreme Harmony, the largest wooden building in China, was the climax of the Forbidden City's long north-south axis. It housed the Ming emperor's throne room.

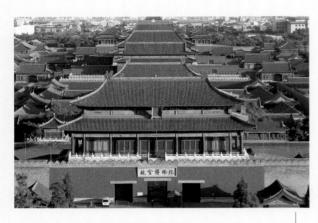

The Forbidden City provided the perfect setting for the rituals surrounding the Ming emperor. Successive gates, such as the Gate of Divine Prowess, regulated access to increasingly restricted areas.

The southern entrance to the Beijing palace complex was the Noon Gate. Only the emperor could walk through the central portal. Those of decreasing rank used the lateral passageways.

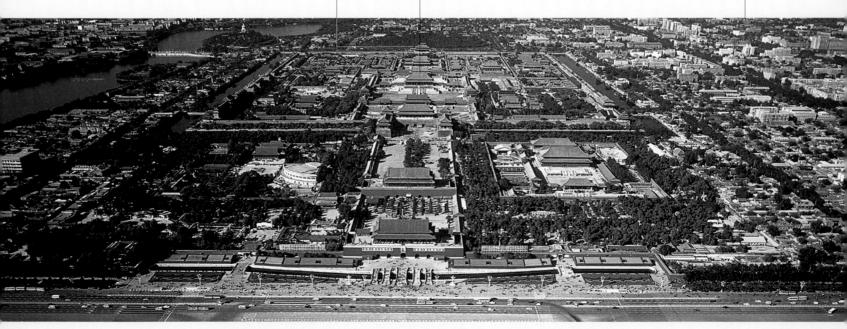

33-1 Aerial view (looking north) of the Forbidden City, Beijing, China, Ming dynasty, 15th century and later.

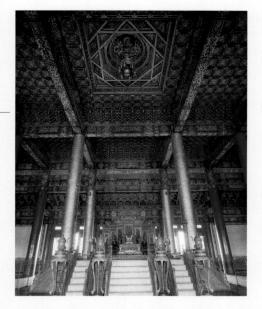

For the columns of the opulently appointed throne room of the Son of Heaven, the Chinese builders had to transport gigantic tree trunks from Sichuan Province down the Yangtze River.

33

CHINA AND KOREA, 1279 TO 1980

THE FORBIDDEN CITY

In 1368, Zhu Yuanzhong led a popular uprising that drove the last Mongol emperor from Beijing. After expelling the foreigners from China, he founded the native Chinese Ming dynasty (r. 1368–1644), proclaiming himself its first emperor under the official name of Hongwu ("Abundantly Martial," r. 1368–1398). The new emperor built his capital at Nanjing (southern capital), but the third Ming emperor, Yongle ("Perpetual Happiness," r. 1403–1424), moved the imperial seat back to Beijing (northern capital). Although Beijing had been home to the Yuan dynasty, Ming architects designed much of the city as well as the imperial palace at its core.

The Ming builders laid out Beijing as three nested walled cities. The outer perimeter wall was 15 miles long and enclosed the walled Imperial City, with a perimeter of 6 miles, and the vast imperial palace compound, the Forbidden City (FIG. 33-1), surrounded by a 50-yard-wide moat. The name "Forbidden City" dates to 1576 and aptly describes the highly restricted access to the inner compound, where the Ming emperor, the Son of Heaven, resided. The layout of the Forbidden City provided the perfect setting for the elaborate ritual of the imperial court. For example, the entrance gateway to the complex, the Noon Gate, has five portals. Only the emperor could walk through the central doorway. The two entrances to its left and right were reserved for the imperial family and high officials. Others had to use the outermost passageways. Entrance to the Forbidden City proper was through the nearly 40-yard-tall triple-passageway Meridian Gate. Only the emperor and his retinue and foreign ambassadors who had been granted an official audience could pass through the Meridian Gate.

Within the Forbidden City, more gates and a series of courtyards, gardens, temples, and other buildings led eventually to the Hall of Supreme Harmony, in which the emperor, seated on his dragon throne on a high stepped platform, received important visitors. The hall is the largest wooden building in China. For its columns, the Ming builders had to transport gigantic tree trunks from Sichuan Province down the Yangtze River. Perched on an immense platform above marble staircases, the Hall of Supreme Harmony was the climax of a long north-south axis. The fill for the platform consists of the soil and rocks the Ming engineers collected from the excavation of the great moat around the imperial complex.

Beyond that grand reception hall is the even more restricted Inner Court and the Palace of Heavenly Purity—the private living quarters of the emperor and his extended family of wives, concubines, and children. At the northern end of the central axis of the Forbidden City is the Gate of Divine Prowess, through which the palace servants gained access to the complex.

CHINA

In 1210, the Mongols invaded northern China from Central Asia (MAP 33-1, page 993), opening a new chapter in the history and art of that ancient land (see Chapter 16). Under the dynamic leadership of Genghis Khan (1167–1230), the Mongol armies pushed into China with extraordinary speed. By 1215, the Mongols had destroyed the Jin dynasty's capital at Beijing and taken control of northern China. Two decades later, they attacked the Song dynasty in southern China. It was not until 1279, however, that the last Song emperor fell at the hands of Genghis Khan's grandson, Kublai Khan (1215–1294). Kublai proclaimed himself emperor (r. 1279–1294) of the new Yuan dynasty.

Yuan Dynasty

During the relatively brief tenure of the Yuan (r. 1279–1368), trade between Europe and Asia increased dramatically. It was no coincidence that Marco Polo (1254–1324), the most famous early European visitor to China, arrived during the reign of Kublai Khan. Part fact and part fable, Marco Polo's chronicle of his travels to and within China was the only eyewitness description of East Asia available in Europe for several centuries. The Venetian's account makes clear he profoundly admired Yuan China. He marveled not only at Kublai Khan's opulent lifestyle and palaces but also at the volume of commercial traffic on the Yangtze River; the splendors of Hangzhou; the use of paper currency, porcelain, and coal; the efficiency of the Chinese postal system; and the hygiene of the

Chinese people. In the early second millennium, China was richer and technologically more advanced than late medieval Europe.

ZHAO MENGFU The Mongols were distrustful of the Chinese and very selective in admitting former Southern Song subjects into their administration. In addition, many Chinese loyal to the former emperors refused to collaborate with their new

33-1A ZHAO MENGFU, Sheep and Goat, ca. 1300. ■◀

foreign overlords, whom they considered barbarian usurpers. Indeed, most of the great art created during the Yuan dynasty was the work of men and women who refused to play any role in the Mongol court. One artist who did accept an official post under Kublai Khan was Zhao Mengfu (1254–1322), a descendant of the first Song emperor. A learned man, skilled in both calligraphy and poetry, he won renown as a painter of horses and of landscapes but also painted other subjects (FIG. 33-1A).

GUAN DAOSHENG Zhao's wife, Guan Daosheng (1262–1319), was also a successful painter, calligrapher, and poet. Although she painted a variety of subjects, including Buddhist murals in Yuan temples, Guan became famous for her paintings of bamboo. The plant was a popular subject because it was a symbol of the ideal Chinese gentleman, who bends in adversity but does not break, and because depicting bamboo branches and leaves approximated the cherished art of calligraphy (see "Calligraphy and Inscriptions").

1 in

33-2 Guan Daosheng, Bamboo Groves in Mist and Rain (detail), Yuan dynasty, 1308. Section of a handscroll, ink on paper, full scroll $9\frac{1}{8}^{"} \times 3' \ 8\frac{7}{8}^{"}$. National Palace Museum, Tabei.

1644

Guan Daosheng was a calligrapher, poet, and painter. She achieved the misty atmosphere in this landscape by using a narrow range of ink tones and blurring the bamboo thickets in the distance.

1279

CHINA AND KOREA, 1279 TO 1980

1368

Mongol invaders establish the Yuan dynasty

Yuan Dynasty

- Huang Gongwang, Ni Zan, Wang Meng, and Wu Zhen achieve fame as the Four Great Masters of landscape painting
- The Jingdezhen kilns produce porcelain pottery with cobaltblue underglaze decoration
- I The third Ming emperor begins construction of the Forbidden City in Beijing

Ming Dynasty

- I The Orchard Factory creates lacquered wood furniture
- Landscape architects design uncultivated scenic gardens at Suzhou
- I Joseon dynasty erects Namdaemun gate in Seoul
- The Manchus overthrow the native Ming emperors and rule China as the Qing dynasty

Qing Dynasty

1911

- I Shitao experiments with bold new approaches to traditional literati landscape painting
- Jesuit missionaries introduce Western painting styles
- Marxist themes dominate the state-sponsored art of the People's Republic of China

Modern China

I With the unwinding of Mao Zedong's Cultural Revolution, Chinese artists begin to rise to prominence in the international art world

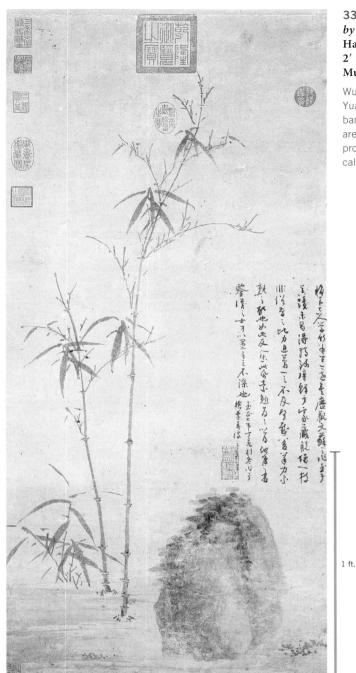

33-3 Wu Zhen, Stalks of Bamboo by a Rock, Yuan dynasty, 1347. Hanging scroll, ink on paper, 2′ 11½″ × 1′ 45″. National Palace Museum, Tabei. ■4

Wu Shen was one of the leading Yuan literati (scholar-artists). The bamboo plants in his hanging scroll are perfect complements to the prominently featured black Chinese calligraphic characters. on Chinese Paintings," page 997). Bamboo Groves in Mist and Rain (FIG. 33-2), a handscroll (see "Chinese Painting Materials and Formats," Chapter 16, page 459), is one of her best paintings. Guan achieved the misty atmosphere by restricting the ink tones to a narrow range and by blurring the bamboo thickets in the distance, suggesting not only the receding terrain but fog as well.

WU ZHEN The Yuan painter WU ZHEN (1280–1354), in stark contrast to Zhao Mengfu and Guan Daosheng, shunned the Mongol court and lived as a hermit, far from the luxurious milieu of the Yuan emperors. He was one of the *literati*, or scholar-artists, who emerged during the Song dynasty. The literati were men and women from prominent families who painted primarily for a small audience of their social peers. Highly educated and steeped in traditional Chinese culture, they cultivated calligraphy, poetry, painting, and other arts as a sign of social status and refined taste. Literati art is usually personal in nature and often shows nostalgia for the past.

Wu Zhen's treatment of the bamboo theme, *Stalks of Bamboo by a Rock* (FIG. 33-3), differs sharply from Guan's. The artist clearly differentiated the individual bamboo plants and reveled in the abstract patterns the stalks and leaves formed. The bamboo stalks in his *hanging scroll* (see "Chinese Painting Materials and Formats," Chapter 16, page 459) are perfect complements to the calligraphic beauty of the Chinese black characters and red seals so prominently featured on the scroll (see "Calligraphy and Inscriptions," page 997). Both the bamboo and the inscriptions gave Wu Zhen the opportunity to display his proficiency with the brush.

HUANG GONGWANG Later artists and critics revered Wu Zhen as one of the Four Great Masters of Yuan painting. The eldest was HUANG GONGWANG (1269–1354), a civil servant and a teacher of Daoist philosophy. His *Dwelling in the Fuchun Mountains* (FIG. 33-4)

33-4 Huang Gongwang, *Dwelling in the Fuchun Mountains*, Yuan dynasty, 1347–1350. Section of a handscroll, ink on paper, full scroll 1' $\frac{7}{8}$ " \times 20' 9". National Palace Museum, Tabei.

In this Yuan handscroll, Huang built up the textured mountains with richly layered wet and dry brushstrokes and ink-wash accents, capturing the landscape's inner structure and momentum.

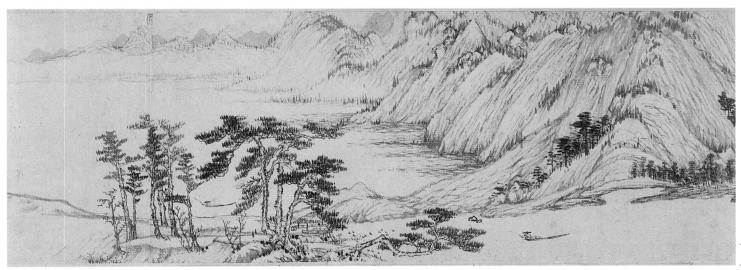

1 in.

Chinese Porcelain

No other Chinese art form has achieved such worldwide admiration, inspired such imitation, or penetrated so deeply into everyday life as porcelain (FIGS. 33-5 and 33-17). Long imported by China's Asian neighbors as luxury goods and treasures, Chinese porcelains later captured great attention in the West, where potters did not succeed in mastering the production process until the early 18th century.

In China, primitive porcelains emerged during the Tang dynasty

dynasty, 1351. White porcelain with cobalt-blue underglaze, 2' $1'' \times 8\frac{1}{8}''$. Percival David Foundation of Chinese Art, London. This vase is an early example

33-5 Temple vase, Yuan

This vase is an early example of porcelain with cobaltblue underglaze decoration. Dragons and phoenixes, symbols of male and female energy, respectively, are the major painted motifs.

(618–906), and mature forms developed in the Song (960–1279). Like *stoneware* (see "Chinese Earthenwares and Stonewares," Chapter 16, page 451), porcelain objects are fired in a kiln at an extremely high temperature (well over 2,000° F) until the clay fully fuses into a dense, hard substance resembling stone or glass. Unlike stoneware, however, ceramists create porcelain from a fine white clay called kaolin mixed with ground petuntse (a type of feldspar). True porcelain is translucent and rings when struck. Its rich, shiny surface resembles jade, a luxurious natural material the Chinese treasured from very early times (see "Chinese Jade," Chapter 16, page 454).

Chinese ceramists often decorate porcelains with colored designs or pictures, working with finely ground minerals suspended in water and a binding agent (such as glue). The minerals change color dramatically in the kiln. The painters apply some mineral colors to the clay surface before the main firing and then apply a clear *glaze* over them. This *underglaze* decoration fully bonds to the piece in the kiln, but because the raw materials must withstand intense heat, Chinese potters could fire only a few colors. The most stable and widely used coloring agents for porcelains are cobalt compounds, which emerge from the kiln as an intense blue (FIG. 33-5). Rarely, ceramists use copper compounds to produce stunning reds by carefully manipulating the kiln's temperature and oxygen content.

To obtain a wider palette, an artist must paint on top of the glaze after firing the work (FIG. 33-17). These *overglaze* colors, or *enamels*, then fuse to the glazed surface in an additional firing at a much lower temperature. Enamels also offer ceramic painters a much brighter palette, with colors ranging from deep browns to brilliant reds and greens, but they do not have the durability of underglaze decoration.

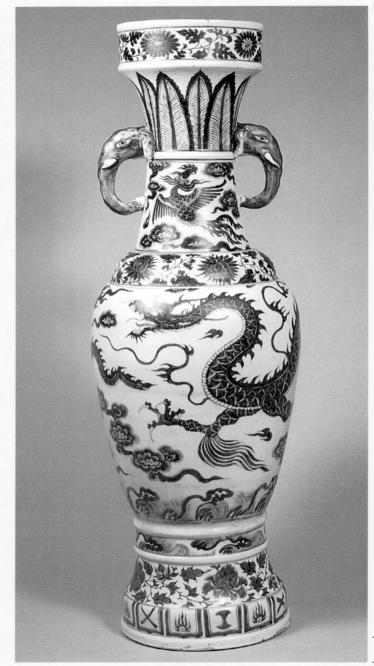

1 in

is one of the great works of Yuan literati painting. According to the artist's explanatory inscription at the end of the long hand-scroll, Huang sketched the full composition in one burst of inspiration, but then added to and modified his painting whenever he felt moved to do so over a period of years. In the detail shown in FIG. 33-4, the painter built up the textured mountains with richly layered brushstrokes, at times interweaving dry brushstrokes and at other times placing dry strokes over wet ones, darker strokes over lighter ones, often with ink-wash accents. The rhythmic play

of brush and ink captures the landscape's inner structure and momentum.

Huang summarized his approach to painting nature in a treatise titled *Secrets of Landscape Painting*, in which he also noted the kinship of ink painting and the art of calligraphy.

In painting each furrow and rock, one should give free rein to the ink allowing it to run unrestrained. . . . [T]oo much detail description will make it look like craftsmanship. . . . For the most part,

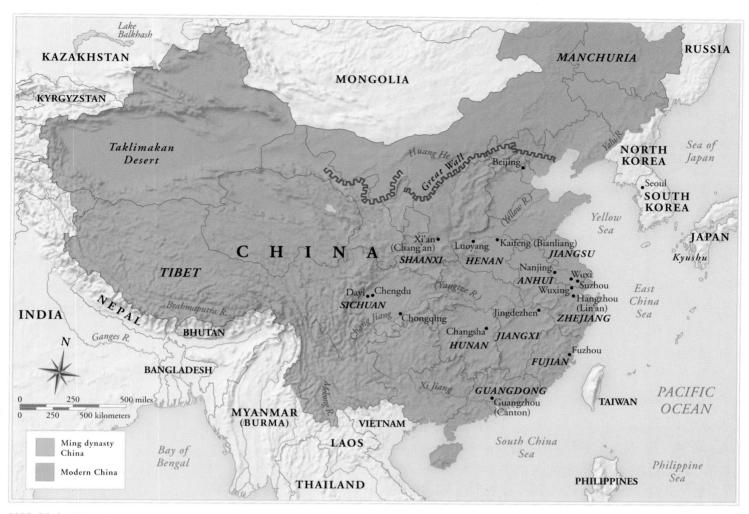

MAP 33-1 China during the Ming dynasty.

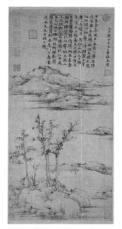

33-4A NI ZAN, Rongxi Studio. 1372.

just as in calligraphy, practicing diligently will make mastery perfect.1

NI ZAN AND WANG MENG Completing the quartet of renowned Yuan masters were two younger artists born in the early 14th century-Ni Zan (1301 or 1306-1374) and Wang Meng (ca. 1308-1385). Both were still active during the early years of the Ming dynasty, when Ni painted his most famous work, Rongxi Studio (FIG. 33-4A), a literati landscape of unsurpassed quality.

JINGDEZHEN PORCELAIN By the Yuan period, Chinese potters had extended their mastery to fully developed porcelains, a technically demanding medium

(see "Chinese Porcelain," page 992). A tall temple vase (FIG. 33-5) from the Jingdezhen kilns, which during the Ming dynasty became the official source of porcelains for the court, is one of a nearly identical pair dated by inscription to 1351. The inscription also says the vases, together with an incense burner, composed an altar set donated to a Buddhist temple as a prayer for peace,

protection, and prosperity for the donor's family. The vase is one of the earliest dated examples of fine porcelain with cobalt-blue underglaze decoration. The painted decoration consists of bands of floral motifs between broader zones containing auspicious symbols, including phoenixes in the lower part of the neck and dragons (compare FIG. 16-1) on the main body of the vessel, both among clouds. These motifs may suggest the donor's high status or invoke prosperity blessings. Because of their vast power and associations with nobility and prosperity, the dragon and phoenix also symbolize the emperor and empress, respectively, and often appear on objects made for the imperial household. The dragon also may represent yang, the Chinese principle of active masculine energy, while the phoenix may represent yin, the principle of passive feminine energy.

Ming Dynasty

The major building project of the Ming emperors who succeeded the Yuan as rulers of China (MAP 33-1) was the imperial palace complex in Beijing—the Forbidden City (see "The Forbidden City," page 989, and FIG. 33-1). Strictly organized along a north-south axis with traditional wooden buildings featuring curved rooflines (see "Chinese Wooden Construction," Chapter 16, page 457) alternating

33-6 Hall of Supreme Harmony (looking north), Forbidden City, Beijing, China, Ming dynasty, 15th century and later.

The Hall of Supreme Harmony is the largest wooden building in China. For its gigantic columns, the Ming builders had to transport huge tree trunks down the Yangtze River from Sichuan Province.

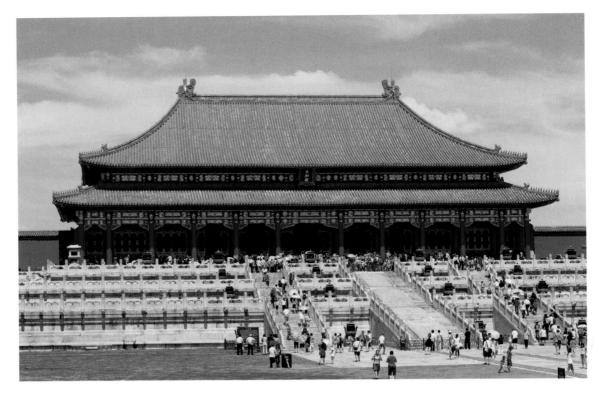

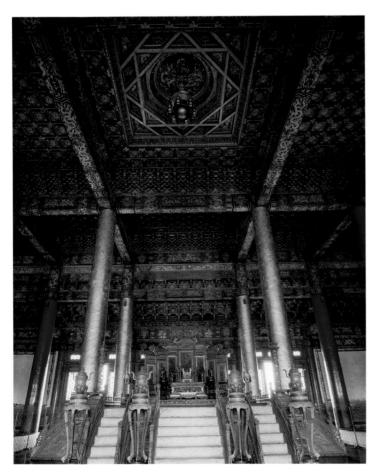

33-7 Throne room, Hall of Supreme Harmony, Forbidden City, Beijing, China, Ming dynasty, 15th century and later.

The Ming emperors held official audiences in the opulently appointed throne room in the Hall of Supreme Harmony. Beyond was the Inner Court, where the emperor and his extended family resided.

with courtyards, the Forbidden City culminated with the Hall of Supreme Harmony (FIG. 33-6) housing the opulently furnished throne room (FIG. 33-7) in which the Son of Heaven received official visitors. In front of the hall were bronze statues of a turtle and a crane, symbols of longevity.

ORCHARD FACTORY The Ming court's lavish appetite for luxury goods to use and display in the imperial palace gave new impetus to brilliant technical achievement in the decorative arts. As did the Yuan emperors, the Ming dynasty turned to the Jingdezhen kilns for fine porcelains. For objects in lacquer-covered wood (see "Lacquered Wood," page 995), their patronage went to a large workshop in Beijing known today as the Orchard Factory. A table with drawers (FIG. 33-8), made between 1426 and 1435, is one of the workshop's masterpieces. The artist carved floral motifs, along with the dragon and phoenix imperial emblems, into the thick cinnabar-colored lacquer, which had to be built up in numerous layers.

SHANG XI At the Ming court, the official painters lived in the Forbidden City itself, and portraiture of the imperial family was their major subject. The court artists also depicted historical figures as exemplars of virtue, wisdom, or heroism. An exceptionally large example of Ming history painting is a hanging scroll painted by SHANG XI (active ca. 1425-1440) around 1430. Guan Yu Captures General Pang De (FIG. 33-9) represents an episode from China's tumultuous third century (Period of Disunity; see Chapter 16), whose wars inspired one of the first great Chinese novels, The Romance of the Three Kingdoms. Guan Yu was a famed general of the Wei dynasty (220-280) and a fictional hero in the novel. Shang's painting depicts the historical Guan, renowned for his loyalty to his emperor and his military valor, being presented with the captured enemy general Pang De. In the painting, Shang used color to focus attention on Guan and his attendants, who stand out sharply from the ink landscape. He also contrasted the victors' armor and bright garments with the vulnerability of the captive, who has been stripped almost naked, further heightening his humiliation.

Lacquered Wood

From ancient times the Chinese used lacquer to cover wood. Artisans produced lacquer from the sap of the Asiatic sumac tree, native to central and southern China. When it dries, lacquer cures to great hardness and prevents the wood from decaying. Often colored with mineral pigments, lacquered objects have a lustrous surface that transforms the appearance of natural wood. The earliest examples of lacquered wood to survive in quantity date to the Eastern Zhou period (770–256 BCE).

33-8 Table with drawers, Ming dynasty, ca. 1426–1435. Carved red lacquer on a wood core, 3' 11" long. Victoria & Albert Museum, London.

The Orchard Factory was the leading Ming workshop for lacquered wood furniture. The lacquer on this table was thick enough to be carved with floral motifs and the imperial dragon and phoenix.

The first step in producing a lacquered object is to heat and purify the sap. Then the lacquer worker mixes the minerals—carbon black and cinnabar red are the most common—into the sap. To apply the lacquer, the artisan uses a hair brush similar to a calligrapher's or painter's brush, building up the coating one layer at a time. Each coat must dry and be sanded before another layer can be applied. If the artisan builds up a sufficient number of layers, the lacquer can be carved as if it were the wood itself. The lacquer workers in the Orchard Factory in Beijing were master carvers and counted the Ming emperors as major clients for luxurious lacquered furniture. Examples such as the illustrated table (FIG. 33-8)

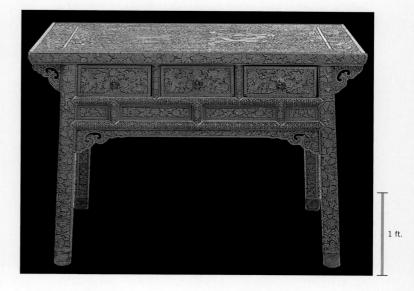

boast elaborate carving in many layers of lacquer and took a great deal of time as well as skill to produce.

Other techniques for decorating lacquer include inlaying metals and lustrous materials, such as mother-of-pearl, and sprinkling gold powder into the still-wet lacquer. Korean and Japanese (FIG. 34-10) artists also employed these techniques to produce masterful lacquered objects.

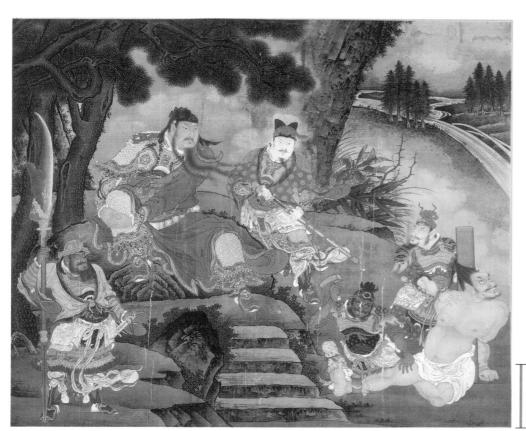

33-9 SHANG XI, Guan Yu Captures General Pang De, Ming dynasty, ca. 1430. Hanging scroll, ink and colors on silk, 6′ 5″ × 7′ 7″. Palace Museum, Beijing. ■◆

The official painters of the Ming court lived in the Forbidden City and specialized in portraiture and history painting. This very large scroll celebrates a famed general of the third century.

1 ft.

SUZHOU GARDENS At the opposite architectural pole from the formality and rigid axiality of Ming palace architecture is the Chinese pleasure garden. Several Ming gardens at Suzhou have been meticulously restored, including the huge (almost 54,000 square feet) Wangshi Yuan (Garden of the Master of the Fishing Nets; FIG. 33-10). Designing a Ming garden was not a matter of cultivating plants in rows or of laying out terraces, flower beds, and avenues in geometric fashion, as was the case in many other cultures (compare, for example, the 17th-century French gardens at Versailles, FIG. 25-26). Instead, Ming gardens are often scenic arrangements of natural and artificial elements intended to reproduce the irregularities of uncultivated nature. Verandas and pavilions rise on pillars above the water, and stone bridges, paths, and causeways encourage wandering through ever-changing vistas of trees, flowers, rocks, and their reflections in the ponds. The typical design is a sequence of carefully contrived visual surprises.

A favorite garden element, fantastic rockwork, is a prominent feature of Liu Yuan (Lingering Garden; FIG. 33-11) in Suzhou. Workmen dredged the stones from nearby Lake Tai, and then sculptors shaped them to create an even more natural look. The one at the center of FIG. 33-11 is about 20 feet tall and weighs approximately five tons. The Ming gardens of Suzhou were the pleasure retreats of high officials and the landed gentry, sanctuaries where the wealthy could commune with nature in all its representative forms and as an ever-changing and boundless presence. Chinese poets never cease to sing of the restorative effect of gardens on mind and spirit.

SHEN ZHOU Just as the formality of Ming official architecture contrasts with the informality of the gardens of Suzhou, the work of Shang Xi (FIG. 33-9) and other professional court painters,

designed to promote the official Ming ideology, differs sharply in both form and content from the venerable tradition of literati painting, which also flourished during the Ming dynasty. As under the Yuan emperors, Ming literati practiced their art largely independently of court patronage. One of the leading figures was Shen Zhou (1427–1509), a master of the Wu School of painting, so called because of the ancient name (Wu) of the city of Suzhou. Shen came from a well-to-do family of scholars and painters and declined an

33-10 Wangshi Yuan (Garden of the Master of the Fishing Nets), Suzhou, China, Ming dynasty, 16th century and later.

Ming gardens are arrangements of natural and artificial elements intended to reproduce the irregularities of nature. This approach to design is the opposite of the formality and axiality of the Ming palace.

33-11 Liu Yuan (Lingering Garden), Suzhou, China, Ming dynasty, 16th century and later.

A favorite element of Chinese gardens was fantastic rockwork. For the Lingering Garden, workmen dredged the stones from a nearby lake, and sculptors shaped them to produce an even more natural look.

offer to serve in the Ming bureaucracy in order to concentrate on poetry and painting. *Lofty Mount Lu* (FIG. **33-12**), perhaps his finest hanging scroll, was a birthday gift to one of his teachers. It bears a long poem the artist wrote in the teacher's honor (see "Calligraphy and Inscriptions on Chinese Paintings," page 997). Shen had never seen Mount Lu, but he stated he chose the subject because he wished the lofty mountain peaks to express the grandeur of his teacher's virtue and character. Shen suggested the immense scale of Mount

Calligraphy and Inscriptions on Chinese Paintings

any Chinese paintings (FIGS. 16-12, 16-16, 16-20, 16-23, 33-1A, 33-3, 33-4A, and 33-12 to 33-14) bear inscriptions, texts written on the same surface as the picture, or colophons, texts written on attached pieces of paper or silk. Throughout history, the Chinese have held calligraphy (Greek, "beautiful writing") in high esteem—higher, in fact, than painting. Inscriptions appear almost everywhere in China—on buildings and in gardens, on

33-12 SHEN ZHOU, Lofty Mount Lu, Ming dynasty, 1467. Hanging scroll, ink and color on paper, 6' $4\frac{1}{4}'' \times 3'$ $2\frac{5}{8}''$. National Palace Museum, Tabei.

Inscriptions and seals are essential elements in this hanging scroll, in which Shen used the lofty peaks of Mount Lu to express visually the grandeur of a beloved teacher's virtue and character.

furniture and sculpture. Chinese calligraphy and painting have always been closely connected. Even the primary implements and materials for writing and drawing are the same a round tapered brush, soot-based ink, and paper or silk. Calligraphy depends for its effects on the controlled vitality of individual brushstrokes and on the dynamic relationships of strokes within a character (an elaborate Chinese sign that by itself can represent several words) and even among the characters themselves. Training in calligraphy was a fundamental part of the education and self-cultivation of Chinese scholars and officials, and inscriptions are especially common on literati paintings. Many stylistic variations exist in Chinese calligraphy. At the most formal extreme, each character consists of distinct straight and angular strokes and is separate from the next character. At the other extreme, the characters flow together as cursive abbreviations with many rounded forms.

A long tradition in China links pictures and poetry. Famous poems frequently provided subjects for paintings, and poets composed poems inspired by paintings. Either practice might prompt inscriptions on art, some addressing painted subjects, some praising the painting's quality or the character of the painter or another individual. The Ming literati painter Shen Zhou added a long poem in beautiful Chinese characters to his painting of Mount Lu (FIG. 33-12). The poem praises a beloved teacher. Sometimes inscriptions explain the circumstances of the work. The Yuan painter Guan Daosheng's Bamboo Groves in Mist and Rain has two inscriptions (not included in the detail reproduced in FIG. 33-2). One is a dedication to another noblewoman. The other states Guan painted the handscroll "in a boat on the green waves of the lake." Later admirers and owners of paintings frequently inscribed their own appreciative words. The inscriptions are often quite prominent and sometimes compete for the viewer's attention with the painted motifs (FIGS. 33-1A and 33-3).

Painters, inscribers, and even owners usually also added *seal* impressions in red ink (FIGS. 33-2 to 33-4A and 33-12 to 33-16) to identify themselves. With all these textual additions, some paintings that have passed through many collections may seem

cluttered to Western viewers. However, the historical importance given to these inscriptions and to the works' ownership history has been and remains a critical aspect of painting appreciation in China.

1 ft.

33-12A SHEN ZHOU, Poet on a Mountaintop, ca. 1490-1500.

Lu by placing a tiny figure at the bottom center of the painting, sketched in lightly and partly obscured by a rocky outcropping. The composition owes a great deal to Fan Kuan (FIG. 16-19) and other early masters. But, characteristic of literati painting in general, the scroll is in the end

a very personal conversation—in pictures and words—between the artist and the teacher it honors. In a later painting (FIG. 33-12A), Shen depicted himself as a poet on a mountaintop, and included a poem he wrote reflecting on the beauty of music and landscape.

DONG QICHANG One of the most intriguing and influential literati of the late Ming dynasty was Dong Qichang (1555-1636), a wealthy landowner and high official who was a poet, calligrapher, and painter. He also amassed a vast collection of Chinese art and achieved great fame as an art critic. In Dong's view, most Chinese landscape painters could be classified as belonging to either the Northern School of precise, academic painting or the Southern School of more subjective, freer painting. "Northern" and "Southern" were not geographic but stylistic labels. Dong chose these names for the two schools because he determined their characteristic styles had parallels in the northern and southern schools of Chan Buddhism (see "Chan Buddhism," Chapter 16, page 470). Northern Chan Buddhists were "gradualists" and believed enlightenment could be achieved only after long training. The Southern Chan Buddhists believed enlightenment could come suddenly. Dong's Northern School therefore comprised professional, highly trained court painters. The leading painters of the Southern School were the literati, whose freer and more expressive style Dong judged to be far superior.

Dong's own work—for example, *Dwelling in the Qingbian Mountains* (FIG. 33-13), painted in 1617—belongs to the Southern School he admired so much. Subject and style, as well as the incorporation of a long inscription at the top, immediately reveal his debt to earlier literati painters. But Dong was also an innovator, especially in his treatment of the towering mountains, where shaded masses of rocks alternate with flat, blank bands, flattening the composition and creating highly expressive and abstract patterns. Some critics have called Dong Qichang the first *modernist* painter, because his work foreshadows developments in 19th-century European landscape painting (FIG. 28-21).

WEN SHU Landscape painting was the most prestigious artistic subject in Ming China, but artists also painted other subjects, for example, flowers. Wen Shu (1595–1634), the daughter of an aristocratic Suzhou family and the wife of Zhao Jun (d. 1640), descended from Zhao Mengfu and the Song imperial house, was probably the finest flower painter of the Ming era. Her *Carnations and Garden Rock* (FIG. 33-14) is also an example of Chinese arcshaped fan painting, a format imported from Japan. In this genre, the artist paints on flat paper, but then folds the completed painting and mounts it on sticks to form a fan. The best fan paintings were

33-13 Dong Qichang, *Dwelling in the Qingbian Mountains*, Ming dynasty, 1617. Hanging scroll, ink on paper, $7' 3\frac{1}{2}'' \times 2' 2\frac{1}{2}''$. Cleveland Museum of Art, Cleveland (Leonard C. Hanna Jr. bequest).

Dong Qichang, "the first modernist painter," conceived his landscapes as shaded masses of rocks alternating with blank bands, flattening the composition and creating expressive, abstract patterns.

33-14 Wen Shu, Carnations and Garden Rock, Ming dynasty, 1627. Fan, ink and colors on gold paper, $6\frac{3''}{8} \times 1'$ $9\frac{1''}{4}$. Honolulu Academy of Arts, Honolulu (gift of Mr. Robert Allerton).

Wen's depiction of a rock formation and three flower sprays is one of the masterpieces of Ming flower painting. It is also an example of fan painting, a format imported from Japan.

probably never used as fans. Collectors purchased them to store in albums. As in her other flower paintings, Wen focused on a few essential elements, in this instance a central rock formation and three sprays of flowers, and presented them against a plain background. Using delicate brushstrokes and a restricted palette, she brilliantly communicated the fragility of the red flowers, contrasting them with the solidity of the brown rock. The spare composition creates a quiet mood of contemplation.

Qing Dynasty

The Ming bureaucracy's internal decay permitted another group of invaders, the Manchus of Manchuria, to overrun China in the 17th century. The Qing dynasty (r. 1644–1911) the Manchus established quickly restored effective imperial rule in the north. Southern China remained rebellious until the second Qing emperor, Kangxi ("Lasting Prosperity," r. 1662–1722), succeeded in pacifying all of China. The Manchus adapted themselves to Chinese life and cultivated knowledge of China's arts.

SHITAO Traditional literati painting continued to be fashionable among conservative Qing artists, but other painters experimented with extreme effects of massed ink or individualized brushwork patterns. Bold and freely manipulated compositions with a new, expressive force began to appear. A prominent painter in this mode was Shitao (Daoji, 1642–1707), a descendant of the Ming imperial family who became a Chan Buddhist monk at age 20. His theoretical writings, most notably his *Sayings on Painting from Monk Bitter Gourd* (his adopted name), called for use of the "single brushstroke" or "primordial line" as the root of all phenomena and representation. Although he carefully studied classical paintings, Shitao opposed mimicking earlier works and believed he could not learn anything from the paintings of others unless he changed them. In *Man in a House beneath a Cliff* (FIG. 33-15), an *album*

leaf (see "Chinese Painting Materials and Formats," Chapter 16, page 459), Shitao surrounded the figure in a hut with vibrant free-floating colored dots and multiple sinuous contour lines. Unlike traditional literati, Shitao did not so much depict the landscape's appearance as animate it, molding the forces running through it.

33-15 Shitao, *Man in a House beneath a Cliff*, Qing dynasty, late 17th century. Album leaf, ink and colors on paper, $9\frac{1}{2}'' \times 11'$. C. C. Wang Collection, New York. $\blacksquare \blacktriangleleft$

Shitao experimented with extreme effects of massed ink and individualized brushwork patterns. In this album leaf, vibrant free-floating colored dots and sinuous contour lines surround a hut.

1 ir

33-16 GIUSEPPE CASTIGLIONE (LANG SHINING), *Auspicious Objects*, Qing dynasty, 1724. Hanging scroll, ink and colors on silk, $7' \, 11\frac{3}{8}'' \times 5' \, 1\frac{7}{8}''$. Palace Museum, Beijing.

Castiglione was a Jesuit painter in Qing China who successfully combined European lighting techniques and three-dimensional volume with traditional Chinese literati subjects and compositions.

GIUSEPPE CASTIGLIONE During the Qing dynasty, European Jesuit missionaries were familiar figures at the imperial court. Many of the missionaries were also artists, and they were instrumental in introducing modern European (that is, High Renaissance and Baroque; see Chapters 22 to 25) painting styles to China. The Chinese, while admiring the Europeans' technical virtuosity, found Western style unsatisfactory. Those Jesuit painters who were successful in China adapted their styles to Chinese tastes. The most prominent European artist at the Qing court was Giuseppe CASTIGLIONE (1688–1768), who went by the name LANG SHINING in China. Auspicious Objects (FIG. 33-16), which Castiglione painted in 1724 in honor of the birthday of the third Qing emperor, Yongzheng ("Concord and Rectitude," r. 1723-1735), exemplifies his hybrid Italian-Chinese painting style. The Jesuit painter's emphasis on a single source of light, consistently cast shadows, and threedimensional volume are unmistakably European stylistic concerns. But the impact of Chinese literati painting on the Italian artist is equally evident, especially in the composition of the branches and

33-17 Dish with lobed rim, Qing dynasty, ca. 1700. White porcelain with multicolored overglaze, 1' $1\frac{5}{8}$ " diameter. Percival David Foundation of Chinese Art, London.

This dish depicting the three star gods of happiness, success, and longevity exemplifies the overglaze porcelain technique in which all the colors come from applying enamels on top of the glaze surface.

leaves of the overhanging pine tree and the rock formations in the lower half of the scroll. Above all, the subject is purely Chinese. The white eagle, the pine tree, the rocks, and the red mushroom-like plants (lingzhi) are traditional Chinese symbols. The eagle connotes imperial status, courage, and military achievement. The evergreen pines and the rocks connote long life, which, according to Chinese belief, eating lingzhi will promote. All are fitting motifs for a painting celebrating the birthday of an emperor.

QING PORCELAIN Qing potters at the imperial kilns at Jingdezhen continued to expand on Yuan and Ming achievements in developing fine porcelain pieces with underglaze and overglaze decoration—a ceramic technology that gained wide admiration in Europe. The dish with a lobed rim reproduced here (FIG. **33-17**) exemplifies the overglaze technique. All of the colors—black, green, brown, yellow, and even blue—come from applying enamels after the first firing and then firing the dish again at a lower temperature (see "Chinese Porcelain," page 992).

The decoration of the dish reflects important social changes in China. Economic prosperity and the possibility of advancement through success on civil service examinations made it realistic for many more families to hope their sons could achieve wealth and higher social standing. In the center of the dish are Fu, Lu, and Shou, the three star gods of happiness, success, and longevity. The cranes and spotted deer, believed to live to advanced ages, and the pine trees around the rim are all symbols of long life. Artists represented similar themes in the inexpensive woodblock prints produced in great quantities during the Qing era. They were the commoners' equivalent of Castiglione's imperial painting of auspicious symbols (FIG. 33-16).

People's Republic

The overthrow of the Qing dynasty and the establishment of the Republic of China under the Nationalist Party in 1912 did not bring an end to the traditional themes and modes of Chinese art. But the triumph of Marxism in 1949, when the Communists took control of China and founded the People's Republic, inspired a social realism that broke drastically with the past. The intended purpose of Communist art was to serve the people in the struggle to liberate and elevate the masses.

YE YUSHAN In *Rent Collection Courtyard* (FIG. 33-18), a 1965 tableau 100 yards long and incorporating 114 life-size figures, YE YUSHAN (b. 1935) and a team of sculptors depicted the grim times before the People's Republic. Peasants, worn and bent by toil, bring their taxes (in produce) to the courtyard of their merciless, plundering landlord. The message is clear—this kind of thing must not happen again. Initially, the authorities did not reveal the artists' names. The anonymity of those who depicted the event was significant in itself. The secondary message was that only collective action could effect the transformations the People's Republic sought.

CHINA TODAY In the second decade of the 21st century, China is one of the world's great economic powers, and the un-

winding of the Cultural Revolution initiated by Mao Zedong (1893–1976) has led to a fruitful artistic exchange between China and the West, with artists such as Xu Bing (FIG. 31-18) and Wu Guanzhong (FIG. 31-22) achieving international reputations. Their works, which can be found in the collections of major museums in Europe and America as well as China, are treated in Chapter 31 in the context of contemporary art worldwide.

KOREA

The great political, social, religious, and artistic changes that took place in China from the Mongol era to the time of the People's Republic find parallels elsewhere in East Asia, especially in Korea.

Joseon Dynasty

At the time the Yuan overthrew the Song dynasty, the Goryeo dynasty (918–1392), which had ruled Korea since the downfall of China's Tang dynasty, was still in power (see Chapter 16). The Goryeo kings outlasted the Yuan as well. Toward the end of the Goryeo dynasty, however, the Ming emperors of China attempted to take control of northeastern Korea. General Yi Seonggye repelled them and founded the last Korean dynasty, the Joseon, in 1392. The long rule of the Joseon kings ended only in 1910, when Japan annexed Korea.

33-18 YE YUSHAN and others, Rent Collection Courtyard (detail of larger tableau), Dayi, China, 1965. Clay, 100 yards long with life-size figures.

In this propagandistic tableau incorporating 114 figures, sculptors depicted the exploitation of peasants by their merciless landlords during the grim times before the Communist takeover of China.

33-19 Namdaemun, Seoul, South Korea, Joseon dynasty, first built in 1398.

The new Joseon dynasty rulers constructed the south gate to their new capital of Seoul as a symbol of their authority. Namdaemun combines stone foundations with Chinese-style bracketed wooden construction.

NAMDAEMUN, SEOUL Public building projects helped give the new Korean state an image of dignity and power. One impressive early monument, built for the new Joseon capital of Seoul, is the city's south gate, or Namdaemun (FIG. 33-19). It combines the imposing strength of its impressive stone foundations with the sophistication of its intricately bracketed wooden superstructure—the latter regrettably severely damaged by an arson fire in 2008. In East Asia, elaborate gateways, often in a processional series, are a standard element in city designs, as well as royal and sacred compounds, all usually surrounded by walls, as in Beijing's Forbidden City (FIG. 33-1). These gateways served as magnificent symbols of the ruler's authority, as did the triumphal arches of imperial Rome (see Chapter 7).

JEONG SEON Over the long course of the Joseon dynasty, Korean painters worked in many different modes and treated the same wide range of subjects seen in Ming and Qing China. One of Korea's most renowned painters was Jeong Seon (1676–1759), a great admirer of Chinese Southern School painting who brought a unique vision to the traditional theme of the mountainous landscape. In *Geumgangsan (Diamond) Mountains* (FIG. **33-20**), he evoked a specific scene, an approach known in Korea as "true view" painting. Using sharper, darker versions of the fibrous brushstrokes most Chinese literati favored, he was able to represent the bright crystalline appearance of the mountains and to emphasize their spiky forms.

Modern Korea

After its annexation in 1910, Korea remained part of Japan until 1945, when the Western Allies and the Soviet Union took control of the peninsula nation at the end of World War II. Korea was divided into the Democratic People's Republic of Korea (North Korea) and the Republic of Korea (South Korea) in 1948. South Korea soon emerged as a fully industrialized nation, and its artists have had a wide exposure to art styles from around the globe. While some Korean artists continue to work in a traditional East Asian manner, others, for example, Song Su-nam (FIG. 31-22A) have embraced developments in Europe and America. Contemporary Korean art is examined in Chapter 31.

33-20 Jeong Seon, Geumgangsan (Diamond) Mountains, Joseon dynasty, 1734. Hanging scroll, ink and colors on paper, 4' $3\frac{1''}{2} \times 1$ ' $11\frac{1''}{4}$ ". Hoam Art Museum, Kyunggi-Do.

In a variation on Chinese literati painting, Jeong Seon used sharp, dark brushstrokes to represent the bright crystalline appearance and spiky forms of the Diamond Mountains.

CHINA AND KOREA, 1279 TO 1980

YUAN DYNASTY 1279-1368

- The Mongols invaded northern China in 1210 and defeated the last Song emperor in 1279. Under the first Yuan emperor, Kublai Khan, and his successors, China was richer and technologically more advanced than medieval Europe.
- Most Chinese artists refused to serve in the Mongol administration, but traditional landscape painting and calligraphy continued to flourish in literati circles during the century of Yuan rule.
- The Jingdezhen kilns gained renown for porcelain pottery with cobalt-blue underglaze decoration.

MING DYNASTY 1368-1644

- A popular uprising in 1368 drove the last Mongol emperor from Beijing. The new native Ming dynasty expanded the capital and constructed a vast new imperial palace compound, the Forbidden City. Surrounded by a moat and featuring an axial plan, it was the ideal setting for court ritual.
- At the opposite architectural pole are the gardens of Suzhou. The Ming designers employed pavilions, bridges, ponds, winding paths, and sculpted rocks to reproduce the irregularities of uncultivated nature.
- Ming painting is also diverse, ranging from formal official portrait and history painting to landscape painting. Another subject artists explored was flowers, sometimes painted on fans.
- The Orchard Factory satisfied the Ming court's appetite for luxury goods with furniture and other objects in lacquered wood.

Temple vase,

Yuan dynasty, 1351

Forbidden City, Beijing, 15th century and later

QING DYNASTY 1644-1911

- In 1644, the Ming dynasty fell to the Manchus, northern invaders who, unlike the Yuan, embraced Chinese art and culture.
- Traditional painting styles remained fashionable, but the Qing painter Shitao experimented with extreme effects of massed ink and free brushwork patterns.
- Increased contact with Europe brought many Jesuit missionaries to the Qing court. The most prominent Jesuit artist was Guiseppe Castiglione, who developed a hybrid Italian-Chinese painting style.
- The Jingdezhen imperial potters developed multicolor porcelains using the overglaze enamel technique.

Shitao, Man in a House beneath a Cliff, late 17th century

MODERN CHINA 1912-1980

■ The overthrow of the Qing dynasty did not bring a dramatic change in Chinese art, but after the Communists gained control in 1949, state art focused on promoting Marxist ideals. Teams of sculptors produced vast propaganda pieces, such as Rent Collection Courtyard.

Ye Yushan. Rent Collection Courtyard, 1965

KOREA 1392-1980

- The last Korean dynasty was the Joseon (r. 1392–1910), which established its capital at Seoul and erected impressive public monuments, such as the Namdaemun gate, to serve as symbols of imperial authority.
- After the division of Korea into two republics following World War II, South Korea emerged as a modern industrial nation. Some of its artists have brilliantly combined native and international traditions.

Namdaemun, Seoul, 1398

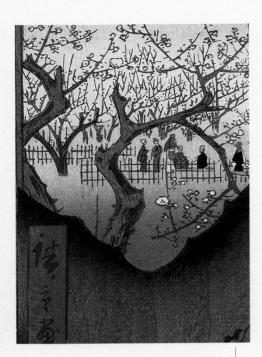

In the 19th century, residents of Edo (modern Tokyo) sought to escape from the noise and pressures of city life to visit places of natural beauty, such as the plum-tree estate at Kameido.

The main attraction of the Kameido estate was the venerable Sleeping Dragon Plum, the most famous tree in Edo, celebrated for its large white blossoms and aromatic fragrance.

Ando Hiroshige's woodblock print shows only a partial view of the Sleeping Dragon Plum, whose branches spread out in abstract patterns resembling the beloved Japanese art of calligraphy.

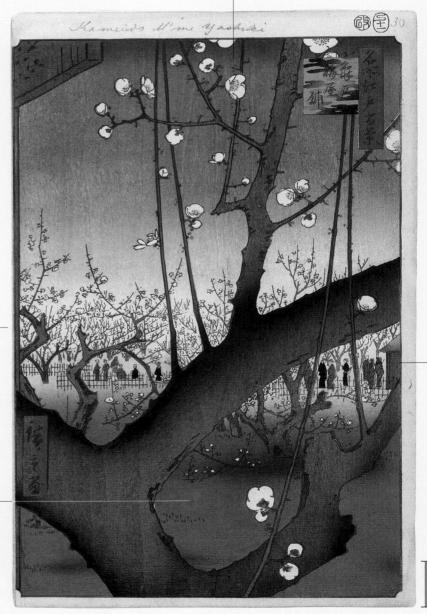

34-1 Ando Hiroshige, *Plum Estate, Kameido*, from *One Hundred Famous Views of Edo*, Edo period, 1857. Woodblock print, ink and color on paper, $1' 1_4^{1''} \times 8_8^{5''}$. Brooklyn Museum, Brooklyn (gift of Anna Ferris).

1 ir

34

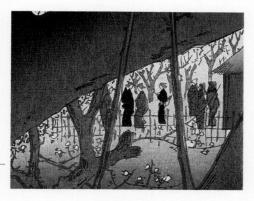

The bold patterns of the Kameido plum tree's limbs seen against the unnaturally colored red sky so dominate the print that the viewer hardly notices the crowd of onlookers behind a fence.

JAPAN, 1336 TO 1980

FAMOUS VIEWS OF EDO

andscape painting—long revered as a major genre of Chinese and Korean painting (see Chapters 16 and 33)—emerged in the 18th century in Japan as an immensely popular subject with the proliferation of inexpensive multicolor woodblock prints (see "Japanese Woodblock Prints," page 1016). Although inspired in part by Dutch landscape engravings imported into Japan at a time when the ruling Tokugawa government was pursuing an isolationist policy (see page 1012), Japanese printmakers radically transformed the compositions and coloration of their Western models.

Ando Hiroshige (1797–1858) and the older Katsushika Hokusai (Fig. 34-13) were the two most renowned Japanese printmakers specializing in landscapes. Hiroshige, born into a wealthy family, decided early on to pursue a career as an artist rather than to follow in his father's footsteps as chief of a fire brigade. In August 1832, he traveled on an official government mission to the emperor in Kyoto and the following year published a series of prints based on sketches he made on that journey—*Fifty-three Stations of the Tokaido Highway*. That collection of views of the countryside along the major roadway on Japan's east coast was an instant success. Many other editions followed, including views of Kyoto (1834) and his last and most ambitious series, published shortly before his death, *One Hundred Famous Views of Edo*.

Plum Estate, Kameido (FIG. 34-1), dated "11th Month, 1857," comes from the Edo series. The "famous views" are not monuments and buildings but places of leisure and natural beauty where the Japanese sought to escape from the noise and pressures of city life. Many of the sites are Shinto shrines (see "Shinto," Chapter 17, page 479) and Buddhist temples. Others, including the plum orchard of Kameido, were favorite spots to visit at particular times of the year, when their natural beauty was at its peak. The main attraction of the Kameido estate was the Sleeping Dragon Plum, the most famous tree in Edo, celebrated for its large white blossoms and aromatic fragrance. Hiroshige's print shows only a partial view of the venerable tree, with its branches spreading out to touch all sides of the print and forming a bold abstract pattern resembling the beloved art of calligraphy. The pattern of the tree's limbs so dominates the print the viewer hardly notices the crowd of onlookers behind a fence in the background. The unnatural coloration of the red sky enhances the abstract effect, flattening the pictorial space in a manner completely foreign to the Western notion of perspective. It was precisely this quality that fascinated 19th-century European painters who were trying to break free of the Renaissance ideals perpetuated by the official painting academies. One such artist was Vincent van Gogh, who paid tribute to Hiroshige by painting his own version of the Kameido woodblock print (FIG. 28-16B).

MUROMACHI

In 1185, the Japanese emperor in Kyoto appointed the first *shogun* (military governor) in Kamakura in eastern Japan (MAP **34-1**). Although the imperial family retained its right to reign and, in theory, the shogun managed the country on the ruling emperor's behalf, in reality the emperor lost all governing authority. The Japanese *shogunate* was a political and economic arrangement in which *daimyo* (local lords), the leaders of powerful warrior bands composed of *samurai* (warriors), pledged allegiance to the shogun. These local lords had considerable power over affairs in their domains. The Kamakura shogunate ruled Japan for more than a century but collapsed in 1332. Several years of civil war followed, ending only when Ashikaga Takauji (1305–1358) succeeded in establishing domination of his clan over all of Japan and became the new imperially recognized shogun.

The rise of the Ashikaga clan marked the beginning of the Muromachi period (1336–1573), named after the district in Kyoto in which the Ashikaga shoguns maintained their headquarters. During the Muromachi period, Zen Buddhism (see "Zen Buddhism," page 1007) rose to prominence alongside the older traditions, such as Pure Land and Esoteric Buddhism. Unlike the Pure Land faith, which stressed reliance on the saving power of Amida, the Buddha of the West, Zen emphasized rigorous discipline and personal responsibility. For this reason, Zen held a special attraction for the upper echelons of samurai, whose behavioral codes placed high values on loyalty, courage, and self-control. Further, familiarity with Chinese Zen culture (see "Chan Buddhism," Chapter 16, page 470) carried implications of superior knowledge and refinement, thereby legitimizing the elevated status of the warrior elite.

Zen, however, was not exclusively the religion of Zen monks and highly placed warriors. Aristocrats, merchants, and others studied at and supported Zen temples. Furthermore, those who embraced Zen, including samurai, also generally accepted other Buddhist teachings, especially the ideas of the Pure Land sects. These sects gave much greater attention to the problems of death and salvation. Zen temples stood out not only as religious institutions but also as centers of secular culture, where people could study Chinese art, literature, and learning, which the Japanese imported along with Zen Buddhism. Some Zen monasteries accumulated considerable wealth overseeing trade missions to China.

SAIHOJI GARDENS The Saihoji temple gardens (FIG. 34-2) in Kyoto bear witness to both the continuities and changes mark-

1573

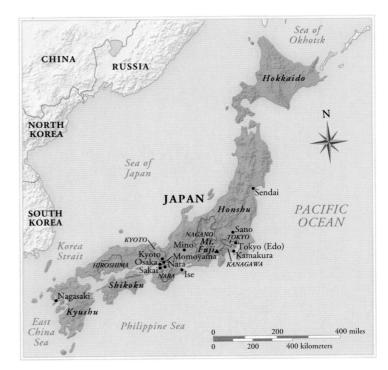

MAP 34-1 Modern Japan.

ing religious art in the Muromachi period. In the 14th century, this Pure Land temple with its extensive gardens became a Zen institution. However, Zen leaders did not attempt to erase other religious traditions, and the Saihoji gardens in their totality originally included some Pure Land elements even as they served the Zen faith's more meditative needs. In this way, they perfectly echo the complementary roles of these two Buddhist traditions in the Muromachi period, with Pure Land providing a promise of salvation and Zen promoting study and meditation.

Saihoji's lower gardens center on a pond in the shape of the Japanese character for "mind" or "spirit" and are thus a perfect setting for monks to meditate. Today, these gardens are famous for their iridescently green mosses, whose beauty is almost otherworldly. In contrast, arrangements of rocks and sand on the hill-sides of the upper garden, especially the dry cascade and pools (FIG. 34-2), are treasured early examples of Muromachi *karesansui*

1868

JAPAN, 1336 TO 1980

Zen Buddhist gardens feature dry landscapes

Muromachi

1336

- Sesshu Toyo produces paintings in the splashed-ink style
- Kano Motonobu helps establish the Kano School as a virtual Japanese national painting academy
- I Japanese shoguns decorate their palatial fortress-castles with painted folding screens featuring lavish use of gold leaf

Momovama

- Sen no Rikyu becomes the most renowned master of the Japanese tea ceremony and designs teahouses that foster humility
- Shino ceramics exemplify the aesthetic principles of wabi and sabi
- The Katsura Imperial Villa at Kyoto sets the standard for Japanese domestic architecture

Edo

1615

- The Rinpa School, named after Ogata Korin, emerges as the major alternative style of painting to the Kano School
- I Japanese woodblock prints depicting the sensual pleasures of Edo's "floating world" reach a wide audience
- European styles and techniques, including oil painting, influence Japanese art after Japan opens its doors to the West

Meiji and Showa

1980

- Ceramic master Hamada Shoji receives official recognition as a Living National Treasure
- Kenzo Tange designs the modernist stadiums for the 1964 Olympics in Tokyo

Zen Buddhism

Zen (Chan in Chinese), as a fully developed Buddhist tradition, began filtering into Japan in the 12th century and had its most pervasive influence on Japanese culture starting in the 14th century during the Muromachi period. As in other forms of Buddhism, Zen followers hoped to achieve enlightenment. Zen teachings assert everyone has the potential for enlightenment, but worldly knowledge and mundane thought patterns are barriers to achieving it. Thus, followers must succeed in breaking through the boundaries of everyday perception and logic. This is most often accomplished through meditation. Indeed, the word zen means "meditation."

Some Zen schools stress meditation as a long-term practice eventually leading to enlightenment, whereas others stress the benefits of sudden shocks to the worldly mind. One of these shocks is the subject of Kano Motonobu's *Zen Patriarch Xiangyen Zhixian Sweeping with a Broom* (FIG. 34-4), in which the shattering of a fallen roof tile opens the monk's mind. Beyond personal commitment, the guidance of an enlightened Zen teacher is essential to arriving at enlightenment. Years of strict training involving manual labor under the tutelage of this master, coupled with meditation, provide the foundation for a receptive mind. According to Zen beliefs, by cultivating discipline and intense concentration, Buddhists can transcend their ego and release themselves from the shackles

of the mundane world. Although Zen is not primarily devotional, followers do pray to specific Buddhas, bodhisattvas, and guardian figures. In general, Zen teachings view mental calm, lack of fear, and spontaneity as signs of a person's advancement on the path to enlightenment.

Zen training for monks takes place at temples, some of which have gardens designed in accord with Zen principles, such as the dry-landscape gardens of Kyoto's Saihoji and Ryoanji temples (FIGS. 34-2 and 34-2A). Zen temples also sometimes served as centers of Chinese learning and handled funeral rites. These temples even embraced many traditional Buddhist observances, such as devotional rituals before images, which had little to do with meditation per se.

As the teachings spread, Zen ideals reverberated throughout Japanese culture. Lay followers as well as Zen monks painted pictures and produced other artworks that appear to reach toward Zen ideals through their subjects and their means of expression. Other cultural practices reflected the widespread appeal of Zen. For example, the tea ceremony (see "The Japanese Tea Ceremony," page 1012), or ritual drinking of tea, as it developed in the 15th and 16th centuries, offered a temporary respite from everyday concerns, a brief visit to a quiet retreat with a meditative atmosphere, such as the Taian teahouse (FIG. 34-7).

34-2 Dry cascade and pools, upper garden, Saihoji temple, Kyoto, Japan, modified in Muromachi period, 14th century.

Zen temples often incorporated gardens to facilitate meditation. The upper garden of the Saihoji temple in Kyoto is an early example of Muromachi dry-landscape gardening (karesansui).

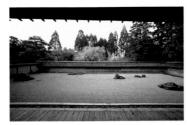

34-2A Karesansui garden, Ryoanji, Kyoto, ca. 1488.

(dry-landscape gardening). The designers stacked the rocks to suggest a swift mountain stream rushing over the stones to form pools below. In East Asia, people long considered gazing at dramatic natural scenery highly beneficial to the human spirit. These activities refreshed people

worn down from too much contact with daily affairs and helped them reach beyond mundane reality. The dry landscape, or rock garden, became very popular in Japan in the Muromachi period and afterward, especially at Zen temples. In its extreme form, as in the severe, walled Zen garden (FIG. 34-2A) in Kyoto's Ryoanji temple, a karesansui garden consists purely of artfully arranged rocks on a raked bed of sand.

SESSHU TOYO As was common in earlier eras of Japanese history, Muromachi painters usually closely followed Chinese precedents (often arriving by way of Korea), which artists throughout East Asia regarded as part of a shared cultural heritage. Muromachi painting nonetheless displays great variety in both style and subject matter. Indeed, individual masters often worked in different styles, as did the most celebrated Muromachi priest-painter, Sesshu Toyo (1420-1506), one of the few Japanese painters who traveled to China and studied contemporaneous Ming painting. His most dramatic works are in the *splashed-ink* (*haboku*) style, a technique with Chinese roots. The painter of a haboku picture pauses to visualize the image, loads the brush with ink, and then applies primarily broad, rapid strokes, sometimes even dripping the ink onto the paper. The result often hovers at the edge of legibility, without dissolving into sheer abstraction. This balance between spontaneity and a thorough knowledge of the painting tradition gives the pictures their artistic strength. In the haboku landscape illustrated here (FIG. 34-3), images of mountains, trees, and buildings emerge from the ink-washed surface. Two figures appear in a boat (to the lower right), and the two swift strokes nearby represent the pole and banner of a wine shop.

KANO MOTONOBU Representing the opposite pole of Muromachi painting style is the Kano School, which by the 17th century had become virtually a national painting academy. The school flourished until the late 19th century. Kano Motonobu (1476–1559) was largely responsible for establishing the Kano style

34-3 Sesshu Toyo, splashed-ink (haboku) landscape, detail of the lower part of a hanging scroll, Muromachi period, 1495. Ink on paper, full scroll 4' $10\frac{1}{4}'' \times 1'\frac{7}{8}''$; detail $4\frac{1}{2}''$ high. Tokyo National Museum, Tokyo.

In this haboku landscape, the artist applied primarily broad, rapid strokes, sometimes dripping the ink on the paper. The result hovers at the edge of legibility, without dissolving into abstraction.

during the Muromachi period. His Zen Patriarch Xiangyen Zhixian Sweeping with a Broom (FIG. 34-4) is one of six panels Motonobu designed as fusuma (sliding door paintings) for the abbot's room in the Zen temple complex of Daitokuji in Kyoto. Each panel depicted a different Zen patriarch. The illustrated example, later refashioned as a hanging scroll, represents Xiangyen Zhiaxian (d. 898) at the moment he achieved enlightenment. Motonobu portrayed the patriarch sweeping the ground near his rustic retreat as a roof tile falls at his feet and shatters. His Zen training is so deep the resonant

34-4 Kano Motonobu, Zen Patriarch Xiangyen Zhixian Sweeping with a Broom, from Daitokuji, Kyoto, Japan, Muromachi period, са. 1513. Hanging scroll, ink and color on paper, 5′ $7\frac{3}{8}'' \times 2'$ $10\frac{3}{4}''$. Tokyo National Museum, Tokyo.

The Kano School represents the opposite pole of Muromachi style from splashed-ink painting. In this scroll depicting a Zen patriarch experiencing enlightenment, bold outlines define the forms.

1 f

sound propels the patriarch into an awakening. In contrast to Muromachi splashed-ink painting, Motonobu's work displays exacting precision in applying ink in bold outlines by holding the brush perpendicular to the paper. Thick clouds obscure the mountainous setting and focus the viewer's attention on the sharp, angular rocks, bamboo branches, and modest hut framing the patriarch. Lightly applied colors also draw attention to Xiangyen Zhixian, whom Motonobu showed as having dropped his broom with his right hand as he recoils in astonishment. Although very different in style, the Japanese painting recalls the subject of Liang Kai's Song hanging scroll (FIG. 16-25) representing the Sixth Chan Patriarch's "Chan moment" while chopping bamboo.

MOMOYAMA

Despite the hierarchical nature of Japanese society during the Muromachi period, the control the Ashikaga shoguns exerted was tenuous and precarious. Ambitious daimyo often seized opportu-

nities to expand their power, sometimes aspiring to become shoguns themselves. By the late 15th century, Japan was experiencing violent confrontations over territory and dominance. In fact, scholars refer to the last century of the Muromachi period as the Era of Warring States, intentionally borrowing the terminology used to describe a much earlier tumultuous period in Chinese history (see Chapter 16). Finally, three successive warlords seized power, and the last succeeded in restoring order and establishing a new and long-lasting shogunate. In 1573, Oda Nobunaga (1534-1582) overthrew the Ashikaga shogunate in Kyoto but was later killed by one of his generals. Toyotomi Hideyoshi (1536-1598) took control of the government after Nobunaga's assassination and ruled until he died of natural causes in 1598. In the struggle following Hideyoshi's death, Tokugawa Ieyasu (1542-1616) emerged victorious and assumed the title of shogun in 1603. Ieyasu continued to face challenges, but by 1615 he had eliminated his last rival and established his clan as the rulers of Japan for two and a half centuries. To reinforce their power, these warlords constructed huge castles

34-4A White Heron Castle, Himeji, begun 1581.

with palatial residences—partly as symbols of their authority and partly as fortresses. An outstanding example is Hideyoshi's White Heron Castle (FIG. 34-4A) at Himeji, west of Osaka. The new era's designation, Momoyama (Peach Blossom Hill), derives from the scenic foliage at another Hideyoshi castle south-

east of Kyoto. The Momoyama period (1573–1615), although only a brief interlude between two major shogunates, produced many outstanding artworks.

KANO EITOKU Each Momoyama warlord commissioned lavish decorations for the interior of his castle, including paintings, fusuma, and *byobu* (folding screens) in ink, color, and gold leaf. Gold screens had been known since Muromachi times, but Momoyama painters made them even bolder, reducing the number of motifs and often greatly enlarging them against flat, shimmering fields of gold leaf.

The grandson of Motonobu, Kano Eitoku (1543–1590), was the leading painter of murals and screens and received numerous commissions from the powerful Momoyama warlords. So extensive were these commissions (in both scale and number) that Eitoku adopted a painting system developed by his grandfather, which depended on a team of specialized painters to assist him. Unfortunately, little of Eitoku's elaborate work remains because of the subsequent destruction of the ostentatious castles he helped decorate—not surprising in an era marked by power struggles. However, a painting on a six-panel screen, *Chinese Lions* (FIG. 34-5), offers a glimpse of his work's gran-

deur. Possibly created for Toyotomi Hideyoshi, this screen, originally one of a pair, appropriately speaks to the emphasis on militarism so prevalent at the time. The lions Eitoku depicted are ancient Chinese mythological beasts. Appearing in both religious and secular contexts, the lions came to be associated with power and bravery, and are thus fitting imagery for a military leader. Indeed, Chinese lions became an important symbolic motif during the Momoyama period. In Eitoku's painting, the colorful beasts' powerfully muscled bodies, defined and flattened by broad contour lines, stride forward within a gold field and minimal setting elements. The dramatic effect of this work derives in part from its scale—it is more than 7 feet tall and nearly 15 feet long.

HASEGAWA TOHAKU Momoyama painters did not work exclusively in the colorful style exemplified by Eitoku's *Chinese Lions*. HASEGAWA TOHAKU (1539–1610) was a leading painter who became familiar with the aesthetics and techniques of Chinese Chan and Japanese Zen painters such as Sesshu Toyo (FIG. 34-3) by studying the art collections of the Daitokuji temple in Kyoto. Tohaku sometimes painted in ink monochrome using loose brushwork with brilliant success, as seen in *Pine Forest* (FIG. 34-6), one of a pair of six-panel byobu. His wet brushstrokes—long and slow, short and quick, dark and pale—present a grove of great pines shrouded in mist. His trees emerge from and recede into the heavy atmosphere, as if the landscape hovers at the edge of formlessness. In Zen terms, the picture suggests the illusory nature of mundane reality while evoking a calm, meditative mood.

SEN NO RIKYU A favorite exercise of cultivation and refinement in the Momoyama period was the tea ceremony (see "The Japanese Tea Ceremony," page 1012). In Japan, this important practice

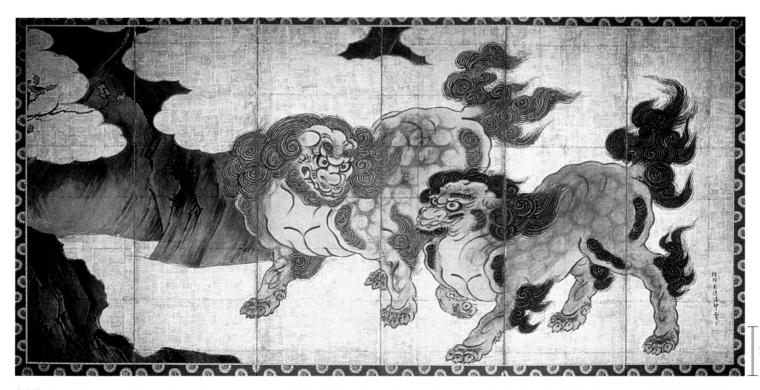

34-5 Kano Eitoku, Chinese Lions, Momoyama period, late 16th century. Six-panel screen, color, ink, and gold-leaf on paper, 7' $4'' \times 14'$ 10''. Museum of the Imperial Collections, Tokyo.

Chinese lions were fitting imagery for the castle of a Momoyama warlord because they exemplified power and bravery. Eitoku's huge screen features boldly outlined forms on a gold ground.

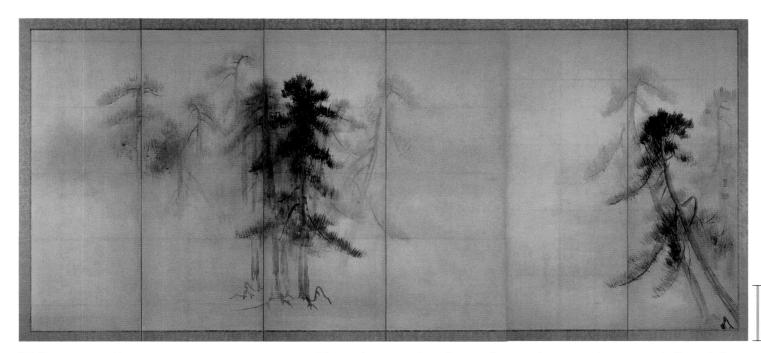

34-6 HASEGAWA TOHAKU, *Pine Forest*, Momoyama period, late 16th century. One of a pair of six-panel screens, ink on paper, 5' $1\frac{3}{8}'' \times 11'$ 4''. Tokyo National Museum, Tokyo.

Tohaku used wet brushstrokes to paint a grove of great pines shrouded in mist. In Zen terms, the six-panel screen suggests the illusory nature of mundane reality while evoking a meditative mood.

eventually came to carry various political and ideological implications. For example, it provided a means for those relatively new to political or economic power to assert authority in the cultural realm. For instance, upon returning from a major military campaign, Toyotomi Hideyoshi held an immense tea ceremony lasting 10 days and open to everyone in Kyoto. The ceremony's political implications became so important that warlords granted or refused

their vassals the right to host these rituals.

The most venerated tea master of the Momoyama period was SEN NO RIKYU (1522-1591), who was instrumental in establishing the rituals and aesthetics of the tea ceremony, for example, the manner of entry into a teahouse (crawling on one's hands and knees). Rikyu believed crawling fostered humility and created the impression, however unrealistic, that there was no rank in a teahouse. Rikyu was the designer of the first Japanese teahouse built as an independent structure as opposed to being part of a house. The Taian teahouse (FIG. 34-7) at the Myokian temple in Kyoto, also attributed to Rikyu, is the oldest in Japan. The interior displays two standard features of Japanese residential architecture of the late Muromachi period—very thick, rigid straw mats called tatami (a Heian innovation) and an alcove called a tokonoma. The tatami accommodate the traditional Japanese customs of not wearing shoes indoors and of sitting on the floor. They are still features of Japanese homes today. Less common in contemporary houses are tokonoma, which developed as places to hang scrolls of painting or calligraphy and to display other prized objects.

The Taian tokonoma and the tearoom as a whole have unusually dark walls, with earthen plaster covering even some of the square corner posts. The room's dimness and tiny size (about six feet square, the size of two tatami mats) produce a cavelike feel and encourage intimacy among the tea host and guests. The guests enter from the garden outside by crawling through a small sliding door. The means of entrance emphasizes a guest's passage into a ceremonial space set apart from the ordinary world.

34-7 Sen no Rikyu, view into the Taian teahouse, Myokian temple, Kyoto, Japan, Momoyama period, ca. 1582.

The dimness and tiny size of the Taian tearoom and its alcove produce a cavelike feel and encourage intimacy among the host and guests, who must crawl through a small door to enter.

The Japanese Tea Ceremony

The Japanese tea ceremony involves the ritual preparation, serving, and drinking of green tea. The fundamental practices began in China, but they developed in Japan to a much higher degree of sophistication, peaking in the Momoyama period. Simple forms of the tea ceremony started in Japan in Zen temples as a symbolic withdrawal from the ordinary world to cultivate the mind and spirit. The practices spread to other social groups, especially

34-8 Kogan (tea-ceremony water jar), Momoyama period, late 16th century. Shino ware with underglaze design, 7" high. Hatakeyama Memorial Museum, Tokyo.

The vessels used in the Japanese tea ceremony reflect the concepts of wabi, the aesthetic of refined rusticity, and sabi, the value found in weathered objects, suggesting the tranquility of old age.

samurai and, by the late 16th century, wealthy merchants. Until the late Muromachi period, grand tea ceremonies in warrior residences served primarily as an excuse to display treasured collections of Chinese objects, such as porcelains, lacquers, and paintings.

Initially, the Japanese held tea ceremonies in a room or section of a house. As the popularity of tea ceremonies increased, freestanding teahouses (FIG. 34-7) became common. The ceremony involves a sequence of rituals in which both host and guests participate. The host's responsibilities include serving the guests; selecting special utensils, such as water jars (FIG. 34-8) and tea bowls; and determining the tearoom's decoration, which changes according to occasion and season. Acknowledged as having superior aesthetic sensibilities, individuals recognized as master tea-ceremony practitioners (tea masters) advise patrons on the ceremony and acquire students. Tea masters even direct or influence the design of teahouses and

1 in.

tearooms within larger structures (including interiors and gardens), as well as the design of tea utensils. They often make simple bamboo implements and occasionally even ceramic vessels.

SHINO CERAMICS Sen no Rikyu also was influential in determining the aesthetics of tea-ceremony utensils. In his view, value and refinement lay in character and ability, not in bloodline or rank, and he therefore encouraged the use of tea items whose value was their inherent beauty rather than their monetary worth. Even before Rikyu, in the late 15th century during the Muromachi period, admiration of the technical brilliance of Chinese objects had begun to give way to ever-greater appreciation of the virtues of rustic Korean and Japanese wares. This new aesthetic of refined rusticity, or *wabi*, was consistent with Zen concepts. Wabi suggests austerity and simplicity. Related to wabi and also important as a philosophical and aesthetic principle was *sabi*—the value found in the old and weathered, suggesting the tranquility reached in old age.

Wabi and sabi aesthetics underlie the ceramic vessels produced for the tea ceremony, such as the Shino water jar named *Kogan* (FIG. 34-8). The name, which means "ancient stream bank," comes from the painted design on the jar's surface as well as from its coarse texture and rough form, both reminiscent of earth cut by water. The term *Shino* generally refers to ceramic wares produced during the late 16th and early 17th centuries in kilns in Mino. Shino vessels typically have rough surfaces and feature heavy glazes containing feldspar. These glazes are predominantly white when fired, but can include pinkish-red or gray hues. The water jar's coarse stoneware body and seemingly casual decoration offer the same sorts of aes-

thetic and interpretive challenges and opportunities as dry-land-scape gardens (FIGS. 34-2 and 34-2A). The jar illustrated here, for example, has a prominent crack in one side and sagging contours (both intentional) to suggest the accidental and natural, qualities essential to the values of wabi and sabi.

EDO

When Tokugawa Ieyasu consolidated his power in 1615, he abandoned Kyoto, the official capital, and set up his headquarters in Edo (modern Tokyo), initiating the Edo period (1615–1868) of Japanese history and art. The new regime instituted many policies designed to limit severely the pace of social and cultural change in Japan. Fearing destabilization of the social order, the Tokugawa rulers banned Christianity and expelled all Western foreigners except the Dutch. The Tokugawa also instituted Confucian ideas of social stratification and civic responsibility as public policy, and they tried to control the social influence of urban merchants, some of whose wealth far outstripped that of most warrior leaders. However, the population's great expansion in urban centers, the spread of literacy in the cities and beyond, and a growing thirst for knowledge and diversion made for a very lively popular culture not easily subject to tight control.

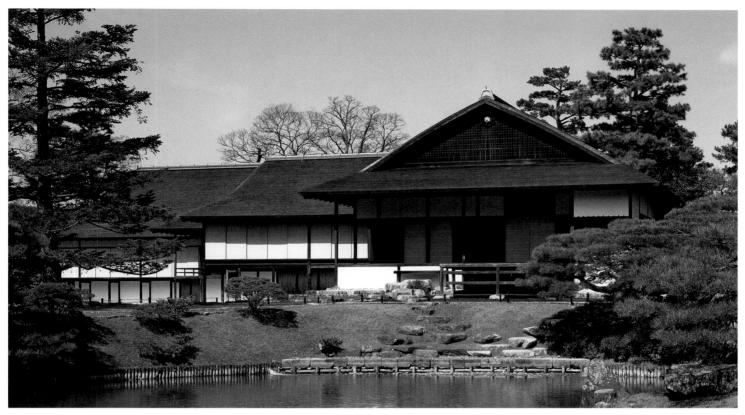

34-9 East facade of the Katsura Imperial Villa, Kyoto, Japan, Edo period, 1620-1663.

The Katsura Imperial Villa became the standard for Japanese residential architecture. The design relies on subtleties of proportion, color, and texture instead of ornamentation for its aesthetic appeal.

KATSURA IMPERIAL VILLA In the Edo period, the imperial court's power remained as it had been for centuries, symbolic and ceremonial, but the court continued to wield influence in matters of taste and culture. For example, for a 50-year period in the 17th century, a princely family developed a modest country retreat into a villa that became the standard for domestic Japanese architecture. Since the early 20th century, it has inspired architects worldwide (FIG. 29-45), even as ordinary living environments in Japan became increasingly Westernized in structure and decor. The Katsura Imperial Villa (FIG. 34-9), built between 1620 and 1663 on the Katsura River southwest of Kyoto, has many features derived from earlier teahouses, such as Rikyu's Taian (FIG. 34-7). However, tea-ceremony aesthetics later retreated from Rikyu's wabi extremes, and the Katsura Villa's designers and carpenters incorporated elements of courtly gracefulness as well.

Ornamentation that disguises structural forms has little place in this architecture's appeal, which relies instead on subtleties of proportion, color, and texture. A variety of textures (stone, wood, tile, plaster) and subdued colors and tonal values enrich the villa's lines, planes, and volumes. Artisans painstakingly rubbed and burnished all surfaces to bring out the natural beauty of their grains and textures. The rooms are not large, but parting or removing the sliding doors between them can create broad rectangular spaces. Perhaps most important, the residents can open the doors to the outside to achieve a harmonious integration of building and garden—one of the primary ideals of Japanese residential architecture.

RINPA In painting, the Kano School enjoyed official governmental sponsorship during the Edo period, and its workshops provided paintings to the Tokugawa shoguns and their major vassals.

By the mid-18th century, Kano masters also served as the primary painting teachers for nearly everyone aspiring to a career in the field. Even so, individualist painters and other schools emerged and flourished, working in quite distinct styles.

The earliest major alternative school to emerge in the Edo period, Rinpa, was quite different in nature from the Kano School. It did not have a similar continuity of lineage and training through father and son, master and pupil. Instead, over time, Rinpa aesthetics and principles attracted a variety of individuals as practitioners and champions. Stylistically, Rinpa works feature vivid color and extensive use of gold and silver and often incorporate decorative patterns. The Rinpa School traced its roots to Tawaraya Sotatsu (d. 1643), an artist who emerged as an important figure during the late Momoyama period, and whose *Waves at Matsushima* (FIG. 34-9A) is one of the early masterworks of Edo painting. Rinpa, however, takes its first syllable from the last syllable in the name of

OGATA KORIN (1658–1716; FIG. I-13). Both Sotatsu and Korin were scions of wealthy merchant families with close connections to the Japanese court. Many Rinpa works incorporate literary themes the nobility favored.

34-9A SOTATSU, Waves at Matsushima, ca. 1630.

HONAMI KOETSU One of the earliest Rinpa masters was Honami Koetsu (1558–1637), the heir of an important family in the ancient capital of Kyoto and a greatly admired calligrapher. He also participated in and produced ceramics for the tea ceremony. Many scholars credit him with overseeing the design of wooden objects with lacquer decoration (see "Lacquered Wood," Chapter 33, page 995), perhaps with the aid of Sotatsu, the proprietor of a

34-10 Honami Koetsu, Boat Bridge, writing box, Edo period, early 17th century. Lacquered wood with sprinkled gold and lead overlay, $9\frac{1}{2}'' \times 9'' \times 4\frac{3}{8}''$. Tokyo National Museum, Tokyo.

Koetsu's writing box is an early work of the Rinpa School, which drew on ancient traditions of painting and craft decoration to develop a style that collapsed boundaries between the two arts.

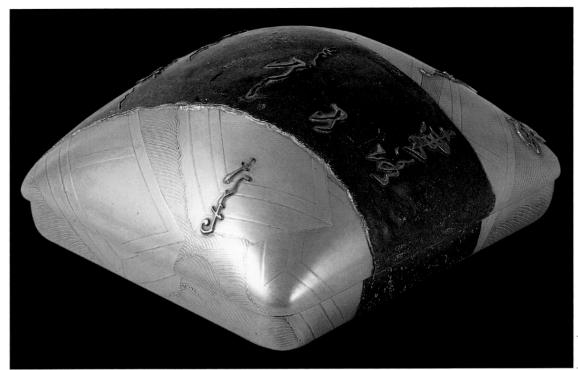

1 in

fan-painting shop. Scholars know the two drew on ancient traditions of painting and craft decoration to develop a style that collapsed boundaries between the two arts. Paintings, the lacquered surfaces of writing boxes, and ceramics shared motifs and compositions.

In typical Rinpa fashion, Koetsu's Boat Bridge writing box (FIG. 34-10) exhibits motifs drawn from a 10th-century poem about the boat bridge at Sano, in the eastern provinces. The lid presents a subtle, gold-on-gold scene of small boats lined up side by side in the water to support the planks of a temporary bridge. The bridge itself, a lead overlay, forms a band across the lid's convex surface. The raised metallic lines on the water, boats, and bridge are a few Japanese characters from the poem, which describes the experience of crossing a bridge as evoking reflection on life's insecurities. The box also shows the dramatic contrasts of form, texture, and color typifying Rinpa aesthetics, especially the juxtaposition of the bridge's dark metal and the box's brilliant gold surface. The gold decoration comes from careful sprinkling of gold dust in wet lacquer (see "Lacquered Wood," Chapter 33, page 995). Whatever Koetsu's contribution to the design process, specialists well versed in the demanding techniques of metalworking and lacquering produced the writing box.

LITERATI PAINTING In the 17th and 18th centuries, Japan's increasingly urban, educated population spurred a cultural and social restlessness among commoners and samurai of lesser rank that the policies of the restrictive Tokugawa could not suppress. People eagerly sought new ideas and images, directing their attention primarily to China, as had happened throughout Japanese history, but also to the West. From each direction, dramatically new ideas about painting emerged.

Starting in the late 17th century, illustrations in printed books and imported paintings of lesser quality brought limited knowledge of Chinese literati painting (see Chapter 33) into Japan. Korea was the essential link at this time between Japan and China, as it was so often in the past. Edo Japan had no official ties with Qing

China but welcomed ambassadors and scholars from Korea. Because of this exposure to Chinese painting, some Edo artists began to emulate Chinese models, although the difference in context resulted in variations. In China, literati were cultured intellectuals whose education and upbringing as landed gentry afforded them positions in the country's governmental bureaucracy. Chinese literati artists were predominantly amateurs and pursued painting as one of the proper functions of an educated and cultivated person. In contrast, although Japanese literati artists acquired a familiarity with and appreciation for Chinese literature, they were mostly professionals, painting to earn a living. Among them, however, were many women, who could more easily work in this painting genre because of its traditional association with amateurism and private intellectual pursuits. Because of the diffused infiltration of Chinese literati painting into Japan, the resulting character of Japanese literati painting was less stylistically defined than in China. Despite the inevitable changes as Chinese ideas disseminated throughout Japan, the newly seen Chinese models were valuable in supporting emerging ideals of self-expression in painting by offering a worthy alternative to the Kano School's standardized repertoire.

YOSA BUSON One of the outstanding early representatives of Japanese literati painting was Yosa Buson (1716–1783). A master writer of *haiku* (the 17-syllable Japanese poetic form very popular from the 17th century on), Buson had a command of literati painting that extended beyond knowledge of Chinese models. His poetic abilities gave rise to a lyricism that pervaded both his haiku and his painting. *Cuckoo Flying over New Verdure* (FIG. 34-11) exemplifies his fully mature style. He incorporated in this work basic elements of Chinese literati painting by rounding the landscape forms and rendering their soft texture in fine fibrous brushstrokes, and by including dense foliage patterns, but the cuckoo is a motif specific to Japanese poetry and literati painting. Moreover, although Buson imitated the vocabulary of brushstrokes associated with the

34-11 Yosa Buson, *Cuckoo Flying over New Verdure*, Edo period, late 18th century. Hanging scroll, ink and color on silk, $5'\frac{1}{2}'' \times 2' 7\frac{1}{4}''$. Hiraki Ukiyo-e Museum, Yokohama.

A master of haiku poetry, Yosa Buson was a leading Japanese literati painter. Although inspired by Chinese works, he used a distinctive palette of pale colors and bolder, more abstract brushstrokes.

houses found in such locales as Edo's Yoshiwara brothel district. The Tokugawa tried to hold such activities in check, but their efforts were largely in vain, in part because of demographics. The population of Edo during this period included significant numbers of merchants and samurai (whose families remained in their home territories), and both groups were eager to enjoy secular city life. Those of lesser means could partake in these pleasures and amusements vicariously. Rapid developments in the printing industry led to the availability of numerous books and printed images (see "Japanese Woodblock Prints," page 1016), and these could convey the city's delights for a fraction of the cost of direct participation. Taking part in the emerging urban culture involved more than simple physical satisfactions and rowdy entertainments. Many who participated were also admirers of literature, music, and art. The best-known products of this sophisticated counterculture are known as ukiyo-e— "pictures of the floating world," a term suggesting the transience of human life and the ephemerality of the material world. The subjects of these paintings and especially prints come mainly from the realms of pleasure, such as the Yoshiwara brothels and the popular theater, but Edo printmakers also frequently depicted beautiful young women in both domestic and public settings (FIGS. 34-12 and 34-12A) and landscapes (FIGS. 34-1 and 34-13).

SUZUKI HARUNOBU The urban appetite for ukiyo pleasures and for their depiction in woodblock prints provided fertile ground for many graphic designers to flourish. Consequently, competition among publishing houses led to ever-greater refinement and experimentation in printmaking. One of the most admired and emulated 18th-century designers, SUZUKI HARUNOBU (ca. 1725–1770), played a key role in developing mul-

ticolored prints. Called *nishiki-e* (brocade pictures) because of their sumptuous and brilliant color, these prints, in contrast to most Edo prints, employed the highest-quality paper and costly pigments. Harunobu gained a tremendous advantage over his competitors when he received commissions from members of a poetry club to design limited-edition nishiki-e prints. He transferred much of the

Chinese literati, his touch was bolder and more abstract, and the gentle palette of pale colors was very much his own.

UKIYO-E The growing urbanization in cities such as Osaka, Kyoto, and Edo led to an increase in the pursuit of sensual pleasure and entertainment in the brash popular theaters and the pleasure

Japanese Woodblock Prints

During the Edo period, woodblock prints with ukiyo-e themes became enormously popular. Sold in small shops and on the street, an ordinary print went for the price of a bowl of noodles. People with very modest incomes could therefore collect prints in albums or paste them on their walls. A highly efficient production system made this wide distribution of Japanese graphic art possible.

Ukiyo-e artists were generally painters who did not themselves manufacture the prints that made them so famous both in their own time and today. As the designers, they sold drawings to publishers, who in turn oversaw their printing. The publishers also played a role in creating ukiyo-e prints by commissioning specific designs or adapting them before printing. Certainly, the names of both designer and publisher appeared on the final prints.

Unacknowledged in nearly all cases, however, were the individuals who made the prints, the block carvers and printers. Using skills honed since childhood, they worked with both speed and precision for relatively low wages and thus made ukiyo-e prints affordable. The master printmakers were primarily men. Women, especially wives and daughters, often assisted painters and other artists, but few gained separate recognition. Among the exceptions was the daughter of Katsushika Hokusai (FIG. 34-13), Katsushika Oi (1818–1854), who became well known as a painter and probably helped her father with his print designs.

Stylistically, Japanese prints during the Edo period tend to have black outlines separating distinct color areas (FIG. 34-12). This format is a result of the printing process. A master carver pasted painted designs face down on a wooden block. Wetting and gently scraping the thin paper revealed the reversed image to guide the cutting of the block. After the carving, only the outlines of the forms and other elements that would be black in the final print remained raised in relief. The master printer then coated the block with black ink and printed several initial outline prints. These master prints became the guides for carving the other blocks, one for each color used. On each color block, the carver left in relief only the areas to be printed in that color. Even ordinary prints sometimes required up to 20 colors and thus 20 blocks. To print a color, a printer applied the appropriate pigment to a block's raised surface, laid a sheet of paper on it, and rubbed the back of the paper with

laid a sheet of paper on it, and rubbed the back of the paper with a smooth flat object. Then another printer would print a different color on the same sheet of paper. Perfect alignment of the paper in each step was critical to prevent overlapping of colors, so the carvers included printing guides in their blocks—an L-shaped ridge in one corner and a straight ridge on one side. The printers could cover small alignment errors with a final printing of the black outlines from the last block.

The materials used in printing varied over time but by the mid-18th century had reached a level of standardization. The blocks were planks of fine-grained hardwood, usually cherry. The best paper came from the white layer beneath the bark of mulberry trees, because its long fibers helped the paper stand up to repeated rubbing on the blocks. The printers used a few mineral pigments but

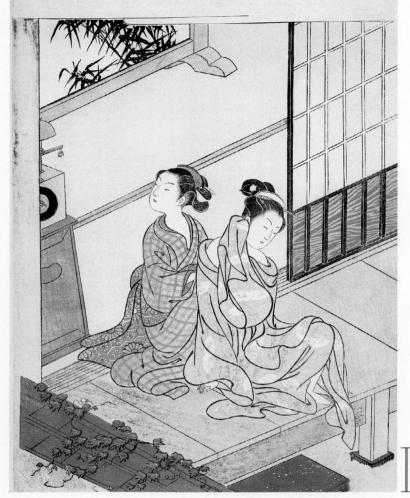

34-12 SUZUKI HARUNOBU, Evening Bell at the Clock, from Eight Views of the Parlor, Edo period, ca. 1765. Woodblock print, $11_4^{1''} \times 8\frac{1}{2}^{1''}$. Art Institute of Chicago, Chicago (Clarence Buckingham Collection).

Harunobu's nishiki-e (brocade pictures) took their name from their costly pigments and paper. The rich color and flatness of the objects, women, and setting in this print exemplify the artist's style.

tended to favor inexpensive dyes made from plants for most colors. As a result, the colors of ukiyo-e prints were and are highly susceptible to fading, especially when exposed to strong light. In the early 19th century, more permanent European synthetic dyes began to enter Japan. The first such color, Prussian blue, appears in Hokusai's *The Great Wave off Kanagawa* (FIG. 34-13).

The popularity of ukiyo-e prints extended to the Western world as well. Their affordability and the ease with which they could be transported facilitated dissemination of the prints, especially throughout Europe. Ukiyo-e prints appear in the backgrounds of a number of Impressionist and Post-Impressionist paintings, attesting to the appeal these works held for Westerners. Some Japanese prints, for example, Ando Hiroshige's *Plum Estate, Kameido* (FIG. 34-1), inspired 19th-century European artists to produce near-copies (see "Japonisme," Chapter 28, page 808, and FIG. 28-16B).

34-12A UTAMARO, *Ohisa on* the Takashima Tea Shop, 1792–1793. ■◀

knowledge he derived from nishiki-e to his design of more commercial prints. Harunobu even issued some of the private designs later under his own name for popular consumption.

The sophistication of Harunobu's work is evident in *Evening Bell at the Clock* (FIG. **34-12**), from a series called *Eight Views of the Parlor*. This series draws upon a Chinese series usually titled *Eight Views of the Xiao and Xiang Rivers*, in which each image focuses on a particular time of day or year. In Harunobu's adaptation, beautiful young women—the favorite subject of ukiyo-e

master KITAGAWA UTAMARO (1753–1806; FIG. 34-12Å)—and the activities occupying their daily lives became subjects. In *Evening Bell at the Clock*, two young women seen from the typically Japanese elevated viewpoint (compare FIG. 17-14) sit on a veranda. One is drying herself after a bath (compare FIG. 28-12). The viewer gets a privileged glimpse of a private moment. Erotic themes are quite common in ukiyo-e. The bather's companion—her maid—turns to face the chiming clock. Here, the artist has playfully transformed the great

temple bell ringing over the waters in the Chinese series into a modern Japanese clock. This image incorporates the refined techniques characteristic of nishiki-e. Further, the flatness of the depicted objects and the rich color recall the traditions of court painting, a comparison many nishiki-e artists openly sought.

KATSUSHIKA HOKUSAI Woodblock prints afforded artists great opportunity for experimentation. For example, in producing landscapes, Japanese artists often incorporated Western perspective techniques, although others, Ando Hiroshige (FIG. 34-1) among them, did not. One of the most famous Japanese landscape artists was Katsushika Hokusai (1760–1849). In The Great Wave off Kanagawa (FIG. 34-13), part of a woodblock series called Thirty-six Views of Mount Fuji, the huge foreground wave dwarfs the artist's representation of a distant Fuji. This contrast and the whitecaps' ominous fingers magnify the wave's threatening aspect. The men in the trading boats bend low to dig their oars against the rough sea and drive their long low vessels past the danger. Although Hokusai's print draws on Western techniques and incorporates the distinctive European color called Prussian blue, it also engages the Japanese pictorial tradition. Against a background with the low horizon typical of Western painting, Hokusai placed in the foreground the wave's more traditionally flat and powerfully graphic forms.

34-13 Katsushika Hokusai, *The Great Wave off Kanagawa*, from *Thirty-six Views of Mount Fuji*, Edo period, ca. 1826–1833. Woodblock print, ink and colors on paper, $9\frac{7}{8}$ \times 1′ $2\frac{3}{4}$. Museum of Fine Arts, Boston (Bigelow Collection).

Adopting the low horizon line typical of Western painting, Hokusai used the traditional flat and powerful graphic forms of Japanese art to depict the threatening wave in the foreground.

MEIJI AND SHOWA

The Edo period and the rule of the shoguns ended in 1868, when rebellious samurai from provinces far removed from Edo toppled the Tokugawa. Facilitating this revolution was the shogunate's inability to handle the increasing pressure from Western nations for Japan to throw open its doors to the outside world. Although the rebellion restored direct sovereignty to the imperial throne, real power rested with the emperor's cabinet. As a symbol of imperial authority, however, the official name of this new period was Meiji ("Enlightened Rule"; 1868–1912), after the emperor's chosen regnal name.

TAKAHASHI YUICHI Oil painting became a major genre in Japan in the late 19th century. Ambitious students studied with Westerners at government schools and during trips abroad. One oil painting highlighting the cultural ferment of the early Meiji period is Oiran (Grand Courtesan; FIG. 34-14), painted by TAKAHASHI YUICHI (1828-1894). The artist created it for a client nostalgic for vanishing elements of Japanese culture. Ukiyo-e printmakers frequently represented similar grand courtesans of the pleasure quarters. In this painting, however, Takahashi did not

34-14 TAKAHASHI YUICHI, Oiran (Grand Courtesan), Meiji period, 1872. Oil on canvas, 2' $6\frac{1}{2}$ " \times 1' $9\frac{5}{8}$ ". Tokyo National University of Fine Arts and Music, Tokyo.

The subject of Takahashi's Oiran and the abstract rendering of the courtesan's garment derive from the ukiyo-e repertoire and traditional Japanese art, but the oil technique is a Western import.

portray the courtesan's features in the idealizing manner of ukiyo-e artists but in the more analytical manner of Western portraiture. Yet the painter's more abstract rendering of the garments reflects a very old practice in East Asian portraiture.

KANO HOGAI Unbridled enthusiasm for Westernization in some quarters led to resistance and concern over a loss of distinctive Japanese identity in other quarters. Ironically, one of those most eager to preserve "Japaneseness" in the arts was Ernest Fenollosa

34-15 KANO HOGAI, Bodhisattva Kannon, Hanging scroll, ink, color, and gold on silk, $5' 4\frac{3''}{8} \times 2' 9\frac{3''}{8}$. Freer Gallery of Art, Smithsonian Institution, Washington, D.C. (gift of Charles Lang Freer).

In composition, theme, medium, and format, this ink-and-color hanging silk scroll epitomizes the nihonga revival of Japanese subject matter and style, a sharp break from Westernized yoga.

(1853–1908), an American professor of philosophy and political economy at Tokyo Imperial University. He and a former student named Okakura Kakuzo (1862–1913) joined with others in a movement that eventually led to the founding under Okakura's direction of a new academy, the Tokyo School of Fine Arts, dedicated to Japanese arts. Their goal was to make Japanese painting viable in the modern age rather than preserve it as a relic. To this end, they encouraged students to incorporate some Western techniques such as chiaroscuro, perspective, and bright hues in Japanese-style paintings. The name given to the resulting style was *nihonga* (Japanese painting), as opposed to *yoga* (Western painting).

One of the first professors Okakura appointed (although he died before he could take up the position) was Kano Hogai (1828–1888), who studied painting in Tokyo under the tutelage of a master of the venerable Kano School. Kano had met Fenellosa in 1883, and the American promoted his career and purchased several of his paintings, including *Bodhisattva Kannon* (FIG. 34-15), later acquired by the American industrialist and art collector Charles Lang Freer (1854–1919). The painting depicts Kannon (Chinese Guanyin; compare FIGS. 16-14A and 16-21A), the mustached but effeminate bodhisattva of infinite compassion, standing on a cloud and pouring drops of the water of wisdom from a small flask upon a newborn suspended in a transparent globe. Fenellosa called the painting *The Creation of Man*. In composition, theme, medium, and format, Kano's ink-and-color silk hanging scroll epitomizes the nihonga style.

SHOWA During the Showa period (1926-1989), Japan became increasingly prominent on the world stage in economics, politics, and culture, and played a leading role in World War II. The most tragic consequences of that conflict for Japan were the widespread devastation and loss of life resulting from the atomic bombings of Hiroshima and Nagasaki in 1945. During the succeeding occupation period, the United States imposed new democratic institutions on Japan, with the emperor serving as a ceremonial head of state. Japan's economy rebounded with remarkable speed, and its gross national product became one of the largest in the world. During the past several decades, Japanese artists have also made a mark in the international art world. As they did in earlier times with the art and culture of China and Korea, many Japanese painters, sculptors, and architects internalized Western styles and techniques and incorporated them as a part of Japan's own vital culture. Others, however, shunned Western art forms and worked in more traditional modes.

HAMADA SHOJI One modern Japanese art form with ancient roots is ceramics. Many contemporary admirers of folk art are avid collectors of traditional Japanese pottery. A formative figure in Japan's folk art movement, the philosopher Yanagi Soetsu (1889–1961), promoted an ideal of beauty inspired by the Japanese tea ceremony. He argued that true beauty could only be achieved in functional objects made of natural materials by anonymous craftspeople, such as the Shino water jar (FIG. 34-8) discussed earlier. Among the ceramists who produced this type of folk pottery, known as *mingei*, was Hamada Shoji

(1894–1978). Although Hamada did espouse Yanagi's selfless ideals, he still gained international fame and in 1955 received official recognition in Japan as a Living National Treasure. Works such as his dish (FIG. 34-16) with casual slip designs are unsigned, but connoisseurs easily recognize them as his. This kind of stoneware is coarser, darker, and heavier than porcelain and lacks the latter's fine decoration. To those who appreciate simpler, earthier beauty, however, this dish holds great attraction. Hamada's artistic influence extended beyond the production of pots. He traveled to England in 1920 and, along with English potter Bernard Leach (1887–1978), established a community of ceramists committed to the mingei aesthetic. Together, Hamada and Leach expanded international knowledge of Japanese ceramics, and even now, the "Hamada-Leach aesthetic" is part of potters' education worldwide.

GUTAI One of the most significant developments in 20th-century art was the emergence of *Performance Art* as a major genre (see Chapter 30), and Japanese artists played a seminal role. Gutai Bijutsu Kyokai (Concrete Art Association) was a group of 18 Japanese artists in Osaka who expanded the principles of *action painting* into the realm of performance—in a sense, taking Jackson Pollock's painting methods (see "Jackson Pollock on Easel and Mural Painting," Chapter 30, page 904, and FIG. 30-7) into a public arena. Led by Jiro Yoshihara (1905–1972), Gutai, founded in 1954, devoted itself to art that combined Japanese traditional practices such as Zen (see "Zen Buddhism," page 1007) with a renewed appreciation for

34-16 Hamada Shoji, large bowl, Showa period, 1962. Black trails on translucent glaze, $5\frac{\pi}{8}$ × 1′ $10\frac{\pi}{2}$. National Museum of Modern Art, Kyoto.

A leading figure in the modern folk art movement in Japan, Hamada Shoji gained international fame. His unsigned stoneware features casual slip designs and a coarser, darker texture than porcelain.

34-17 KAZUO SHIRAGA, Making a Work with His Own Body, Showa period, 1955. Mud.

The members of the Gutai Bijutsu Kyokai (Concrete Art Association) expanded postwar action painting into the realm of Performance Art. Shiraga used his body to "paint" with mud.

materials. In the *Gutai Art Manifesto*, Yoshihara explained: "Gutai does not alter the material. Gutai imparts life to the material. . . . [T]he human spirit and the material shake hands with each other, but keep their distance." Accordingly, the Gutai group's performances, for example, *Making a Work with His Own Body* (FIG. 34-17), by KAZUO SHIRAGA (1924–2008), involved actions such as throwing paint balls at blank canvases or wallowing in mud as a means of shaping it. In *Making a Work*, Shiraga used his body to "paint" with mud. The Gutai group disbanded upon Yoshihara's death in 1972, but their work was an important influence on Western performance artists such as Carolee Schneemann (FIG. 30-51).

KENZO TANGE In the 20th century, Japanese architecture, especially public and commercial building, underwent rapid transformation along Western lines. In fact, architecture may be the most influential Japanese art form on the world stage today. Japanese architects have made major contributions to both modern and postmodern developments (see Chapters 30 and 31). One of the most daringly experimental architects of the post-World War II period was Kenzo Tange (1913–2005). In his design of the stadiums (FIG. 34-18) for the 1964 Olympics, he employed a cable suspension system that enabled him to shape steel and concrete into remarkably graceful structures. His attention to both the sculptural qualities of each building's raw concrete form and the fluidity of its spaces allied him with architects worldwide who carried on the legacy of the late style of Le Corbusier (FIG. 30-40) in France. His stadiums thus bear comparison with Joern Utzon's Sydney Opera House (FIG. 30-42).

CONTEMPORARY ART In the "global village" the world has become over the past few decades, some Japanese artists have also achieved international renown. The work of Tsuchiya Kimio (FIG. 31-23) and other contemporary Asian sculptors and painters is treated in its worldwide context in Chapter 31.

34-18 Kenzo Tange, national indoor Olympic stadiums (looking east), Tokyo, Japan, Showa period, 1961–1964.

Tange was one of the most daring architects of postwar Japan. His Olympic stadiums employ a cable suspension system that enabled him to shape steel and concrete into remarkably graceful structures.

JAPAN, 1336 TO 1980

MUROMACHI 1336-1573

- The Muromachi period takes its name from the Kyoto district in which the Ashikaga shoguns maintained their headquarters.
- At this time, Zen Buddhism rose to prominence in Japan. Zen temples often featured gardens of the karesansui (dry-landscape) type, which facilitated meditation.
- Muromachi painting displays great variety in both subject and style. One characteristic technique is the haboku (splashed-ink) style, which has Chinese roots. An early haboku master was Sesshu Toyo.

Sesshu Toyo, splashed-ink landscape. 1495

MOMOYAMA 1573-1615

- Three successive warlords dominated this brief but artistically rich interlude between two long-lasting shogunates. The period takes its name from one of the warlord's castles (Momoyama, Peach Blossom Hill) outside Kyoto.
- Many of the finest works of this period were commissions from those warlords, including Chinese Lions by Kano Eitoku, a six-part folding screen featuring animals considered to be symbols of power and bravery.
- During the Momoyama period, the Japanese tea ceremony became an important social ritual. The tea master Sen no Rikyu designed the first teahouse built as an independent structure. The favored tea utensils were rustic Shino wares.

Kano Eitoku, Chinese Lions, late 16th century

EDO 1615-1868

- The Edo period began when the shogun Tokugawa leyasu (1542–1616) moved his headquarters from Kyoto to Edo (modern Tokyo).
- The Katsura Imperial Villa, which relies for its aesthetic appeal on subtleties of proportion, color, and texture instead of ornamentation, set the standard for later Japanese domestic architecture.
- I The Rinpa School, named for Ogata Korin, emerged as a major alternative school of painting to the Kano School, which had become a virtual national art academy. Rinpa paintings and crafts feature vivid colors and extensive use of gold, as in the *Boat Bridge* writing box by Honami Koetsu.
- Growing urbanization in major Japanese cities fostered a lively popular culture focused on sensual pleasure and theatrical entertainment. The best-known products of this sophisticated counterculture are the ukiyo-e woodblock prints of Edo's "floating world" by Suzuki Harunobu and others. The prints feature scenes from brothels and the theater as well as beautiful women in domestic settings.

Katsura Imperial Villa, Kyoto, 1620-1663

Suzuki Harunobu, Evening Bell at the Clock, ca. 1765

MEIJI AND SHOWA 1868-1989

- The Tokugawa shogunate toppled in 1868, opening the modern era of Japanese history. In art, Western styles and techniques had a great influence, and many Japanese artists incorporated shading and perspective in their works and even produced oil paintings.
- In the post–World War II period, many Japanese artists and architects achieved worldwide reputations. Kazuo Shiraga played a seminal role in the development of Performance Art as a major modern genre. Kenzo Tange was a master of creating dramatic shapes using a cable suspension system for his concrete-and-steel buildings.

Kenzo Tange, Olympic stadiums, Tokyo, 1961–1964

Produced for Charles V, the *Codex Mendoza* recounts the history of the Aztec Empire. The frontispiece represents the legendary landing of the eagle on a cactus and the founding of Tenochtitlán in 1325.

At the heart of Tenochtitlán was the Templo Mayor, a gigantic pyramid surmounted by temples to Huitzilopochtli and Tlaloc, represented in the *Codex Mendoza* in abbreviated form as a single shrine.

The representation of Tenochtitlán's sacred precinct also includes a rack of skulls of the sacrificial victims the Aztecs threw down the steps of the lofty pyramid after cutting out their hearts.

35-1 The founding of Tenochtitlán, folio 2 recto of the *Codex Mendoza*, from Mexico City, Mexico, Aztec, ca. 1540–1542. Ink and color on paper, $1'\frac{2''}{8}\times 8\frac{5''}{8}$. Bodleian Library, Oxford University, Oxford.

35

At the bottom of the page, the painter depicted two historical events. Aztec warriors with clubs and shields conquer the cities of Colhuacán and Tenayuca, shown as temple-pyramids set ablaze.

NATIVE ARTS OF THE AMERICAS, 1300 TO 1980

THE FOUNDING OF TENOCHTITLÁN

When their insatiable quest for gold brought the Spaniards, led by Hernán Cortés, into contact in 1519 with the Aztec Empire in what is today Mexico, they encountered the latest of a series of highly sophisticated indigenous *Mesoamerican* art-producing cultures. Two decades later, the first Spanish viceroy of New Spain, Antonio de Mendoza, commissioned native scribes and painters to produce a remarkable illustrated manuscript (on European paper). The *Codex Mendoza* recounted the history of the empire Cortés had vanquished and included a description of the customs of the people who called themselves Mexica. The book took the form of a *codex* (pl. *codices*)—a bound volume resembling a modern book, in contrast to earlier books in the form of scrolls (*rotulus*, pl. *rotuli*). The intended audience for the *Codex Mendoza* was Charles V of Spain, but the king never saw the manuscript because French pirates intercepted the Spanish ship at sea. Although produced for a Spanish patron, the *Codex Mendoza* closely reflects the format and style of contemporaneous Aztec illustrated manuscripts.

The opening 16 pages of the 71-page codex summarize the 196-year history of the Mexica through the Spanish conquest of 1521. The frontispiece (FIG. 35-1), with explanatory labels in Aztec *hieroglyphs* and Spanish, represents the founding of the capital city of Tenochtitlán in 1325 on an island in Lake Texcoco (Lake of the Moon). There, according to legend, an eagle landed on a prickly pear cactus, marking the spot where the chief Aztec deity, Huitzilopochtli, instructed the nomadic warriors to settle. The artist depicted the eagle on the cactus (now the central motif on the Mexican flag) at the intersection of two canals, referring to the division of Tenochtitlán into four quarters. At the center of the city—considered the center of the universe—was the sacred precinct archaeologists call the Templo Mayor ("Great Temple," FIG. 35-3), represented in abbreviated form above the eagle as a single temple—one of two surmounting a great pyramid. To the right of the cactus is the rack of skulls of the sacrificial victims whose bodies the Aztec priests threw down the pyramid's steps after cutting out their hearts. The labeled figures seated on reed mats in Tenochtitlán's four quarters are the legendary founders of the city. Below, the painter represented two historical events in stereotypical form. Aztec warriors with clubs and shields conquer two cities, Colhuacán and Tenayuca, shown as temple-pyramids set ablaze. The border contains the hieroglyphs for 51 of the 52 years of one of the recurring cycles of the Aztec calendar system.

Today, Tenochtitlán lies at the heart of densely populated Mexico City. In the early 16th century, the Aztec capital was home to more than 100,000 people. The total population of the area of Mexico the Aztecs dominated was approximately 11 million.

MESOAMERICA

In the years following the arrival of Christopher Columbus (1451-1506) in the New World in 1492, Spain poured money into expeditions probing the coasts of North and South America, but the Spaniards had little luck finding the wealth they sought. When brief stops on the coast of Yucatán, Mexico, yielded a small but still impressive amount of gold and other precious artifacts, the Spanish governor of Cuba outfitted yet another expedition. Headed by Hernán Cortés (1485-1547), this contingent of explorers was the first to make contact with the great Aztec emperor Moctezuma II (r. 1502-1521) at Tenochtitlán (MAP 35-1). In only two years, with the help of guns, horses, native allies revolting against their Aztec overlords, and perhaps also a smallpox epidemic that had swept across the Caribbean and already thinned the Aztec ranks, Cortés managed to overthrow the vast and rich Aztec Empire. His victory in 1521 opened the door to hordes of Spanish conquistadors seeking their fortunes and to missionaries eager for new converts to Christianity. The ensuing clash of cultures led to a century of turmoil throughout New Spain.

The Aztec Empire of the early 16th century succeeded several other great Mesoamerican civilizations (see Chapter 18). After the fall and destruction of the important central Mexican city of Teotihuacán in the eighth century and the abandonment of the southern Maya sites around 900, new cities arose to take their places. Notable were the Maya city of Chichén Itzá (FIGS. 18-1 and 18-16 to 18-18) in Yucatán and the Toltec capital of Tula (FIG. 18-19), not far from the later seat of Aztec power in Tenochtitlán. Their dominance was relatively short-lived, however. For the early Postclassic period (ca. 900–1200) in Mesoamerica, scholars have less information than for Classic Mesoamerica, but much more evidence exists for the cultures of the late Postclassic period (ca. 1200–1521).

Mixteca-Puebla

One of the most impressive art-producing peoples of the Postclassic period in Mesoamerica was the Mixtecs, who succeeded the Zapotecs at Monte Albán in southern Mexico after 700. They extended their political sway in Oaxaca by dynastic intermarriage as well as by warfare. The treasures found in the tombs at Monte Albán bear witness to Mixtec wealth, and the quality of these works demonstrates the culture's high level of artistic achievement. The Mixtec were highly skilled goldsmiths and won renown for their work in *mosaic* using turquoise obtained from far-off regions such as present-day New Mexico.

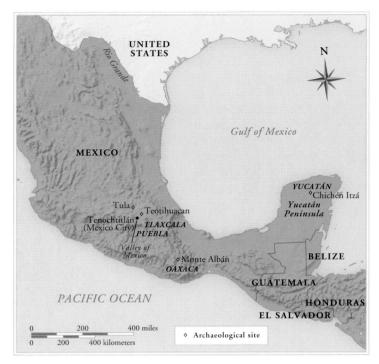

MAP 35-1 Mixteca-Puebla and Aztec sites in Mesoamerica.

BORGIA CODEX The peoples of Mesoamerica prized illustrated books, such as the Codex Mendoza (FIG. 35-1). The Postclassic Maya were preeminent in the art of writing. Their books—almost all destroyed by the Spanish conquistadors—were precious vehicles for recording history, rituals, astronomical tables, calendar calculations, maps, and trade and tribute accounts. The texts consisted of hieroglyphic columns read from left to right and top to bottom. Miraculously, three pre-conquest Maya books survived the depredations of the Europeans. Bishop Diego de Landa (1524–1579), the author of an invaluable treatise on the Maya of Yucatán, described how the Maya made their books and why so few remain:

They wrote their books on a long sheet doubled in folds, which was then enclosed between two boards finely ornamented; the writing was on one side and the other, according to the folds. . . . We found a great number of books in these [Mayan] letters and, since they contained nothing but superstitions and falsehoods of the devil, we burned them all, which they took most grievously, and which gave them great pain. \(^1\)

1300

NATIVE ARTS OF THE AMERICAS, 1300 TO 1980

1800

1532

Mixteca-Puebla artists produce illustrated codices

- Aztecs build the Templo Mayor at Tenochtitlán and place monumental statues and reliefs in the sacred precinct
- Inka construct 14,000 miles of roads in the Andes and build the city of Machu Picchu and the Temple of the Sun in Cuzco
- Kwakiutl and Tlingit artists carve transformation and war masks
- I Great Plains artists fashion elaborate robes and regalia for the elite
- I During the reservation period, Native American artists record traditional lifestyles in ledger books
- Many Native American artists continue to practice traditional crafts

1980

1900

- Southwest ceramists develop black-onblack glazed pottery
- Bill Reid carves monumental wood sculptures illustrating traditional Haida themes

folio 56 of the *Borgia Codex*, possibly from Puebla or Tlaxcala, Mexico, Mixteca-Puebla, ca. 1400–1500. Mineral and vegetable pigments on deerskin, $10\frac{5}{2}'' \times 10\frac{3}{2}''$. Facsimile, Biblioteca Apostolica Vaticana, Rome.

35-2 Mictlantecuhtli and Quetzalcoatl,

One of the rare surviving Mesoamerican books, the Mixteca-Puebla *Borgia Codex* includes this painting depicting the gods of life and death above an inverted skull symbolizing the Underworld.

The origins of this calendar, used even today in remote parts of Mexico and Central America, are unknown. Save for the Mixtec genealogical codices, most books painted before and immediately after the Spanish conquest deal with astronomy, calendars, divination, and ritual—with the notable exception of the *Codex Mendoza* (FIG. 35-1), which, as already discussed, records the history of the Aztecs, the greatest Mesoamerican culture at the time Cortés and his compatriots arrived in Mexico.

Aztec

The Aztecs were a Nahuatl-speaking people who left behind, in the *Codex Mendoza* and elsewhere, a history of their rise to power. Scholars have begun to question the accuracy of that

Aztec account, however, and some think it is a mythic construct. According to the traditional history, the destruction of Toltec Tula about 1200 (see Chapter 18) brought a century of anarchy to the Valley of Mexico, the vast highland valley 7,000 feet above sea level now home to sprawling Mexico City. Waves of northern invaders established warring city-states and wrought destruction in the valley. The Aztecs were the last of these conquerors. With astonishing rapidity, they transformed themselves within a few generations from migratory outcasts and serfs to mercenaries for local rulers and then to masters in their own right of the Valley of Mexico's small kingdoms. They began to call themselves Mexica, and, fulfilling a legendary prophecy that they would build a city where they saw an eagle perched on a cactus with a serpent in its mouth, they settled on an island in Lake Texcoco. Their settlement grew into the magnificent city of Tenochtitlán (see "The Founding of Tenochtitlán," page 1023), which in 1519 so amazed the Spaniards.

Recognized by those they subdued as fierce in war and cruel in peace, the Aztecs indeed seemed to glory in battle and in military prowess. They radically changed the social and political situation in Mexico. Subservient groups not only had to submit to Aztec military power but also had to provide victims to be sacrificed to Huitzilopochtli, the hummingbird god of war, and to other Aztec deities (see "Aztec Religion," page 1027). The Mexica practiced bloodletting and human sacrifice to please the gods and sustain the great cycles of the universe. These rites had a long history in Mesoamerica (see Chapter 18). The Aztecs, however, engaged in

In contrast, 10 non-Maya Postclassic books survive, five from Mixtec Oaxaca and five from the Puebla region. Art historians have named the style they represent Mixteca-Puebla, an interesting example of a Mesoamerican style crossing both ethnic and regional boundaries. The Mixteca-Puebla artists painted on long sheets of deerskin, which they first coated with fine white lime plaster and folded into accordion-like pleats to form codices with covers of wood, mosaic, or feathers.

One extensively illustrated book that escaped the Spanish destruction is the Borgia Codex, from somewhere in central highland Mexico (possibly the states of Puebla or Tlaxcala). It is the largest and most elaborate of several manuscripts known as the Borgia Group. The page reproduced here (FIG. 35-2) shows two richly attired and vividly gesticulating gods rendered predominantly in reds and yellows with black outlines. The god of life, the black Quetzalcoatl (depicted here as a masked human rather than in the usual form of a feathered serpent), sits back-to-back with the god of death, the white Mictlantecuhtli. Below them is an inverted skull with a double keyboard of teeth, a symbol of the Underworld (Mictlan), which could be entered through the mouth of a great earth monster. Both figures hold scepters in one hand and gesticulate with the other. The image conveys the inevitable relationship of life and death, an important theme in Mesoamerican art. Some scholars believe the image may also be a kind of writing conveying a specific divinatory meaning. Symbols of the 13 divisions of 20 days in the 260-day Mesoamerican ritual calendar appear in panels in the margins (compare FIG. 35-1).

1025

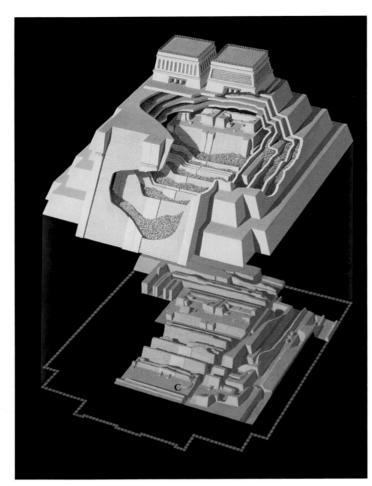

35-3 Reconstruction drawing with cutaway view of various rebuildings of the Great Temple, Tenochtitlán, Mexico City, Mexico, Aztec, ca. 1400–1500. C = Coyolxauhqui disk (FIG. 35-4).

The Great Temple in the Aztec capital encases successive earlier structures. The latest temple honored the gods Huitzilopochtli and Tlaloc, whose sanctuaries were at the top of a stepped pyramid.

human sacrifice on a greater scale than any of their predecessors, even waging special battles, called the "flowery wars," expressly to obtain captives for future sacrifice. It is one of the reasons Cortés found ready allies among the peoples the Aztecs had subjugated.

TENOCHTITLÁN The ruins of the Aztec capital, Tenochtitlán, lie directly beneath the center of Mexico City in the Zócalo, the modern city's main square. The Aztecs laid out Tenochtitlán on a grid plan dividing the city into quarters (FIG. 35-1) and wards, reminiscent of Teotihuacán (FIG. 18-5), which, long abandoned, had become a pilgrimage site for the Aztecs. Tenochtitlán's island location required conducting communication and transport via canals and other waterways. Many of the Spaniards thought of Venice in Italy when they saw the city rising from the waters like a radiant vision. Crowded with buildings, plazas, and courtyards, the city also boasted a vast and bustling marketplace. In the words of Bernal Díaz del Castillo (ca. 1495-1585), a soldier who accompanied Cortés when the Spaniards first entered Tenochtitlán, "Some of the soldiers among us who had been in many parts of the world, in Constantinople, and all over Italy, and in Rome, said that so large a marketplace and so full of people, and so well regulated and arranged, they had never beheld before."2

HUETEOCALLI In the 1970s, Mexican archaeologists identified the exact location of many of the most important structures within Tenochtitlán's sacred precinct. The excavations in the Zócalo near the city's cathedral have already uncovered impressive remains of architecture and sculpture, most recently a 12-ton monolithic (one-piece) relief (FIG. 35-5) discovered in 2006. Additional extraordinary artworks are likely to come to light in the years ahead as excavations continue. The principal building of Tenochtitlán's religious center was the Hueteocalli—the Templo Mayor, or Great Temple (FIG. 35-3)—a temple-pyramid honoring the Aztec god Huitzilopochtli and the local rain god Tlaloc (see "Aztec Religion," page 1027). Two great staircases originally swept upward from the plaza level to the two sanctuaries at the summit. The Hueteocalli is a remarkable example of superimposition, a common trait in Mesoamerican architecture. The excavated structure, composed of seven shells, indicates how earlier walls nested within later ones. (Today, only two of the inner structures remain. The Spaniards destroyed the later ones in the 16th century.) The sacred precinct also contained the temples of other deities, a ball court (see "The Mesoamerican Ball Game," Chapter 18, page 501), a skull rack for the exhibition of the heads of victims killed in sacrificial rites (compare FIG. 35-1, top right), and a school for children of the nobility.

Thousands of priests served in Aztec temples. Distinctive hairstyles, clothing, and black body paint identified the priests. Women served as priestesses, particularly in temples dedicated to various earth-mother cults. Bernal Díaz del Castillo recorded his shock upon seeing a group of foul-smelling priests with uncut fingernails, long hair matted with blood, and ears covered in cuts, not realizing they were performing rites in honor of the deities they served, including piercing their skin with cactus spines to draw blood. These priests were the opposite of the "barbarians" the European conquistadors considered them to be. They were, in fact, the most highly educated Aztecs. The European reaction to the customs the conquistadors encountered in the New World has colored popular opinion about Aztec culture ever since. The religious practices that horrified the Spanish conquerors, however, were not unique to the Aztecs but were deeply rooted in earlier Mesoamerican society (see Chapter 18).

AZTEC SCULPTURE Given the Aztecs' almost meteoric rise from obscurity to their role as the dominant culture of Mesoamerica, the quality of the art they sponsored is astonishing. Granted, they swiftly appropriated the best artworks and most talented artists of conquered territories, bringing both back to Tenochtitlán. Thus, craftspeople from other areas, such as the Mixtecs of Oaxaca, may have created much of the exquisite pottery, goldwork, and turquoise mosaics the Aztec elite used. Gulf Coast artists probably made the life-size terracotta sculptures of eagle warriors found at the Great Temple. Nonetheless, the Aztecs' sculptural style, developed at the height of their power in the later 15th and early 16th centuries, is unique.

COYOLXAUHQUI The Temple of Huitzilopochtli at Tenochtitlán commemorated the god's victory over his sister and 400 brothers, who had plotted to kill their mother, Coatlicue (see "Aztec Religion," page 1027, and Fig. 35-6). The myth signifies the birth of the sun at dawn, a role Huitzilopochtli sometimes assumed, and the sun's battle with the forces of darkness, the stars and moon. Huitzilopochtli killed or chased away his brothers and dismembered the body of his sister, the moon goddess Coyolxauhqui, at Coatepec Mountain near Tula (represented by the pyramid itself). The mythical event is the subject of a huge stone disk (Fig. 35-4),

Aztec Religion

The Aztecs saw their world as a flat disk resting on the back of a monstrous earth deity. Tenochtitlán, their capital, was at its center. Hueteocalli, the Great Temple (FIG. 35-3) at the heart of the city, represented the Hill of Coatepec, the sacred Serpent Mountain and reputed birthplace of Huitzilopochtli, and formed the axis passing up to the heavens and down through the Underworld—a concept with parallels in other cultures (see, for example, "The Stupa," Chapter 15, page 430). Each of the four cardinal points had its own god, color, tree, and calendar symbol. The sky consisted of 13 layers, whereas the Underworld had nine. The Aztec Underworld was an unpleasant place where the dead gradually ceased to exist.

Because the Aztecs often adopted the gods of conquered peoples, their pantheon was complex and varied. When the Aztecs arrived in the Valley of Mexico, their own chief god, Huitzilopochtli (Hummingbird of the South), a war and sun/fire deity, joined such well-established Mesoamerican gods as the rain and fertility god Tlaloc and the feathered serpent Quetzalcoatl, who was a benevolent god of life, wind, and learning and culture, as well as the patron of priests. Huitzilopochtli was the son of Coatlicue (She of the Serpent Skirt). Coatlicue was also the mother of Coyolxauhqui (She of the Golden Bells) and 400 sons, the Centzon Huitznahua (Four Hundred Southerners), who, jealous their mother was pregnant with Huitzilopochtli, banded together to murder her. At the moment of her death, she gave birth to Huitzilopochtli, who slaughtered Coyolxauhqui and most of her brothers, then cut his sister's body into pieces and threw it down Coatepec Mountain. Other important Aztec deities were Mictlantecuhtli (Lord of the Underworld) and Tlaltecuhtli (Lord of the Earth), the earth goddess with a masculine name. As the Aztecs went on to conquer much of Mesoamerica, they appropriated the gods of their subjects, such as Xipe Totec, a god of spring fertility and patron of gold workers imported from the Gulf Coast and Oaxaca. Freestanding images of the various gods made of stone (FIG. 35-6), terracotta, wood, and even dough (eaten at the end of rituals) stood in and around their temples. Reliefs (FIGS. 35-4 and 35-5) depicting Aztec deities also adorned the temple complexes.

The Aztecs' ritual cycle was very full, because they celebrated events in two calendars—a sacred calendar of 260 days and a solar calendar of 360 days plus five unlucky and nameless days. The Spanish friars of the 16th century noted the solar calendar dealt largely with agricultural matters. The two Mesoamerican calendars functioned simultaneously, requiring 52 years for the same date to recur in both. A ritual called the New Fire Ceremony commemorated this rare event. The Aztecs broke pots and made new ones for the next period, hid their pregnant women, and extinguished all fires. At midnight on a mountaintop, fire priests took out the heart of a sacrificial victim and with a fire drill renewed the flame in the exposed cavity. Then they set ablaze bundles of sticks representing

35-4 Coyolxauhqui, from the Great Temple of Tenochtitlán, Mexico City, Mexico, Aztec, ca. 1469. Stone, diameter 10' 10". Museo del Templo Mayor, Mexico City.

The bodies of sacrificed foes the Aztecs hurled down the stairs of the Great Temple landed on this disk, which depicts the segmented body of the moon goddess, Coyolxuahqui, Huitzilopochtli's sister.

the 52 years just passed, ensuring the sun would rise in the morning and another cycle would begin. The Aztecs celebrated the last New Fire Ceremony in 1507.

Most Aztec ceremonies involved the burning of incense. Colorfully attired dancers and actors performed, and musicians played conch-shell trumpets, drums, rattles, rasps, bells, and whistles. Almost every Aztec festival also included human sacrifice. To Tlaloc, the priests offered small children because their tears brought the rains.

Rituals also marked the completion of important religious structures. The dedication of the last major rebuilding of Hueteocalli at Tenochtitlán in 1487, for example, reportedly involved the sacrifice of thousands of captives from recent wars in the Gulf Coast region. Varied offerings have been found within earlier layers of the temple, many representing tribute from subjugated peoples. These include blue-painted stone and ceramic vessels, conch shells, a jaguar skeleton, flint and obsidian knives, and even Mesoamerican "antiques"—carved stone Olmec and Teotihuacán masks made hundreds of years before the Aztec ascendancy.

whose discovery in 1971 set off the ongoing archaeological investigations in the Zócalo. The Aztecs placed the relief at the foot of the staircase leading up to one of Huitzilopochtli's earlier temples on the site. (Cortés and his army never saw the disk because it lay within the outermost shell of the Great Temple.) The relief presents

the image of the murdered and segmented body of Coyolxauhqui. The mythological theme also carried a contemporary political message. The Aztecs sacrificed their conquered enemies at the top of the Great Temple and then hurled their bodies down the temple stairs to land on this stone. The victors thus forced their foes to reenact

35-5 Tlaltecuhtli (Earth Lord), from the Great Temple of Tenochtitlán, Mexico City, Mexico, Aztec, 1502. Andesite, painted with mineral colors, 13' 9" \times 11' $10\frac{1}{2}$ ". Museo del Templo Mayor, Mexico City.

This 12-ton relief depicts
Tlaltecuhtli squatting to give
birth while drinking her own
blood. The slab covered a
treasure-filled shaft probably
associated with the grave of
Emperor Ahuitzotl, who died
in 1502.

1 ft

the horrible fate of the dismembered goddess. The Coyolxauhqui disk is a superb example of art in the service of state ideology. The unforgettable image of the fragmented goddess proclaimed the power of the Mexica over their enemies and the inevitable fate that must befall their foes when defeated. Marvelously composed, the relief has a kind of dreadful beauty. Within the circular space, the design's carefully balanced, richly detailed components have a slow turning rhythm reminiscent of a revolving galaxy. The carving is in low relief, a smoothly even, flat surface raised from a flat ground. It is the sculptural equivalent of the line and flat tone, the figure and neutral ground, characteristic of Mesoamerican painting.

TLALTECUHTLI In 2006, Mexican archaeologists uncovered a gigantic pink andesite relief (FIG. 35-5) painted in ocher, red, blue, white, and black depicting the earth goddess Tlaltecuhtli. The Aztec sculptor depicted the goddess facing the viewer with arms raised, wearing elaborate headgear, and posed in a squatting position to give birth while drinking her own blood. She has claws instead of hands and feet and skulls in place of knees. The relief weighs nearly 12 tons even in its fragmentary state and required at least 200 men to transport it from the quarry at Lake Texcoco to Tenochtitlán. The colossal slab covered a deep shaft at the foot of the north side of the Templo Mayor pyramid. Below, the excavators discovered sacrificial knives, gold bells, two eagles with jade and gold ornaments, and a dog or wolf with a jade necklace and turquoise ear ornaments, as well as 62 species of marine creatures from both the Atlantic and Pacific Oceans—that is, from every corner of the Aztec world. The relief and the treasure-filled shaft are

probably associated with the as-yet-unlocated grave of the Aztec emperor Ahuitzotl (r. 1486–1502).

COATLICUE In addition to relief carving, the Aztecs produced freestanding statuary. Perhaps the most impressive is the colossal statue (FIG. 35-6) of the beheaded Coatlicue discovered in 1790 near Mexico City's cathedral. The sculpture's original setting is unknown, but some scholars believe it was one of a group set up at the Great Temple. The main forms are in high relief, the details executed either in low relief or by incising. The overall aspect is of an enormous blocky mass, its ponderous weight looming over awed viewers. From the beheaded goddess's neck writhe two serpents whose heads meet to form a tusked mask. Coatlicue wears a necklace of severed human hands and excised human hearts. The pendant of the necklace is a skull. Entwined snakes form her skirt. From between her legs emerges another serpent, symbolic perhaps of both menses and the male member. Like most Aztec deities, Coatlicue has both masculine and feminine traits. Her hands and feet have great claws, which she uses to tear the human flesh she consumes. All her attributes symbolize sacrificial death. Yet, in Aztec thought, this mother of the gods combined savagery and tenderness, for out of destruction arose new life, a theme seen earlier at Teotihuacán (FIG. 18-7).

AZTECS AND SPANIARDS Unfortunately, despite the occasional spectacular find, such as the Tlaltecuhtli monolith (FIG. 35-5), most Aztec and Aztec-sponsored art did not survive the Spanish conquest and the subsequent period of evangelization.

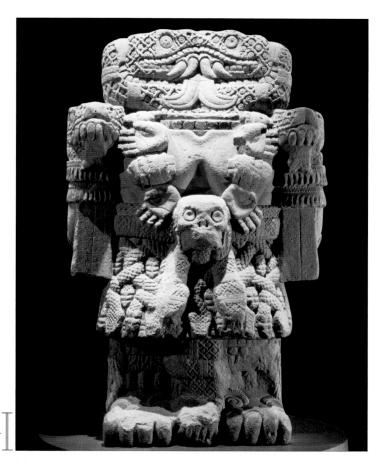

35-6 Coatlicue, from Tenochtitlán, Mexico City, Mexico, Aztec, ca. 1487–1520. Andesite, 11′ 6″ high. Museo Nacional de Antropología, Mexico City.

This colossal statue may have stood near the Great Temple. The beheaded goddess wears a necklace of human hands and hearts. Entwined snakes form her skirt. All her attributes symbolize sacrificial death.

The conquerors took Aztec gold artifacts back to Spain and melted them down, zealous friars destroyed "idols" and illustrated books, and perishable materials such as textiles and wood largely disappeared. Aztec artisans also fashioned beautifully worked feathered objects and even created mosaic-like images with feathers, an art they put to service for the Catholic Church for a brief time after the Spanish conquest, creating religious pictures and decorating ecclesiastical clothing with the bright feathers of tropical birds.

The Spanish conquerors found it impossible to reconcile the beauty of the great city of Tenochtitlán with what they regarded as its hideous cults. They admired its splendid buildings ablaze with color, its luxuriant and spacious gardens, its sparkling waterways, its teeming markets, and its grandees resplendent in exotic bird feathers. But when Moctezuma II brought Cortés and his entourage into the shrine of Huitzilopochtli's temple, the newcomers started back in horror, recoiling in disgust at the huge statues clotted with dried blood. Cortés was furious. Denouncing Huitzilopochtli as a devil, he proposed to put a high cross above the pyramid and a statue of the Virgin in the sanctuary to exorcise its evil. This proposal came to symbolize the avowed purpose and the historical result of the Spanish conquest of Mesoamerica. The conquistadors venerated the cross and the Virgin, triumphant, in new shrines built on the ruins of the plundered temples of the ancient American gods. In turn, the banner of the Most Catholic King of Spain waved over new atrocities of a European kind.

SOUTH AMERICA

Late Horizon is the name of the period in the Andes Mountains of Peru and Bolivia (MAP **35-2**) corresponding to the end of the late Postclassic period in Mesoamerica. The dominant power in the region at that time was the Inka.

Inka

The Inka were a small highland group who established themselves in the Cuzco Valley around 1000. In the 15th century, however, they rapidly extended their power until their empire stretched from modern Quito, Ecuador, to central Chile. At the time of the Spanish conquest, the Inka Empire, although barely a century old, was the largest in the world. Expertise in mining and metalwork enabled the Inka to accumulate enormous wealth and to amass the fabled troves of gold and silver the Spanish coveted. An empire as vast and rich as the Inka's required skillful organizational and administrative control. The Inka had rare talent for both. They divided their Andean empire, which they called Tawantinsuyu, the Land of the Four Quarters, into sections and subsections, provinces and communities, whose boundaries all converged on, or radiated from, the capital city of Cuzco.

The Inka aimed at imposing not only political and economic control but also their art style throughout their realm, subjugating local traditions to those of the empire. Control extended even to clothing, which communicated the social status of the person wearing the garment. The Inka wove bands of small squares of various repeated abstract designs into their fabrics. Scholars believe the patterns had political meaning, connoting membership in

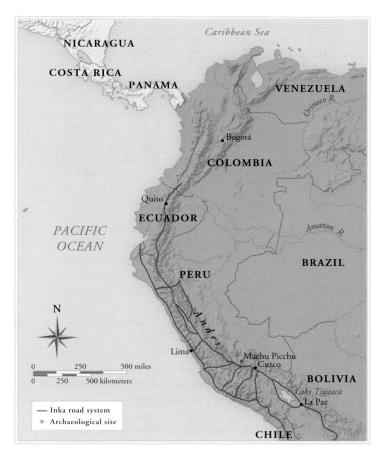

MAP 35-2 Inka sites in Andean South America.

Inka Technology

The Inka ruled a vast empire in Andean South America. During the century preceding the Spanish conquest, the Inka Empire probably boasted a population of some 12 million living as much as 3,000 miles apart. To feed their far-flung subjects, the Inka mastered the difficult problems of agriculture in a mountainous region with expert terracing and irrigation. They knitted together their extensive territories with networks of highways and bridges, upgrading more than 14,000 miles of roads, one

35-7 Machu Picchu (looking northwest), Peru, Inka, 15th century.

Machu Picchu was the estate of an Inka ruler. Large upright stones echo the contours of nearby sacred peaks. Precisely placed windows and doors facilitated astronomical observations.

main highway running through the highlands and another along the coast, with connecting roads linking the two regions. Shunning wheeled vehicles and horses, they used their highway system to move goods by llama herds. They also established a highly efficient, swift communication system of relay runners who carried messages the length of the empire. The Inka emperor in Cuzco could get fresh fish from the coast in only three days. Where the terrain was too steep for a paved flat surface, the Inka built stone steps, and their rope bridges crossed canyons high over impassable rivers. They placed small settlements along the roads no more than a day apart where travelers could rest and obtain supplies for the journey. The terraced cities of the Inka, for example, Machu Picchu (FIG. 35-7) near Cuzco, Peru, are among the engineering wonders of the premodern world.

The Inka never developed a writing system, but they employed a remarkably sophisticated record-keeping system using a device known as the *khipu*, with which they recorded calendar and astronomical information, census and tribute totals, and inventories. For example, the Spaniards noted admiringly that Inka officials always knew exactly how much maize or cloth was in any storeroom in their empire. Not a book or a tablet, the khipu consisted of a main fiber cord and other knotted threads hanging perpendicularly off it. The color and position of each thread, as well as the kind of knot and its location, signified numbers and categories of things, whether people,

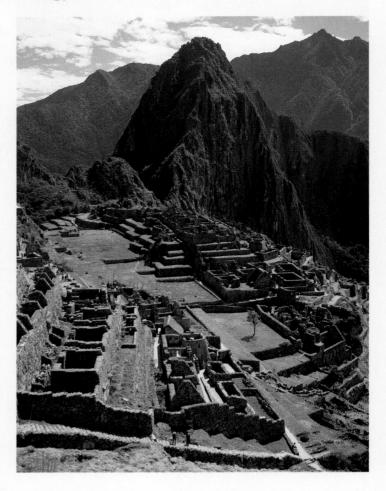

llamas, or crops. Studies of khipus have demonstrated the Inka used the decimal system, were familiar with the concept of zero, and could record numbers up to five digits. The Inka census taker or tax collector could easily roll up and carry the khipu, one of the most lightweight and portable "computers" ever invented.

particular social groups. The Inka ruler's tunics displayed a full range of abstract motifs, perhaps to indicate his control over all groups. Those the Inka conquered had to wear their characteristic local dress at all times, a practice reflected in the distinctive and varied clothing of today's indigenous Andean peoples.

MACHU PICCHU The engineering prowess of the Inka matched their talent for governing (see "Inka Technology," above), and they were gifted architects as well. Although they also worked with adobe, the Inka were supreme masters of shaping and fitting stone. As a militant people, they selected breathtaking, naturally fortified sites and further strengthened them by building various defensive structures. Inka city planning reveals an almost instinctive grasp of the harmonious relationship of architecture to site.

One of the world's most awe-inspiring sights is the Inka city of Machu Picchu (FIG. **35-7**), which perches on a ridge between two

jagged peaks 9,000 feet above sea level. Invisible from the Urubamba River Valley some 1,600 feet below, the site remained unknown to the outside world until Hiram Bingham (1875–1956), an American explorer, discovered it in 1911. In the very heart of the Andes, Machu Picchu is about 50 miles north of Cuzco and, like some of the region's other cities, was the estate of a powerful mid-15th-century Inka ruler. Though relatively small and insignificant compared with its neighbors (its resident population was a little more than a thousand), the city is of great archaeological importance as a rare site left undisturbed since Inka times. The accommodation of its architecture to the landscape is so complete that Machu Picchu seems a natural part of the mountain ranges surrounding it on all sides. The Inka even cut large stones to echo the shapes of the mountain beyond. Terraces spill down the mountainsides and extend even up to the very peak of Huayna Picchu, the great hill just beyond the city's main plaza. The Inka carefully sited buildings so that

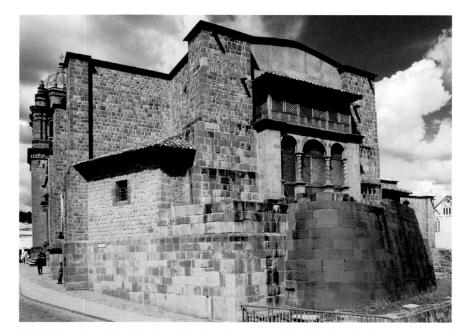

35-8 Remains of the Temple of the Sun (surmounted by the church of Santo Domingo), Cuzco, Peru, Inka, 15th century. General view of the exterior (*left*) and detail of the interior masonry (*right*).

Perfectly constructed ashlar masonry walls are all that remain of the Temple of the Sun, the most important shrine in the Inka capital. Gold, silver, and emeralds covered the temple's interior walls.

windows and doors framed spectacular views of sacred peaks and facilitated the recording of important astronomical events.

CUZCO In the 16th century, the Spanish conquistadors largely destroyed the Inka capital at Cuzco. Consequently, architectural historians have gleaned most of their information about the city from often contradictory Spanish sources rather than from archaeology. Some accounts describe Cuzco's plan as having the shape of a puma, with a great shrine-fortress on a hill above the city representing its head and the southeastern convergence of two rivers forming its tail. Cuzco residents still refer to the river area as "the puma's tail." A great plaza, still the hub of the modern city, nestled below the animal's stomach. The puma was a symbol of Inka royal power.

One Inka building at Cuzco that survives in small part is the Temple of the Sun (FIG. 35-8), built of ashlar masonry (stone blocks fit together without mortar), an ancient construction technique the Inka had mastered. Cuzco masons laid the stones with perfectly joined faces, leaving almost undetectable the lines of separation between blocks. Remarkably, the Inka produced the close joints of their masonry by abrasion alone, grinding the surfaces to a perfect fit. The stonemasons usually laid the blocks in regular horizontal courses (FIG. 35-8, right). Inka builders were so skilled they could fashion walls with curved surfaces (FIG. 35-8, left), their planes as level and continuous as if they were a single form. The surviving walls of the Temple of the Sun are a prime example of this single-form effect. On the exterior, for example, the stones, precisely fitted and polished, form a curving semiparabola. The Inka set the ashlar blocks for flexibility in earthquakes, allowing for a temporary dislocation of the courses, which then return to their original position.

Known to the Spaniards as Coricancha (Golden Enclosure), the Temple of the Sun was the most magnificent of all Inka shrines. The 16th-century Spanish chroniclers wrote in awe of Coricancha's splendor, its interior veneered with sheets of gold, silver, and emeralds and housing life-size statues of silver and gold. Nothing survives,

but some preserved Inka statuettes (FIG. 35-8A) may suggest the appearance of the lost large-scale statues. Built on the site of the home of Manco Capac, son of the sun god and founder of the Inka dynasty, the Temple of the Sun housed mummies of some of the early rulers. Dedicated to the worship of several Inka deities, including the creator god Viracocha and the gods

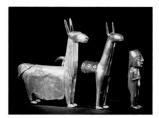

35-8A Inka Ilama, alpaca, and woman, ca. 1475–1532.

of the sun, moon, stars, and the elements, the temple was the center point of a network of radiating sight lines leading to some 350 shrines, which had both calendar and astronomical significance.

END OF THE INKA Smallpox spreading south from Spanish-occupied Mesoamerica killed the last Inka emperor and his heir before they ever laid eyes on a Spaniard. The deaths of the emperor and his named successor unleashed a struggle among competing elite families and aided the Europeans in their conquest. In 1532, Francisco Pizarro (1471-1541), the Spanish explorer of the Andes, ambushed the would-be emperor Atawalpa on his way to be crowned at Cuzco after vanquishing his rival half-brother. Although Atawalpa paid a huge ransom of gold and silver, the Spaniards killed him and took control of his vast domain, only a decade after Cortés had defeated the Aztecs in Mexico. Following the murder of Atawalpa, the conquistadors erected the church of Santo Domingo (FIG. 35-8, left), in an imported European style, on what remained of the Golden Enclosure. A curved section of Inka wall serves to this day as the foundation for Santo Domingo's apse. A violent earthquake in 1950 seriously damaged the colonial building, but the Peruvians rebuilt the church. The two contrasting structures remain standing one atop the other. The Coricancha is therefore of more than architectural and archaeological interest. It is a symbol of the Spanish conquest of the Americas and serves as a composite monument to it.

NORTH AMERICA

In North America during the centuries preceding the arrival of Europeans, power was much more widely dispersed and the native art and architecture more varied than in Mesoamerica and Andean South America. Three major regions of the United States and Canada are of special interest: the American Southwest, the Northwest Coast (Washington and British Columbia) and Alaska, and the Great Plains (MAP 35-3).

Southwest

The dominant culture of the American Southwest between 1300 and 1500 was the Ancestral Puebloan (formerly called the Anasazi), the builders of great architectural complexes such as Chaco Canyon and Cliff Palace (FIG. 18-34). The spiritual center of Puebloan life (*pueblo* is Spanish for "urban settlement") was the *kiva*, or male council house, usually decorated with elaborate mural paintings representing deities associated with agricultural fertility. According to their descendants, the present-day Hopi and Zuni, the detail of the Kuaua Pueblo mural shown here (FIG. 35-9) depicts a "lightning man" on the left side. Fish and eagle images (associated with rain) appear on the right side. Seeds, a lightning bolt, and a rainbow stream from the eagle's mouth. All these figures are associated with the fertility of the earth and the life-giving properties of the

seasonal rains, a constant preoccupation of Southwest farmers. The Ancestral Puebloan painter depicted the figures with great economy, using thick black lines, dots, and a restricted palette of black, brown, yellow, and white. The frontal figure of the lightning man seen against a neutral ground makes an immediate visual impact.

NAVAJO PAINTING When the first Europeans came into contact with the ancient peoples of the Southwest, they called them "Pueblo Indians." The successors of the Ancestral Puebloan and other Southwest groups, the Pueblo Indians include linguistically diverse but culturally similar peoples such as the Hopi of northern Arizona and the Rio Grande Pueblos of New Mexico. Living among them are the descendants of nomadic hunters who arrived in the Southwest from their homelands in northwestern Canada sometime between 1200 and 1500. These are the Apache and Navajo, who, although culturally quite distinct from the original inhabitants of the Southwest, adopted many features of Pueblo life.

Among these borrowed elements is *sand painting*, which the Navajo learned from the Pueblos but transformed into an extraordinarily complex ritual art form. The temporary sand paintings (also known as *dry paintings*), constructed to the accompaniment of prayers and chants, are an essential part of ceremonies for curing disease. In the healing ceremony, the patient sits in the painting's center to absorb the life-giving powers of the gods and their

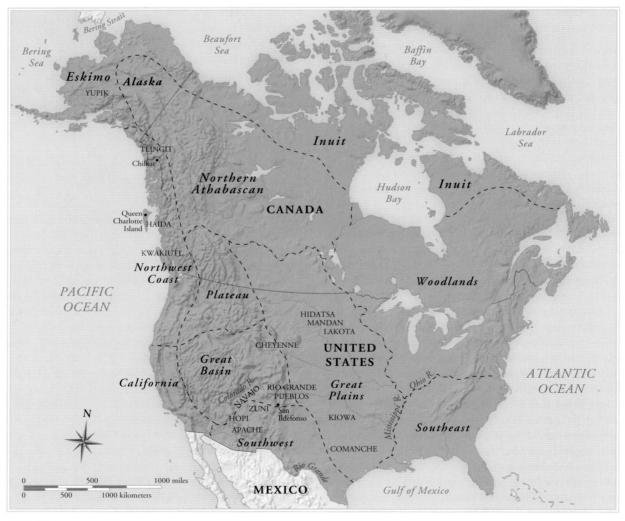

MAP 35-3 Later Native American sites in North America.

35-9 Detail of a kiva mural from Kuaua Pueblo (Coronado State Monument), New Mexico, Ancestral Puebloan, late 15th to early 16th century. Interior of the kiva, $18' \times 18'$. Museum of New Mexico, Santa Fe.

The kiva, or male council house, was the spiritual center of Puebloan life. Kivas were decorated with mural paintings associated with agricultural fertility. This one depicts a lightning man, fish, birds, and seeds.

representations. The Navajo perform similar rites to assure success in hunting and to promote fertility in human beings and nature alike. The artists who supervise the making of these complex images are religious leaders or "medicine men" (rarely women), thought to have direct contact with the powers of the supernatural world, which they use to help both individuals and the community.

The natural materials used—sand, varicolored powdered stones, corn pollen, and charcoal—play a symbolic role reflecting the Native Americans' preoccupation with the forces of nature. The paintings depict the gods and mythological heroes whose help the Navajo seek. As part of the ritual, the participants destroy the sand paintings, so no models exist. However, the traditional prototypes, passed on from artist to artist, must be adhered to as closely as possible. Mistakes can render the ceremony ineffective. Navajo dry painting is therefore highly stylized. Simple curves, straight lines, right angles, and serial repetition characterize most sand paintings.

Because of the sacred nature of sand paintings, the Navajo do not permit anyone to photograph them. Indeed, the study of Native American art presents special problems for art historians, especially since the passage in November 1990 of the Native American Graves Protection and Repatriation Act (NAGPRA), which, among other provisions, requires any museum receiving federal funding to repatriate sacred Native American objects when requested by a descendant. Native views about what is sacred and what should not

be illustrated in textbooks may lead to the removal in future editions of *Art through the Ages* of some works reproduced in the 14th and earlier editions.

NAVAJO TEXTILES By the mid-17th century, the Navajo had learned how to weave from their Hopi and other Pueblo neighbors, quickly adapting to new materials such as sheep's wool and synthetic dyes introduced by Spanish settlers and, later, by Anglo-Americans. They rapidly transformed their wearing blankets into handsome rugs in response to the new market created by the arrival of the railroad and early tourists in the 1880s. Other tribes, including those of the Great Plains, also purchased Navajo textiles, which became famous for their quality (the thread count in a typical Navajo rug is extraordinarily high) as well as the sophistication of their designs. Navajo rugs often incorporate vivid abstract motifs known as "eye dazzlers" and copies of sand paintings (altered slightly to preserve the sacred quality of the impermanent ritual images).

HOPI KATSINAS Another art form from the Southwest, the *katsina* figurine, also has deep roots in the area. Katsinas are benevolent supernatural spirits personifying ancestors and natural elements living in mountains and water sources. Humans join their world after death. Among contemporary Pueblo groups, masked dancers ritually impersonate katsinas during yearly festivals

dedicated to rain, fertility, and good hunting. To educate young girls in ritual lore, the Hopi traditionally give them miniature representations of the masked dancers. The Hopi katsina illustrated here (FIG. **35-10**), carved in cottonwood root with added feathers, is the work of Otto Pentewa (d. 1963). It represents a rain-bringing deity who wears a mask painted in geometric patterns symbolic of water and agricultural fertility. Topping the mask is a stepped shape signifying thunderclouds and feathers to carry the Hopis' airborne prayers. The origins of the katsina figurines have been lost in time (they even may have developed from carved saints the Spanish introduced during the colonial period). However, the cult is probably very ancient.

PUEBLO POTTERY The Southwest has also provided the finest examples of North American pottery. Originally producing utilitarian forms, Southwest potters worked without the potter's wheel and instead coiled shapes of clay they then slipped, polished, and fired. Decorative motifs, often abstract and conventionalized, dealt largely with forces of nature—clouds, wind, and rain. The efforts of San Ildefonso Pueblo potter María Montoya Martínez (1887–1980) and her husband Julian Martínez (see "Gender Roles in Native American Art," page 1035) in the early decades of the 20th century revived old techniques to produce forms of striking shape, proportion, and texture. Her black-on-black pieces (FIG. 35-11) feature matte designs on highly polished surfaces achieved by extensive polishing and special firing in an oxygen-poor atmosphere.

Northwest Coast and Alaska

The Native Americans of the coasts and islands of northern Washington state, the province of British Columbia in Canada, and southern Alaska have long enjoyed a rich and reliable environment. They fished, hunted sea mammals and game, gathered edible plants, and made their homes, utensils, ritual objects, and even clothing from the region's great cedar forests. Among the numerous groups who make up the Northwest Coast area are the Kwakiutl of southern British Columbia; the Haida, who live on the Queen Charlotte Islands off the coast of the province; and the Tlingit of southern Alaska (MAP 35-3). In the Northwest, a class of professional artists developed, in contrast to the more typical Native American pattern of part-time artists. Working in a highly formalized, subtle style, Northwest Coast artists have produced a wide variety of art objects for centuries: totem poles, masks, rattles, chests, bowls, clothing, charms, and decorated houses and canoes. Some artistic traditions originated as early as 500 BCE, although others developed only after the arrival of Europeans in North America.

KWAKIUTL AND TLINGIT MASKS Northwest Coast religious specialists used masks in their healing rituals. Men also wore masks in dramatic public performances during the winter ceremonial season. The animals and mythological creatures represented in masks and a host of other carvings derive from the

35-10 Otto Pentewa, Katsina figurine, New Oraibi, Arizona, Hopi, carved before 1959. Cottonwood root and feathers, 1' high. Arizona State Museum, University of Arizona, Tucson.

Katsinas are benevolent spirits living in mountains and water sources. This Hopi katsina represents a rain-bringing deity wearing a mask with geometric patterns symbolic of water and agricultural fertility.

Gender Roles in Native American Art

A lthough both Native American women and men have created art objects for centuries, they have traditionally worked in different media or at different tasks. Among the Navajo, for example, weavers tend to be women, whereas among the neighboring Hopi the men weave. According to Navajo myth, long ago Spider Woman's husband built her a loom for weaving. In turn, she taught Navajo women how to spin and weave so they might have clothing to wear. Today, young girls learn from their mothers how to work the loom, just as Spider Woman instructed their ancestors, passing along the techniques and designs from one generation to the next.

Among the Pueblos, pottery making normally has been the domain of women. But in response to heavy demand for her wares, María Montoya Martínez, of San Ildefonso Pueblo in New Mexico, coiled, slipped, and burnished her pots, and her husband, Julian, painted the designs. Although they worked in many styles, some based on prehistoric ceramics, around 1918 they invented the black-on-black ware (FIG. 35-11) that made María, and indeed the whole pueblo, famous. The elegant shapes of the pots, as well as the traditional but abstract designs, had affinities with the contemporaneous Art Deco style in architecture (FIG. 29-47) and interior design, and collectors avidly sought (and continue to seek) them. When nonnative buyers suggested she sign her pots to increase their value, María obliged, but in the communal spirit typical of the Pueblos, she also signed her neighbors' names so they might share in her good fortune. María died in 1980, but her descendants continue to garner awards as outstanding potters.

Women also produced the elaborately decorated animal-skin and, later, the trade-cloth clothing of the Woodlands and Plains using moose hair, dyed porcupine quills, and imported beads. Among the Cheyenne, quillworking was a sacred art, and young women worked at learning both proper ritual and correct techniques to obtain membership in the prestigious quillworkers' guild. Women gained the same honor and dignity from creating finely worked utilitarian objects that men earned from warfare. Both women and men painted on tipis and clothing (Figs. 35-16A, 35-17, and 35-18), with women creating abstract designs (Fig. 35-17) and men working in a more realistic narrative style, often celebrating their exploits in war (Fig. 35-16A) or recording the cultural changes the transfer to reservations brought about.

In the far north, women tended to work with soft materials such as animal skins, whereas men were sculptors of wood masks (FIG. 35-13) among the Alaskan Eskimos and of walrus ivory pieces

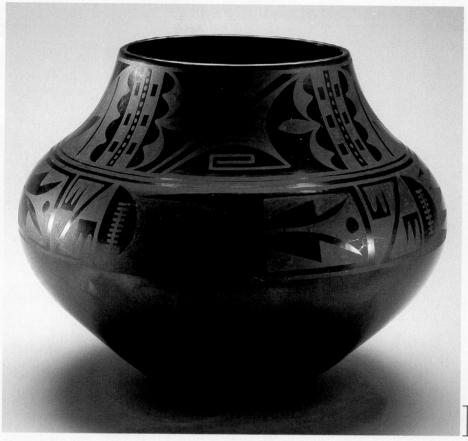

35-11 María Montoya Martínez, jar, San Ildefonso Pueblo, New Mexico, ca. 1939. Blackware, $11\frac{1}{8}'' \times 1'$ 1". National Museum of Women in the Arts, Washington, D.C. (gift of Wallace and Wilhelmina Hollachy).

Pottery is traditionally a Native American woman's art form. María Montoya Martínez won renown for her black-on-black vessels of striking shapes with matte designs on highly polished surfaces.

(FIG. 18-29) throughout the Arctic. The introduction of printmaking, a foreign medium with no established gender associations, to some Canadian Inuit communities in the 1950s provided both native women and men with a new creative outlet. Printmaking became an important source of economic independence vital to these isolated and once-impoverished settlements. Today, both Inuit women and men make prints, but men still dominate in carving stone sculpture, another new medium also produced for and sold to outsiders.

Throughout North America, indigenous artists continue to work in traditional media, such as ceramics, beadwork, and basketry, marketing their wares through museum shops, galleries, regional art fairs, and, most recently, the Internet. Many also obtain degrees in art and express themselves in European media such as oil painting, often using their art to comment on political, social, and economic issues of central concern to Native Americans (FIG. 31-1).

35-12 Eagle transformation mask, closed (*top*) and open (*bottom*) views, Alert Bay, Canada, Kwakiutl, late 19th century. Wood, feathers, and string, 1' 10" × 11". American Museum of Natural History, New York.

The wearer of this Kwakiutl mask could open and close it rapidly by manipulating hidden strings, magically transforming himself from human to eagle and back again as he danced.

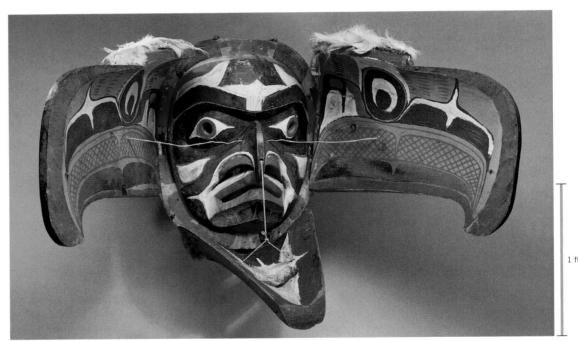

Northwest Coast's rich oral tradition and celebrate the mythological origins and inherited privileges of high-ranking families. The artist who made the Kwakiutl mask illustrated here (FIG. 35-12) meant it to be seen in flickering firelight, and ingeniously constructed it to open and close rapidly when the wearer manipulated hidden strings. He could thus magically transform himself from human to eagle and back again as he danced. The transformation theme, in myriad forms, is a central aspect of the art and religion of the Americas. The Kwakiutl mask's human aspect also owes its dramatic character to the exaggeration and distortion of facial parts—such as the hooked beaklike nose and flat flaring nostrils—and to the deeply undercut curvilinear depressions, which form strong shadows. In contrast to the carved human face, but painted in the

same colors, is the two-dimensional abstract image of the eagle painted on the inside of the outer mask.

The Kwakiutl mask is a refined yet forceful carving typical of the area's more dramatic styles. Others are more subdued, and some, such as a wooden Tlingit war helmet (FIG. 35-13), are exceedingly naturalistic. Although the helmet mask may be a portrait, it might also represent a supernatural being whose powers enhance the wearer's strength. In either case, the artist surely created its grimacing expression to intimidate the enemy.

HAIDA TOTEM POLES Although Northwest Coast arts have a spiritual dimension, they are often more important as expressions of social status. Haida house frontal poles, displaying totemic

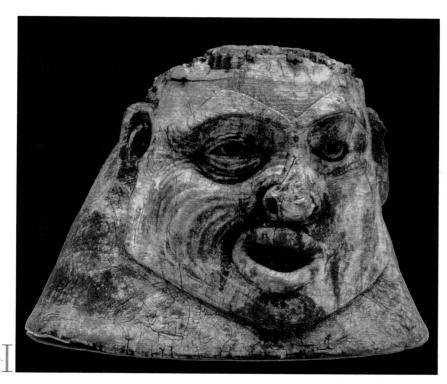

35-13 War helmet mask, Canada, Tlingit, collected 1888–1893. Wood, 1' high. American Museum of Natural History, New York.

This war helmet mask may be a naturalistic portrait of a Tlingit warrior or a representation of a supernatural being. The carver intended the face's grimacing expression to intimidate enemies.

emblems of clan groups, strikingly express this interest in prestige and family history. Totem poles emerged as a major art form about 300 years ago. The examples in Fig. 35-14 date to the 19th century. They stand today in a reconstructed Haida village BILL REID (1920–1998, Haida) and his assistant DOUG CRANMER (1927–2006), Kwakiutl) completed in 1962. Reid was a master wood-

carver who also made monumental sculptures featuring Haida themes, for example, *The Raven and the First Men* (FIG. **35-14A**). Each of the superimposed forms carved on the Haida totem poles represents a crest, an animal, or a supernatural being who fig-

35-14A REID, The Raven and the First Men, 1978–1980.

ures in the clan's origin story. Additional crests could also be obtained through marriage and trade. The Haida so jealously guarded the right to own and display crests that even warfare could break out over the disputed ownership of a valued crest. In the poles shown, the crests represented include an upside-down dogfish (a small shark), an eagle with a downturned beak, and a killer whale with a crouching human between its snout and its upturned tail flukes. During the 19th century, the Haida erected more poles and made them larger in response to greater competitiveness and the availability of metal tools. The artists carved poles up to 60 feet tall from the trunks of single cedar trees.

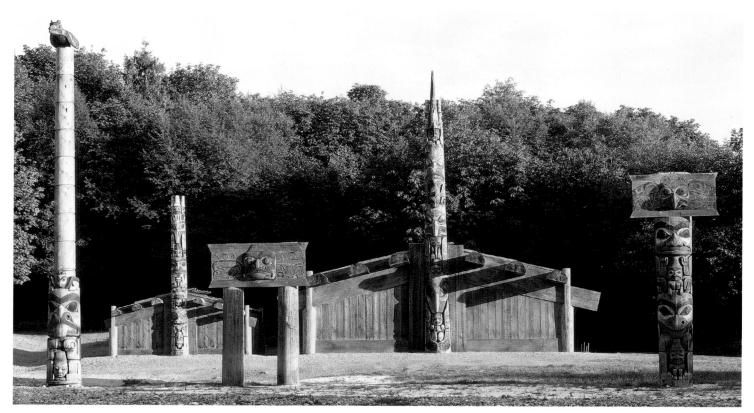

35-14 BILL REID (Haida), assisted by Doug Cranmer (Namgis), re-creation of a 19th-century Haida village with totem poles, Queen Charlotte Island, Canada, 1962.

Each of the superimposed forms carved on Haida totem poles represents a crest, an animal, or a supernatural being who figures in the clan's origin story. Some Haida poles are 60 feet tall.

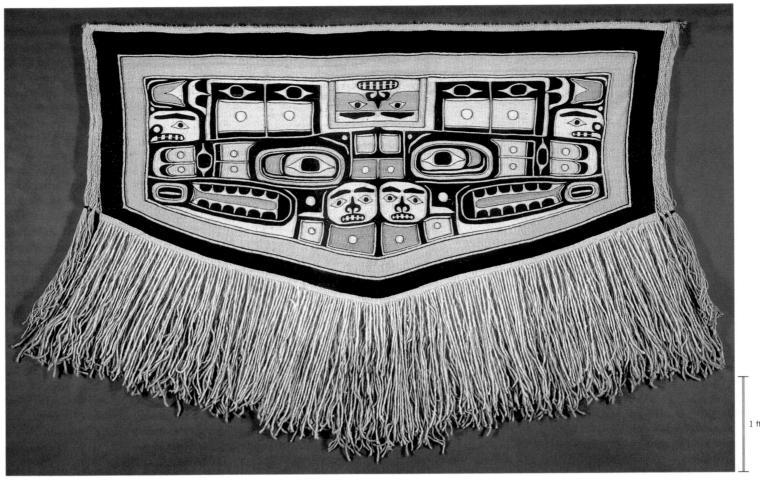

35-15 Chilkat blanket with stylized animal motifs, Canada, Tlingit, early 20th century. Mountain goat wool and cedar bark, $2'11'' \times 6'$. Southwest Museum of the American Indian, Los Angeles.

Chilkat blankets were collaborations between male designers and female weavers. Decorated with animal and abstract motifs, they were worn over the shoulder and were items of ceremonial dress.

CHILKAT BLANKETS Another characteristic Northwest Coast art form is the Chilkat blanket (FIG. 35-15), named for an Alaskan Tlingit village. Male designers provided the templates for these blankets in the form of wooden pattern boards for female weavers. Woven of shredded cedar bark and mountain goat wool on an upright loom, the Tlingit blankets took at least six months to complete. These blankets, which served as robes worn over the shoulders, became widespread prestige items of ceremonial dress during the 19th century. They display several characteristics of the Northwest Coast style recurrent in all media: symmetry and rhythmic repetition, schematic abstraction of animal motifs (a bear in the illustrated robe), eye designs, a regularly swelling and thinning line, and a tendency to round off corners.

YUPIK MASKS Farther north, the 19th-century Yupik Eskimos living around the Bering Strait of Alaska had a highly developed ceremonial life focused on game animals, particularly seal. Their religious specialists wore highly imaginative masks with moving parts. The Yupik generally made these masks for single occasions and then abandoned them. Consequently, many masks have ended up in museums and private collections. The example shown here (FIG. 35-16) represents the spirit of the north wind, its face surrounded by a hoop signifying the universe, its voice mimicked by the rattling appendages. The paired human hands commonly

found on these masks refer to the wearer's power to attract animals for hunting. The painted white spots represent snowflakes.

The devastating effects of 19th-century epidemics, coupled with government and missionary repression of Native American ritual and social activities, threatened to wipe out the traditional arts of the Northwest Coast and the Eskimos. The past half century, however, has brought an impressive revival of traditional art forms (some created for collectors and the tourist trade) as well as the development of new ones, such as printmaking. In recent years, for example, Canadian Eskimos, known as the Inuit, have set up cooperatives to produce and market stone carvings and prints. With these new media, artists generally depict themes from the rapidly vanishing, traditional Inuit way of life.

Great Plains

After colonial governments disrupted settled indigenous communities on the East Coast and the Europeans introduced the horse to North America, a new mobile Native American culture flourished on the Great Plains for a short time. Great Plains artists worked in materials and styles quite different from those of the Northwest Coast and Eskimo/Inuit peoples. Much artistic energy went into the decoration of leather garments, pouches, and horse trappings, first with compactly sewn quill designs and later with bead-

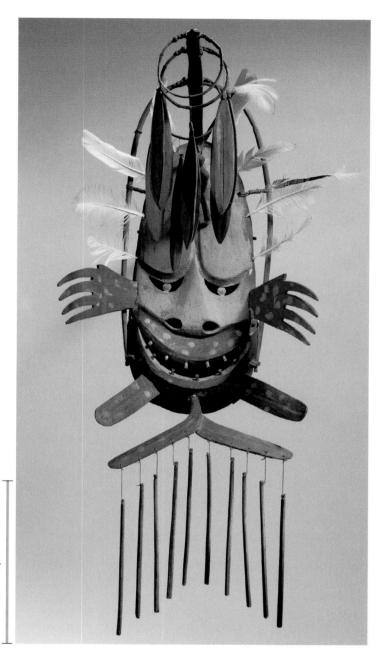

35-16 Mask, Alaska, Yupik Eskimo, early 20th century. Wood and feathers, 3′ 9″ high. Metropolitan Museum of Art, New York (Michael C. Rockefeller Memorial Collection, gift of Nelson Rockefeller).

This Yupik mask represents the spirit of the north wind, its face surrounded by a hoop signifying the universe, its voice mimicked by the rattling appendages. The white spots represent snowflakes.

35-16A Mandan buffalo-hide robe, ca. 1800.

work patterns. Artists painted tipis, tipi linings, and buffalo-skin robes with geometric and stiff figural designs prior to about 1800. Later, they gradually introduced naturalistic scenes, often of war exploits (as, for example, on a Mandan buffalo-hide robe; FIG. 35-16A), sometimes in styles adapted from those of visiting European artists.

35-17 KARL BODMER, Hidatsa Warrior Pehriska-Ruhpa (Two Ravens), 1833. Engraving by PAUL LEGRAND after the original watercolor in the Joslyn Art Museum, Omaha, $1'\ 3\frac{7''}{8}\times 11\frac{1}{2}''$. Engraving: Buffalo Bill Historical Center, Cody.

The personal regalia of a Hidatsa warrior included his pipe, painted buffalo-hide robe, bear-claw necklace, and feather decorations, all symbols of his affiliations and military accomplishments.

HIDATSA REGALIA Because most Plains peoples were nomadic, at least in later periods, they focused their aesthetic attention largely on their clothing and bodies and on other portable objects, such as shields, clubs, pipes, tomahawks, and various containers. Transient but important Plains art forms can sometimes be found in the paintings and drawings of visiting American and European artists, who recorded Native American costumes as anthropological curiosities, relics of a soon-to-be-lost era as the descendants of Europeans pursued their Manifest Destiny to take over the continent (see Chapter 26). KARL BODMER (1809-1893) of Switzerland, for example, portrayed the personal decoration of Pehriska-Ruhpa (Two Ravens), a Hidatsa warrior, in an 1833 watercolor (FIG. 35-17). The painting depicts his pipe, painted buffalohide robe, bear-claw necklace, and feather decorations, all symbolic of his affiliations and military accomplishments. These items represent his life story—a composite artistic statement in several media immediately intelligible to other Native Americans. The concentric circle design over his left shoulder, for example, is an abstract rendering of an eagle-feather war bonnet.

Plains peoples also made shields and shield covers that were both artworks and symbols of power. Shield paintings often de-

35-18 Honoring song at painted tipi, in Julian Scott Ledger, Kiowa, 1880. Pencil, ink, and colored pencil, $7\frac{1}{2}^{"} \times 1'$. Mr. and Mrs. Charles Diker Collection.

During the reservation period, some Plains artists recorded their traditional lifestyle in ledger books. This one depicts men and women dancing an honoring song in front of three painted tipis.

rived from personal religious visions. The owners believed the symbolism, the pigments themselves, and added materials, such as feathers, provided them with magical protection and supernatural power.

LEDGER PAINTINGS Plains warriors battled incursions into their territory throughout the 19th century. The pursuit of Plains natives culminated in the 1890 slaughter of Lakota participants who had gathered for a ritual known as the Ghost Dance at Wounded Knee Creek, South Dakota. Indeed, from the 1830s on, U.S. troops forcibly removed Native Americans from their homelands and resettled them in other parts of the country. Toward the end of the century, governments confined them to reservations in both the United States and Canada.

During the reservation period, some Plains arts continued to flourish, notably beadwork for the women and painting in ledger books for the men. Traders, the army, and Indian agents had for years provided Plains peoples with pencils and new or discarded ledger books. They, in turn, used them to draw their personal exploits for themselves or for interested Anglo buyers. Sometimes warriors carried them into battle, where U.S. Army opponents retook the ledgers. After confinement to reservations, Plains artists began to record not only their heroic past and vanished lifestyle but also their reactions to their new surroundings, frequently in a

place far from home. These images, often poignant and sometimes humorous, are important native documents of a time of great turmoil and change. In the example shown here (FIG. 35-18), the work of an unknown Kiowa artist, a group of men and women, possibly Comanches (allies of the Kiowa), appear to dance an honoring song before three tipis, the left forward one painted with red stone pipes and a dismembered leg and arm. The women (in the middle and rear rows) wear the mixture of clothing typical of the late 19th century among the Plains Indians—traditional high leather moccasins, dresses made from calico trade cloth, and (at the far right) a red Hudson's Bay blanket with a black stripe. Although the Plains peoples no longer paint ledger books, beadwork has never completely died out. The ancient art of creating quilled, beaded, and painted clothing has evolved into the elaborate costumes displayed today at competitive dances called *powwows*.

Whether secular and decorative or spiritual and highly symbolic, the diverse styles and forms of Native American art in the United States and Canada have traditionally reflected the indigenous peoples' reliance on and reverence toward the environment they considered it their privilege to inhabit. Today, some Native American artists work in media and styles indistinguishable from those of other contemporary artists worldwide, but in the work of others, for example Jaune Quick-to-See Smith (FIG. 31-1), the Native American experience remains central to their artistic identity.

NATIVE ARTS OF THE AMERICAS AFTER 1300

MESOAMERICA

- When the first Europeans arrived in the New World, they encountered native peoples with sophisticated civilizations and a long history of art production, including illustrated books. The few surviving pre-conquest books, the *Borgia Codex* among them, provide precious insight into Mesoamerican rituals, science, mythology, and painting style.
- The Aztec Empire was the dominant power in Mesoamerica in the centuries before Hernan Cortés overthrew it. Tenochtitlán (Mexico City), the Aztec capital with a population of more than 100,000, was a magnificent island city laid out on a grid plan.
- The Great Temple at Tenochtitlán was a towering pyramid encasing several earlier pyramids. Dedicated to the worship of Huitzilopochtli and Tlaloc, it was also the place where the Aztecs sacrificed their enemies and threw their battered bodies down the stone staircase to land on a huge disk with a representation in relief of the dismembered body of the goddess Coyolxauhqui.
- In addition to relief carving, Aztec sculptors produced stone statues, some of colossal size, for example, the 11' 6" image from Tenochtitlán of the beheaded Coatlicue, who wears a necklace of severed human hands and excised human hearts.

Borgia Codex, ca. 1400–1500

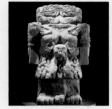

Coatlicue, ca. 1487-1520

SOUTH AMERICA

- In the 15th century, the Inka Empire, with its capital at Cuzco in present-day Peru, extended from Ecuador to Chile. The Inka were superb engineers and constructed 14,000 miles of roads to exert control over their vast empire. They kept track of inventories, census and tribute totals, and astronomical information using a "computer of strings" called a khipu.
- Master architects, the Inka were experts in ashlar masonry construction. The most impressive preserved Inka site is Machu Picchu, the estate of an Inka ruler. Stone terraces spill down the mountainsides, and the buildings have windows and doors designed to frame views of sacred peaks and facilitate the recording of important astronomical events.

Machu Picchu, 15th century

NORTH AMERICA

- In North America, power was much more widely dispersed and the native art and architecture more varied than in Mesoamerica and Andean South America.
- In the American Southwest, the Ancestral Puebloans built urban settlements (pueblos) and decorated their council houses (kivas) with mural paintings. The Navajo produced magnificent textiles and created temporary sand paintings as part of complex rituals. The Hopi carved katsina figurines representing benevolent supernatural spirits. The Pueblo Indian pottery produced by artists such as María Montoya Martínez is among the finest in the world.
- On the Northwest Coast, masks played an important role in religious rituals. Some examples can open and close rapidly so the wearer can magically transform himself from human to animal and back again. Haida totem poles sometimes reach 60 feet in height and are carved with superimposed forms representing clan crests, animals, and supernatural beings. Chilkat blankets are the result of a fruitful collaboration between male designers and female weavers.
- I The peoples of the Great Plains won renown for their magnificent painted buffalo-hide robes, bead necklaces, feather headdresses, and shields. Native American art lived on even after the U.S. government forcibly removed the Plains peoples to reservations. Painted ledger books record their vanished lifestyle, but the production of fine crafts continues to the present day.

Kiva mural, Kuaua Pueblo, late 15th to early 16th century

Kwakiutl eagle transformation mask, late 19th century

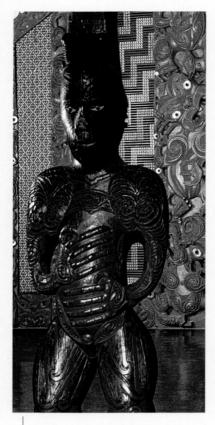

Maori meetinghouses symbolically represent an ancestor's body. Freestanding figures (pou tokomanawa) literally support the ridgepole that is the symbolic spine of the meetinghouse.

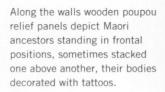

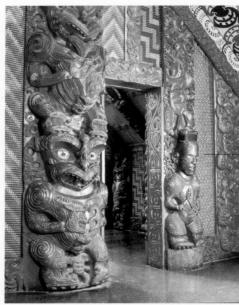

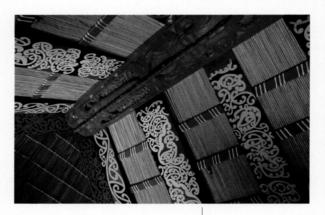

The rafters of a Maori meetinghouse are the symbolic ribs of the ancestor's body. The tukutuku panels are the work of female fabric artists, who were not permitted to enter the men's house.

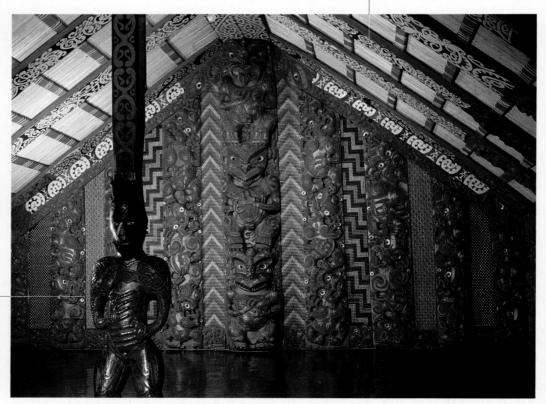

36-1 RAHARUHI RUKUPO AND OTHERS, interior of Te Hau-ki-Turanga meetinghouse, Poverty Bay, New Zealand, Polynesia, 1842–1845. Reconstructed in the National Museum of New Zealand, Wellington.

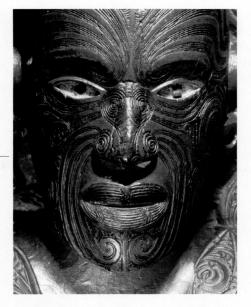

The lead sculptor, Raharuhi Rukupo, who was also chief of the Rongowhakaata tribe, included a self-portrait among the ancestor portraits. His face features an elaborate Maori moko tattoo.

36

OCEANIA BEFORE 1980

MAORI MEN'S MEETINGHOUSES

The number and variety of preserved Oceanic artworks are extraordinary, especially in light of the relatively sparse population of this vast region encompassing some 25,000 islands. But in Oceania, as in many non-Western cultures worldwide, artists did not create "artworks" purely for display as aesthetic objects. The art objects Pacific Islanders have produced over the centuries always played important functional roles in religious and communal life. Oceanic art thus cannot be understood apart from its cultural context.

One of the major venues for the display of art in many Oceanic societies was the men's communal house, which itself should be considered a "work of art." A premier example is the Te Hau-ki-Turanga (Spirit of Turanga) meetinghouse (FIG. 36-1) of the Rongowhakaata tribe at Poverty Bay in New Zealand. Raharuhi Rukupo (ca. 1800–1873) and a team of 18 Maori woodcarvers constructed and decorated the building between 1842 and 1845. The Turanga meetinghouse was a place for the male members of the community to assemble in the benevolent presence of their ancestors. The very structure of the building symbolized the body of an ancestor or of the ultimate ancestor, the sky father, with the exterior *barge boards* (the angled boards outlining the house gables) representing his outstretched arms, the *ridgepole* his spine, and the rafters his ribs. Along the walls, relief panels (*poupou*) depict ancestors standing in frontal positions, sometimes stacked one above another, their bodies decorated with tattoos. Freestanding figures (*pou tokomanawa*) comparable to classical caryatids (FIGS. 5-17 and 5-54) literally support the symbolic spine of the ancestral body that is the meetinghouse. The *tukutuku* (stitched lattice panels) between the poupou are the work of female fabric artists, but since women could not enter the meetinghouse, they installed the panels from the outside.

Raharuhi Rukupo was not only a master carver. He was a priest, warrior, and, after the death of his older brother, the chief of the Rongowhakaata. He dedicated the Turanga meetinghouse in honor of his late brother and, as chief, included a self-portrait holding a woodcutter's adze among the ancestor portraits of the poupou. His face features an elaborate *moko tattoo* (see "Tattoo in Polynesia," page 1055). Working in the long-established Maori tradition of woodcarving but using Western metal tools in place of the stone tools their predecessors employed, Rukupo and his assistants were able to complete the meetinghouse in only three years. The house remains the property of the Rongowhakaata tribe but in 1935 was restored and installed in the National Museum of New Zealand at Wellington.

ISLAND CULTURES OF THE SOUTH PACIFIC

When people think of the South Pacific (MAP **36-1**), images of balmy tropical islands usually come to mind. But the islands of the Pacific Ocean encompass a wide range of habitats. Environments range from the arid deserts of the Australian outback to the tropical rainforests of inland New Guinea and the coral atolls of the Marshall Islands. The region is not only geographically varied but also politically, linguistically, culturally, and artistically diverse.

In 1831, the French explorer Jules Sébastien César Dumont d'Urville (1790–1842) proposed dividing the Pacific Ocean islands into major regions based on general geographical, racial, and linguistic distinctions. Despite its limitations, his division of Oceania into the areas of Melanesia (black islands), Micronesia (small

islands), and Polynesia (many islands) continues in use today. Melanesia includes the islands of New Guinea, New Ireland, New Britain, New Caledonia, the Admiralty Islands, and the Solomon Islands, along with other smaller island groups. Micronesia consists primarily of the Caroline, Mariana, Gilbert, and Marshall Islands in the western Pacific. Polynesia covers much of the eastern Pacific and consists of a triangular area defined by the Hawaiian Islands in the north, Rapa Nui (Easter Island) in the east, and Aotearoa (New Zealand) in the southwest.

Although documentary evidence is lacking about Oceanic cultures before the arrival of seafaring Europeans in the early 16th century, archaeologists have determined humans have inhabited the islands for tens of thousands of years. The archaeological evidence indicates different parts of the Pacific experienced distinct migratory waves. The first group arrived during the last Ice Age,

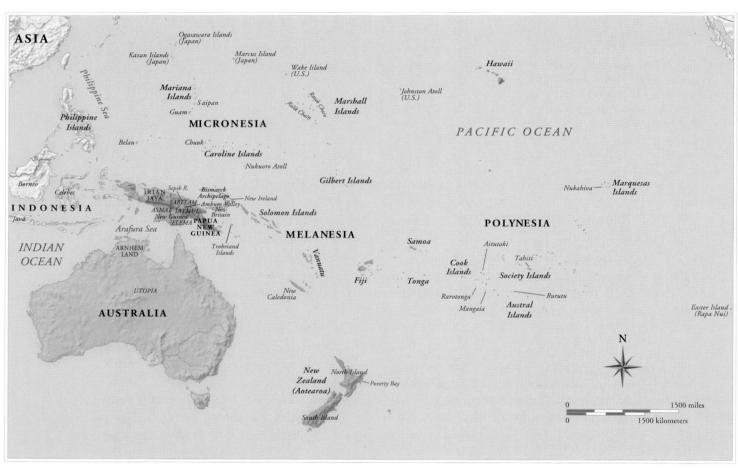

MAP 36-1 Oceania.

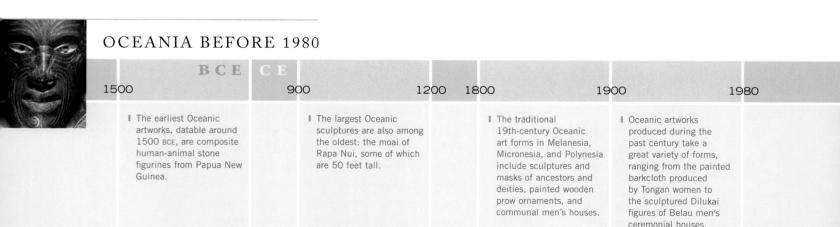

at least 40,000 and perhaps as many as 75,000 years ago, when a large continental shelf extended from Southeast Asia and enabled land access to Australia and New Guinea. After the end of the Ice Age, descendants of these first settlers dispersed to other islands in Melanesia. The most recent migratory wave took place sometime after 3000 BCE and involved peoples of Asian ancestry moving to areas of Micronesia and Polynesia. The last Pacific islands to be settled were those of Polynesia, but habitation of its most far-flung islands—Hawaii, New Zealand, and Easter Island—began no later than 500 to 1000 CE. Because of the expansive chronological span of these migrations, Pacific cultures vary widely. For example, the Aboriginal peoples of Australia speak a language unrelated to any of those of New Guinea, whose languages fall into a distinct but diverse group. In contrast, most of the rest of the Pacific islanders speak languages derived from the Austronesian language family.

These island groups came to Western attention as a result of the extensive exploration and colonization that began in the 16th century and reached its peak in the 19th century. Virtually all of the major Western nations—including Great Britain, France, Spain, Holland, Germany, and the United States—established a presence in the Pacific. Much of the history of Oceania in the 20th century revolved around indigenous peoples' struggles for independence from these colonial powers. Yet colonialism also facilitated an exchange of ideas—not solely the transfer of Western cultural values and technology to the Pacific. Oceanic art, for example, had a strong influence on many Western artists, especially the late-19th-century French painter Paul Gauguin (FIG. 28-20). The "primitive" art of Oceania also inspired many early-20th-century artists (see "Primitivism," Chapter 29, page 846).

36-1A *Ambum Stone,* Papua New Guinea, ca. 1500 BCE.

This chapter focuses on Oceanic art from the European discovery of the islands in the 16th century until 1980, although the colossal stone statues of Easter Island (FIG. 36-12)—probably the most famous artworks in the South Pacific—predate the arrival of Europeans by several centuries, and the earliest preserved sculptures, for example, the *Ambum Stone* (FIG. 36-1A) from Papua New Guinea, date to around 1500 BCE. Knowledge of early Oceanic art and the history of the Pacific islands in

general is unfortunately very incomplete. Traditionally, the transmission of information from one generation to the next in Pacific societies was largely oral, rather than written, and little archival documentation exists. Nonetheless, archaeologists, linguists, anthropologists, ethnologists, and art historians continue to make progress in illuminating the Oceanic past.

AUSTRALIA AND MELANESIA

The westernmost Oceanic islands are the continent-nation of Australia and New Guinea in Melanesia. Together they dwarf the area of all the other Pacific islands combined.

Australia

Over the past 40,000 years, the Aboriginal peoples of Australia spread out over the entire continent and adapted to a variety of ecological conditions, ranging from those of tropical and subtropical areas in the north to desert regions in the continent's interior and more temperate locales in the south. European explorers reaching the region in the late 18th and early 19th centuries found the

Aborigines had a special relationship with the land on which they lived. The Aboriginal perception of the world centers on a concept known as the Dreamings—ancestral beings whose spirits pervade the present. All Aborigines identify certain Dreamings as totemic ancestors, and those who share the same Dreamings have social links. The Aborigines call the spiritual domain the Dreamings occupy Dreamtime, which is both a physical space within which the ancestral beings moved in creating the landscape and a psychic space providing Aborigines with cultural, religious, and moral direction. Because of the importance of Dreamings to all aspects of Aboriginal life, native Australian art symbolically links Aborigines with these ancestral spirits. The Aborigines recite creation myths in concert with songs and dances, and many art forms-body painting, carved figures, sacred objects, decorated stones, and rock and bark painting-serve as essential props in these dramatic recreations. Most Aboriginal art is relatively small and portable. As hunters and gatherers in difficult terrain, the Aborigines were generally nomadic peoples, rendering monumental art impractical.

BARK PAINTING Bark, widely available in Australia, is portable and lightweight, and bark painting thus became a main-

stay of Aboriginal art. Dreamings, mythic narratives (often tracing the movement of various ancestral spirits through the landscape), and sacred places were common subjects. Ancestral spirits pervade the lives of the Aborigines, and these paintings served to give visual form to that presence. Traditionally, an Aborigine could only depict a Dreaming with which the artist had a connection. Thus, specific Aboriginal lineages, clans, or regional groups "owned" individual designs. The bark painting illustrated here (FIG. 36-2) depicts a Dreaming known as Auuenau and comes from Arnhem Land in northern Australia. The artist represented the elongated figure in a style known as "X-ray," which Aboriginal painters used to depict both animal and human forms. In this style, the artist simultaneously depicts the subject's internal organs and exterior appearance. The painting possesses a fluid and dynamic quality, with the X-ray-like figure clearly defined against a solid background.

36-2 Auuenau, from Western Arnhem Land, Australia, 1913. Ochre on bark, $4' \, 10\frac{5''}{8} \times 1' \, 1''$. South Australian Museum, Adelaide.

Aboriginal painters frequently depicted Dreamings, ancestral beings whose spirits pervade the present, using the X-ray style that shows both the figure's internal organs and external appearance.

EMILY KAME KNGWARREYE Aboriginal artists today retain close ties to the land and the spirits that inhabit it, but some painters, such as EMILY KAME KNGWARREYE (1910–1996), have eliminated figures from their work and produced canvases (for example, FIG. 31-22B) that, superficially at least, resemble American Abstract Expressionist paintings (FIG. 30-6).

New Guinea

Because of its sheer size, New Guinea, the third-largest island in the world, dominates Melanesia. This 309,000-square-mile island consists today of parts of two countries—Irian Jaya, a province of nearby Indonesia, on the island's western end, and Papua New Guinea on the eastern end. New Guinea's inhabitants together speak more than 800 different languages, almost one-quarter of the world's known tongues. Among the Melanesian cultures discussed in this chapter, the Asmat, Iatmul, Elema, and Abelam peoples of New Guinea all speak Papuan-derived languages. Scholars believe they are descendants of the early settlers who came to the island in the remote past. In contrast, the people of New Ireland and the Trobriand Islands are Austronesian speakers and probably descendants of a later wave of Pacific migrants.

Typical Melanesian societies are fairly democratic and relatively unstratified. What political power exists belongs to groups of elder men and, in some areas, elder women. The elders handle the people's affairs in a communal fashion. Within some of these groups, persons of local distinction, known as "Big Men," renowned for their political, economic, and, historically, warrior skills, have accrued power. Because power and position in Melanesia can be earned (within limits), many cultural practices (such as rituals and cults) revolve around the acquisition of knowledge that enables advancement in society. To represent and acknowledge this advancement in rank, Melanesian societies mount elaborate festivals, construct communal meetinghouses, and produce art objects. These cultural products serve to reinforce the social order and maintain social stability. Given the wide diversity in environments and languages, it should come as no surprise that hundreds of art styles flourished on New Guinea alone. Only a sample can be presented here.

ASMAT Living along the southwestern coast of New Guinea, the Asmat of Irian Jaya eke out their existence by hunting and gathering the varied flora and fauna found in the mangrove swamps, rivers, and tropical forests. Each Asmat community is in constant competition for limited resources. Historically, the Asmat extended this competitive spirit beyond food and materials to energy and power as well. To increase one's personal energy or spiritual power, one had to take it forcibly from someone else. As a result, warfare and headhunting became central to Asmat culture and art. The Asmat did not believe any death was natural. Death could result only from a direct assault (headhunting or warfare) or sorcery, and it diminished ancestral power. Thus, to restore a balance of spirit power, an enemy's head had to be taken to avenge a death and to add to one's communal spirit power. Headhunting was still common in the 1930s when Europeans established an administrative and missionary presence among the Asmat. As a result of European efforts, headhunting ceased by the 1960s.

When they still practiced headhunting, the Asmat erected *bisj* poles (FIG. **36-3**) that served as a pledge to avenge a relative's death. A man would set up a bisj pole when he could command the support of enough men to undertake a headhunting raid. Carved in one piece from the trunk of a single mangrove tree, bisj poles include superimposed figures of deceased individuals. At the top, ex-

36-3 Asmat bisj poles, village near Mula, Irian Jaya, Melanesia, mid-20th century, photographed in 2003.

The Asmat carved bisj poles from mangrove tree trunks and erected them before undertaking a headhunting raid. The carved figures represent the relatives whose deaths the hunters must avenge.

tending winglike from the abdomen of the uppermost figure on the bisj pole, is the cemen, one of the tree's buttress roots carved into an openwork pattern. All of the decorative elements on the pole related to headhunting and foretold a successful raid. The many animals carved on bisj poles (and in Asmat art in general) are symbols of headhunting. The Asmat see the human body as a tree—the feet and legs as the roots, the torso as the trunk, the arms and hands as the branches, and the head as the fruit. Thus any fruit-eating animal (such as the black king cockatoo, the hornbill, or the flying fox) was symbolic of the headhunter and appeared frequently on bisj poles. Asmat art also often includes representations of the praying mantis. The Asmat consider the female praying mantis's practice of beheading her mate after copulation and then eating him as another form of headhunting. The curvilinear or spiral patterns filling the pierced openwork at the top of the bisj poles can be related to the characteristic curved tail of the cuscus (a fruit-eating mammal) or the tusk of a boar (related to hunting and virility). Once bisj poles were carved, the Asmat placed them on a rack near the community's men's house. After the success of the headhunting expedition, the men discarded the bisi poles and allowed them to rot, because they had served their purpose.

IATMUL The Iatmul live along the middle Sepik River in Papua New Guinea in communities based on kinship. Villages include extended families as well as different clans. The social center of every Iatmul village is a massive saddle-shaped men's ceremonial house (FIG. 36-4). In terms of both function and form, the men's house reveals the primacy of the kinship network. The meetinghouse reinforces kinship links by serving as the locale for initiation of local youths for advancement in rank, for men's discussions of community issues, and for ceremonies linked to the Iatmul's ancestors. Because only men can advance in Iatmul society, women and uninitiated boys cannot enter the men's house. In this manner, the Iatmul men control access to knowledge and therefore to power. Given its important political and cultural role, the men's house is appropriately monumental, physically dominating Iatmul villages and dwarfing family houses. Although men's houses are common in New Guinea, those of the Iatmul are the most lavishly decorated.

Traditionally, the house symbolizes the protective mantle of the ancestors and represents an enormous female ancestor. The facade is her face and the rest of the house her body. The Iatmul house and its female ancestral figures symbolize a reenacted death and rebirth when a clan member enters and exits the second story of the building. The gable ends of men's houses are usually covered and include a giant female gable mask, making the ancestral symbolism visible. The interior carvings, however, are normally hidden from view. The Iatmul placed carved images of clan ancestors on the central ridge-support posts and on the roof-support posts

36-4 Iatmul ceremonial men's house, East Sepik, Papua New Guinea, Melanesia, mid- to late 20th century.

The men's house is the center of latmul life. Its distinctive saddle-shaped roof symbolizes the protective mantle of ancestors. The carved decoration includes female ancestors in the birthing position.

on both sides of the house. They topped each roof-support post with large faces representing mythical spirits of the clans. At the top of the two raised spires at each end, birds symbolizing the war spirit of the village men sit above carvings of headhunting victims (on occasion, male ancestors).

The subdivision of the house's interior into parts for each clan reflects the social demographic of the village. Many meetinghouses have three parts—a front, middle, and end representing the three major clans who built it. These parts have additional subclan divisions, which also have support posts carved with images of mythical male and female ancestors. Beneath the house, each clan keeps large carved slit-gongs to serve as both instruments of communication (for sending drum messages within and between villages) and the voices of ancestral spirits. On the second level of the house, above the horizontal crossbeam beneath the gable, the Iatmul place carved wooden figures symbolizing female clan ancestors, depicted in a birthing position. The Iatmul also keep various types of portable art in their ceremonial

houses. These include ancestors' skulls covered with clay modeled to form a likeness of the deceased (a practice similar to one documented thousands of years before in Neolithic Jericho, FIG. 1-14), ceremonial chairs, sacred flutes, hooks for hanging sacred items and food, and several types of masks.

ELEMA Central to the culture of the Elema people of Orokolo Bay in the Papuan Gulf was *Hevehe*, an elaborate cycle of ceremonial activities. Conceptualized as the mythical visitation of the water spirits (*ma-hevehe*), the Hevehe cycle involved the production and presentation of large, ornate masks (also called hevehe). The Elema last practiced Hevehe in the 1930s. Primarily organized by the male elders of the village, the cycle was a communal undertaking, and normally took from 10 to 20 years to complete. The duration of the Hevehe and the resources and human labor required reinforced cultural and economic relations and maintained the social structure in which elder male authority dominated.

Throughout the cycle, the Elema held ceremonies to initiate male youths into higher ranks. These ceremonies involved the exchange of wealth (such as pigs and shell ornaments), thereby also serving an economic purpose. The cycle culminated in the display of the finished hevehe masks. Each mask consisted of painted barkcloth (see "Barkcloth," page 1053) stretched around a cane-and-wood frame fitted over the wearer's body. A hevehe mask was normally 9 to 10 feet in height, although extensions often raised the height to as much as 25 feet. Because of its size and intricate design, a hevehe

36-5 Elema hevehe masks retreating into the men's house, Orokolo Bay, Papua New Guinea, Melanesia, early to mid-20th century.

The Hevehe was a cycle of ceremonial activities spanning 10 to 20 years, culminating in the dramatic appearance of hevehe masks from the Elema men's house. The masks represent female sea spirits.

mask required great skill to construct, and only trained men would participate in mask making. Designs were specific to particular clans, and elder men passed them down to the next generation from memory. Each mask represented a female sea spirit, but the decoration of the mask often incorporated designs from local flora and fauna as well.

The final stage of the cycle (FIG. **36-5**) focused on the dramatic appearance of the masks from the *eravo* (men's house). After a procession, men wearing the hevehe mingled with relatives. Upon conclusion of related dancing (often lasting about a month),

the Elema ritually killed and then dumped the masks in piles and burned them. This destruction allowed the sea spirits to return to their mythic domain and provided a pretext for commencing the cycle again.

ABELAM The art of the Abelam people illustrates how Oceanic art often includes references both to fundamental spiritual beliefs and to basic subsistence. The Abelam are agriculturists living in the hilly regions north of the Sepik River. Relatively isolated, the Abelam received only sporadic visits from foreigners until the 1930s, so little is known about early Abelam history. The principal crop is the yam. Because of the importance of yams to the survival of Abelam society, those who can grow the largest yams achieve power and prestige. Indeed, the Abelam developed a complex yam cult, which involves a series of rites and activities intended to promote the growth of the tubers. Special plantations focus on yam cultivation. Only initiated men who observe strict rules of conduct, including sexual abstinence, can work these fields. The Abelam believe ancestors aid in the growth of yams, and they hold ceremonies to honor these ancestors. Special long yams (distinct from the short yams cultivated for consumption) are on display during these festivities, and the largest (9 to 10 feet long) bear the names of important ancestors. Yam masks (FIG. 36-6) with cane or wood frames, usually painted red, white, yellow, and black, are an integral part of the ceremonies. The most elaborate masks also incorporate sculpted faces, cassowary feathers, and shell ornaments. They covered the "heads" of the long yams. Humans never wear the yam masks, but the Abelam use the same designs to decorate their bodies for dances, revealing how closely they identify with their principal food source.

36-6 Abelam yam mask, from Maprik district, Papua New Guinea, Melanesia, early to mid-20th century. Painted cane, 1' $6\frac{9}{10}''$ high. Musée Barbier-Mueller, Geneva.

The Abelam believe their ancestors aid in the growth of their principal crop, the yam. Painted cane yam masks are an important part of the elaborate ceremonies honoring these ancestors.

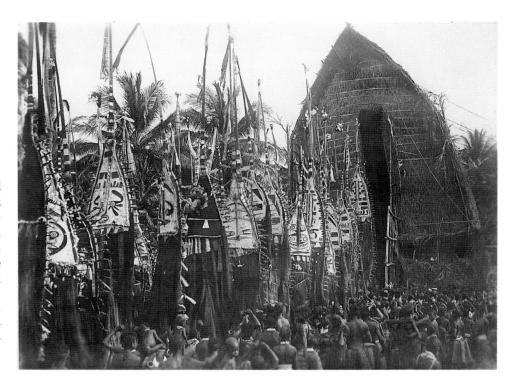

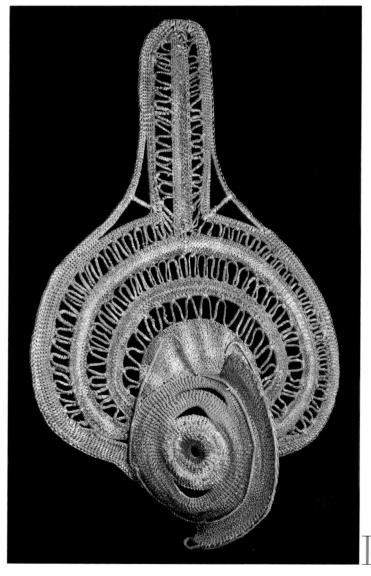

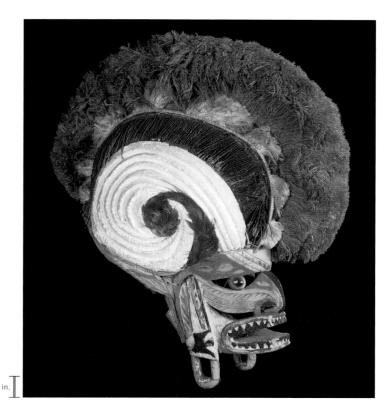

New Ireland and the Trobriand Islands

East of New Guinea but part of the modern nation of Papua New Guinea are New Ireland and the Trobriand Islands, two important Melanesian art centers.

NEW IRELAND Mortuary rites and memorial festivals are a central concern of the Austronesian-speaking peoples who live in the northern section of New Ireland. The term *malanggan* refers to both the festivals held in honor of the deceased and the carvings and objects produced for these festivals. Malanggan rites are part of an ancestor cult and are critical in facilitating the transition of the soul from the world of the living to the realm of the dead and the

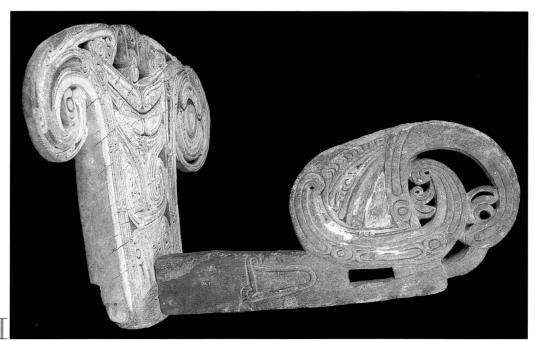

36-7 Tatanua mask, from New Ireland, Papua New Guinea, Melanesia, 19th to 20th centuries. Wood, fiber, shell, lime, and feathers, $1' 5\frac{1}{2}''$ high. Otago Museum, Dunedin.

In New Ireland, malanggan rites facilitate the transition of the soul from this world to the land of the dead. Dancers wearing tatanua masks representing the deceased play a key role in these ceremonies.

rechanneling of energy from the deceased into the community of the living. In addition to the religious function of malanggan, the extended ceremonies also promote social solidarity and stimulate the economy (as a result of the resources necessary to mount impressive festivities). To educate the younger generation about these practices, malanggan also includes the initiation of young men.

Among the many malanggan carvings produced—masks, figures, poles, friezes, and ornaments—are tatanua masks (FIG. 36-7). *Tatanua* represent the spirits of specific deceased people. The materials used to make New Ireland tatanua masks are primarily soft wood, vegetable fiber, and rattan. The crested hair, made of fiber, duplicates a hairstyle formerly common among the men. For the eyes, the mask makers insert sea-snail shells. Traditionally, artists paint the masks black, white, yellow, and red—colors the people of New Ireland associate with warfare, magic spells, and violence. Although some masks are display pieces, dancers wear most of them. Rather than destroying their ritual masks after the conclusion of the ceremonies, as some other cultures do, the New Irelanders store them for future use.

TROBRIAND ISLANDS The various rituals of Oceanic cultures discussed thus far often involve exchanges intended to cement social relationships and reinforce or stimulate the economy. Further, these rituals usually have a spiritual dimension. All of these aspects apply to the practices of the Trobriand Islanders, who live off the coast of the southeastern corner of New Guinea. *Kula*—an exchange of white conus-shell arm ornaments for red chama-shell necklaces—is a characteristic practice of the Trobriand Islanders. Kula exchanges may have originated some 500 years ago. They can be complex, and there is great competition for valuable shell ornaments (determined by aesthetic appeal and exchange history).

Because of the isolation imposed by their island existence, the Trobriand Islanders had to undertake potentially dangerous voyages to participate in kula trading. Appropriately, the Trobrianders lavish a great deal of effort on decorating their large and elaborately carved canoes, which feature ornate prows and splashboards (FIG. 36-8). To ensure a successful

36-8 Canoe prow and splashboard, from Trobriand Islands, Papua New Guinea, Melanesia, 19th to 20th centuries. Wood and paint, 1' 3½" high, 1' 11" long. Musée du quai Branly, Paris.

To participate in kula exchanges, the Trobriand Islanders had to undertake dangerous sea voyages. They decorated their canoes with abstract human, bird, and serpent motifs referring to sea spirits.

kula expedition, the Trobrianders invoke spells when attaching these prows to the canoes. Human, bird, and serpent motifs—references to sea spirits, ancestors, and totemic animals—appear on the prows and splashboards. Because the sculptors use highly stylized motifs in intricate intertwined curvilinear designs, identification of the specific representations is difficult. In recent decades, the Trobrianders have adapted kula to modern circumstances, largely abandoning canoes for motorboats. The exchanges now facilitate business and political networking.

MICRONESIA

Some 2,500 islands, most of them tiny, scattered over nearly three million square miles of ocean make up Micronesia, home to about 200,000 people today. The Austronesian-speaking cultures of Micronesia tend to be more socially stratified than those found in New Guinea and other Melanesian areas. Micronesian cultures frequently center on chieftainships with craft and ritual specializations, and their religions include named deities as well as honored ancestors. Life in virtually all Micronesian cultures focuses on seafaring activities—fishing, trading, and long-distance travel in large oceangoing vessels. For this reason, much of the artistic imagery of Micronesia relates to the sea.

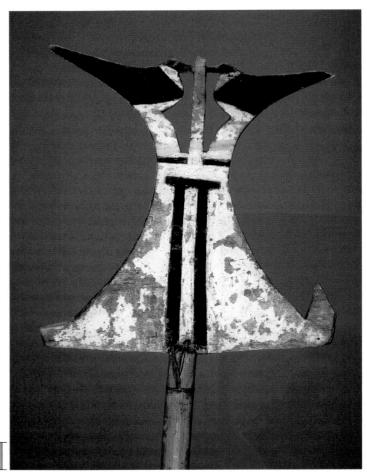

36-9 Canoe prow ornament, from Chuuk, Caroline Islands, Micronesia, late 19th century. Painted wood, birds $11'' \times 10^{\frac{5}{8}''}$. British Museum, London.

Prow ornaments protected canoe paddlers and could be lowered to signal a peaceful voyage. This Micronesian example may represent facing sea swallows or perhaps a stylized human figure.

Caroline Islands

The Caroline Islands are the largest island group in Micronesia. The arts of the Caroline Islands include the carving of canoes and the fashioning of charms and images of spirits to protect travelers at sea and for fishing and fertility magic.

CHUUK Given the importance of seafaring, it is not surprising many of the most highly skilled artists in the Caroline Islands were master canoe builders. The canoe ornament illustrated here (FIG. 36-9) comes from Chuuk. Carved from a single plank of wood and fastened to the prow of a large, paddled war canoe, the ornament served a decorative purpose but also provided protection on arduous or long voyages. That this and similar ornaments are not permanent parts of the canoes reflects their function. When approaching another vessel, the Micronesian seafarers lowered these ornaments as a signal their voyage was a peaceful one. The Chuuk prow seems at first to be an abstract design but may represent, at the top, two facing sea swallows—creatures capable of navigating long distances. Some scholars, however, think the entire piece represents a stylized human figure, with the "swallows" constituting the arms.

BELAU On Belau (formerly Palau) in the Caroline Islands, the islanders put much effort into creating and maintaining elaborately painted men's ceremonial clubhouses called *bai* (FIGS. **36-10** and **36-11**). Although the bai was the domain of men, women figured prominently in the clubhouse's imagery, consistent with the important symbolic and social positions women held in Belau culture (see "Women's Roles in Oceania," page 1051). A common element surmounting the main bai entrance was a simple, symmetrical

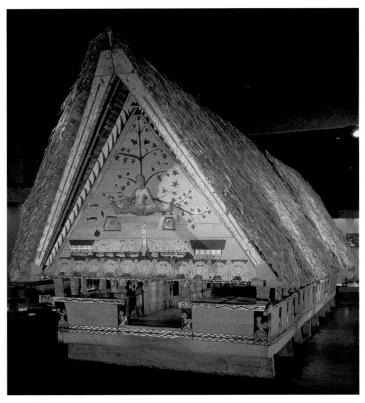

36-10 Men's ceremonial house, from Belau (Palau), Micronesia, 20th century. Ethnologisches Museum, Staatliche Museen zu Berlin, Berlin.

The Belau men's clubhouses (bai) have extensive carved and painted decorations illustrating important events and myths related to the clan who built the bai. The central motif is a Dilukai (Fig. 36-11).

Women's Roles in Oceania

Given the prominence of men's houses and the importance of male initiation in so many Oceanic societies, women might appear to be peripheral members of these cultures. Much of the extant material culture—ancestor masks, shields, clubs—seems to corroborate this. In reality, however, women play crucial roles in most Pacific cultures. In addition to their significant contributions through exchange and ritual activities to the maintenance and perpetuation of the social network upon which the stability of village life depends, women are important producers of art.

Historically, women's artistic production has been restricted mainly to forms such as barkcloth, weaving, and pottery. In some cultures in New Guinea, potters were primarily female. Throughout much of Polynesia, women produced barkcloth (see "Tongan Barkcloth," page 1053), which they often dyed and stenciled, and sometimes even perfumed. Women in the Trobriand Islands still make brilliantly dyed skirts of shredded banana fiber that not only are aesthetically beautiful but also serve as a form of wealth, presented symbolically during mortuary rituals.

In most Oceanic cultures, women usually do not use the same adzes and axes male sculptors employ, and they do not work in hard materials, such as wood, stone, bone, or ivory. Further, they do not produce images having religious or spiritual powers or that confer status on their users. Scholars investigating the role of the artist in Oceania have concluded that the reason for these restrictions is a perceived difference in innate power. Because women have the natural power to create and control life, male-dominated societies developed elaborate ritual practices to counteract this female power. By excluding women from participating in these rituals and denying them access to knowledge about specific practices, men derived a political authority that could be perpetuated. It is important to note, however, that even in rituals or activities restricted to men,

women often participate. For example, in the now-defunct Hevehe ceremonial cycle (FIG. 36-5) in Papua New Guinea, women made the fiber skirts for the hevehe masks but feigned ignorance about these sacred objects, because such knowledge was the exclusive privilege of initiated men.

Pacific cultures often acknowledged women's innate power in the depictions of women in Oceanic art. For example, the splayed Dilukai female sculpture (FIG. 36-11) that appears regularly on Palauan bai (men's houses; FIG. 36-10) celebrates women's procreative powers. Often flanked by figures of sexually aroused men, these female figures were surrounded by images of sun disks, trees, and birds. They faced east toward the rising sun and symbolized the sun's gifts to earth as well as human fertility. The Dilukai figure also confers protection upon visitors to the bai, another symbolic acknowledgment of female power. Similar concepts underlie the design of the Iatmul men's house (FIG. 36-4). Conceived as a giant female ancestor, the men's house incorporates women's natural power into the conceptualization of what is normally the most important architectural structure in an Iatmul village. In addition, the Iatmul associate entrance and departure from the men's house with death and rebirth, thereby reinforcing the primacy of fertility and the perception of the men's house as representing a woman's body.

One reason scholars have tended to overlook the active participation of women in all aspects of Oceanic life is that until recently the objects visitors to the Pacific collected were primarily those suggesting aggressive, warring societies. That the majority of these Western travelers were men and therefore had contact predominantly with men no doubt accounts for this pattern of collecting. Recent scholarship has done a great deal to rectify this misperception, thereby revealing the richness of social, artistic, and political activity in the Pacific.

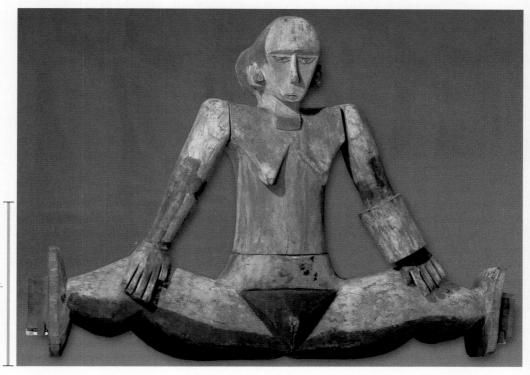

36-11 Dilukai, from Belau (Palau), Micronesia, late 19th or early 20th century. Wood, paint, and kaolin, 2' 15" high. Metropolitan Museum of Art, New York (Michael C. Rockefeller Collection).

Sculpted wooden figures of a splayed female, or Dilukai, commonly appear over the entrance to a Belau bai (Fig. 36-10). The figures served as symbols of fertility and protected the men's house.

1 ft

wooden sculpture (on occasion, a painting) of a splayed female figure, known as *Dilukai* (FIG. 36-11). She wears jewelry and an armband, emblems of wealth and power, and serves as a symbol of both protection and fertility.

Whereas the Iatmul make their ceremonial houses (FIG. 36-4) by tying, lashing, and weaving different-size posts, trees, saplings, and grasses, the Belau people make the main structure of the bai entirely of worked, fitted, joined, and pegged wooden elements, which enables them to assemble it easily. The Belau bai have steep overhanging roofs decorated with geometric patterns along the roof boards. Skilled artists carve the gable in low relief and paint it with narrative scenes, as well as various abstracted forms of the shell money used traditionally on Belau as currency. These decorated storyboards illustrate important historical events and myths related to the clan who built the bai. Similar carved and painted crossbeams are inside the house. The rooster images along the base of the facade symbolize the rising sun, while the multiple frontal human faces carved and painted above the entrance and on the vertical elements above the rooster images represent a deity called Blellek. He warns women to stay away from the ocean and the bai or he will molest them.

POLYNESIA

Polynesia was one of the last areas in the world humans settled. Habitation in the western Polynesian islands did not begin until about the end of the first millennium BCE, and in the south not

until the first millennium CE. The settlers brought complex sociopolitical and religious institutions with them. Whereas Melanesian societies are fairly egalitarian and advancement in rank is possible, Polynesian societies typically are highly stratified, with power determined by heredity. Indeed, rulers often trace their genealogies directly to the gods of creation. Most Polynesian societies possess elaborate political organizations headed by chiefs and ritual specialists. By the 1800s, some Polynesian cultures (Hawaii and the Society Islands, for example) had evolved into kingdoms. Because of this social hierarchy, historically most Polynesian art belonged to persons of noble or high religious background and served to reinforce their power and prestige. These objects, like their chieftain owners, often possessed *mana*, or spiritual power.

Rapa Nui (Easter Island)

Some of the earliest datable artworks in Oceania are also the largest. This is especially true of the colossal sculptures of Rapa Nui.

MOAI The moai (FIG. 36-12) of Rapa Nui are monumental sculptures as much as 50 feet tall and weighing up to 100 tons. They stand as silent sentinels on stone platforms (ahu) marking burial or sacred sites used for religious ceremonies. Most of the moai consist of huge, blocky figures with fairly planar facial features—large staring eyes, strong jaws, straight noses with carefully articulated nostrils, and elongated earlobes. A number of the moai have pukao—small red scoria (a local volcanic stone) cylinders that serve as a sort of topknot or hat—atop their heads. Although debate continues,

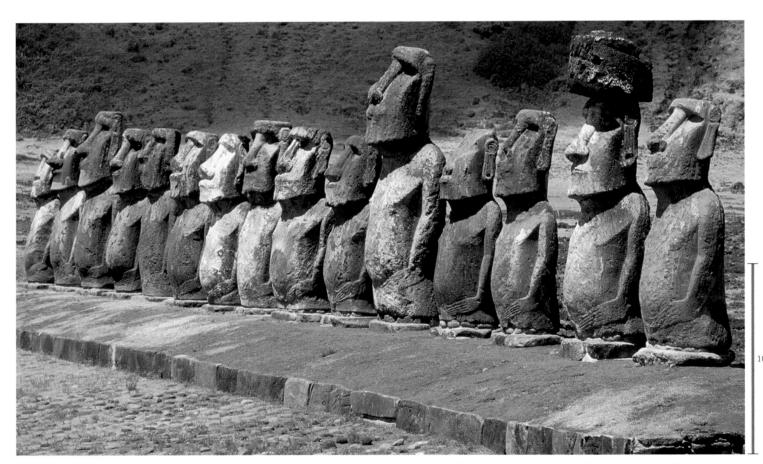

36-12 Row of moai on a stone platform, Rapa Nui (Easter Island), Polynesia, 10th to 12th centuries. Volcanic tuff and red scoria, tallest statues approximately 19′ high. ■◀

The moai of Rapa Nui are monoliths as much as 50 feet tall. Most scholars believe they portray ancestral chiefs. They stand on platforms marking burials or sites for religious ceremonies.

Tongan Barkcloth

Tongan barkcloth provides an instructive example of the laborintensive process of tapa production. At the time of early contact between Europeans and Polynesians in the late 18th and early 19th centuries, ranking women in Tonga made decorated barkcloth (ngatu). Today, women's organizations called kautaha produce it. The kautaha may have the honorary patronage of ranking women. In Tonga, men plant the paper mulberry tree and harvest it in two to three years. They cut the trees into about 10-foot lengths and allow them to dry for several days. Then the women strip off the outer bark and soak the inner bark in water to prepare it for further processing. They place these soaked inner bark strips over a wooden anvil and repeatedly strike them with a wooden beater until they spread out and flatten. Folding and layering the strips while beating them, a felting process, results in a wider piece of ngatu than the

original strips. Afterward, the beaten barkcloth dries and bleaches in the sun.

The next stage of ngatu production involves the placement of the thin, beaten sheets over semicircular boards. The women then fasten embroidered design tablets (*kupesi*—usually produced by men) of coconut-leaf midribs and string patterns to the boards. They transfer the patterns on the design tablets to the outer bark-cloth by rubbing. Then the women fill in the lines and patterns by painting, covering the large white spaces with colored figures. The Tongans use brown, red, and black pigments derived from various types of bark, clay, fruits, and soot to create the colored patterns on ngatu. Sheets, rolls, and strips of ngatu play an important role in weddings, funerals, and ceremonial presentations for ranking persons.

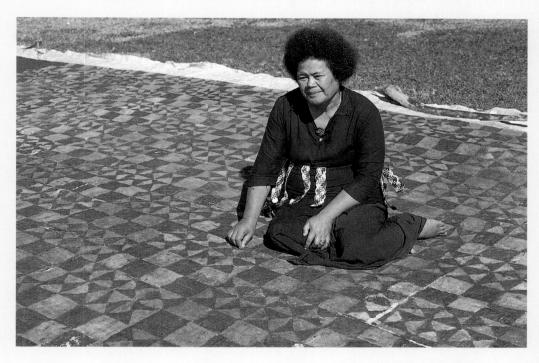

36-13 MELE SITANI, ngatu with manulua designs, Tonga, Polynesia, 1967. Barkcloth.

In Tonga, the production of decorated barkcloth, or ngatu, involves dyeing, painting, stenciling, and perfuming. Mele Sitani made this one with a two-bird design for the coronation of Tupou IV.

many scholars believe lineage chiefs or their sons erected the moai and the sculptures depict ancestral chiefs. The moai, however, are not individual portraits but generic images the Easter Islanders believed had the ability to accommodate spirits or gods. The statues thus mediate between chiefs and gods, and between the natural and cosmic worlds.

Archaeological surveys have documented nearly 1,000 moai erected on some 250 ahu. Most of the stones are soft volcanic tuff and came from the same quarry at Rano Raraku. Some of the sculptures are red scoria, basalt, or trachyte. After quarrying, the Easter Islanders dragged the moai to the ahu sites, and then positioned them vertically. Given the extraordinary size of these *monoliths*, their production and placement serve as testaments to the achievements of this Polynesian culture. According to one scholar, it would have taken 30 men one year to carve a moai, 90 men two

months to transport it from the quarry to the ahu site (often several miles away), and 90 men three months to position it vertically on the platform.

Tonga

Tonga is the westernmost island group in Polynesia. One of its most distinctive products is barkcloth, which women have traditionally produced throughout Polynesia.

BARKCLOTH Artists produce barkcloth from the inner bark of the paper mulberry tree. The finished product goes by various names in Polynesia, but during the 19th century, when the production of barkcloth reached its zenith, *tapa* became the most widely used term. Although the primary use of tapa in Polynesia was for clothing and bedding, in Tonga, large sheets (FIG. **36-13**) were (and

still are) produced for exchange (see "Tongan Bark-cloth," page 1053). Barkcloth can also have a spiritual dimension and can serve to confer sanctity upon the object wrapped in it. Appropriately, the Polynesians traditionally wrapped the bodies of high-ranking deceased chiefs in barkcloth.

The use and decoration of tapa have varied over the years. In the 19th century, tapa used for everyday clothing was normally unadorned, whereas tapa used for ceremonial or ritual purposes was dyed, painted, stenciled, and sometimes even perfumed. The designs applied to the tapa differed depending upon the particular island group producing it and the function of the cloth. The production process was complex and time-consuming. Indeed, some Oceanic cultures, such as those of Tahiti and Hawaii, constructed buildings specifically for the beating stage in the production of barkcloth. Tapa production reached its peak in the early 19th century, partly as a result of the interest expressed by Western whalers and missionaries. By the late 19th century, the use of tapa for cloth had been abandoned throughout much of eastern Polynesia, although its use in rituals (for example, as a wrap for corpses of

deceased chiefs or as a marker of tabooed sites) continued. Even today, tapa exchanges are still an integral part of funerals and marriage ceremonies, and even the coronation of kings.

The decorated *ngatu* (barkcloth) shown in FIG. 36-13 clearly demonstrates the richness of pattern, subtlety of theme, and variation of geometric forms characteristic of Tongan royal barkcloths. MELE SITANI made this ngatu for the accession ceremony of King Tupou IV (r. 1965–2006) of Tonga. She kneels in the middle of the ngatu, which features triangular patterns known as *manulua*. This pattern results from the intersection of three or four pointed triangles. *Manulua* means "two birds," and the design gives the illusion of two birds flying together. The motif symbolizes chieftain status derived from both parents.

Marquesas, Austral, and Cook Islands

Even though the Polynesians were skillful navigators, various island groups remained isolated from one another for centuries by the vast distances they would have had to cover in open outriggers. This geographical separation explains the development of distinct regional styles within a recognizable general Polynesian style.

MARQUESAS ISLANDS Although Marquesan chiefs trace their right to rule genealogically, the political system before European contact allowed for the acquisition of power by force. As a result, warfare was widespread through the late 19th century. Among the items produced by Marquesan artists were ornaments (FIG. 36-14) that often adorned the hair of warriors. The hollow, cylindrical bone or ivory ornaments (*ivi p'o*) functioned as protective amulets. Warriors wore them until they avenged the death of a kinsman. The ornaments are in the form of *tiki*—carvings of exalted, deified ancestor figures. The large, rounded eyes and wide mouths of the tiki are typically Marquesan, as is the use of a continuous line to outline both the nose, with its wide nostrils, and the oversized eyes.

Another important art form for Marquesan warriors during the 19th century was *tattoo*, which protected the individual, serv-

36-14 Hair ornaments, from the Marquesas Islands, Polynesia, early to mid-19th century. Bone, $1\frac{1}{2}''$ high (*left*), $1\frac{2}{3}''$ high (*right*). University of Pennsylvania Museum of Archaeology and Anthropology, Philadelphia.

These hollow cylindrical bone ornaments representing deified ancestors adorned the hair of Marquesan warriors during the 19th century. The warriors were them until they avenged the death of a kinsman.

ing in essence as a form of spiritual armor, as did the hair ornaments. Body decoration in general is among the most pervasive art forms found throughout Oceania. Polynesians developed the painful but prestigious art of tattoo more fully than many other Oceanic peoples (see "Tattoo in Polynesia," page 1055), although tattooing also occurred in various parts of Micronesia. In Polynesia, with its hierarchical social structure, nobles and warriors in particular accumulated various tattoo patterns over the years to enhance their status, mana, and personal beauty. Largely as a result of missionary pressure in the 19th century, tattooing virtually disappeared in many Oceanic societies, but some Pacific peoples have revived tattooing as an expression of cultural pride.

An 1813 engraving (FIG. 36-15) depicts a Marquesan warrior from Nukahiva Island covered with elaborate tattoo patterns. The warrior holds a large wooden war club over his right shoulder and carries a decorated water gourd in his left hand. The various tattoo patterns marking his entire body seem to subdivide his body parts into zones on both sides of a line down the center. Some tattoos accentuate joint areas, whereas others separate muscle masses into horizontal and vertical geometric shapes. The warrior also covered his face, hands, and feet with tattoos.

RURUTU Deity images with multiple figures attached to their bodies are characteristic of Rurutu in the Austral Islands and of Rarotonga (FIG. 36-15A) and Mangaia in the Cook Islands. These carvings probably represented clan and district ancestors, honored for their protective and procreative powers. Ultimately, the images refer to the creator deities the Polynesians revere for their central role in human fertility.

Rurutu is the northernmost of the Austral Islands in French Polynesia. In August 1821, following an edict of its leaders, the entire population converted to Christianity. As a symbol of their embrace of the new monotheistic religion, the inhabitants presented statues of their gods to the British missionaries stationed on a neighboring island.

36-15A Rarotonga staff god, 19th or early 20th century.

Tattoo in Polynesia

hroughout Oceanic cultures, as in Africa (see Chapter 37), body decoration was an important means of representing cultural and personal identity. In addition to clothing and ornaments, body adornment most often took the form of tattoo. Although tattooing was a common practice in Micronesia, it was more pervasive in Polynesia. Indeed, the English term tattoo is Polynesian in origin, related to the Tahitian, Samoan, and Tongan word tatau or tatu. In New Zealand, the markings are called moko. Within Polynesian cultures, tattoo reached its zenith in the highly stratified societies of New Zealand, the Marquesas Islands, Tahiti, Tonga, Samoa, and Hawaii. Both sexes displayed tattoos. In general, men had more tattoos than women, and the location of tattoos on the body differed. For instance, in New Zealand, the face and buttocks were the primary areas of male tattoo, whereas tattoos appeared on the lips and chin

Historically, tattooing served a variety of functions in Polynesia beyond personal beautification. It indicated status, because the quantity and quality of tattoos often reflected rank. In the Marquesas Islands, for example, tattoos completely covered the bodies of men of high status (FIG. 36-15). Certain patterns could be applied only to ranking individuals, but commoners also had tattoos, generally on a less extensive scale than elite individuals. For identification purposes, slaves had tattoos on their foreheads in Hawaii and on their backs in New Zealand. According to some accounts, victors placed tattoos on defeated warriors. In Polynesia, tattoos often identified clan or familial connections. Tattoos could also serve a protective function by in essence wrapping the body in a spiritual armor. On occasion, tattoos marked significant events. In Hawaii, for example, a tattooed tongue was a sign of grief. The pain the tattooed person endured was a sign of respect for the deceased.

Priests who were specially trained in the art form usually applied the tattoos. Rituals, chants, or ceremonies often accompanied the procedure, which took place in a special structure. Tattooing involves the introduction of black, carbon-based pigment under the skin with the use of a bird-bone tattooing comb or chisel and a mallet. In New Zealand, a distinctive technique emerged for tattooing the face. In a manner similar to Maori woodcarving, a serrated chisel created a groove in the skin to receive pigment, thereby producing a colored line.

Polynesian tattoo designs were predominantly geometric, and affinities with other forms of Polynesian art are evident. For example, the curvilinear patterns found on decorated wall panels (poupou) in Maori meetinghouses (FIGS. 36-1 and 36-19A) resemble and make reference to the patterns that predominate in Maori facial moko. Depending on their specific purpose, many tattoos could be "read" or deciphered. For facial tattoos, the Maori generally divided the face into four major, symmetrical zones: the left and right forehead down to the eyes, the left lower face, and the

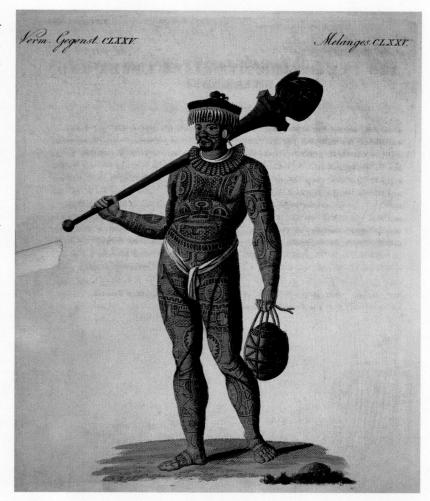

36-15 Tattooed warrior with war club, Nukahiva, Marquesas Islands, Polynesia, early 19th century. Color engraving in Carl Bertuch, *Bilderbuch für Kinder* (Weimar, 1813).

In Polynesia, with its hierarchical social structure, noblemen and warriors accumulated tattoo patterns to enhance their status and beauty. Tattoos wrapped a warrior's body in spiritual armor.

right lower face. The right-hand side conveyed information on the father's rank, tribal affiliations, and social position, whereas the left-hand side provided matrilineal information. Smaller secondary facial zones provided information about the tattooed individual's profession and position in society. Te Pehi Kupe (FIG. I-19) was the chief of the Ngati Toa tribe in the early 19th century. The upward and downward *koru* (unrolled spirals) in the middle of his forehead connote his descent from two paramount tribes. The small design in the center of his forehead documents the extent of his domain—north, south, east, and west. The five double koru in front of his left ear indicate the supreme chief (the highest rank in Maori society) was part of his matrilineal line. The designs on his lower jaw and the anchor-shaped koru nearby reveal Te Pehi Kupe was not only a master carver but descended from master carvers as well.

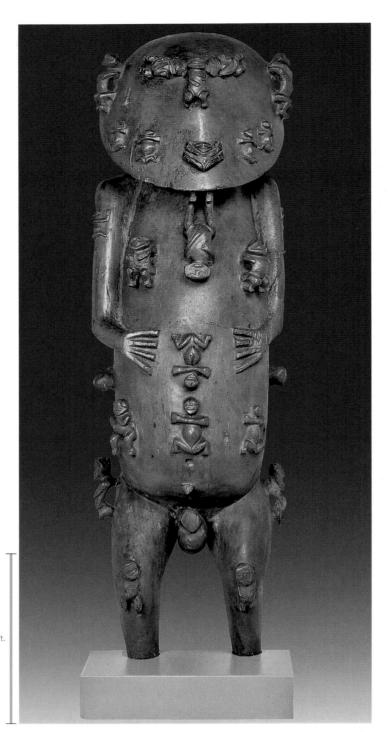

36-16 A'a, from Rurutu, Austral Islands, Polynesia, late 18th or early 19th century. Wood, 3' 8" high. British Museum, London.

A'a is the chief Rurutu ancestor god. Covering his body—and forming the features of his head—are relief figures of his progeny. A large cavity at the back of the statue held 24 more figures.

The wooden statue illustrated here (FIG. 36-16), representing the god A'a, was one of those gifts to the London Missionary Society. A'a was the original inhabitant of Rurutu, the ancestor of all its people. He was deified after his death. Distributed over the front and back of the god's body—and forming the eyes, nose, mouth, and ears of the disk-shaped head—are tiny relief figures of the gods and men A'a created. The sculptor depicted them in a variety of positions, including head downward. At the back of the figure is a large cavity that once

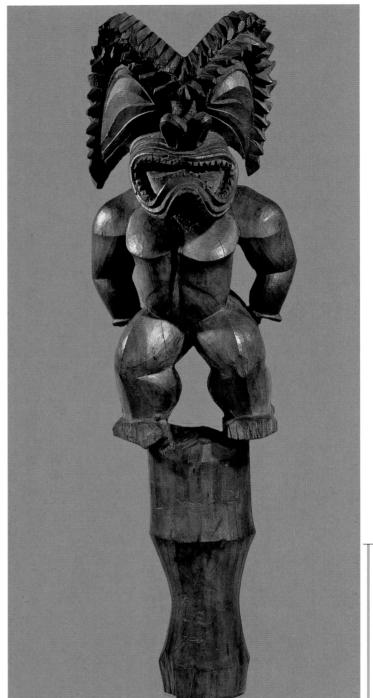

36-17 Kuka'ilimoku, from Hawaii, Polynesia, late 18th or early 19th century. Wood, 4' 3\frac{1}{4}" high. British Museum, London.

This wooden statue of the Hawaiian war god comes from a temple. His muscular body is flexed to attack, and his wide mouth with bared teeth set in a large head conveys aggression and defiance.

contained 24 additional miniature figures. The god places his hands on his belly, a gesture that calls attention to the interior compartment holding his progeny.

Hawaii

The Hawaiians developed the most highly stratified social structure in the Pacific. By 1795, the chief Kamehameha unified the major islands of the Hawaiian archipelago and ascended to the pinnacle

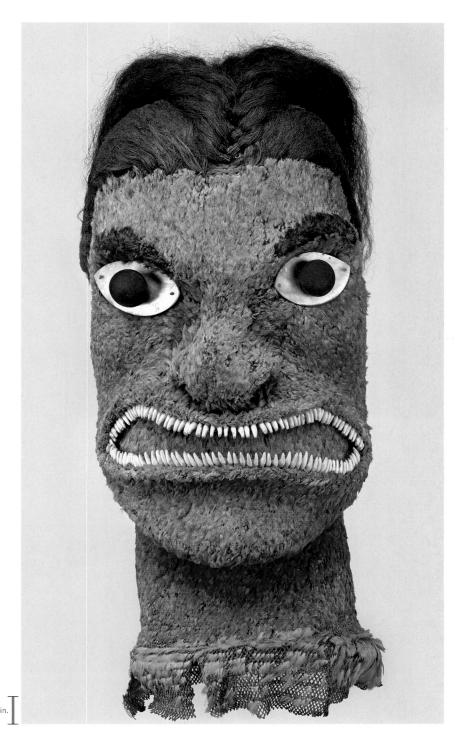

of power as King Kamehameha I (r. 1810–1819). The kingdom he established did not endure, however, and Hawaii soon came under American control. The United States annexed Hawaii as a territory in 1898 and eventually conferred statehood on the island group in 1959.

KUKA'ILIMOKU As elsewhere in Oceania, the gods were a pervasive presence in Hawaiian society and were part of every person's life, regardless of status. Chiefs in particular invoked them regularly and publicized their genealogical links to the gods to reinforce their right to rule. One of the more prominent Hawaiian deities was Kuka'ilimoku, the war god. As chiefs in the prekingdom years struggled to maintain and expand their control, warfare

36-18 Head of Lono, from Hawaii, Polynesia, ca. 1775–1780. Human hair, dog's teeth, pearl shells, and feathers over wicker work, $2'\frac{3}{4}''$ high. British Museum, London.

Feather heads of the Hawaiian gods with grimacing mouths, such as this one of Lono with human hair, pearl-shell eyes, and dog's teeth, were mounted on poles and carried in processions and into battle.

was endemic-hence the god's importance. Indeed, Kuka'ilimoku served as Kamehameha's special tutelary deity, and the Kuka'ilimoku sculpture illustrated here (FIG. 36-17) stood in a heiau (temple) on the island of Hawaii (Big Island), where Kamehameha I originally ruled before expanding his authority to the entire Hawaiian chain. This late-18th- or early-19th-century Hawaiian wooden temple image, which is more than four feet tall, confronts its audience with a ferocious expression. The war god's head comprises nearly a third of his entire body. His enlarged, angled eyes and wide-open figure-eight-shaped mouth, with its rows of teeth, convey aggression and defiance. His muscular body appears to stand slightly flexed, as if ready to attack. The artist realized this Hawaiian war god's overall athleticism through the full-volumed, faceted treatment of his arms, legs, and the pectoral area of the chest. In addition to sculptures of deities such as this, Hawaiians placed smaller versions of lesser deities and ancestral images in the heiau. Differing styles surface in the various islands of the Hawaiian chain, but the sculptured figures share a tendency toward athleticism and expressive defiance.

LONO Hawaiian artists also fashioned images of their gods from rare bird feathers and other natural materials placed over a wickerwork armature. The head illustrated here (FIG. 36-18), which incorporates pearl shells for eyes as well as human hair and dog's teeth, is one of five heads in the British Museum that Captain James Cook (1728–1779) took back to England after his third voyage to the South Pacific from 1776 to 1779. The Hawaiian feather heads were sacred objects and costly to produce because they incorporated feathers from thousands of birds. The Hawaiians believed their gods had feathers covering their flesh. Feathers therefore connoted prestige, and the feather heads were

also thought to be faithful reproductions of the deities' appearance. The Hawaiians mounted the gods' heads on poles, displayed them in religious processions, and carried them as standards into battle. When not in use, they were on exhibit in temples under the care of religious officials.

Although very different in material and overall character, the feather heads of the gods share many iconographical and stylistic traits with Hawaiian full-length wooden statues (FIG. 36-17) of gods, especially the larger-than-life grimacing mouths. Scholars believe the heads with large central crests of feathers represent the war god Kuka'ilimoku. The head in the British Museum instead has a crown of parted human hair and probably depicts Lono, the god of agriculture, fertility, and peace.

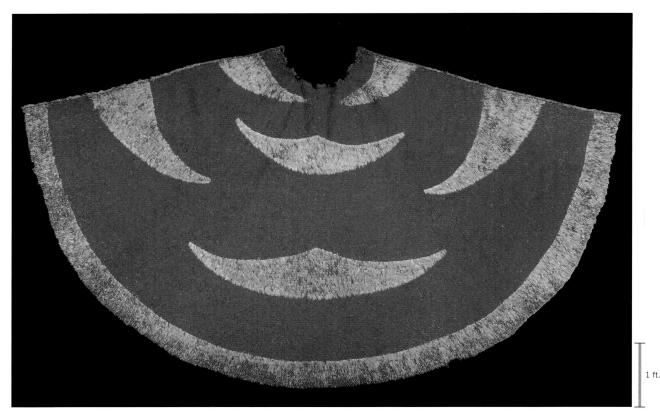

36-19 Feather cloak, from Hawaii, Polynesia, ca. 1824–1843. Feathers and fiber netting, $4' 8\frac{1}{3}'' \times 8'$. Bishop Pauahi Museum, Honolulu.

Costly Hawaiian feather cloaks ('ahu 'ula) such as this one, which belonged to King Kamehameha III, provided the protection of the gods. Each cloak required the feathers of thousands of birds.

FEATHER CLOAKS Because perpetuation of the social structure was crucial to social stability, chiefs' regalia, which visualized and reinforced the hierarchy of Hawaiian society, were a prominent part of artistic production. For example, elegant feather cloaks ('ahu 'ula) such as the early-19th-century example shown here (FIG. 36-19) belonged to men of high rank. Every aspect of the 'ahu 'ula reflected the status of its wearer. The materials were exceedingly precious, particularly the red and yellow feathers from the 'i 'iwi, 'apapane, 'o 'o, and mamo birds. Some of these birds yield only six or seven suitable feathers, and because a full-length cloak could require up to 500,000 feathers, the resources and labor required to produce a cloak were extraordinary. The cloak also linked its owner to the gods. The Polynesians associated the plaited fiber base for the feathers with deities. Not only did these cloaks confer the protection of the gods on their wearers, but their dense fiber base and feather matting also provided physical protection. The artists who fashioned the cloaks chanted as they worked, believing the power of the sacred chants permeated the fabric lining. The cloak in FIG. 36-19 originally belonged to King Kamehameha III (r. 1824-1854), who gave it to Commodore Lawrence Kearny of the U.S. frigate Constellation in 1843 in gratitude for Kearny's assistance during a temporary occupation of Hawaii.

New Zealand

The Maori of Aotearoa (New Zealand) share many cultural practices with other Polynesian societies. Ancestors and lineage traditionally played an important role, as is evident in the form and decoration of Maori meetinghouses, such as those at Poverty

Bay (FIG. 36-1) and at Whakatane (Wepiha Apanui, lead sculptor; FIG. 36-19A) and in the design of Maori facial moko (see "Tattoo in Polynesia," page 1055, and FIG. I-19). But as in many other Oceanic cultures, in New Zealand, largely as a result of colonial and missionary intervention in the 18th through 20th centuries, traditional practices were gradually abandoned, and production of many of the art forms illus-

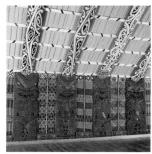

36-19A Mataatua meetinghouse, Maori, 1871–1875.

trated in this chapter ceased. In recent years, however, a new confident cultural awareness has led many Pacific artists to reassert their inherited values with pride and to express them in a resurgence of traditional arts, such as weaving, painting, tattooing, and carving. Today's thriving tourist trade has also contributed to a resurgence of traditional art production.

CLIFF WHITING In New Zealand, CLIFF WHITING (TE WHANAU-A-APANUI, b. 1936) and others have carried on the historical Maori woodcarving craft. Whiting has achieved renown for his stunning "carved murals" (Fig. 31-11). He and other artists throughout the Pacific islands have championed not only the renewal of native cultural life and its continuity in art but also the education of the young in the values that made the Pacific cultures great. The preservation of native identity will depend on the success of the next generation in making the traditional Oceanic cultures once again their own.

OCEANIA BEFORE 1980

AUSTRALIA AND MELANESIA

- The westernmost Oceanic islands have been populated for at least 40,000 years, but most of the preserved art dates to the last several centuries.
- The Aboriginal art of Australia focuses on ancestral spirits called Dreamings, whom artists represented in an X-ray style showing the internal organs.
- The Asmat of New Guinea avenged a relative's death by headhunting. Before embarking on a raid, they erected bisj poles with carved and painted figures of ancestors and animals.
- The center of every latmul village was a saddle-shaped ceremonial men's house representing a woman.
 Images of clan ancestors decorated the interior.
- Masks figured prominently in many Melanesian cultures. The Elema celebrated water spirits in the festive cycle called Hevehe, which involved ornate masks up to 25 feet tall. The Abelam fashioned yam masks for rituals revolving around their principal crop. In New Ireland, dancers were tatanua masks representing the spirits of the deceased.
- Seafaring was also a major theme of much Melanesian art. The Trobriand Islanders decorated their canoes with elaborately carved prows and splashboards.

Asmat bisj poles, Irian Jaya, early to mid-20th century

Tatanua mask, Papua New Guinea, 19th to 20th century

MICRONESIA

- The major themes of Melanesian art are also found in Micronesia. For example, in the Caroline Islands, many of the most skilled artists carved and painted wooden prow ornaments for their canoes.
- If the Micronesian peoples also erected ceremonial men's houses. The bai of Belau are distinctive in having Dilukai figures in the gable of the eastern entrance. The Dilukai is a woman with splayed legs who faces the sun and serves as a symbol of procreation and as a guardian of the house.

Dilukai, Belau, late 19th or early 20th century

POLYNESIA

- Polynesia was one of the last areas of the world humans settled, but the oldest monumental art of Oceania is the series of moai on Rapa Nui (Easter Island). These colossal monolithic sculptures, which stood in rows on stone platforms, probably represent ancestors.
- Barkcloth is an important art form in Polynesia even today. The decorated barkcloth, or ngatu, of Tonga was used to wrap the corpses of deceased chiefs and for other ritual purposes, including the coronation of kings.
- Body adornment in the form of tattooing was widespread in Polynesia, especially in the Marquesas Islands and New Zealand. Beyond personal beautification, tattoos served to distinguish rank and provided warriors with a kind of spiritual armor.
- Meetinghouses played an important role in Polynesian societies, as elsewhere in the Pacific islands. The meetinghouses of the Maori of Aotearoa (New Zealand) are notable for their elaborate ornamentation featuring carved relief panels depicting ancestors.
- Images of named gods are common in Polynesia. Wood sculptures from Rurutu represent the chief ancestor god A'a. The Hawaiians erected statues of the war god Kuka'ilimoku in their temples and fashioned images of deities from rare bird feathers. Hawaiian artists also produced elite regalia using feathers, for example, in cloaks worn exclusively by kings and other men of high rank.

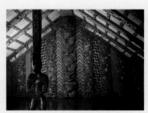

Maori meetinghouse, New Zealand, 1842–1845

Feather cloak, Hawaii, ca. 1824-1843

The name for these screens is *nduen fobara* ("foreheads of the deceased"). The chief's headdress is in the form of a 19th-century European sailing ship, a reference to the deceased's trading business.

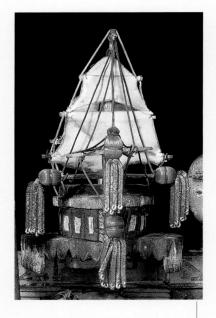

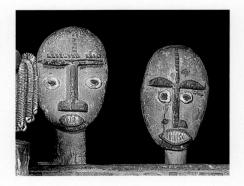

To either side of the chief are his attendants and, at the top of the shrine, the heads of his slaves. Both attendants and slaves are smaller in size than the chief, as is appropriate for their lower rank.

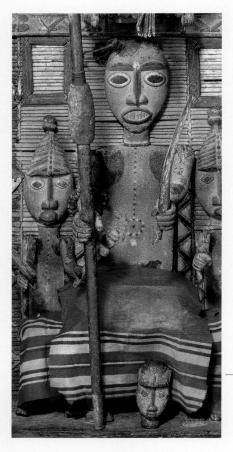

Kalabari Ijaw ancestral screens are memorials to the chiefs of trading companies called canoe houses. The deceased, the central figure holding a long staff and curved knife, is also the largest.

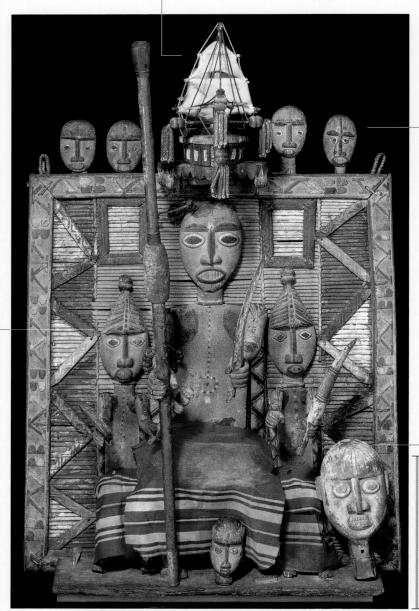

37-1 Ancestral screen (nduen fobara), Kalabari Ijaw, Nigeria, late 19th century. Wood, fiber, and cloth, 3' $9\frac{1}{2}''$ high. British Museum, London.

The chief is bare-chested with colorful drapery covering the lower part of his body. At his feet are the heads of conquered rivals, completing the exceptionally rich iconographical program.

37

AFRICA, 1800 TO 1980

KALABARI IJAW ANCESTRAL SCREENS

Throughout the continent, Africans venerate ancestors for the continuing aid they believe they provide the living, including help in maintaining the productivity of the earth for bountiful crop production and ensuring successful hunts. In some African societies, for example, the Fang and Kota, people place the bones of their ancestors in containers guarded by sculptured figures (FIGS. 37-4 and 37-5) in order to protect these treasured relics from theft or harm. In highly stratified societies headed by a monarch, for example, the Benin kingdom, the royal family maintains altars (FIG. 37-13) at which the current king offers animal sacrifices to honor his ancestors and enlist their help in protecting the living and assuring prosperity.

The Kalabari Ijaw peoples have hunted and fished in the eastern delta of the Niger River in present-day Nigeria for several centuries. As in so many other African cultures, Kalabari artists and patrons have lavished attention on memorials to ancestors. Their shrines, however, take a unique form because a cornerstone of the Kalabari economy has long been trade, and trading organizations known locally as "canoe houses" play a central role in Kalabari society. Kalabari ancestor shrines are elaborate screens of wood, fiber, textiles, and other materials. An especially elaborate example (FIG. 37-1) is the almost four-foot-tall nduen fobara (foreheads of the deceased) honoring a former chief of a trading company. The chief's family usually commissioned these memorial screens on or about the one-year anniversary of his death. Displayed in the house in which the chief lived, the screen represents the deceased himself at the center, holding a long silver-tipped staff in his right hand and a curved knife in his left hand. His chest is bare and drapery covers the lower part of his body. His impressive headdress is in the form of a 19th-century European sailing ship, a reference to the chief's successful trading business. Flanking him are his attendants, smaller in size as is appropriate for their lower rank. The heads of his slaves are at the top of the screen and those of his conquered rivals are at the bottom. The hierarchical composition and the stylized rendition of human anatomy and facial features are common in African art, but the richness and complexity of this shrine are exceptional.

Unusual, too, is the way the sculptor created the shrine by assembling it from separately carved sections and then painting it. Most African sculptors fashioned their works from a single block of wood. The carpentry technique employed for the Kalabari screens may be the result of sustained contact with European traders and firsthand knowledge of European woodworking techniques.

19TH CENTURY

Africa (MAP 37-1) was one of the first art-producing regions of the world (see Chapters 1 and 19), but its early history remains largely undocumented. In fact, a generation ago, scholars still often presented African art as if it had no history. For the period treated in this chapter, however, art historians are on firmer ground. Information gleaned from archaeology and field research in Africa (mainly interviews with local people) has provided much more detail on the

use, function, and meaning of art objects produced during the past two centuries than for the period before 1800. As in earlier eras, the arts in Africa are integral to a great variety of human situations, and knowledge of these contexts is essential for understanding the artworks. In Africa, art is nearly always an active agent in the lives of its diverse peoples. This chapter presents a sample of characteristic works from different regions of the continent from the early 19th century to 1980. Chapter 31 treats African art of the past few decades in its worldwide context.

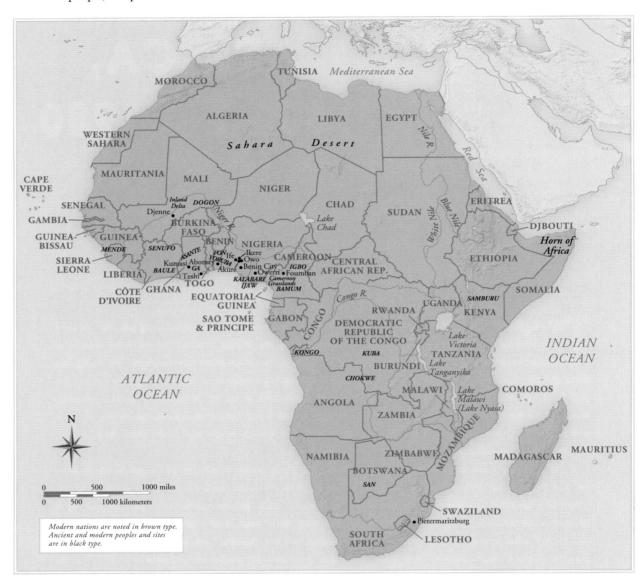

MAP 37-1 Africa in the early 21st century.

AFRICA, 1800 TO 1980

1800 1900 1980

- I San rock paintings record contemporaneous events
- I Fang, Kota, and Kalabari Ijaw artists produce reliquary guardian figures and memorial screens to venerate ancestors
- Royal arts include the throne of Bamum king Ngansu and Fon king Glele's bocio of the god Gu
- I Yombe, Dogon, and Baule sculptors carve wood groups of mother and child or man and woman
- Royal arts continue to flourish in highly stratified societies, such as the Benin kingdom
- If The recording of artists' names becomes more common. Osei Bonsu and llowe of Ise achieve wide renown as sculptors
- Throughout the continent, African peoples produce elaborate masks to be danced at masquerades
- Personal adornment is a major art form, including body painting, complex coiffures, rich textiles, and the lavish regalia of kings

San

Rock paintings are among the most ancient arts of Africa (FIGS. 1-3 and 19-2). Yet the tradition also continued well into the historical period. The latest examples date as recently as the 19th century, and some of these depict events involving Europeans. Many examples have been found in South Africa. Some of the most interesting are those produced by the peoples scholars refer to as San, who occupied parts of southwestern Africa in present-day Namibia and Botswana at the time of the earliest European colonization. The San were hunters and gatherers, and their art often centered on the animals they pursued.

BAMBOO MOUNTAIN One of the most impressive preserved San rock paintings (FIGS. 37-2 and 37-3), originally about eight feet long but now regrettably in fragments, comes from near the source of the Mzimkhulu River at Bamboo Mountain and dates to the mid-19th century. At that time, the increasing development of colonial ranches and the settlements of African agriculturists had greatly affected the lifestyle and movement patterns of San hunters and gatherers, often displacing them from their ancestral lands. In some regions, the San began to raid local ranches for livestock and horses as an alternate food source. The Bamboo Moun-

tain rock painting probably depicts one of a series of stock raids carried out between about 1838 and 1848. Various South African military and police forces unsuccessfully pursued the San raiders. Poor weather, including frequent rains and fog, added to the difficulty of capturing a people who had lived in the region for many generations and knew its terrain intimately.

Reproduced here are two details of the larger, fragmentary composition. On the right side (not illustrated), two San riders on horses laden with meat drive a large herd of cattle and horses toward a San encampment located left of center (FIG. 37-2) and encircled by an outline. Within the camp are various women and children. To the far left (FIG. 37-3), a single figure (perhaps a diviner or rainmaker) leads an eland, an animal the San considered effective in rainmaking and ancestor rituals, toward the encampment. The similarity of this scene to other rock paintings with spiritual interpretations (a human leading an animal) suggests this may represent a ritual leader in a trance state. The leader calls on rain—brought by the intervention of the sacred eland—to foil the attempts of the government soldiers and police to locate and punish the San raiders. The close correspondence between the painting's imagery and the raids of 1838-1848 adds to the likelihood San painters created this work to record contemporaneous events as well as to facilitate rainmaking.

37-2 Stock raid with cattle, horses, and encampment, rock painting, San, from Bamboo Mountain, South Africa, mid-19th century. Natal Museum, Pietermaritzburg.

Rock paintings are among the most ancient arts in Africa, and the tradition continued into the 19th century. This example depicts the 1838–1848 stock raids by San hunters.

37-3 Magical "rain animal," rock painting, San, from Bamboo Mountain, South Africa, mid-19th century. Natal Museum, Pietermaritzburg.

Another fragment of the eight-foot-long rock painting from Bamboo Mountain depicts a man, possibly a diviner in a trance, leading an eland, an animal believed to facilitate rainmaking.

Fang and Kota

Although African works of art are often difficult to date precisely (see "Dating African Art," Chapter 19, page 523), art historians have been able to assign to the 19th century with some confidence a large number of objects that, unlike the Bamboo Mountain rock paintings, lack historical references. These include the Kalabari Ijaw nduen fobara (FIG. 37-1) already discussed and the *reliquary* guardian figures of the Fang and several other migratory peoples just south of the equator in Gabon and Cameroon. The reliquary figures play an important role in ancestor worship. Among both the Fang and the peoples scholars usually refer to as Kota in neighboring areas, ancestor veneration takes material form as collections of cranial and other bones (*relics*) gathered in special containers. These portable reliquaries were ideal for African nomadic population groups such as the Fang and Kota.

37-4 Reliquary guardian figure (bieri), Fang, Gabon, late 19th century. Wood, $1' 8\frac{3''}{8}$ high. Philadelphia Museum of Art, Philadelphia.

Bieri guard cylindrical bark boxes of Fang ancestor bones (reliquaries). The figures have the bodies of infants and the muscularity of adults, a combination of traits suggesting the cycle of life.

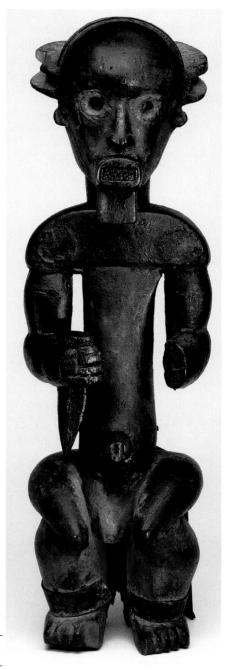

1 in.

FANG BIERI Stylized carved wood human figures (FIG. 37-4), or in some cases simply heads, protected the Fang relic containers. The sculptors of these Fang guardian figures, or *bieri*, designed them to sit on the edge of cylindrical bark boxes of ancestral bones, ensuring no harm would befall the ancestral spirits. The wood figures are symmetrical, with proportions greatly emphasizing the head, and they feature a rhythmic buildup of forms suggestive of contained power. Particularly striking are the proportions of the bodies of the bieri, which resemble those of an infant, although the muscularity of the figures implies an adult. Scholars believe Fang sculptors chose this combination of traits to suggest the cycle of life, appropriate for an art form connected with the cult of ancestors.

KOTA MBULU NGULU The Kota of Gabon also produced reliquary guardian figures, called *mbulu ngulu* (FIG. 37-5), but they differ markedly from the Fang bieri. The Kota figures have severely

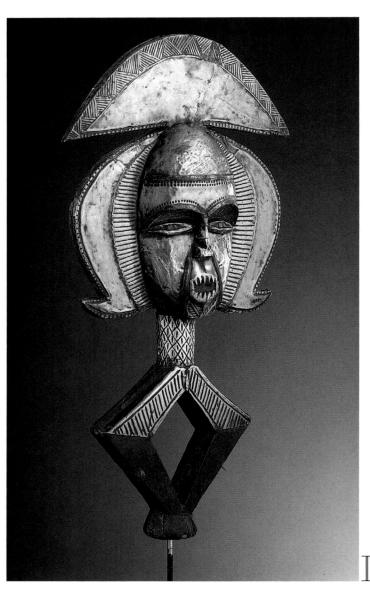

37-5 Reliquary guardian figure (mbulu ngulu), Kota, Gabon, 19th or early 20th century. Wood, copper, iron, and brass, 1′ $9\frac{1}{16}$ ″ high. Musée Barbier-Mueller, Geneva.

Kota guardian figures have large heads and bodies in the form of an open diamond. Polished copper and brass sheets cover the wood forms. The Kota believe gleaming surfaces repel evil.

37-6 Throne and footstool of King Nsangu, Bamum, Cameroon, ca. 1870. Wood, textile, glass beads, and cowrie shells, 5' 9" high. Museum für Völkerkunde, Staatliche Museen zu Berlin, Berlin.

King Nsangu's throne features luminous beads and shells and richly colored textiles. The decoration includes intertwining serpents, male and female retainers, and bodyguards with European rifles

stylized bodies in the form of an open diamond below a wood head. The sculptors of these reliquary guardians covered both the head and the abstract body with strips and sheets of polished copper and brass. The Kota believed the gleaming surfaces repel evil. The simplified heads have hairstyles flattened out laterally above and beside the face. Geometric ridges, borders, and subdivisions add a textured elegance to the shiny forms. The copper alloy on most of these images is reworked sheet brass (or copper wire) taken from brass basins originating in Europe and traded into this area of equatorial Africa in the 18th and 19th centuries. The Kota inserted the lower portion of the image into a basket or box of ancestral relics.

Bamum

In addition to celebrating ancestors, much African art glorifies living rulers (see "Art and Leadership in Africa," Chapter 19, page 526). In the kingdom of Bamum in present-day Cameroon,

the ruler lived in a palace compound at the capital city of Foumban until its destruction in 1910. Some items of royal regalia survive.

THRONE OF NSANGU The royal arts of Bamum make extensive use of richly colored textiles and luminous materials, such as glass beads and cowrie shells. The ultimate status symbol was the king's throne. The throne illustrated here (FIG. 37-6), a masterpiece of Bamum art, belonged to King Nsangu (r. 1865–1872 and 1885–1887). Intertwining blue and black serpents decorate the cylindrical seat. Above are the figures of two of the king's retainers, perpetually at his service. One, a man, holds the royal drinking horn. The other is a woman holding a serving bowl in her hands. Below are two of the king's bodyguards wielding European rifles. Dancing figures decorate the rectangular footstool. When the king sat on this throne (compare FIG. 37-23), his rich garments complemented the bright colors of his seat, advertising his wealth and power to all who were admitted to his palace.

Fon

The founding of the Fon kingdom in the present-day Republic of Benin dates to around 1600. Under King Guezo (r. 1818–1858), the Fon became a regional power with an economy based largely on trade in palm oil. In 1900, the French dismantled the kingdom and brought many artworks to Paris, where they inspired several prominent early-20th-century Western artists (see "Primitivism and Colonialism," Chapter 29, page 846).

KING GLELE After his first military victory, Guezo's son Glele (r. 1858–1889) commissioned a prisoner of war, Akati Akpele Kendo, to make a life-size iron statue (fig. 37-7) of a warrior, probably Gu, the Fon god of war and iron, for a battle shrine in Glele's palace at Abomey. This *bocio*, or empowerment figure, was the centerpiece of a circle of iron swords and other weapons set vertically into the ground. The warrior strides forward with swords in both hands, ready to do battle. He wears a crown of miniature weapons and tools on his head. The form of the crown echoes the circle of swords around the statue. The Fon believed the bocio protected their king, and they transported it to the battlefield whenever they set out to fight an enemy force. King Glele's iron warrior is remarkable for its size and for the fact that not only is the patron's name known but so too is the artist's name—a rare instance in Africa before the 20th century (see "African Artists," page 1071).

Kongo

The Congo River formed the principal transportation route for the peoples of central Africa during the 19th century, fostering cultural exchanges as well as trade, both among Africans and with Europeans.

YOMBE PFEMBA Some scholars have suggested the mother-and-child groups (*pfemba*) of the Yombe in the Democratic Republic of Congo may reflect the influence of Christian Madonna-and-Child imagery. The Yombe pfemba are not deities, however, but images of Kongo royalty. One masterful 19th-century example (FIG. **37-8**) represents a woman with a royal cap, chest scarification, and jewelry. The image may commemorate an ancestor or, more likely, a legendary founding clan mother. The Kongo call some of these figures "white chalk," a reference to the medicinal power of white kaolin clay. Diviners own some of them, and others have been used by women's organizations to treat infertility, but the function of this 19th-century pfemba is uncertain.

NKISI N'KONDI Among the most distinctive African sculptures of the 19th century are Kongo power figures (nkisi n'kondi), such as the statue illustrated here (FIG. 37-9), which depicts a man bristling with nails and blades. These images, which trained priests consecrated using precise ritual formulas, embodied spirits believed to heal and give life, or sometimes to inflict harm, disease, or even death. Each figure had its specific role, just as it wore particular medicines—here protruding from the abdomen and featuring a large cowrie shell. The Kongo also activated every image differently. Owners appealed to a figure's forces every time they inserted a nail or blade, as if to prod the spirit to do its work. People invoked other spirits by repeating specific chants, by rubbing the images, or by applying special powders. The roles of power figures varied enormously, from curing minor ailments to stimulating crop growth, from punishing thieves to weakening enemies. Very large standing Kongo figures, such as this one, which is nearly four feet tall, had exceptional ascribed powers and aided entire communities. Although benevolent for their owners, the figures stood at the boundary between life and death, and most villagers held them in awe. As

37-7 AKATI AKPELE KENDO, Warrior figure (Gu?), from the palace of King Glele, Abomey, Fon, Republic of Benin, 1858–1859. Iron, 5' 5" high. Musée du quai Branly, Paris.

This bocio, or empowerment figure, probably representing the war god Gu, was the centerpiece of a circle of iron swords. The Fon believed it protected their king, and they set it up on the battlefield.

37-8 Yombe mother and child (pfemba), Kongo, Democratic Republic of Congo, late 19th century. Wood, glass, glass beads, brass tacks, and pigment, $10\frac{1}{8}''$ high. National Museum of African Art, Washington, D.C.

The mother in this Yombe group wears a royal cap and jewelry and displays her chest scarification. The image may commemorate an ancestor or, more likely, a legendary founding clan mother.

is true of the Yombe pfemba group (FIG. 37-8), compared with the sculptures of other African peoples, this Kongo figure is relatively naturalistic, although the carver simplified the facial features and magnified the size of the head for emphasis.

Chokwe

The Chokwe occupy the area of west-central Africa corresponding to parts of northeastern Angola and southwestern Democratic Republic of Congo.

CHIBINDA ILUNGA Local legend claims the Chokwe are the descendants of the widely traveled Chibinda Ilunga, who won fame as a hunter. He married a princess named Lueji, who was a

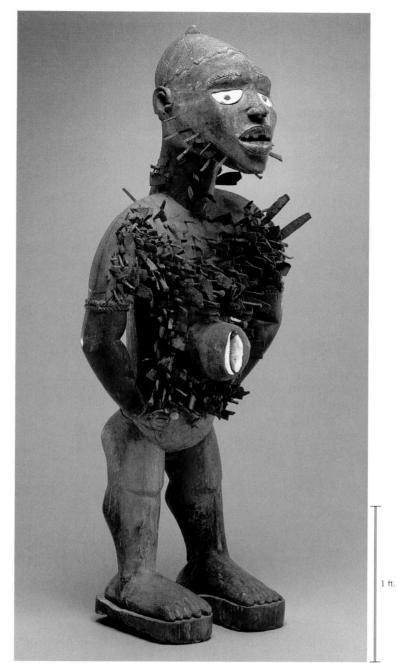

37-9 Nail figure (nkisi n'kondi), Kongo, from Shiloango River area, Democratic Republic of Congo, ca. 1875–1900. Wood, nails, blades, medicinal materials, and cowrie shell, 3' $10\frac{3''}{4}$ high. Detroit Institute of Arts, Detroit.

Only priests using ritual formulas could consecrate Kongo power figures, which embody spirits that can heal or inflict harm. The statue has simplified anatomical forms and an oversized head.

hereditary ruler of one of the kingdoms of the Lunda Empire, an important regional power during the 16th through 19th centuries. Lueji gave Chibinda a sacred bracelet, the basis and symbol of her rule, and he taught the Lunda to be great hunters, enriched the kingdom, and extended its territory. The Chokwe, one of the population groups resulting from that territorial expansion, became skilled elephant hunters and ivory traders. They eventually revolted against the Lunda kings and brought about the collapse of the Lunda Empire in the mid-19th century.

The Chokwe revere Chibinda Ilunga as founder, hunter, and civilizing hero, and he figures prominently in their royal arts. The statue illustrated here (FIG. 37-10) is one of the finest examples. It shows the legendary hunter-king wearing a chief's barkcloth-andrattan headdress and holding a staff in his right hand and, in his left hand, a medicine horn containing powerful substances to aid hunters. The sculptor portrayed Chibinda with a muscular body and oversized arms and feet to underscore the hunter's manual dexterity and ability to undertake long journeys. A rare feature of this and other Chokwe figures is the use of human hair for Chi-

binda's beard.

37-10 Chibinda Ilunga, Chokwe, from Angola or Democratic Republic of Congo, late 19th to 20th century. Wood and human hair, 1' 4" high. Kimbell Art Museum, Fort Worth.

The Chokwe claim descent from the legendary hunter Chibinda Ilunga, portrayed in art as a muscular man with a chief's headdress, oversized hands and feet, and a beard of human hair.

Dogon

The Dogon live in the Bandiagara escarpment south of the inland delta region of the great Niger River in what is today Mali. Numbering almost 300,000, spread among hundreds of small villages, the Dogon practice farming as their principal occupation.

LINKED MAN AND WOMAN One of the most common themes in African art is the human couple. A Dogon example of exceptional quality is the statue of a linked man and woman reproduced here (FIG. 37-11). It dates to the early 19th century and is probably a shrine or altar, although contextual information is

37-11 Seated couple, Dogon, Mali, ca. 1800-1850. Wood, 2' 4" high. Metropolitan Museum of Art, New York (gift of Lester Wunderman).

This Dogon carving of a linked man and woman documents gender roles in traditional African society. The protective man wears a guiver on his back. The nurturing woman carries a child on hers.

37-12 Male and female figures, probably bush spirits (asye usu), Baule, Côte d'Ivoire, late 19th or early 20th century. Wood, beads, and kaolin, man 1' $9\frac{3''}{4}$ high, woman 1' $8\frac{5''}{8}$ high. Metropolitan Museum of Art, New York (Michael C. Rockefeller Memorial Collection, gift of Nelson A. Rockefeller).

In contrast to the Dogon couple (FIG. 37-11), this pair includes many naturalistic aspects of human anatomy, but the sculptor enlarged the necks, calves, and heads, a form of idealization in Baule culture.

lacking. Interpretations vary, but the image vividly documents primary gender roles in traditional African society. The man wears a quiver on his back. The woman carries a child on hers. Thus, the man assumes a protective role as hunter or warrior, the woman a nurturing role. The slightly larger man reaches behind his mate's neck and touches her breast, as if to protect her. His left hand points to his genitalia. Four stylized figures support the stool upon which they sit. They are probably either spirits or ancestors, but the identity of the larger figures is uncertain.

The strong stylization of Dogon sculptures contrasts sharply with the organic, relatively realistic treatment of the human body in Kongo and Chokwe art (FIGS. 37-8 to 37-10). The artist who

carved the Dogon couple (FIG. 37-11) based the forms more on the idea or concept of the human body than on observation of individual heads, torsos, and limbs. The linked body parts are tubes and columns articulated inorganically. The carver reinforced the almost abstract geometry of the overall composition by incising rectilinear and diagonal patterns on the surfaces. The Dogon artist also understood the importance of space, and charged the voids, as well as the sculptural forms, with rhythm and tension.

Baule

The Baule of present-day Côte d'Ivoire do not have kings, and their societies are relatively egalitarian, especially compared with other highly stratified African population groups, but Baule art encompasses many of the same basic themes seen elsewhere on the continent.

BUSH SPIRITS The Baule statues of a man and woman illustrated here (FIG. 37-12) probably portray bush spirits (asye usu). The sculptor most likely carved the pair of wood figures for a trance diviner, a religious specialist who consulted the spirits symbolized by the statues on behalf of clients who were either sick or in some way troubled. In Baule thought, bush spirits are short, horrible-looking, and sometimes deformed creatures, yet Baule sculptors represent them in the form of beautiful, ideal human beings, because ugly figures would offend the spirits and refuse to work for the diviner. Among the Baule, as among many West African peoples, bush or wilderness spirits not only cause difficulties in life but, if properly addressed and placated, also may solve problems or cure sickness. In dance and trance performances—with wood figures and other objects displayed nearby—the diviner can divine, or understand, the will of unseen spirits as well as their needs or prophecies, which the diviner passes on to clients. When not set up outdoors for a performance, the figures and other objects remain in the diviner's house or shrine, where more private consultations take place. In striking contrast to the Dogon sculptor of the seated man and woman (FIG. 37-11), the artist who created this matched pair of Baule male and female images recorded many naturalistic aspects of human anatomy, skillfully translating them into finished sculptural form. At the same time, the sculptor was well aware of creating waka sran (people of wood) rather than living beings. Thus, the artist freely exaggerated the length of the figures' necks and the size of their heads and calf muscles, all of which are forms of idealization in Baule culture.

20TH CENTURY

The art of Africa during the past 100 years ranges from traditional works depicting age-old African themes to modern works that are international in both content and style (for example, FIGS. 31-9A and 31-12). Both men and women have long been active in African art production, usually specializing in different types of objects (see "Gender Roles in African Art Production," page 1070).

Benin

Some of the most important 20th-century African artworks come from areas with strong earlier artistic traditions. The kingdom of Benin (see Chapter 19 and FIGS. I-1, 19-1, 19-13, and 19-13A) in present-day Nigeria is a prime example.

SHRINE OF EWEKE II In 1897, when the British sacked Benin City, there were still 17 shrines to ancestors in the Benin

Gender Roles in African Art Production

Until the late 20th century, art production in Africa has been quite rigidly gender-specific. Men have been, and largely still are, ironsmiths and gold and copper-alloy casters. Men were architects, builders, and carvers of both wood and ivory. Women were, and for the most part remain, wall and body painters, calabash decorators, potters, and often clay sculptors, although men make clay figures in some areas. Both men and women work with beads and weave baskets and textiles, with men executing narrow strips (later sewn together) on horizontal looms and women working wider pieces of cloth on vertical looms.

Much African art, however, is collaborative. Men may build a clay wall, for example, but women will normally decorate it. The Igbo people build *mbari* houses (FIG. 37-25)—for ceremonies to honor the earth goddess—that are truly collaborative despite the fact professional male artists model the figures displayed in the houses. Festivals, invoking virtually all the arts, are also collaborative. Masquerades (see "African Masquerades," page 1073) are largely the province of men, yet in some cases women contribute costume elements such

as skirts, wrappers, and scarves. Even though women dance masks among the Mende and related peoples (see "Mende Women as Maskers," page 1075), men have always carved the masks themselves.

In late colonial and especially in postcolonial times, earlier gender distinctions in art production began breaking down. Today, women as well as men weave *kente* cloth (FIG. 37-13A), and a number of women are now sculptors in wood, metal, stone, and composite materials. Men are making pottery, once the exclusive prerogative of women. Both women and men make international art forms in urban and university settings, although male artists are more numerous. One well-known Nigerian woman artist, Sokari Douglas Camp (b. 1958), produces welded metal sculptures, sometimes of masqueraders. Douglas Camp is thus doubly unusual. She might find it difficult to do this work in her traditional home in the Niger River delta, but because she lives and works in London, she encounters no adverse response. In the future there will undoubtedly be a further breaking down of restrictive barriers and greater mobility for artists.

royal palace. Today, only one 20th-century altar (FIG. 37-13) remains. According to oral history, it is similar to centuries-earlier versions. With a base of sacred riverbank clay, it is an assemblage of varied materials, objects, and symbols: a central copper-alloy altarpiece depicting a sacred king flanked by members of his entourage, plus copper-alloy heads, each fitted on top with an ivory tusk carved in relief. Behind are wood staffs and metal bells. The heads represent both the kings themselves and, through the durability of the material, the enduring nature of kingship. Their glistening surfaces, seen as red and signaling danger, repel evil forces

that might adversely affect the shrine and thus the king and kingdom. Elephant-tusk relief carvings atop the heads commemorate important events and personages in Benin history. Their bleached white color signifies purity and goodness (probably of royal ancestors), and the tusks themselves represent male physical power. The carved wood rattle-staffs standing at the back refer to generations of dynastic ancestors by their bamboolike, segmented forms. The rattle-staffs and the pyramidal copper-alloy bells serve the important function of calling royal ancestral spirits to rituals performed at the altar.

37-13 Royal ancestral altar of King Eweka II, in the palace in Benin City, Nigeria, photographed in 1970. Clay, copper alloy, wood, and ivory.

This shrine to the heads of royal ancestors is an assemblage of materials, objects, and symbols. By sacrificing animals at this altar, the Benin king annually invokes the collective strength of his ancestors.

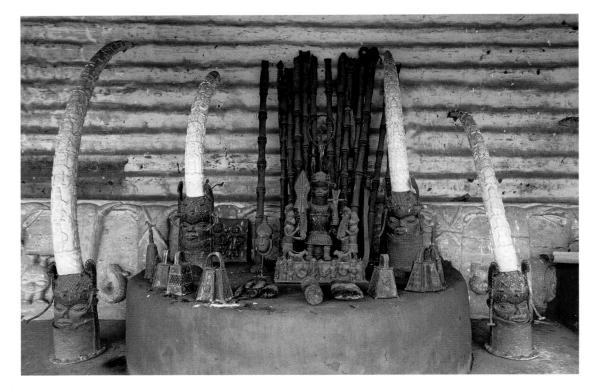

African Artists and Apprentices

raditionally, Africans have tended not to exalt artistic indi-▲ viduality as much as Westerners have. Many people, in fact, still consider African art as anonymous, primarily because early researchers rarely asked for artists' names (see "Dating African Art and Identifying African Artists," Chapter 19, page 523). Nonetheless, art historians can recognize many individual hands or styles even when an artist's name has not been recorded. During the past century, art historians and anthropologists have been systematically noting the names and life histories of specific individual artists, many of whom have strong regional reputations. One of the earliest recorded names is that of the mid-19th-century Fon sculptor and metalsmith Akati Akpele Kendo (FIG. 37-7). Two 20thcentury artists, renowned even from one kingdom to another, were Osei Bonsu (FIGS. 37-14 and 37-15), based in the Asante capital of Kumasi, and the Yoruba sculptor called Olowe of Ise (FIGS. 37-16 and 37-16A) because he came from the town of Ise. Both artists were master carvers, producing sculptures for kings and commoners alike.

As did other great artists in other places and times, both Bonsu and Olowe had apprentices to assist them for several years while learning their trade. Although there are various kinds of apprenticeship in Africa, novices typically lived with their masters and were household servants as well as assistant carvers. They helped fell trees, carry logs, and rough out basic shapes the master later transformed into finished work. African sculptors typically worked on commission. Sometimes, as in Bonsu's case, patrons traveled to the home of the artist. But other times, even Bonsu moved to the home of a patron for weeks or months while working on a commission. Masters, and in some instances also apprentices, lived and ate in the patron's compound. Olowe, for example, resided with different kings for many months at a time while he carved doors (FIG. 37-16), veranda posts (FIG. 37-16A), and other works for royal families.

37-14 OSEI BONSU, Akua'ba (Akua's child), Asante, Ghana, ca. 1960. Wood and glass beads, 1' 2½" high. National Museum of African Art, Washington, D.C. (gift of Herbert C. Madison).

Osei Bonsu was one of Africa's leading sculptors. This figure, carried by women hoping to conceive a child, has a flattened face and crosshatched eyebrows, typical features of the artist's style.

1 in

The Benin king's head stands for wisdom, good judgment, and divine guidance for the kingdom. The several heads in the ancestral altar multiply these qualities. By means of animal sacrifices at this site, the living king annually purifies his own head (and being) by invoking the collective strength of his ancestors. Thus the varied objects, symbols, colors, and materials comprising this shrine contribute both visually and ritually to the imaging of royal power, as well as to its history, renewal, and perpetuation. The composition of the shrine, like that of the altar at its center and the mid-18th-century Altar to the Hand and Arm (FIG. 19-1), is hierarchical. At the center of all Benin hierarchies stands the king (FIG. 1-1).

Asante

The Asante of modern Ghana formed a strong confederacy around 1700. They are one of several peoples, including the Baule of Côte d'Ivoire, who speak an Akan dialect. Asante artists work in many media but are probably most famous today for vividly colored and patterned *kente* cloth robes (FIG. 37-13A).

OSEI BONSU A common stylistic characteristic of Asante figural art is the preference for conventionalized, flattened heads. Many Akan peoples considered long, slightly flattened foreheads to be emblems of beauty, and mothers gently molded their children's cranial bones to reflect this value. These anatomical features occur in a wooden image of a young girl (FIG. 37-14), or *akua'ba* (Akua's child), carved by OSEI BONSU (1900–1976), one of the 20th century's leading African sculptors (see "African

37-13A Asante noblemen in kente cloth robes, 1972.

Artists and Apprentices," above). After consecrating a simplified wood akua'ba sculpture at a shrine, a young woman hoping to conceive carried it with her. Once pregnant, she continued to carry the figure to ensure the safe delivery of a healthy and handsome child—among these matrilineal people, preferably a girl. Compared with

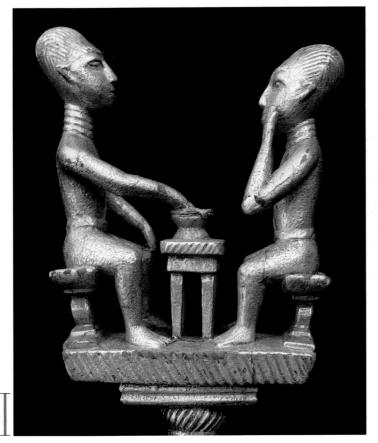

37-15 OSEI BONSU, two men sitting at a table of food (linguist's staff), Asante, Ghana, mid-20th century. Wood and gold leaf, section shown 10" high. Collection of the Paramount Chief of Offinso, Asante.

Bonsu carved this gold-covered wood linguist's staff for someone who could speak for the Asante king. At the top are two men sitting at a table of food—a metaphor for the office of the king.

traditional sculptures of this type, the more naturalistic rendering of the face and crosshatched eyebrows in Osei Bonsu's sculpture are distinctive features of his personal style.

LINGUIST'S STAFF Bonsu also carved the gold-covered wood sculpture (FIG. 37-15) depicting two men sitting at a table of food. This object, commonly called a *linguist's staff* because its carrier often speaks for a king or chief, has a related proverb: "Food is for its rightful owner, not for the one who happens to be hungry." Food is a metaphor for the office the king or chief rightfully holds. The "hungry" man lusts for the office. The linguist, who is an important counselor and adviser to the king, might carry this staff to a meeting at which a rival contests the king's title to the stool (his throne, the office). Many hundreds of sculptures from this region have proverbs or other sayings associated with them, which has created a rich verbal tradition relating to the visual arts of the Akan peoples.

Yoruba

The Yoruba have a long history in southwestern Nigeria and the southern Republic of Benin going back to the founding of Ile-Ife in the 11th century (see Chapter 19). In the 20th century, Yoruba artists were among the most skilled on the continent. One who achieved international recognition was Olowe of Ise (ca. 1873–1938).

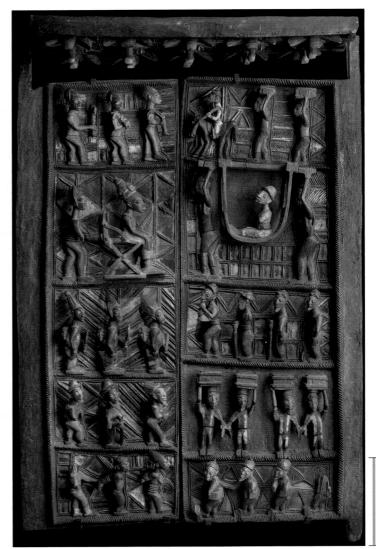

37-16 OLOWE OF ISE, doors from the shrine of the king's head in the royal palace, Ikere, Yoruba, Nigeria, 1910–1914. Painted wood, 6' high. British Museum, London.

These masterfully carved and painted doors to the shrine of the king's head in the Ikere palace are the work of Olowe of Ise, one of the few African artists whose name and career have been recorded.

OLOWE OF ISE In 1925, the British Museum acquired directly from the ogoga (king) of Ikere (in exchange for a British throne) the elaborately carved and painted doors (FIG. 37-16) of the shrine of the king's head in his palace in northeastern Yorubaland. At the time, the museum did not inquire about the artist's name. Not until after World War II, when art historians began to document the careers of individual African artists (see "African Artists and Apprentices," page 1071), did the British curators learn the master carver was Olowe of Ise, the most famous Yoruba sculptor of the early 20th century. Kings and aristocrats throughout Yorubaland employed Olowe to carve reliefs, masks, bowls, veranda posts (FIG. 37-16A), and other works for them, 37-16A OLOWE OF ISE,

and he traveled widely in

37-16A OLOWE OF ISE, veranda post, Akure, 1920s.

African Masquerades

he art of masquerade has long been a quintessential African expressive form, laden with meaning and of the highest importance culturally. This is so today, but was even more critically true in colonial times and earlier, when African masking societies boasted extensive regulatory and judicial powers. In stateless societies, such as those of the Senufo (FIGS. 37-17 and 37-18), Dogon (FIG. 37-19), and Mende (FIG. 37-20), masks sometimes became so influential they had their own priests and served as power sources or as oracles. Societies empowered maskers to levy fines and to apprehend witches (usually defined as socially destructive people) and criminals, and to judge and punish them. Normally, however-especially today-masks are less threatening and more secular and educational and serve as diversions from the humdrum of daily life. Masked dancers usually embody either ancestors, seen as briefly returning to the human realm, or various nature spirits called upon for their special powers.

The mask, a costume ensemble's focal point, combines with held objects, music, and dance gestures to invoke a specific named character, almost always considered a spirit. A few masked spirits appear by themselves, but more often several characters come out together or in turn. Maskers enact a broad range of human, animal, and fantastic otherworldly behavior that is usually both stimulating and didactic. Masquerades, in fact, vary in function or effect along a continuum from weak spirit power and strong entertainment value to those rarely seen but possessing vast executive powers backed by powerful shrines. Most operate between these extremes, crystallizing varieties of human and animal behavior—caricatured, ordinary, comic, bizarre, serious, or threatening. Such actions inform and affect audience members because of their dramatic staging. It is the purpose of most masquerades to move people, to affect them, to effect change.

Thus, masks and masquerades are mediators—between men and women, youths and elders, initiated and uninitiated, powers of nature and those of human agency, and even life and death. For many groups in West and Central Africa, masking plays (or once played) an active role in the socialization process, especially for men, who control most masks. Maskers carry boys (and, more

37-17 Senufo masqueraders, Côte d'Ivoire, photographed ca. 1980-1990. ■◀

Senufo masqueraders are always men. Their masks often represent composite creatures incarnating both ancestors and bush powers. They fight malevolent spirits with their aggressively powerful forms.

rarely, girls) away from their mothers to bush initiation camps, put them through ordeals and schooling, and welcome them back to society as men months or even years later. A second major role is in aiding the transformation of important deceased persons into productive ancestors who, in their new roles, can bring benefits to the living community. Because most masking cultures are agricultural, it is not surprising Africans often invoke masquerades to increase the productivity of the fields, to stimulate the growth of crops, and later to celebrate the harvest.

his homeland to execute those commissions. Between 1910 and 1914 he resided at Ikere while working for the ogoga. The palace shrine doors date from that time.

Departing from convention, Olowe made the two doors of unequal width to accommodate a rare historical narrative in 10 panels in five registers. The reliefs recount the 1897 visit of the representative of the British Empire, Captain Ambrose, commissioner of Ondo province. Litter-bearers carry Ambrose into the palace compound, where the enthroned king, far larger than the British emissary, and his principal wife receive him. The other panels on each door depict the entourage of the two protagonists including, at the left, the king's bodyguards and other wives, and, on the right door, shackled slaves carrying chests. Characteristically for Olowe, the relief is so high some of the figures project as much as six inches from the surface, which has a vividly colored patterned background. Olowe also carved the veranda posts of the courtyard in front of the shrine.

Senufo

The Senufo of the western Sudan region in what is now northern Côte d'Ivoire have a population today of more than a million. They speak several different languages, sometimes even in the same village. Not surprisingly, there are many different Senufo art forms, including mask-making (FIGS. 37-17 and 37-18) and woodcarving (FIG. 37-17A), all closely tied to community life.

MASQUERADES Senufo men dance many masks (see "African Masquerades," above), mostly in the context of Poro, the main association for socialization and initiation, a protracted process taking nearly 20 years for men to complete. Maskers also perform at funerals and other public spectacles. Large Senufo masks (for example,

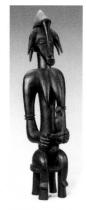

37-17A Ancient Mother, Senufo, early 20th century.

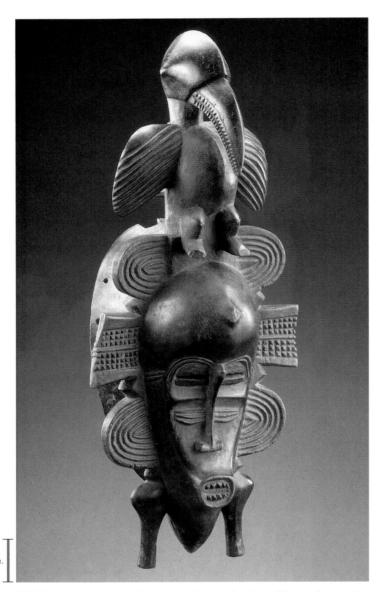

37-18 "Beautiful Lady" dance mask, Senufo, Côte d'Ivoire, late 20th century. Wood, $1'\frac{1}{2}''$ high. Musée Barbier-Mueller, Geneva.

Some Senufo men dance female masks such as this one with a hornbill bird rising from the forehead. The female characters are sometimes the wives of the terrorizing male masks (Fig. 37-17).

FIG. 37-17) are composite creatures, combining characteristics of antelope, crocodile, warthog, hyena, and human: sweeping horns, a head, and an open-jawed snout with sharp teeth. These masks incarnate both ancestors and bush powers that combat witchcraft and sorcery, malevolent spirits, and the wandering dead. They are protectors who fight evil with their aggressively powerful forms and their medicines.

At funerals Senufo maskers attend the corpse and help expel the deceased from the village. This is the deceased individual's final transition, a rite of passage parallel to that undergone by all men during their years of Poro socialization, when masks also play a role. When an important person dies, the convergence of several masking groups, as well as the music, dancing, costuming, and feasting of many people, constitute a festive and complex work of art that transcends any one mask or character.

Some men also dance female masks. The most recurrent type has a small face with fine features, several extensions, and varied

37-19 Satimbe masquerader, Dogon, Mali, mid- to late 20th century.

Satimbe (sister on the head) masks commemorate the legend describing women as the first masqueraders. The mask's crown is a woman with large breasts and sticklike bent arms.

motifs—a hornbill bird in the illustrated example (FIG. 37-18)—rising from the forehead. The men who dance these feminine characters also wear knitted body suits or trade-cloth costumes to indicate their beauty and their ties with the order and civilization of the village. They may be called "pretty young girl," "beautiful lady," or "wife" of one of the heavy, terrorizing masculine masks (FIG. 37-17) appearing before or after them.

Dogon

The Dogon (FIG. 37-11) continue to excel at carving wood figures, but many Dogon artists are specialists in fashioning large masks for elaborate cyclical masquerades.

SATIMBE MASKS Dogon masquerades dramatize creation legends. These stories say women were the first ancestors to imitate spirit maskers and thus the first human masqueraders. Men later took over the masks, forever barring women from direct involvement with masking processes. A mask called *Satimbe* (FIG. 37-19), that is, "sister on the head," seems to represent all women and commemorates this legend. Satimbe masks consist of a roughly rectangular covering for the head with narrow rectangular openings

Mende Women as Maskers

he Mende and neighboring peo-L ples of Sierra Leone, Liberia, and Guinea are distinctive in Africa because the women perform masquerades. The masks (FIG. 37-20) and costumes they wear conceal the women's bodies from the audience attending their performance. The Sande society of the Mende controls the initiation, education, and acculturation of Mende girls. Women leaders who dance the Sande masks serve as priestesses and judges during the three years the women's society controls the ritual calendar (alternating with the men's society in this role), thus serving the community as a whole. Women maskers, who function as initiators, teachers, and mentors, help girl novices with their transformation into educated and marriageable women.

37-20 Female mask, Mende, Sierra Leone, mid- to late 20th century. Painted wood, 1' 2½" high. Fowler Museum of Cultural History, University of California, Los Angeles (gift of the Wellcome Trust). ■◀

This Mende mask refers to ideals of female beauty, morality, and behavior. The large forehead signifies wisdom, the neck design beauty and health, and the plaited hair the order of ideal households.

Sande women associate their Sowie masks with water spirits and the color black, which the society, in turn, connects with human skin color and the civilized world. The women wear these helmet masks on top of their heads as headdresses, with black raffia and cloth costumes to hide the wearers' identity during public performances. Elaborate coiffures, shiny black color, dainty triangular-shaped faces with slit eyes, rolls around the neck, and real and carved versions of amulets and various emblems on the top commonly characterize Sowie masks (FIG. 37-20). These symbolize the adult women's roles as wives, mothers, providers for the family, and keepers of medicines for use within the Sande association and the society at large.

Sande members commission the masks from male carvers, with the carver and patron together determining the type of mask needed for a particular societal purpose. The Mende often keep, repair, and reuse masks for many decades, thereby preserving them as models for subsequent generations of carvers.

1 in.

for the eyes and a crowning element, much larger than the mask proper, depicting a schematic woman with large protruding breasts and sticklike bent arms. In ceremonies called Dama, held every several years to honor the lives of people who have died since the last Dama, Satimbe is among the dozens of different masked spirit characters escorting dead souls away from the village. The deceased are sent off to the land of the dead where, as ancestors, they will be enjoined to benefit their living descendants and stimulate agricultural productivity.

Mende

The Mende are farmers who occupy the Atlantic coast of Africa in Sierra Leone. Although men own and perform most masks in Africa, in Mende society women control and dance Sande society masks (see "Mende Women as Maskers," above), while Mende men perform the Poro society masks.

SOWIE MASKS The glistening black surface of Mende Sowie masks (FIG. 37-20) evokes female spirits newly emergent from their underwater homes (also symbolized by the turtle on top). The mask and its parts refer to ideals of female beauty, morality, and behavior. A high broad forehead signifies wisdom and success. The neck ridges have multiple meanings. They are signs of beauty, good health, and prosperity and also reference the ripples in the water from which the water spirits emerge. Intricately woven or plaited hair is the essence of harmony and order found in ideal households. A small closed mouth and downcast eyes indicate the silent, serious demeanor expected of recent initiates.

37-21 Bwoom masquerader, Kuba, Democratic Republic of Congo, photographed ca. 1950.

At Kuba festivals, masqueraders reenact creation legends involving Bwoom, Mwashamboy, and Ngady Amwaash. The first two characters are males who vie for the attention of Ngady, the first female ancestor.

Kuba

The Kuba have been well established in the Democratic Republic of Congo since at least the 16th century. They represent almost 20 different ethnic groups who all recognize the authority of a single king.

BWOOM AND NGADY AMWAASH At the court of Kuba kings, three masks, known as Mwashamboy, Bwoom, and Ngady Amwaash, represent legendary royal ancestors. Mwashamboy symbolizes the founding ancestor, Woot, and embodies the king's supernatural and political powers. Bwoom (FIG. 37-21), with its bulging forehead, represents a legendary dwarf or pygmy who signifies the indigenous peoples on whom kingship was imposed. Bwoom also vies with Mwashamboy for the attention of the beautiful ancestress, Ngady Amwaash (FIG. 37-22), who symbolizes both the first woman and all women. On her cheeks are striped tears from the pain of childbirth, and because to procreate, Ngady must commit incest with her father, Woot. These three characters reenact creation stories during royal initiation ceremonies. The masks and their costumes, with elaborate beads, feathers, animal pelts, cowrie shells, cut-pile cloth, and ornamental trappings, as well as geometric patterning, make for a sumptuous display at Kuba festivals.

KING KOT A-MBWEEKY III Throughout history, African costumes have been laden with meaning and have projected

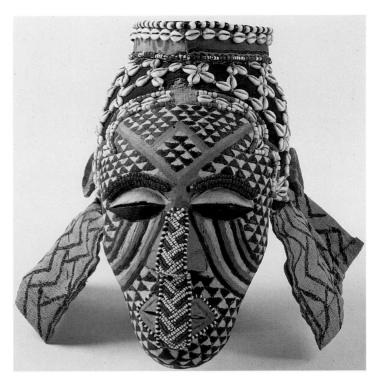

37-22 Ngady Amwaash mask, Kuba, Democratic Republic of Congo, late 19th or early 20th century. Peabody Museum of Archaeology and Ethnology, Harvard University, Cambridge. ■◀

Ngady's mask incorporates beads, shells, and feathers in geometric patterns. The stripes on her cheeks are tears from the pain of childbirth after incest with her father, represented by the Mwashamboy mask.

messages all members of the society could read. A photograph (FIG. 37-23) taken in 1970 shows Kuba King Kot a-Mbweeky III (r. 1969-) seated in state before his court, bedecked in a dazzling multimedia costume with many symbolic elements. The king commissioned the costume he wears and now has become art himself. Eagle feathers, leopard skin, cowrie shells, imported beads, raffia, and other materials combine to overload and expand the image of the man, making him larger than life and most certainly a work of art. He is an assemblage. He holds not one but two weapons, symbolic of his military might and underscoring his wealth, dignity, and grandeur. The man, with his regalia, embodies the office of sacred kingship. He is a superior being, in fact and figuratively, raised upon a dais, flanked by ornate drums, with a treasure basket of sacred relics by his left foot. The geometric patterns on the king's costume and nearby objects, and the abundance and redundancy of rich materials, epitomize the opulent style of Kuba court arts.

Samburu

In addition to wearing masks and costumes on special occasions, people in many rural areas of eastern Africa, including the Samburu in northern Kenya, continue to embellish their own bodies.

BODY ADORNMENT The Samburu men and women shown in FIG. 37-24 at a spontaneous dance have distinct styles of personal decoration. Men, particularly warriors who are not yet married, expend hours creating elaborate hairstyles for one another. They paint their bodies with red ocher and wear bracelets, necklaces, and other bands of beaded jewelry made for them by young women. For themselves, women fashion more lavish constellations

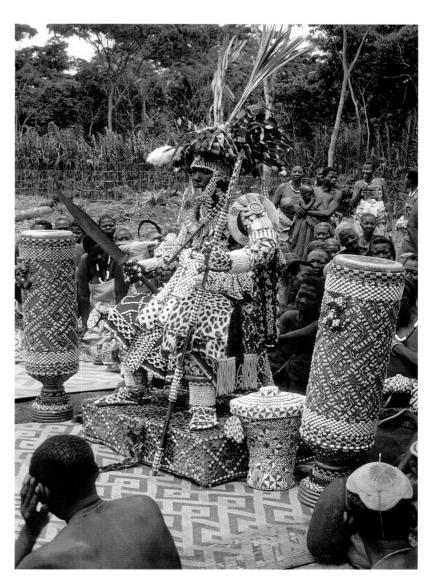

37-23 Kuba King Kot a-Mbweeky III during a display for photographer and filmmaker Eliot Elisofon in 1970, Mushenge, Democratic Republic of Congo.

Eagle feathers, leopard skin, cowrie shells, imported beads, raffia, and other materials combine to make the Kuba king larger than life. He is a collage of wealth, dignity, and military might.

of beaded collars, which they mass around their necks. As if to help separate the genders, women shave their heads and adorn them with beaded headbands. Personal decoration begins in childhood, increasing to become lavish and highly self-conscious in young adulthood and diminishing as people age. Much of the decoration contains coded information—age, marital or initiation status, parentage of a warrior son—that can be read by those who know the codes. Dress ensembles have evolved over time. Different colors and sizes of beads became available, as did plastics and aluminum, and specific fashions have changed, but the overall concept of fine personal adornment—that is, dress raised to the level of art—remains much the same today as it was centuries ago.

Igbo

The Igbo of the Lower Niger region in present-day Nigeria have a distinguished artistic tradition dating back more than a thousand years (see Chapter 19). The arts still play a vital role in Igbo society today.

MBARI HOUSES The powerful nature gods of the Igbo demand about every 50 years that a community build an *mbari* house. The Igbo construct these houses from mud as sacrifices to major deities, often Ala, goddess of the earth. The houses are elaborate unified artistic complexes incorporating numerous unfired clay sculptures and paintings—occasionally more than a hundred in a single mbari house. At Umugote Orishaeze, near Owerri,

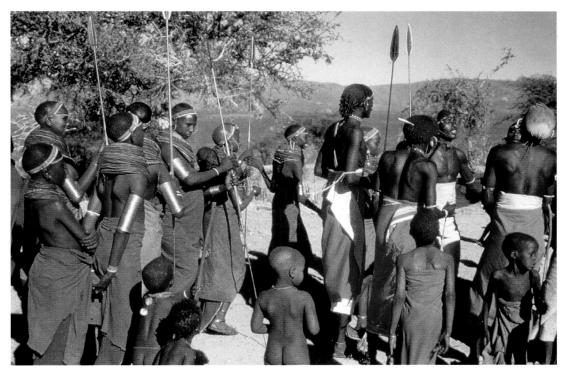

37-24 Samburu men and women dancing, northern Kenya, photographed in 1973.

Men and women in many rural areas of Africa paint their bodies and wear elaborate hairstyles and beaded jewelry. This personal adornment reveals their age, marital status, and parentage.

37-25 Ala and Amadioha, painted clay sculptures in an mbari house, Igbo, Umugote Orishaeze, Nigeria, photographed in 1966.

The Igbo build mud mbari houses to the earth goddess Ala. The painted statues inside this one represent Ala in traditional dress with body paint and the thunder god Amadioha in modern dress.

one mbari house contains, among many others, two sculptures (FIG. 37-25) depicting Ala and her consort, the thunder god Amadioha. The god wears modern clothing, whereas Ala appears with traditional body paint and a fancy hairstyle. These differing modes of dress relate to Igbo concepts of modernity and tradition, both viewed as positive by the men who control the ritual and art. They allow themselves

modern attire but want their women to remain traditional. The artist enlarged and extended the torso, neck, and head of both figures to express their aloofness, dignity, and power. More informally posed figures and groups appear on the other sides of the house, including beautiful, amusing, or frightening figures of animals, humans, and spirits taken from mythology, history, dreams, and everyday life-a kaleidoscope of subjects and meanings. The mbari construction process, veiled in secrecy behind a fence, is a stylized world-renewal ritual. Ceremonies for unveiling the house to public view indicate Ala has accepted the sacrificial offering (of the mbari) and, for a time at least, will be benevolent. An mbari house never undergoes repair. Instead, the Igbo allow it to disintegrate and return to its source, the earth.

Contemporary Art

The art forms of contemporary Africa vary immensely and defy easy classification. Those of international character with strong Western influence are discussed in Chapter 31. Others, for example, the Dogon men's house treated here, testify to the continuing vitality of traditional African art in the 21st century.

DOGON TOGU NA Traditionalism and modernism unite in the Dogon togu na, or "men's house of words." The togu na is so called because men's deliberations vital to community welfare take place under its sheltering roof. The Dogon consider it the "head" and the most important part of the community, and they characterize the togu na with human attributes. The Dogon build the men's houses over time. Earlier posts, such as the central one in the illustrated togu na (FIG. 37-26), show schematic renderings of legendary female ancestors, similar to stylized ancestral couples (FIG. 37-11) or masked figures (FIG. 37-19). Recent replacement posts display narrative and topical scenes of varied subjects, such as horsemen or hunters or women preparing food, and feature abundant descriptive detail, bright polychrome painting in enamels, and even some writing. Unlike earlier traditional sculptors, the contemporary artists who made these posts want to be recognized, and they are eager to sell their work (other than these posts) to tourists.

AFRICAN ART TODAY During the past two centuries and especially in recent decades, the encroachments of Christianity, Islam, Western education, and market economies have led to increasing secularization in all the arts of Africa. Many figures and masks earlier commissioned for shrines or as incarnations of ancestors or spirits are now made mostly for sale to outsiders, essentially as tourist arts. They are also sold in art galleries abroad as collector's items for display. In towns and cities, painted murals and cement sculptures appear frequently, often making implicit comments about modern life. Nonetheless, despite the growing importance of urbanism, most African people still live in rural communities. Traditional values, although under pressure, hold considerable force in villages especially, and some people adhere to spiritual beliefs that uphold traditional art forms. African art remains as varied as the vast continent itself and continues to evolve.

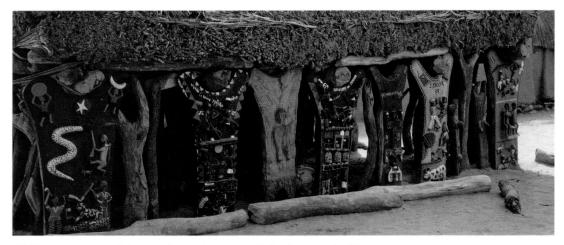

37-26 Togu na (men's house of words), Dogon, Mali, photographed in 1989.

Dogon men hold their communal deliberations in a togu na. The posts of this one are of varied date. The oldest have traditional carvings, and the newest feature polychrome narrative or topical paintings.

AFRICA, 1800 TO 1980

19TH CENTURY

- Most of the traditional forms of African art continued into the 19th century. Among these are sculptures and shrines connected with the veneration of ancestors. Wood or metal-covered wood figures guarded Fang and Kota reliquaries. Especially elaborate are some Kalabari Ijaw screens with figures of a deceased chief, his retainers, and the heads of his slaves and conquered rivals.
- The royal arts also flourished in the 19th century. The ultimate status symbol was the ruler's throne, for example the throne of King Nsangu of Bamum, which makes extensive use of richly colored textiles and glass beads, cowrie shells, and other luminous materials.
- One of the earliest African artists whose name survives is Akati Akpele Kendo, who worked for the Fon king Glele around 1858, but until the later 20th century, most African art remains anonymous.
- I Throughout history, African artists have been masters of woodcarving. Especially impressive examples are the Kongo power figures bristling with nails and blades, and the Dogon and Baule sculptures of male and female couples. Although stylistically diverse, most African sculpture exhibits hierarchy of scale, both among figures and within the human body. For example, enlarged heads are common features of African statues.

Throne of King Nsangu, Bamum, ca. 1870

Kongo power figure, ca. 1875–1900

20TH CENTURY

- As in the 19th century, traditional arts flourished in 20th-century Africa. These include multimedia shrines, such as the ancestral altar of King Eweka II of Benin.
- The names of many more individual 20th-century artists are known. Two of the most famous are the Asante sculptor Osei Bonsu and the Yoruba sculptor Olowe of Ise.
- Osei Bonsu worked for kings and commoners alike, carving both single figures and groups, sometimes for the linguist's staff of a leader's spokesman. The distinctive features of his style are the flattened faces and crosshatched eyebrows of his figures.
- Olowe of Ise won renown for the painted wood doors and multifigure veranda posts he carved for houses and palaces. Elongated bodies and finely textured detail characterize his sculptures, both in relief and in the round.
- In Africa, art is nearly always an active agent in the lives of its peoples. A major African art form is the fashioning of masks for festive performances. Masqueraders are almost always men, even when the masks they dance are female, as among the Senufo, Dogon, and Kuba, but in Mende society, women are maskers too.
- Africans have also traditionally lavished attention on costume and jewelry and other forms of body adornment such as elaborate coiffures and body painting. The decoration often contains coded information about age, status, and parentage. Royal costumes consisting of animal skins, feathers, shells, beads, and raffia, and symbols of power such as crowns, swords, and scepters make kings seem larger than they really are in life.

Benin ancestral altar, photographed in 1970

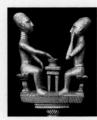

Bonsu, linguist's staff, mid-20th century

Mende female mask, mid- to late 20th century

Smith's mixed-media canvases celebrate her Native American identity. Above the painting, as if hung from a clothesline, are cheap trinkets she proposes to trade for the return of confiscated land.

Overlapping the collage and the central motif of the canoe in Smith's anti-Columbus Quincentenary Celebration is dripping red paint, symbolic of the shedding of Native American blood.

The sports teams represented in *Trade* all have American Indian–derived names, reminding viewers of the vocal opposition to these names and to practices such as the Atlanta Braves' "tomahawk chop."

31-1 Jaune Quick-to-See Smith, Trade (Gifts for Trading Land with White People), 1992. Oil and mixed media on canvas, $5' \times 14'$ 2". Chrysler Museum of Art, Norfolk.

Newspaper clippings chronicle the conquest of Native America by Europeans and include references to the problems facing those living on reservations today—poverty, alcoholism, disease.

31

CONTEMPORARY ART WORLDWIDE

ART AS SOCIOPOLITICAL MESSAGE

Although televisions, cell phones, and the Internet have brought people all over the world closer together than ever before in history, national, ethnic, religious, and racial conflicts are unfortunate and unavoidable facts of contemporary life. Some of the most eloquent voices raised in protest about the major political and social issues of the day have been those of painters and sculptors, who can harness the power of art to amplify the power of the written and spoken word.

Jaune Quick-to-See Smith (b. 1940) is a Native American artist descended from the Shoshone, Salish, and Cree peoples. Raised on the Flatrock Reservation in Montana, she is steeped in the traditional culture of her ancestors, but she trained as an artist in the European-American tradition at Framingham State College in Massachusetts and at the University of New Mexico. Smith's ethnic heritage has always informed her art, however, and her concern about the invisibility of Native American artists has led her to organize exhibitions of their art. Her self-identity has also been the central theme of her mature work as an artist.

In 1992, Smith created what many critics consider her masterpiece: *Trade* (FIG. 31-1), subtitled *Gifts for Trading Land with White People*. A complex multimedia work of monumental size, *Trade* is Smith's response to what she called "the Quincentenary Non-Celebration," that is, White America's celebration of the 500th anniversary of Christopher Columbus's arrival in what Europeans called the New World. *Trade* combines collage elements and attached objects, reminiscent of a Rauschenberg combine (FIG. 30-23), with energetic brushwork recalling Willem de Kooning's Abstract Expressionist canvases (FIG. 30-8) and clippings from Native American newspapers. The clippings include images chronicling the conquest of Native America by Europeans and references to the problems facing those living on reservations today—poverty, alcoholism, disease. The dripping red paint overlaying the collage with the central motif of the canoe is symbolic of the shedding of Native American blood.

Above the painting, as if hung from a clothesline, is an array of objects. These include Native American artifacts, such as beaded belts and feather headdresses, plastic tomahawks and "Indian princess" dolls, and contemporary sports memorabilia from teams with American Indian-derived names—the Cleveland Indians, Atlanta Braves, and Washington Redskins. The inclusion of these objects reminds viewers of the vocal opposition to the use of these and similar names for high school and college as well as professional sports teams. All the cheap artifacts together also have a deeper significance. As the title indicates and Smith explained:

Why won't you consider trading the land we handed over to you for these silly trinkets that so honor us? Sound like a bad deal? Well, that's the deal you gave us.

SOCIAL AND POLITICAL ART

Jaune Quick-to-See Smith's *Trade* (FIG. 31-1) is the unique product of the artist's heritage as a Native American who has sought to bridge native and European artistic traditions, but her work parallels that of many other innovative artists of the decades since 1980 in addressing contemporary social and political issues. This focus on the content and meaning of art represents, as did the earlier work of the Pop artists and Superrealists (see Chapter 30), a rejection of modernist formalist doctrine and a desire on the part of artists once again to embrace the persuasive powers of art to communicate with a wide audience.

POSTMODERNISM The rejection of the principles underlying modernism is a central element in the diverse phenomenon in art, as in architecture, known as postmodernism (see page 929). No simple definition of *postmodernism* is possible, but it represents the erosion of the boundaries between high culture and popular culture—a separation Clement Greenberg and the modernists had staunchly defended.

For many recent artists, postmodernism involves examining the process by which meaning is generated and the negotiation or dialogue that transpires between viewers and artworks. This kind of examination of the nature of art parallels the literary field of study known as critical theory. Critical theorists view art and architecture, as well as literature and the other humanities, as a culture's intellectual products or "constructs." These constructs unconsciously suppress or conceal the real premises informing the culture, primarily the values of those politically in control. Thus, cultural products function in an ideological capacity, obscuring, for example, racist or sexist attitudes. When revealed by analysis, the facts behind these constructs, according to critical theorists, contribute to a more substantial understanding of artworks, buildings, books, and the overall culture.

Many critical theorists use an analytical strategy called *deconstruction*, after a method developed by French intellectuals in the 1960s and 1970s. In deconstruction theory, all cultural contexts are "texts." Critical theorists who employ this approach seek to uncover—to deconstruct—the facts of power, privilege, and prejudice underlying the practices and institutions of any given culture. In so doing, scholars can reveal the precariousness of structures and systems, such as language and cultural practices, along with the assumptions underlying them.

Critical theorists do not agree upon any single philosophy or analytical method, because in principle they oppose firm definitions. They do share a healthy suspicion of all traditional truth claims and value standards, all hierarchical authority and institutions. For them, deconstruction means destabilizing established meanings, definitions, and interpretations while encouraging subjectivity and individual differences. Indeed, if there is any common denominator in the art of the decades since 1980, it is precisely the absence of any common denominator. Diversity of style and content and the celebration of individual personalities, backgrounds, and approaches to art are central to the notion of postmodernist art. The art of the 1980s and 1990s and of the opening decades of the 21st century is worldwide in scope, encompasses both abstraction and realism, and addresses a wide range of contemporary social and political issues.

Social Art: Gender and Sexuality

Many artists who have embraced the postmodern interest in investigating the dynamics of power and privilege have focused on issues of gender and sexuality in the contemporary world.

BARBARA KRUGER In the 1970s, some feminist artists, chief among them Cindy Sherman (FIG. 30-35), explored the "male gaze" and the culturally constructed notion of gender in their art. BARBARA KRUGER (b. 1945), who studied at Syracuse University and then at the Parsons School of Design in New York under Diane Arbus (FIG. 30-31), examines similar issues in her photographs. The strategies and techniques of contemporary mass media fascinate Kruger, who was a commercial graphic designer early in her career and the art director of Mademoiselle magazine in the late 1960s. In Untitled (Your Gaze Hits the Side of My Face; FIG. 31-2), Kruger incorporated the layout techniques magazines and billboards use to sell consumer goods. Although she favored the reassuringly familiar format and look of advertising, Kruger's goal was to subvert the typical use of advertising imagery. She aimed to expose the deceptiveness of the media messages the viewer complacently absorbs. Kruger wanted to undermine the myths—particularly those about women—the media constantly reinforce. Her large (often four by six feet) word-and-photograph collages challenge the cultural attitudes embedded in commercial advertising. She has often used T-shirts, postcards, matchbooks, and billboards to present her work to a wide public audience.

In *Your Gaze*, Kruger overlaid a photograph of a classically beautiful sculpted head of a woman (compare FIG. 5-62A) with a vertical row of text composed of eight words. The words cannot be taken in with a single glance. Reading them is a staccato exercise, with an overlaid cumulative quality that delays understanding and

1980

CONTEMPORARY ART WORLDWIDE

1990

Social and political issues—gender and

sexuality; ethnic, religious, and national identity; violence, homelessness, and AIDS—figure prominently in the art of Kruger, Wojnarowicz, Wodiczko, Ringgold, Weems, and many others

I Stirling, Pei, and other postmodern architects incorporate historical references into designs for museums and other public buildings

Site-specific artworks by Lin and Serra and exhibitions of the work of Mapplethorpe and Ofili become lightning rods for debate over public financing of art Artworks addressing pressing political and social issues continue to be produced in great numbers by, among others, Quick-to-See Smith, Sikander, Bester, Hammons, and Neshat

Realistic figure painting and sculpture (Kiki Smith, Saville) as well as abstraction (Schnabel, Kiefer, Donovan) remain vital components of the contemporary art scene

I Deconstructivism (Behnisch, Gehry, Hadid) and green architecture (Piano) emerge as major architectural movements Modern, postmodern, and traditional art forms coexist today in the increasingly interconnected worldwide art scene as artists on all continents work with ageold materials and also experiment with the new media of digital photography, computer graphics, and video

2000

31-2 BARBARA KRUGER, Untitled (Your Gaze Hits the Side of My Face), 1981. Photograph, red painted frame, 4′ 7″ × 3′ 5″. Courtesy Mary Boone Gallery, New York. ■◀

Kruger has explored the "male gaze" in her art. Using the layout techniques of mass media, she constructed this word-and-photograph collage to challenge culturally constructed notions of gender.

intensifies the meaning (rather like reading a series of roadside billboards from a speeding car). Kruger's use of text in her work is significant. Many cultural theorists have asserted language is one of the most powerful vehicles for internalizing stereotypes and conditioned roles. Some feminist artists, most notably the Guerrilla Girls (FIG. 31-2A), have created

THE ADVANTAGES OF BEING A WOMAN ARTIST:

We briefly the his shows with many feeting or except the first and will a your of conclusion jobs. Leaving you couper might job by a place gov's might have been proved to the province of the property of the best of the best being required. In conclusion of the state of the property of the property of the leaving your place has to in the sand of others. More than the property of the property of the property of the leaving your place to the leaving or point in Public solds. More than the property of the property of the property of the leaving to the property of the property of the property of the leaving best of the property of the property of the leaving best of the property of the property of the leaving best of the property of the collection property of the collection of the property of leaving property of the or all property of property of the property of the property of property of the property of property of the property of the property of property

31-2A GUERRILLA GIRLS, Advantages of Being a Woman Artist, 1988.

powerful artworks consisting only of words—presented in a style and format reminiscent of the same kinds of magazine ads Kruger incorporates in her photo-collages.

DAVID WOJNAROWICZ For many artists, their homosexuality is as important—or even more important—an element of their personal identity as their gender, ethnicity, or race. Beginning in the early 1980s, unwelcome reinforcement for their self-identification came from confronting daily the devastating effects of AIDS (acquired immune deficiency syndrome) in the gay community. Some sculptors and painters responded by producing deeply moving works of art. David Wojnarowicz (1955-1992) dropped out of high school in his hometown of Red Bank, New Jersey, and moved to New York City, where he lived on the streets before achieving success as an artist. A gay activist, he watched his lover and many of his friends die of AIDS. He reacted by creating disturbing yet eloquent works about the tragedy of this disease, which eventually claimed his own life. In When I Put My Hands on Your Body (FIG. 31-3), he overlaid a photograph of a pile of skeletal remains with evenly spaced typed commentary communicating his feelings about watching a loved one dying of AIDS. Wojnarowicz movingly describes the effects of AIDS on the human body and soul:

When I put my hands on your body on your flesh I feel the history of that body. . . . I see the flesh unwrap from the layers of fat and disappear. . . . I see the organs gradually fade into transparency. . . . It makes me weep to feel the history of you of your flesh beneath my hands.

31-3 DAVID WOJNAROWICZ, When I Put My Hands on Your Body, 1990. Gelatin silver print and silk-screened text on museum board, 2' 2" × 3' 2". Private collection.

In this disturbing yet eloquent print, Wojnarowicz overlaid typed commentary on a photograph of skeletal remains. He movingly communicated his feelings about watching a loved one die of AIDS.

1 ft.

Public Funding of Controversial Art

A lthough art can be beautiful and uplifting, throughout history art has also challenged and offended. Since the early 1980s, a number of heated controversies about art have surfaced in the United States. There have been many calls to remove "offensive" works from public view (see "Richard Serra's *Tilted Arc*," page 967) and, in reaction, accusations of censorship. The central questions in all cases have been whether there are limits to what art can appropriately be exhibited, and whether governmental authorities have the right to monitor and pass judgment on creative endeavors. A related question is whether the acceptability of a work should be a criterion in determining the public funding of art.

Two exhibits in 1989 placed the National Endowment for the Arts (NEA), a U.S. government agency charged with distributing federal funds to support the arts, squarely in the middle of this debate. One of the exhibitions, devoted to recipients of the Awards for the Visual Arts (AVA), took place at the Southeastern Center for Contemporary Art in North Carolina. Among the award winners was Andres Serrano, whose Piss Christ, a photograph of a crucifix submerged in urine, sparked an uproar. Responding to this artwork, Reverend Donald Wildmon, an evangelical minister from Mississippi and head of the American Family Association, expressed outrage that this kind of work was in an exhibition funded by the NEA and the Equitable Life Assurance Society (a sponsor of the AVA). He demanded the work be removed and launched a letter-writing campaign that caused Equitable Life to cancel its sponsorship of the awards. To Wildmon and other staunch conservatives, this exhibition, along with Robert Mapplethorpe: The Perfect Moment, which included erotic and openly homosexual images of the artist (FIG. 31-4) and others, served as evidence of cultural depravity and immorality. These critics insisted that art of an offensive character should not be funded by government agencies such as the NEA. As a result of media furor over The Perfect Moment, the director of the Corcoran Museum of Art decided to cancel the scheduled exhibition of this traveling show. But Dennis Barrie, Director of the Contemporary Arts Center in Cincinnati, chose to mount the show. The government indicted Barrie on charges of obscenity, but a jury acquitted him six months later.

These controversies intensified public criticism of the NEA and its funding practices. The next year, the head of the NEA, John Frohnmayer, vetoed grants for four lesbian, gay, or feminist performance artists—Karen Finley, John Fleck, Holly Hughes, and Tim Miller—who became known as the "NEA Four." Infuriated by what they perceived as overt censorship, the artists filed suit, eventually settling the case and winning reinstatement of their grants. Congress responded by dramatically reducing the NEA's budget, and the agency no longer awards grants or fellowships to individual artists.

31-4 ROBERT MAPPLETHORPE, Self-Portrait, 1980. Gelatin silver print, $7\frac{3''}{4} \times 7\frac{3''}{4}$. Robert Mapplethorpe Foundation, New York.

Mapplethorpe's *Perfect Moment* show led to a landmark court case on freedom of expression for artists. In this self-portrait, an androgynous Mapplethorpe confronts the viewer with a steady gaze.

Controversies have also erupted on the municipal level. In 1999, Rudolph Giuliani, then mayor of New York, joined a number of individuals and groups protesting the inclusion of several artworks in the exhibition *Sensation: Young British Artists from the Saatchi Collection* at the Brooklyn Museum. Chris Ofili's *The Holy Virgin Mary* (FIG. 31-10), a collage of Mary incorporating cutouts from pornographic magazines and shellacked clumps of elephant dung, became the flashpoint for public furor. Denouncing the show as "sick stuff," the mayor threatened to cut off all city subsidies to the museum.

Art that seeks to unsettle and challenge is critical to the cultural, political, and psychological life of a society. The regularity with which this kind of art raises controversy suggests it operates at the intersection of two competing principles: free speech and artistic expression on the one hand and a reluctance to impose images upon an audience that finds them repugnant or offensive on the other. What these controversies do demonstrate, beyond doubt, is the enduring power of art.

Wojnarowicz juxtaposed text with imagery, which, like works by Barbara Kruger (FIG. 31-2) and the Guerrilla Girls (FIG. 31-2A), paralleled the use of both words and images in advertising. The public's familiarity with this format ensured greater receptivity to the artist's message.

ROBERT MAPPLETHORPE One brilliant gay artist who became the central figure in a heated debate in the halls of the U.S. Congress as well as among the public at large was ROBERT MAPPLETHORPE (1946–1989). Born in Queens, New York, Mapplethorpe studied drawing, painting, and sculpture at the Pratt

Institute in Brooklyn, but after he purchased a Polaroid camera in 1970, he became increasingly interested in photography. Mapplethorpe's *The Perfect Moment* traveling exhibition, funded in part by the National Endowment for the Arts, featured his photographs of flowers and people, many nude, some depicting children, some homoerotic and sadomasochistic in nature. The show led to a landmark court case in Cincinnati on freedom of expression for artists and prompted new legislation establishing restrictions on government funding of the arts (see "Public Funding of Controversial Art," page 944).

Never at issue was Mapplethorpe's technical mastery of the photographic medium. His gelatin silver prints have glowing textures with rich tonal gradations of black, gray, and white. In many ways, Mapplethorpe was the heir of Edward Weston, whose innovative compositions of still lifes (FIG. 29-44) and nudes (FIG. 29-44A) helped establish photography as an art form on a par with painting and sculpture. What shocked the public was not nudity per se—a traditional subject with roots in antiquity, indeed at the very birth of art during the Old Stone Age (FIGS. 1-5, 1-6, and 1-6A)—but the

31-5 Shahzia Sikander, *Perilous Order*, 1994–1997. Vegetable color, dry pigment, watercolor, and tea on Wasli paper, $10\frac{1}{2}^{"} \times 8"$. Whitney Museum of American Art, New York (purchase, with funds from the Drawing Committee).

Imbuing miniature painting with a contemporary message about hypocrisy and intolerance, Sikander portrayed a gay friend as a homosexual Mughal emperor who enforced Muslim orthodoxy.

openly gay character of many of Mapplethorpe's images. *The Perfect Moment* photographs included, in addition to some very graphic images of homosexual men, a series of self-portraits documenting Mapplethorpe's changing appearance almost up until he died from AIDS only months after the show opened in Philadelphia in December 1988. The self-portrait reproduced here (FIG. 31-4) presents Mapplethorpe as an androgynous young man with long hair and makeup, confronting the viewer with a steady gaze. Mapplethorpe's photographs, like the work of David Wojnarowicz (FIG. 31-3) and other gay and lesbian artists of the time, are inextricably bound with the social upheavals in American society and the struggle for equal rights for women, homosexuals, minorities, and the disabled during the second half of the 20th century.

SHAHZIA SIKANDER The struggle for recognition and equal rights has never been confined to the United States, least of all in the present era of instant global communication. In the Muslim world, women and homosexuals face especially difficult challenges, which Shahzia Sikander (b. 1969) brilliantly addresses in her

work. Born in Lahore, Pakistan, and trained at the National College of Arts in the demanding South Asian/ Persian art of miniature painting (see "Indian Miniature Painting," Chapter 32, page 979), she earned an MFA from the Rhode Island School of Design and now lives in New York City. So thoroughly immersed in the methods of miniature painting that she makes her own paper, pigments, and squirrel-hair brushes, Sikander nonetheless imbues this traditional art form with contemporary meaning. In Perilous Order (FIG. 31-5), she addresses homosexuality, intolerance, and hypocrisy by portraying a gay friend in the guise of the Mughal emperor Aurangzeb (r. 1658-1707), who was a strict enforcer of Islamic orthodoxy although reputed to be a homosexual. Sikander depicted him framed against a magnificent marbleized background ringed by voluptuous nude Hindu nymphs and behind the shadow of a veiled Hindu goddess. Perilous Order thus also incorporates a reference to the tensions between the Muslim and Hindu populations of Pakistan and India today.

Social Art: Race, Ethnicity, and National Identity

Gender and sexual-orientation issues are by no means the only societal concerns contemporary artists have addressed in their work. Race, ethnicity, and national identity are among the other pressing issues that have given rise to important artworks during the past few decades.

FAITH RINGGOLD One of the leading artists addressing issues associated with African American women is Harlem native FAITH RINGGOLD (b. 1930), who studied painting at the City College of New York and taught art education in the New York public schools for 18 years. In the 1960s, Ringgold produced numerous works that provided pointed and incisive commentary on the realities of racial prejudice. She increasingly incorporated references to gender as well and, in the 1970s, turned to fabric as the predominant material in her art. Using fabric enabled Ringgold to make more pointed reference to the domestic sphere, traditionally

31-6 Faith Ringgold, Who's Afraid of Aunt Jemima? 1983. Acrylic on canvas with fabric borders, quilted, 7' $6'' \times 6'$ 8''. Private collection.

In this quilt, a medium associated with women, Ringgold presented a tribute to her mother that also addresses African American culture and the struggles of women to overcome oppression.

associated with women, and to collaborate with her mother, Willi Posey, a fashion designer. After her mother's death in 1981, Ringgold created *Who's Afraid of Aunt Jemima?* (FIG. 31-6), a quilt composed of dyed, painted, and pieced fabric. A moving tribute to her mother, this "story quilt"—Ringgold's signature art form—merges

31-6A SIMPSON, Stereo Styles, 1988.

31-6B WEEMS, Man Smoking/ Malcolm X. 1990.

the personal and the political. Combining words with pictures, as did Barbara Kruger (FIG. 31-2) and David Wojnarowicz (FIG. 31-3), Ringgold incorporates a narrative in her quilt. Aunt Jemima tells the witty story of the family of the stereotypical black "mammy" in the mind of the public, but here Jemima is a successful African American businesswoman. Ringgold narrates the story using black dialect interspersed with embroidered portraits and traditional patterned squares. Aunt Jemima, while resonating with autobiographical references, also speaks to the larger issues of the history of African American culture

and the struggles of women to overcome oppression. Other contemporary feminist artists who have addressed similar racial and social issues are Lorna Simpson (b. 1960; Fig. 31-6A) and Carrie Mae Weems (b. 1953; Fig. 31-6B).

MELVIN EDWARDS In his art, Californian MELVIN EDWARDS (b. 1937) explores a very different aspect of the black experience in America—the history of collective oppression of African Americans. One of Edwards's major sculptural series focused on the metaphor of lynching to provoke thought about the legacy of racism. His Lynch Fragments series, produced over more than three decades beginning in 1963, encompassed more than 150 weldedsteel sculptures. Lynching as an artistic theme prompts an immediate and visceral response, conjuring chilling and gruesome images from the past. Edwards sought to extend this emotional resonance further in his art. He constructed the series' relatively small sculptures, such as Tambo (FIG. 31-7), from found metal objects—for example, chains, hooks, hammers, spikes, knife blades, and handcuffs. Although Edwards often intertwined or welded together the individual metal components so as to diminish immediate identification of them, the sculptures still retain a haunting connection to the overall theme. These works refer to a historical act that evokes a

31-7 Melvin Edwards, *Tambo*, 1993. Welded steel, 2' $4\frac{1}{8}$ " \times 2' $1\frac{1}{4}$ ". Smithsonian American Art Museum, Washington, D.C.

Edwards's welded sculptures of chains, spikes, knife blades, and other found objects allude to the lynching of African Americans and the continuing struggle for civil rights and an end to racism.

collective memory of oppression, but they also speak to the continuing struggle for civil rights and an end to racism. While growing up in Los Angeles, Edwards experienced racial conflict firsthand. Among the metal objects incorporated into his *Lynch Fragments* sculptures are items he found in the streets in the aftermath of the Watts riots in 1965. The inclusion of these found objects imbues his disquieting, haunting works with an even greater intensity.

JEAN-MICHEL BASQUIAT The work of JEAN-MICHEL BASQUIAT (1960–1988) focuses on still another facet of the minority cultural experience in America. Born in Brooklyn in a comfortable home—his father was an accountant from Haiti and his mother a black Puerto Rican—Basquiat rebelled against middleclass values, dropped out of school at 17, and took to the streets. He first burst onto the New York art scene as the anonymous author of witty graffiti in Lower Manhattan signed SAMO (a dual reference to the derogatory name *Sambo* for African Americans and to "same old shit"). Basquiat first drew attention as an artist in 1980 when he participated in a group show—the "Times Square Show"—in an abandoned 42nd Street building. Eight years later, after a meteoric rise to fame, he died of a heroin overdose at age 27.

31-8 Jean-Michel Basquiat, *Horn Players*, 1983. Acrylic and oil paintstick on three canvas panels, $8' \times 6'$ 3". Broad Foundation, Santa Monica.

In this tribute to two legendary African American musicians, Basquiat combined bold colors, fractured figures, and graffiti to capture the dynamic rhythms of jazz and the excitement of New York.

Basquiat was self-taught, both as an artist and about the history of art, but he was not a "primitive." His sophisticated style owes a debt to diverse sources, including the late paintings of Pablo Picasso, Abstract Expressionism, and the "art brut" of Jean Dubuffet (FIG. 30-4). Many of Basquiat's paintings celebrate black heroes, for example, the legendary jazz musicians Charlie "Bird" Parker and Dizzy Gillespie, whom he memorialized in *Horn Players* (FIG. 31-8). The fractured figures, the bold colors against a black background, and the deliberately scrawled, crossed-out, and misspelled graffiti ("ornithology"—the study of birds—is a pun on Parker's nickname) create a dynamic composition suggesting the rhythms of jazz music and the excitement of the streets of New York, "the city that never sleeps."

KEHINDE WILEY Many African American artists have lamented the near-total absence of blacks in Western painting and sculpture, except as servants (compare FIG. 31-13), as well as in histories of Western art until quite recently. Los Angeles native Kehinde Wiley (b. 1977) set out to correct that discriminatory imbalance. Wiley earned his MFA at Yale University and is currently artist-in-residence at the Studio Museum in Harlem, where he has achieved renown for his large-scale portraits of young urban African American men. Wiley's trademark paintings, however, are reworkings of historically important portraits in which he substitutes

31-9 Kehinde Wiley, Napoleon Leading the Army over the Alps, 2005. Oil on canvas, $9' \times 9'$. Brooklyn Museum, Brooklyn (Collection of Suzi and Andrew B. Cohen).

Wiley's trademark paintings are reworkings of famous portraits (FIG. 27-1A) in which he substitutes young African American men in contemporary dress in order to situate them in "the field of power."

figures of young black men in contemporary dress in order to situate them in what he calls "the field of power." One example is *Napoleon Leading the Army over the Alps* (FIG. 31-9), based on Jacques-Louis David's painting (FIG. 27-1A) of the same subject. To evoke the era of the original, Wiley presented his portrait of an African American Napoleon on horseback in a gilt wood frame. Although in many details an accurate reproduction of David's canvas, Wiley's version is not a slavish copy. His heroic narrative unfolds against a vibrantly colored ornate wallpaper-like background instead of a dramatic

31-9A PIULA, Ta Tele, 1988.

sky—a distinctly modernist reminder to the viewer that this is a painting and not a window onto an Alpine landscape.

CHRIS OFILI In the global artistic community of the contemporary world, the exploration of personal social, ethnic, and national identity is a universal theme. Three artists who, like Shahzia Sikander (FIG. 31-5), incorporate their

national artistic heritages in their work are Trigo Piula (b. ca. 1950; Fig. **31-9A**), Chris Ofili (b. 1968; Fig. 31-10), and Cliff Whiting (Fig. 31-11).

One theme Ofili has treated is religion, interpreted through the eyes of a British-born Catholic of Nigerian descent. Ofili's The Holy Virgin Mary (FIG. 31-10) depicts Mary in a manner that departs radically from conventional Renaissance representations. Ofili's work presents the Virgin in simplified form, and she appears to float in an indeterminate space. The artist employed brightly colored pigments, applied to the canvas in multiple layers of beadlike dots (inspired by images from ancient caves in Zimbabwe). Surrounding the Virgin are tiny images of genitalia and buttocks cut out from pornographic magazines, which, to the artist, parallel the putti often surrounding Mary in Renaissance paintings. Another reference to Ofili's African heritage surfaces in the clumps of elephant dung—one attached to the Virgin's breast, and two more on which the canvas rests, serving as supports. The dung enabled Ofili to incorporate Africa into his work in a literal way. Still, he wants the viewer to move beyond the cultural associations of the materials and see them in new ways.

31-10 Chris Ofili, *The Holy Virgin Mary*, 1996. Paper collage, oil paint, glitter, polyester resin, map pins, elephant dung on linen, $7' 11'' \times 5' 11\frac{5}{16}''$. Saatchi Collection, London.

Ofili, a British-born Catholic of Nigerian descent, represented the Virgin Mary with African elephant dung on one breast and surrounded by genitalia and buttocks. The painting produced a public outcry.

Not surprisingly, *The Holy Virgin Mary* elicited strong reactions. Its inclusion in the *Sensation* exhibition at the Brooklyn Museum in 1999 with other intentionally "sensational" works by young British artists prompted indignant (but unsuccessful) demands for cancellation of the show and countercharges of censorship (see "Public Funding of Controversial Art," page 944).

CLIFF WHITING In New Zealand today, some artists draw on their Maori heritage for formal and iconographic inspiration. The historic Maori woodcarving craft (FIGS. 36-1 and 36-19A) brilliantly reemerges in what CLIFF WHITING (TE WHANAU-A-APANUI, b. 1936) calls a "carved mural" (FIG. 31-11). Whiting's Tawhiri-Matea is a masterpiece in the venerable tradition of Oceanic wood sculpture, but it is a work designed for the very modern environment of an exhibition gallery. The artist suggested the wind turbulence with the restless curvature of the main motif and its myriad serrated edges. The 1984 mural depicts events in the Maori creation myth. The central figure, Tawhiri-Matea, god of the winds, wrestles to control the children of the four winds, seen as blue spiral forms. Ra, the sun, energizes the scene from the top left, complemented by Marama, the moon, in the opposite corner. The top right image refers to the primal separation of Ranginui, the Sky Father, and Papatuanuku, the Earth Mother. Spiral koru motifs symbolizing growth and energy flow through the composition. Blue waves and green fronds around Tawhiri suggest his brothers Tangaroa and Tane, gods of the sea and forest.

Whiting is securely at home with the native tradition of form and technique, as well as with the worldwide aesthetic of modern design. Out of the seamless fabric made by uniting both, he feels something new can develop that loses nothing of the power of the old. The artist champions not only the renewal of Maori cultural life and its continuity in art but also the education of the young in the values that made their culture great—values he asks them to perpetuate.

31-11 CLIFF WHITING (TE WHANAU-A-APANUI), Tawhiri-Matea (God of the Winds), 1984. Oil on wood and fiberboard, 6' $4\frac{3''}{8} \times 11'$ $10\frac{3''}{4}$. Meteorological Service of New Zealand, Wellington.

In this carved wooden mural depicting the Maori creation myth, Cliff Whiting revived Oceanic formal and iconographic traditions and techniques. The abstract curvilinear design suggests wind turbulence.

31-12 WILLIE BESTER, Homage to Steve Biko, 1992. Mixed media, $3' 7\frac{5''}{6} \times 3' 7\frac{5''}{6}$. Collection of the artist.

Homage to Steve Biko is a tribute to a leader of the Black Liberation movement, which protested apartheid in South Africa. References to the injustice of Biko's death fill this complex painting.

Political Art

Although almost all of the works discussed thus far are commentaries on contemporary society—seen through the lens of these artists' personal experiences—they do not incorporate references to specific events, nor do they address conditions affecting all people regardless of their gender, race, or national origin, for example, street violence, homelessness, and industrial pollution. Other artists, however, have confronted precisely those aspects of contemporary life in their work.

WILLIE BESTER Political oppression in South Africa figures prominently in the paintings of WILLIE BESTER (b. 1956), one of many South African artists who were vocal critics of apartheid (government-sponsored racial separation). Bester's 1992 *Homage to Steve*

Biko (FIG. 31-12) is a tribute to the gentle and heroic leader of the South African Black Liberation Movement whom the authorities killed while in detention. The exoneration of the two white doctors in charge of him sparked protests around the world. Bester packed his picture with references to death and injustice. Biko's portrait, at the center, is near another of the police minister, James Kruger, who had Biko transported 1,100 miles to Pretoria in the yellow Land Rover ambulance seen left of center and again beneath Biko's portrait. Bester portrayed Biko with his chained fists raised in the classic worldwide protest gesture. This portrait memorializes both Biko and the many other antiapartheid activists, as indicated by the white graveyard crosses above a blue sea of skulls beside Biko's head. The crosses stand out against a red background, recalling the inferno of burned townships. The stop sign (lower left) seems to mean "stop Kruger," or perhaps "stop apartheid." The tagged foot, as if in a morgue, above the ambulance (to the left) also refers to Biko's death. The red crosses on this vehicle's door and on Kruger's reflective dark glasses repeat, with sad irony, the graveyard crosses.

Blood-red and ambulance-yellow are in fact unifying colors dripped or painted on many parts of the canvas. Writing and numbers, found fragments and signs, both stenciled and painted—favorite Cubist motifs (FIGS. 29-14 and 29-16)—also appear throughout the composition. Numbers refer to dehumanized life under apartheid. Found objects—wire, sticks, cardboard, sheet metal, cans, and other discards—from which the poor construct fragile, impermanent township dwellings, remind viewers of the degraded lives of most South African people of color. The oilcan guitar (bottom center), another recurrent Bester symbol, refers both to the social harmony and joy provided by music and to the control imposed by apartheid policies. The whole composition is rich in texture and dense in its collage combinations of objects, photographs, signs,

symbols, and pigment. *Homage to Steve Biko* is a radical and powerful critique of an oppressive sociopolitical system, and it exemplifies the extent to which art can be invoked in the political process.

DAVID HAMMONS Racism of all kinds is a central theme of the work of David Hammons (b. 1943). Born in Springfield, Illinois, Hammons, an African American, moved to Los Angeles in 1962, where he studied art at the Chouinard and Otis Art Institutes before settling in Harlem in 1974. In his installations (artworks creating an artistic environment in a room or gallery), Hammons combines sharp social commentary with beguiling sensory elements to push viewers to confront racism in American society. He created Public Enemy (FIG. 31-13) for an exhibition at the Museum of Modern Art in New York in 1991. Hammons enticed viewers to interact with the installation by scattering fragrant autumn leaves on the floor and positioning helium-filled balloons throughout the gallery. The leaves crunched underfoot, and the dangling strings of the balloons gently brushed spectators walking around the installation. Once drawn into the environment, viewers encountered the centerpiece of Public Enemy-large black-and-white photographs of a public monument in front of the American Museum of Natural History in New York City depicting President Theodore Roosevelt (1858–1919) triumphantly seated on a horse, flanked by an African American man and a Native American man, both men appearing in the role of servants. Around the edge of the installation, circling the photographs of the monument, were piles of sandbags with both real and toy guns propped on top, aimed at the statue. By selecting evocative found objects and presenting them in a dynamic manner, encouraging viewer interaction, Hammons attracted an audience and then revealed the racism embedded in received cultural heritage and prompted reexamination of American values and cultural emblems.

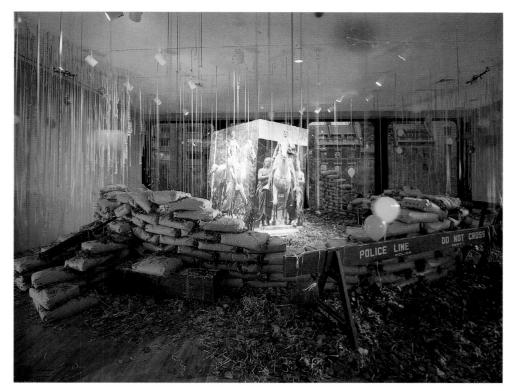

LEON GOLUB During his long and successful career as a painter, Leon Golub (1922–2004) expressed a brutal vision of contemporary life. Born in Chicago and trained at the University of Chicago and the Art Institute of Chicago, he is best known for his two series of paintings titled *Assassins* and *Mercenaries*. In these large-scale works on unstretched canvases, anonymous characters inspired by newspaper and magazine photographs participate in atrocious street violence, terrorism, and torture. The paintings have a universal impact because they suggest not specific stories but a condition of being. As Golub observed:

Through media we are under constant, invasive bombardment of images—from all over—and we often have to take evasive action to avoid discomforting recognitions. . . . The work [of art] should have an edge, veering between what is visually and cognitively acceptable and what might stretch these limits as we encounter or

31-13 DAVID HAMMONS, Public Enemy, installation at Museum of Modern Art, New York, 1991. Photographs, balloons, sandbags, guns, and other mixed media.

Hammons intended this multimedia installation, with Theodore Roosevelt flanked by an African American and a Native American as servants, to reveal the racism embedded in America's cultural heritage.

try to visualize the real products of the uses of power.²

Mercenaries IV (FIG. 31-14), a canvas rivaling the monumental history paintings of the 19th century in size, presents a mysterious tableau of five tough freelance military professionals willing to fight, for a price, for any political cause. The three clustering at the right side of the canvas react with tense physical gestures to something one of the two other mercenaries standing at the far left is saying. The dark uniforms and skin tones of the four black fighters flatten their figures and make them stand out against the searing dark

red background. The slightly modulated background seems to push their forms forward up against the picture plane and becomes an echoing void in the space between the two groups. Golub painted the mercenaries so that the viewer's eye is level with the menacing figures' knees. He placed the men so close to the front plane of the work that the lower edge of the painting cuts off their feet, thereby trapping the viewer in the painting's compressed space. Golub emphasized both the scarred light tones of the white mercenary's skin and the weapons. Modeled with shadow and gleaming highlights, the guns contrast with the harshly scraped, flattened surfaces of the figures. The rawness of the canvas reinforces the rawness of the imagery. Golub often dissolved certain areas with solvent after applying pigment and scraped off applied paint with, among other tools, a meat cleaver. The feeling of peril confronts viewers mercilessly. They become one with all the victims caught in today's political battles.

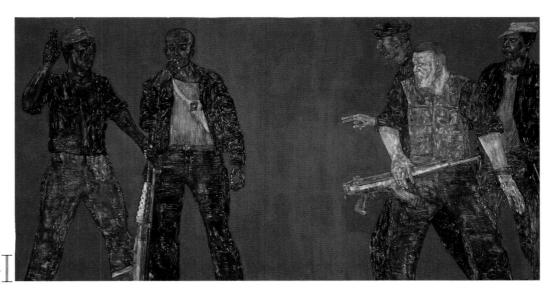

31-14 LEON GOLUB, Mercenaries IV, 1980. Acrylic on linen, $10' \times 19'$ 2". © Estate of Leon Golub/Licensed by VAGA, New York, NY. Courtesy Ronald Feldman Gallery.

The violence of contemporary life is the subject of Golub's huge paintings. Here, five mercenaries loom over the viewer, instilling a feeling of peril. The rough textures reinforce the raw imagery.

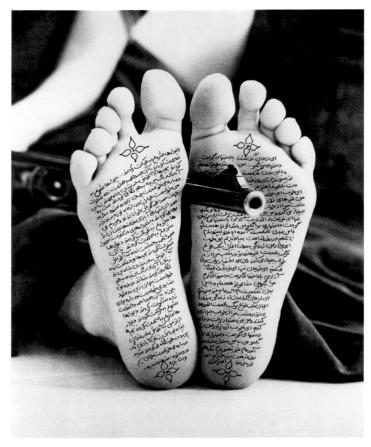

31-15 Shirin Neshat, *Allegiance and Wakefulness*, 1994. Offset print. Israel Museum, Jerusalem.

Neshat's photographs address the repression of women in postrevolutionary Iran. She poses in traditional veiled garb but wields a rifle and displays militant Farsi poetry on her exposed body parts.

SHIRIN NESHAT Violence also plays a significant role in the art of Shirin Neshat (b. 1957), who grew up in a Westernized Iranian home and attended a Catholic boarding school in Tehran before leaving her homeland to study art in California, where she earned undergraduate and graduate degrees from the University of California, Berkeley. Today, she lives in New York City and produces films, video, and photographs critical of the fundamentalist Islamic regime in Iran, especially in its treatment of women. Neshat often poses for her photographs wearing a veil—the symbol for her of the repression of Muslim women—and with her face and exposed parts of her body covered with Farsi (Persian) messages. A rifle often figures prominently in the photographs as an emblem of militant feminism, a notion foreign to the Muslim faith. In Allegiance and Wakefulness (FIG. 31-15) from her Women of Allah series, the viewer sees only Neshat's feet covered with verses of militant Farsi poetry and the barrel of a rifle.

KRZYSZTOF WODICZKO Born in Poland, Krzysztof Wodiczko (b. 1943) focuses on more universal concerns in his art. When working in Canada in 1980, he developed artworks involving outdoor slide images. He projected photographs on specific buildings to expose how civic buildings embody, legitimize, and perpetuate power. When Wodiczko moved to New York City in 1983, the pervasive homelessness troubled him, and he resolved to use his art to publicize this problem. In 1987, he produced *The Home-*

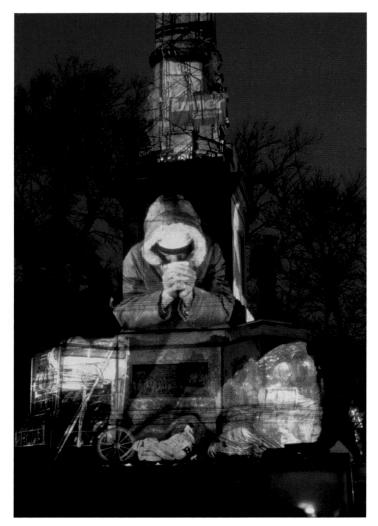

31-16 Krzysztof Wodiczko, The Homeless Projection, 1986. Outdoor slide projection at the Civil War Soldiers and Sailors Monument, Boston.

To publicize their plight, Wodiczko projected on the walls of a monument on Boston Common images of homeless people and their plastic bags filled with their few possessions.

less Projection (FIG. 31-16) as part of a New Year's celebration in Boston. The artist projected images of homeless people on all four sides of the Civil War Soldiers and Sailors Monument on Boston Common. In these photos, the homeless appear flanked by plastic bags filled with their few possessions. At the top of the monument, Wodiczko projected a local condominium construction site, which helped viewers make a connection between urban development and homelessness.

HANS HAACKE Some contemporary artists have produced important works exposing the politics of the art world itself, specifically the role of museums and galleries in validating art, the discriminatory policies and politics of these cultural institutions, and the corrupting influence of corporate sponsorship of art exhibitions. German artist Hans Haacke (b. 1936) has focused his attention on the politics of art museums and how acquisition and exhibition policies affect the public's understanding of art history. The specificity of his works, based on substantial research, makes them stinging indictments of the institutions whose practices he critiques.

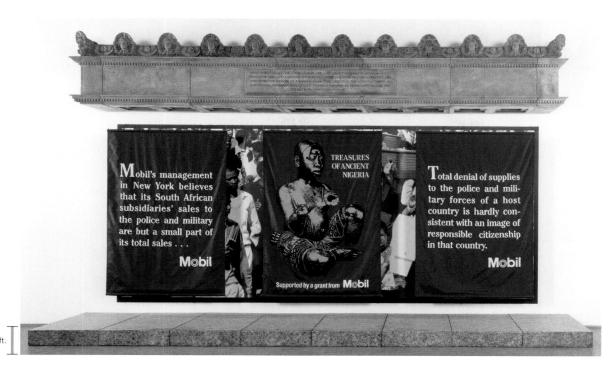

31-17 Hans Haacke, MetroMobiltan, 1985. Fiberglass construction, three banners, and photomural, 11' 8" \times 20' \times 5'. Musée National d'Art Moderne, Centre Georges Pompidou, Paris.

MetroMobiltan focuses attention on the connections between political and economic conditions in South Africa and the conflicted politics of corporate patronage of art exhibitions.

In MetroMobiltan (FIG. 31-17), Haacke illustrated the connection between the realm of art (more specifically, the Metropolitan Museum of Art in New York) and the world of political and economic interests. MetroMobiltan is a large sculptural work that includes a photomural of the funeral procession for black victims shot by the South African police at Cross Roads, near Cape Town, on March 16, 1985. This photomural serves as the backdrop for a banner for the 1980 Mobil Oil-sponsored Metropolitan Museum show Treasures of Ancient Nigeria. In 1980, Mobil was a principal investor in South Africa, and Haacke's work suggests one major factor in Mobil's sponsorship of this exhibition was that Nigeria is one of the richest oil-producing countries. In 1981, political activists pressured Mobil's board of directors to stop providing oil to the white South African military and police. Printed on the blue banners hanging on either side of Metro-Mobiltan is the official corporate response refusing to comply with this demand. Haacke set the entire tableau in a fiberglass replica of the Metropolitan Museum's entablature. By bringing together these disparate visual and textual elements referring to the museum, Mobil Oil, and Africa, the artist forced viewers to think about the connections among multinational corporations, political and economic conditions in South Africa, and the conflicted politics of corporate patronage of art exhibitions, thereby undermining the public's naive view that cultural institutions are exempt from political and economic concerns.

XU BING A different kind of political/cultural commentary has been the hallmark of Xu Bing (b. 1955), a Chongqing, China, native who was forced to work in the countryside with peasants during the Cultural Revolution of 1966 to 1976 under Mao Tse-tung (1893–1976). Xu later studied printmaking in Beijing at the Central Academy of Fine Arts. He moved to the United States in 1990 at the invitation of the University of Wisconsin, where two years earlier he had exhibited his most famous work, a large installation called *A Book from the Sky* (Fig. **31-18**). First exhibited in China and Japan before being installed at Wisconsin's Chazen Museum of Art, the work presents an enormous number of woodblock-printed texts in characters evocative of Chinese writing but invented by the artist.

Producing them required both an intimate knowledge of genuine Chinese characters and extensive training in block carving. Xu's work, however, is no hymn to tradition. Critics have interpreted it both as a stinging critique of the meaninglessness of contemporary political language and as a commentary on the illegibility of the past. Like many works of art, past and present, Eastern and Western, Xu's postmodern masterpiece can be read on many levels.

31-18 Xu Bing, *A Book from the Sky*, 1987. Installation at Chazen Museum of Art, University of Wisconsin, Madison, 1991. Moveable-type prints and books.

Xu trained as a printmaker in Beijing. A Book from the Sky, with its invented Chinese woodblock characters, may be a stinging critique of the meaninglessness of contemporary political language.

31-19 EDWARD BURTYNSKY, Densified Scrap Metal #3a, Hamilton, Ontario, 1997. Dye coupler print, $2' 2^{3''}_8 \times 2' 10^{3''}_8$. National Gallery of Canada, Ottawa (gift of the artist, 1998).

Burtynsky's "manufactured landscapes" are commentaries on the destructive effects on the environment of industrial plants and mines, but his photographs transform ugliness into beauty.

1 ft.

EDWARD BURTYNSKY Concern with the destructive effects of industrial plants and mines on the environment has been the motivation for the photographs of "manufactured landscapes" by Canadian EDWARD BURTYNSKY (b. 1955). The son of a Ukrainian immigrant who worked in the General Motors plant in St. Catharines, Ontario, Burtynsky studied photography and graphic design at Ryerson University and Niagara College. He uses a large-format field camera to produce high-resolution negatives of industrial landscapes littered with tires, scrap metal, and industrial refuse. His choice of subjects is itself a negative commentary on modern manufacturing processes, but Burtynsky transforms ugliness into beauty in his color prints. His photograph (FIG. 31-19) of a Toronto recycling plant from his Urban Mines series converts bundles of compressed scrap metal into a striking abstract composition of multicolored rectangles. Burtynsky's work thus merges documentary and fine-art photography and bears comparison with the photographs of Margaret Bourke-White (FIG. 29-76) and Minor White (FIG. 30-32).

OTHER MOVEMENTS AND THEMES

Despite the high visibility of contemporary artists whose work deals with the pressing social and political issues of the world, some critically acclaimed living artists have produced innovative modernist art during the postmodern era. Abstraction remains a valid and compelling approach to painting and sculpture in the 21st century, as does more traditional figural art.

Abstract Painting and Sculpture

Already in the 1970s, Susan Rothenberg (FIG. 30-8D) had produced monumental "Neo-Expressionist" paintings inspired by German Expressionism and American Abstract Expressionism. Today, sev-

eral important contemporary artists continue to explore this dynamic style.

JULIAN SCHNABEL New Yorker Julian Schnabel (b. 1951), who wrote and directed a 1996 film about fellow artist Jean-Michel Basquiat (FIG. 31-8), has experimented widely with media and materials in his forceful restatements of the premises of Abstract Expressionism. Schnabel's Neo-Expressionist works range from paint on velvet and tarpaulin to a mixture of pigment and fragmented china plates bonded to wood. He has a special interest in the physicality of objects, and by combining broken crockery and paint, as in The Walk Home (FIG. 31-20), he has found an extension of what paint can do. Superficially, Schnabel's paintings recall the work of the gestural abstractionists, especially the spontaneous drips of Jackson Pollock (FIG. 30-6) and the energetic brushstrokes of Willem de Kooning (FIG. 30-8), but their Abstract Expressionist works lack the thick, mosaiclike texture of Schnabel's canvases. The amalgamation of media brings together painting, mosaic, and low-relief sculpture, and considerably amplifies the expressive impact of his paintings.

ANSELM KIEFER Neo-Expressionism was by no means a solely American movement. German artist Anselm Kiefer (b. 1945), who studied art in Düsseldorf with Joseph Beuys (Fig. 30-52) in the early 1970s, and has lived and worked in Barjac, France, since 1992, has produced some of the most lyrical and engaging works of recent decades. Like Schnabel's canvases, Kiefer's paintings, such as Nigredo (Fig. 31-21), are monumental in scale, recall Abstract Expressionist works, and draw the viewer to their textured surfaces, made more complex by the addition of materials such as straw and lead. It is not merely the impressive physicality of Kiefer's paintings that accounts for the impact of his work, however. His images function on a mythological or metaphorical level as well as on a historically specific one. Kiefer's works of the 1970s and 1980s often involve a reexamination of German history, particularly the painful Nazi era of 1933–1945, and evoke the feeling of despair.

31-20 JULIAN SCHNABEL, *The Walk Home*, 1984–1985. Oil, plates, copper, bronze, fiberglass, and Bondo on wood, 9′ 3″ × 19′ 4″. Broad Art Foundation and the Pace Gallery, New York. ■4

Schnabel's paintings recall the work of the gestural abstractionists, but he employs an amalgamation of media, bringing together painting, mosaic, and low-relief sculpture.

Kiefer believes Germany's participation in World War II and the Holocaust left permanent scars on the souls of the German people and on the souls of all humanity.

Nigredo (blackening) pulls the viewer into an expansive landscape depicted using Renaissance perspective principles. This landscape, however, is far from pastoral or carefully cultivated. Rather, it appears bleak and charred. Although it does not make specific reference to the Holocaust, this incinerated landscape indirectly alludes to the horrors of that historical event. More generally, the blackness of the landscape may refer to the notion of alchemical change or transformation, a concept of great interest to Kiefer. Black is one of the four symbolic colors of the alchemist—a color referencing both death and the molten, chaotic state of substances broken down by fire. Because the alchemist focuses on the transformation of substances, the emphasis on blackness is not absolute, but can also be perceived as part of a process of renewal and redemption. Kiefer thus imbued his work with a deep symbolic meaning that, when combined with the intriguing visual quality of his parched, congealed surfaces, results in paintings of enduring power.

31-21 Anselm Kiefer, Nigredo, 1984. Oil paint on photosensitized fabric, acrylic emulsion, straw, shellac, relief paint on paper pulled from painted wood, 11' × 18'. Philadelphia Museum of Art, Philadelphia (gift of Friends of the Philadelphia Museum of Art).

Kiefer's paintings have thickly encrusted surfaces incorporating materials such as straw. Here, the German artist used perspective to pull the viewer into an incinerated landscape alluding to the Holocaust.

31-22 Wu Guanzhong, Wild Vines with Flowers Like Pearls, 1997. Ink on paper, $2' 11\frac{1}{2}'' \times 5' 11''$. Singapore Art Museum, Singapore (donation from Wu Guanzhong).

In a brilliant fusion of traditional Chinese subject matter and technique with modern Western Abstract Expressionism, Wu depicted the wild vines of the Yangtze River valley.

humankind's position as part of the totality of nature (see "Shinto," Chapter 17, page 479) holds great appeal for contemporary artists such as KIMIO TSUCHIYA (b. 1955), who studied sculpture in London and Tokyo. Tsuchiya is best known for his large-scale sculptures (FIG. 31-23) constructed of branches or driftwood. Despite their abstract nature, his works assert the life forces found in natu-

ral materials, thereby engaging viewers in a consideration of their

WU GUANZHONG Abstraction is a still-vital pictorial mode in Asia, where the most innovative artists working in the Neo-Expressionist mode have merged Western and Eastern traditions in their work. Wu Guanzhong (1919-2010) attended the National Art College in Hangzhou, graduating in 1942, and then studied painting in Paris at the École Nationale Supérieure des Beaux-Arts from 1946 to 1950, when he returned to China to take up teaching positions at several prestigious art academies. His early work, reflecting his exposure to the Western tradition, was primarily oil painting on canvas, but in the 1970s he began to embrace the traditional Chinese medium of ink and color on paper, later often restricting his palette only to ink. His mature work, for example, Wild Vines with Flowers Like Pearls (FIG. 31-22), painted in 1997, combines the favored medium as d subject matter of the centuries-old literati tradition—the 17th-century paintings of Shitao (FIG. 33-15) were important forerunners—with an abstract style strongly influenced by Pollock. American Abstract Expressionist painting was politically impossible to pursue during the Cultural Revolution, when Wu, like Xu Bing (FIG. 31-18), was sentenced to labor on a rural farm because of his refusal to conform to official doctrine.

The inspiration for *Wild Vines*, as for so many of Wu's paintings, was the mountainous landscape and forests of the Yangtze

31-22A Song, Summer Trees, 1983.

31-22B KNGWARREYE, Untitled,

River. The free composition and bold thick brushstrokes brilliantly balance abstract, sweeping, crisscrossing lines with the suggestive shapes of vines and flowers. His work, like that of Song Su-Nam (b. 1938; FIG. 31-22A) in Korea and EMILY KAME KNGWARREYE (1910–1996; FIG. 31-22B) in Australia, represents a highly successful fusion of traditional local and modern Western style and subject matter.

KIMIO TSUCHIYA In contemporary Japan, as in China, no single artistic style, medium, or subject dominates, but much of the art produced during the past few decades springs from ideas or beliefs integral to the national culture over many centuries. For example, the Shinto belief in the generative forces in nature and in

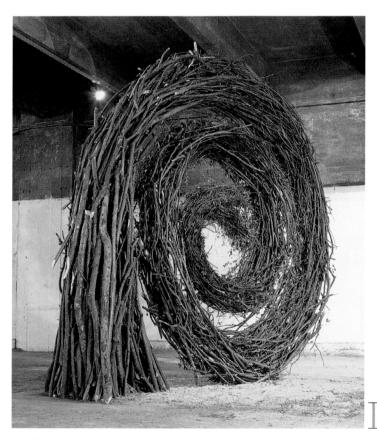

31-23 Kimio Tsuchiya, *Symptom*, 1987. Branches, 13' $1\frac{1}{2}'' \times 14'$ $9\frac{1}{8}'' \times 3'$ $11\frac{1}{4}''$. Installation at the exhibition *Jeune Sculpture* '87, Paris 1987.

Tsuchiya's sculptures consist of branches or driftwood, and despite their abstract nature, they assert the life forces found in natural materials. His approach to sculpture reflects ancient Shinto beliefs.

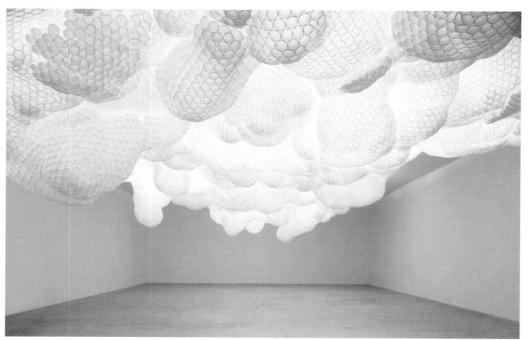

31-24 TARA DONOVAN, *Untitled*, 2003. Styrofoam cups and hot glue, variable dimensions. Installation at the Ace Gallery, Los Angeles, 2005.

Donovan's sculptures consist of everyday components, such as straws, plastic cups, and wire. The abstract forms suggest rolling landscapes, clouds, fungus, and other natural forms.

of Egon Schiele (FIG. 29-10), despite the vivid contrast between Schiele's emaciated body and Saville's obesity.

Saville's paintings are a commentary on the contemporary obsession with the lithe bodies of fashion models. In *Branded* (FIG. **31-25**), she underscores the dichotomy between the popular notion of a beautiful body and the imperfect bodies of

most people by "branding" her body with words inscribed in her flesh—delicate, decorative, petite. Art critic Michelle Meagher has described Saville's paintings as embodying a "feminist aesthetics of disgust."

own relationship to nature. Tsuchiya does not specifically invoke Shinto when speaking about his art, but it is clear he has internalized Shinto principles. He identifies as his goal "to bring out and present the life of nature emanating from this energy of trees. . . . It is as though the wood is part of myself, as though the wood has the same kind of life force."³

TARA DONOVAN Brooklynite Tara Donovan (b. 1969) studied at the School of Visual Arts in New York City, the Corcoran College of Art and Design in Washington, D.C., and Virginia Commonwealth University in Richmond. She was the first recipient (in 2005) of the Alexander Calder Foundation's Calder Prize for sculpture. Donovan has won an international reputation for her installations (FIG. 31-24) of large sculptural works composed of thousands of small everyday objects, such as toothpicks, straws, pins, paper plates, plastic cups, and electrical wire. Her abstract sculptures often suggest rolling landscapes, clouds, fungus, and other natural forms, although she seeks in her work not to mimic those forms but to capture nature's dynamic growth. Some of Donovan's installations are unstable and can change shape during the course of an exhibition.

Figural Painting and Sculpture

Recent decades have brought a revival of interest in figural art, both in painting and sculpture, a trend best exemplified in the earlier postwar period by Lucian Freud (FIG. 30-29), who remains an active and influential painter.

JENNY SAVILLE Fellow Briton JENNY SAVILLE (b. 1970) is the leading figure painter in the Freud mold of the younger generation of European and American artists. Born in Cambridge, England, and trained at the Glasgow School of Art in Scotland, Saville lives and paints in an old palace in Palermo, Italy. Her best-known works are over-life-size self-portraits in which she exaggerates the girth of her body and delights in depicting heavy folds of flesh with visible veins in minute detail and from a sharply foreshortened angle, which further distorts the body's proportions. Her nude self-portraits deserve comparison not only with those of Freud but also

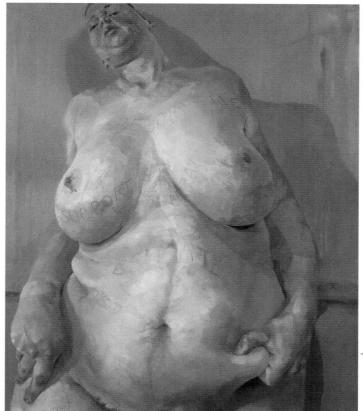

31-25 Jenny Saville, *Branded*, 1992. Oil on canvas, $7' \times 6'$. Charles Saatchi Collection, London.

Saville's unflattering foreshortened self-portrait "branded" with words such as *delicate* and *petite* underscores the dichotomy between the perfect bodies of fashion models and those of most people.

KIKI SMITH A distinctly unflattering approach to the representation of the human body is also the hallmark of New York-based Kiki Smith (b. 1954), the daughter of Minimalist sculptor Tony Smith (Fig. 30-17). In her work, Smith has explored the question of who controls the human body, an interest that grew out of her training as an emergency medical service technician. Smith, however, also wants to reveal the socially constructed nature of the body, and she encourages the viewer to consider how external forces shape people's perceptions of their bodies. In works such as *Untitled* (Fig. 31-26), the artist dramatically departed from conventional representations of the body, both in art and in the media. She suspended two life-size wax figures, one male and one female, both nude, from metal stands. Smith marked each of the sculptures with long white drips—body fluids running from the woman's breasts and down the man's leg. She commented:

Most of the functions of the body are hidden . . . from society. . . . [W]e separate our bodies from our lives. But, when people are

dying, they are losing control of their bodies. That loss of function can seem humiliating and frightening. But, on the other hand, you can look at it as a kind of liberation of the body. It seems like a nice metaphor—a way to think about the social—that people lose control despite the many agendas of different ideologies in society, which are trying to control the body(ies) . . . medicine, religion, law, etc. Just thinking about control—who has control of the body? . . . Does the mind have control of the body? Does the social?⁵

JEFF KOONS The sculptures of JEFF KOONS (b. 1955) form a striking counterpoint to the figural art of Kiki Smith. Trained at the Maryland Institute College of Art in Baltimore, Koons worked early in his career as a commodities broker. He first became prominent in the art world for a series of works in the early 1980s involving the exhibition of everyday commercial products such as vacuum cleaners. Clearly following in the footsteps of Marcel Duchamp (FIG. 29-27), Koons made no attempt to manipulate or

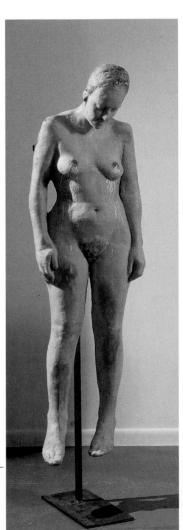

31-26 Kiki Smith, *Untitled*, 1990. Beeswax and microcrystalline wax figures on metal stands, female figure installed height 6' 1^{1}_{2} " and male figure installed height 6' 5". Whitney Museum of American Art, New York (purchased with funds from the Painting and Sculpture Committee).

Asking "Who controls the body?" Kiki Smith sculpted two life-size wax figures of a nude man and woman with body fluids running from the woman's breasts and down the man's leg.

31-27 JEFF KOONS, *Pink Panther*, 1988. Porcelain, 3′ 5″ high. Museum of Contemporary Art, Chicago (Gerald S. Elliot Collection). ■

Koons creates sculptures highlighting everything he considers wrong with contemporary American consumer culture. In this work, he intertwined a centerfold nude and a cartoon character.

31-27A ARNESON, California Artist, 1982.

alter the machine-made objects. More recently, he, like Californian Robert Arneson (1930–1992; Fig. 31-27A), turned to ceramic sculpture. In *Pink Panther* (Fig. 31-27), Koons, who divides his time between his hometown of York, Pennsylvania, and New York City, intertwined a magazine centerfold nude with a famous cartoon character. He reinforced the trite and kitschy nature of this imagery by titling the exhibition of which this work was a part *The Banality Show*. Some art critics have argued Koons and his work instruct viewers because both artist and artwork serve as the most visible symbols of everything wrong with contemporary American society. Regardless of whether this is true, Koons's prominence in

the art world indicates he has developed an acute understanding of the dynamics of consumer culture.

MARISOL ESCOBAR Known simply by her first name, Marisol Escobar (b. 1930) grew up in a wealthy, widely traveled Venezuelan family. Born in Paris and educated there, in Los Angeles, and in New York City, Marisol first studied painting and drawing, but after discovering Pre-Columbian art in 1951, she pursued a career as a sculptor. Marisol also spent time in Italy, where she developed a deep admiration for Renaissance art.

In the 1960s, Marisol was one of the inner circle of New York Pop artists, and she appeared in two of Andy Warhol's films. Some of her works at that time portrayed prominent public figures, including the Hollywood actor John Wayne and the family of U.S. president John F. Kennedy. Her subjects were always people, however, not the commercial products of consumer culture that fascinated most leading Pop artists and still are prominent in the art of Jeff Koons and others.

Marisol retained her interest in figural sculpture long after Pop Art gave way to other movements. One of her most ambitious works (FIG. 31-28) is a multimedia three-dimensional version of Leonardo da Vinci's *Last Supper* (FIG. 22-4), including the walls and windows of the dining room in order to replicate the Renaissance master's application of linear perspective. By reproducing the fresco in three dimensions, she transformed it into an object. Marisol's figures are painted wood, with the exception of Christ, whose stone body is the physical and emotional anchor of the composition. In many of her sculptures, the female figures have Marisol's features, and in this tableau she added a seated armless portrait of herself looking at the Last Supper. Catholic and deeply religious—as a teenager she emulated martyr saints by inflicting physical harm on herself-Marisol may have wanted to show herself as a witness to Christ's last meal. But more likely her presence here is a tribute to the 16th-century painter. (She also made a sculptural replica of Leonardo's Madonna and Child with Saint Anne [FIG. 22-3].)

Marisol's Self-Portrait Looking at the Last Supper is a commentary on the artist not only as a creator but also as a viewer of the works of earlier artists, a link in an artistic chain extending back to antiquity. One pervasive element in the work

31-28A TANSEY, A Short History of Modernist Painting, 1982.

of contemporary artists is a self-consciousness of the postmodern painter or sculptor's position in the continuum of art history. No one better exemplifies that aspect of contemporary art than MARK TANSEY (b. 1949; FIG. 31-28A).

KANE KWEI AND PAA JOE Painted wood sculpture remains a vital artistic medium in Africa, where it has a venerable heritage throughout the continent (see Chapters 19 and 37). Some contemporary African artists have pioneered new forms, however,

31-28 Marisol Escobar, Self-Portrait Looking at the Last Supper, 1982–1984. Painted wood, stone, plaster, and aluminum, $10' 1\frac{1}{2}'' \times 29' 10'' \times 5' 1''$. Metropolitan Museum of Art, New York (gift of Mr. and Mrs. Roberto C. Polo, 1986).

In a tribute to the Renaissance master, Marisol created a sculptural replica of Leonardo's Last Supper (FIG. 22-4), transforming the fresco into an object. She is the seated viewer as well as the artist.

31-29 PAA JOE, running shoe, airplane, automobile and other coffins inside the artist's showroom in Teshi, Ghana, 2000. Painted wood.

The caskets of Paa Joe take many forms, including items of clothing, airplanes, and automobiles. The forms always relate to the deceased, but many collectors buy the caskets as art objects.

often under the influence of modern Western art movements. Kane Kwei (1922–1992) of the Ga people in urban coastal Ghana created a new kind of wooden casket that brought him both critical acclaim and commercial success. Beginning around 1970, Kwei, trained as a carpenter, created one-of-a-kind coffins crafted to reflect the deceased's life, occupation, or major accomplishments. On commission he made such diverse shapes as a cow, a whale, a bird, a Mercedes Benz, and various local food crops, such as onions and cocoa pods, all pieced together using nails and glue rather than carved. Kwei also created coffins in traditional African leaders' symbolic forms, such as an eagle, an elephant, a leopard, and a stool.

Kwei's sons and his cousin PAA JoE (b. 1944) have carried on his legacy. In a photograph (FIG. 31-29) shot around 2000 outside Joe's showroom in Teshi, several large caskets are on display, including a running shoe, an airplane, and an automobile. Many of the coffins Kwei and Joe produced never served as burial containers. Collectors and curators purchased them for display in private homes, art galleries, and museums. The coffins' forms, derived from popular culture, strike a familiar chord in the Western world because they recall Pop Art sculptures (FIG. 30-26), which accounts in large part for the international appeal of Kwei and Joe's work.

ARCHITECTURE AND SITE-SPECIFIC ART

The work of architects and Environmental artists today is as varied as that of contemporary painters and sculptors, but the common denominator in the diversity of contemporary architectural design and site-specific projects is the breaking down of national boundaries, with leading practitioners working in several countries and even on several continents, often simultaneously.

Architecture

In the late 20th and early 21st century, one of the by-products of the globalization of the world's economy has been that leading architects have received commissions to design buildings far from their home bases. In the rapidly developing emerging markets of Asia, the Middle East, Africa, Latin America, and elsewhere, virtually every architect with an international reputation can list a recent building in Beijing or another urban center on his or her résumé.

NORMAN FOSTER Award-winning architect Norman Foster (b. 1935) began his study of architectural design at the University of Manchester, England. After graduating, he won a fellowship to attend the master's degree program at the Yale School of Architecture, where he met Richard Rogers (FIG. 30-49). The two decided to open a joint architectural firm when they returned to London in 1962, but they established separate practices several years later. Their designs still have much in common, however,

31-30 NORMAN FOSTER, Hong Kong and Shanghai Bank (looking southwest), Hong Kong, China, 1979–1986.

Foster's High-Tech tower has an exposed steel skeleton featuring floors with uninterrupted working spaces. At the base is a 10-story atrium illuminated by computerized mirrors that reflect sunlight.

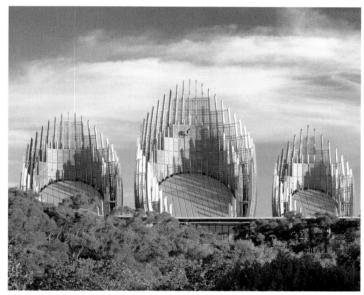

31-31 Renzo Piano, aerial view (*top*; looking northwest) and three "huts" (*bottom*; looking southeast), Tjibaou Cultural Centre, Noumea, New Caledonia, 1998.

A pioneering example of "green architecture," Piano's complex of 10 bamboo units, based on traditional New Caledonian village huts, has adjustable skylights in the roofs for natural climate control.

because they share a similar outlook. Foster and Rogers are the leading proponents of what critics call *High-Tech* architecture, the roots of which can be traced to Joseph Paxton's mid-19th-century Crystal Palace (FIG. 27-47) in London. High-Tech architects design buildings incorporating the latest innovations in engineering and technology and exposing the structures' component parts. High-Tech architecture is distinct from other postmodern architectural movements in dispensing with all historical references.

Foster's design for the headquarters (FIG. 31-30) of the Hong Kong and Shanghai Bank Corporation (HSBC), which cost \$1 billion to build, exemplifies the High-Tech approach to architecture. The banking tower is as different from Philip Johnson's postmodern AT&T Building (FIG. 30-46) as it is from the modernist glass-and-steel Seagram Building (FIG. 30-43) and Sears Tower (FIG. 30-44). The 47-story Hong Kong skyscraper has an exposed steel skeleton with the elevators and other service elements located in giant piers at the short ends of the building, a design that provides uninterrupted communal working spaces on each cantilevered floor. Foster divided the tower into five horizontal units of six to nine floors

each that he calls "villages," suspended from steel girders resembling bridges. Escalators connect the floors in each village—the floors are related by function—but the elevators stop at only one floor in each community of floors. At the base of the building is a plaza opening onto the neighboring streets. Visitors ascend on escalators from the plaza to a spectacular 10-story, 170-feet-tall atrium bordered by balconies with additional workspaces. What Foster calls "sun scoops"—computerized mirrors on the south side of the building—track the movement of the sun across the Hong Kong sky and reflect the sunlight into the atrium and piazza, flooding the dramatic spaces with light at all hours of the day. Not surprisingly, the roof of this High-Tech skyscraper serves as a landing pad for corporate helicopters.

GREEN ARCHITECTURE The harnessing of solar energy as a power source is one of the key features of what critics commonly refer to as green architecture—ecologically friendly buildings that use "clean energy" and sustain the natural environment. Green architecture is the most important trend in architectural design in the early 21st century. A pioneer in this field is Renzo Piano, the codesigner with Richard Rogers of the Pompidou Center (FIG. 30-49) in Paris. Piano won an international competition to design the Tjibaou Cultural Centre (FIG. 31-31, left) in Noumea, New Caledonia. Named in honor of the assassinated political leader Jean-Marie Tjibaou (1936-1989), the center consists of 10 beehive-shaped bamboo "huts" nestled in pine trees on a narrow island peninsula in the Pacific Ocean. Rooted in the village architecture of the Kanak people of New Caledonia (see Chapter 36), each unit of Piano's postmodern complex has an adjustable skylight as a roof (FIG. 31-31, right) to provide natural—sustainable—climate control. The curved profile of the Tjibaou pavilions also helps the structures withstand the pressure of the hurricane-force winds common in the South Pacific.

31-32 GÜNTER BEHNISCH, Hysolar Institute (looking north), University of Stuttgart, Stuttgart, Germany, 1987.

The roof, walls, and windows of the Deconstructivist Hysolar Institute seem to explode, avoiding any suggestion of stable masses and frustrating viewers' expectations of how a building should look

DECONSTRUCTIVISM In architecture, as in painting and sculpture, deconstruction as an analytical and design strategy emerged in the 1970s. The name given to this postmodern architectural movement is Deconstructivism. Deconstructivist architects attempt to disrupt the conventional categories of architecture and to rupture the viewer's expectations based on them. Destabilization plays a major role in Deconstructivist architecture. Disorder, dissonance, imbalance, asymmetry, irregularity, and unconformity replace their opposites—order, harmony, balance, symmetry, regularity, and clarity. The seemingly haphazardly presented volumes, masses, planes, borders, lighting, locations, directions, spatial relations, as well as the disguised structural facts of Deconstructivist design, challenge the viewer's assumptions about architectural form as it relates to function. According to Deconstructivist principles, the very absence of the stability of traditional categories of architecture in a structure announces a "deconstructed" building.

GÜNTER BEHNISCH Audacious in its dissolution of form is the Hysolar Institute (FIG. 31-32) at the University of Stuttgart, Germany, by GÜNTER BEHNISCH (1922–2010). Behnisch, who gained

international attention as the architect of the Olympic Park in Munich for the 1972 Olympic Games, designed the institute as part of a joint German–Saudi Arabian research project on the technology of solar energy. In the Hysolar Institute, Behnisch intended to deny the possibility of spatial enclosure altogether, and his apparently chaotic arrangement of the structural units defies easy analysis. The shapes of the roof, walls, and windows seem to explode, avoiding any suggestion of clear, stable masses. Behnisch aggressively played with the traditional concepts of architectural design. The disordered architectural elements of the Hysolar Institute seem precarious and visually threaten to collapse, frustrating the viewer's expectations of how a building should look.

FRANK GEHRY The architect most closely identified with Deconstructivist architecture is Canadian Frank Gehry (b. 1929). Trained in sculpture, and at different times a collaborator with Donald Judd (Fig. 30-18) and Claes Oldenburg (Fig. 30-26), Gehry works up his designs by constructing models and then cutting them up and arranging the parts until he has a satisfying composition. Among Gehry's most notable projects is the Guggenheim Museum (Figs. 31-33 and 31-34) in Bilbao, Spain, one

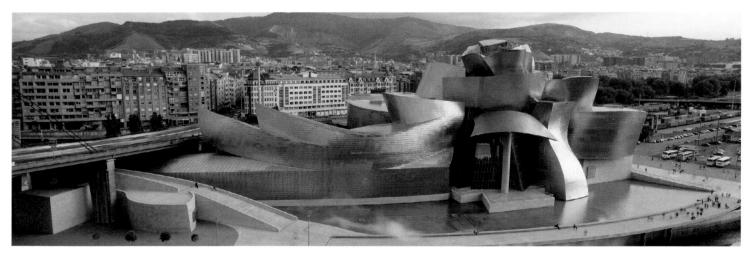

31-33 Frank Gehry, Guggenheim Bilbao Museo (looking south), Bilbao, Spain, 1997.

Gehry's limestone-and-titanium Bilbao museum is an immensely dramatic building. Its disorder and seeming randomness of design epitomize Deconstructivist architectural principles.

Frank Gehry on Architectural Design and Materials

Frank Gehry has been designing buildings since the 1950s, but only in the 1970s did he begin to break away from the rectilinearity of modernist architecture and develop the dramatic sculptural style seen in buildings such as the Guggenheim Museum (FIGS. 31-33 and 31-34) in Bilbao. In 1999, the Deconstructivist architect reflected on his career and his many projects in a book simply titled *Gehry Talks*.

My early work was rectilinear because you take baby steps. I guess the work has become a kind of sculpture as architecture. . . . I'm a strict modernist in the sense of believing in purity, that you shouldn't decorate. And yet buildings need decoration, because

they need scaling elements. They need to be human scale, in my opinion. They can't just be faceless things. That's how some modernism failed.*

They teach materials and methods in architecture school, as a separate course. I'm a craftsman. . . . It seems to me that when you're doing architecture, you're building something out of something. There are social issues, there's context, and then there's how do you make the enclosure and what do you make it with? . . . I explored metal: how it dealt with the light . . . It does beautiful things with light Flat was a fetish, and everybody was doing that. I found out that I could use metal if I didn't worry about it being flat; I could do it cheaper. It was intuitive. I just went with it. I liked it. Then when I saw it on the building, I loved it. . . . Bilbao . . . [is] titanium. . . . [I] prefer titanium because it's stronger; it's an element, a pure element, and it doesn't oxidize. It stays the same forever. They give a hundred-year guarantee!

*Milton Friedman, ed., *Gehry Talks: Architecture + Process*, rev. ed. (New York: Universe, 2002), 47–48.

¹Ibid., 44, 47.

The glass-walled atrium of the Guggenheim Bilbao Museum soars skyward 165 feet. The asymmetrical and imbalanced screens and vaults flow into one another, creating a sense of disequilibrium.

31-34A STIRLING, Neue Staatsgalerie, Stuttgart, 1977–1983.

31-34B LIBESKIND, Denver Art Museum, 2006.

of several art museum projects of the past few decades as notable for their innovative postmodern architectural designs as for the important art collections they house. These include the Neue Staatsgalerie (FIG. 31-34A) in Stuttgart, Germany, by British architect James Stirling (1926–1994); the Denver Art Museum (FIG. 31-34B) by Polish-born Daniel Libeskind (b. 1946); and the Grande Louvre Pyramide (FIG. 31-36) in Paris.

Gehry's Bilbao museum appears to be a collapsed or collapsing aggregate of units. Visitors approaching the building see a mass of irregular asymmetrical and imbalanced forms whose profiles change dramatically with every shift of the viewer's position. The limestone- and titanium-clad exterior lends a space-age character to the structure and highlights further the unique cluster effect of the many forms (see "Frank Gehry on Architectural Design and Materials," above). A group of organic forms Gehry refers to as a "metallic flower" tops the museum. In the center of the museum, an enormous glass-walled atrium (FIG. 31-34) soars 165 feet above the ground, serving as the focal point for the three levels of galleries radiating from it. The seemingly weightless screens, vaults, and volumes of the interior float and flow into one another, guided only by light and dark cues. The Guggenheim Museum in Bilbao is a profoundly compelling structure. Its disorder, its deceptive randomness of design, and the disequilibrium it prompts in viewers epitomize Deconstructivist principles.

31-35 Zaha Hadid, Vitra Fire Station (looking east), Weil-am-Rhein, Germany, 1989–1993.

Inspired by Suprematism, Hadid employed dynamically arranged, unadorned planes for the Vitra Fire Station. The design suggests the burst of energy of firefighters racing out to extinguish a blaze.

ZAHA HADID One of the most innovative living architects is Iraqi Deconstructivist Zaha Hadid (b. 1950). Born in Baghdad, Hadid studied mathematics in Beirut, Lebanon, and architecture in London and has designed buildings in England, Germany, Austria, France, Italy, Spain, and the United States. Deeply influenced by the Suprematist theories and paintings of Kazimir Malevich (FIG. 29-30), who championed the use of pure colors and abstract geometric shapes to express "the supremacy of pure feeling in creative art," Hadid employs unadorned planes in dynamic arrangements that

have an emotional effect upon the viewer. A prime example of her work is the Vitra Fire Station (Fig. 31-35) in Weil-am-Rhein, Germany, completed in 1993. Composed of layers of reinforced concrete slabs and unframed window panes, the building features a boldly projecting (functionless) "wing" that suggests a burst of energy shooting out from the structure. It expresses the sudden mobilization of the firefighters within the time the alarm sounds and the time they jump into their trucks to race out to extinguish a blaze.

Zaha Hadid is the first woman to win the Pritzker Architecture Prize (in 2004), the architectural equivalent of the Nobel Prize in literature. The first recipient was Philip Johnson in 1979. Other previous winners include Norman Foster, Frank Gehry, Renzo Piano, James Stirling, Joern Utzon, Robert Venturi, and Ieoh Ming Pei.

IEOH MING PEI The latest chapter in the long architectural history of the Louvre—the former French royal residence (FIGS. 20-16, 23-14, and 25-25), now one of the world's greatest art museums—is a monumental glass-and-steel pyramid erected in the palace's main courtyard in 1988. Designed by the Chinese-American architect IEOH MING PEI (b. 1917), the Grand Louvre Pyramide (FIG. 31-36) is the dramatic postmodern entryway to the museum's priceless collections. Although initially controversial because conservative critics considered it a jarring, dissonant intrusion in a hallowed public space left untouched for centuries, Pei's pyramid, like Rogers and Piano's Pompidou Center (FIG. 30-49) a decade before, quickly captured the French public's imagination and admiration.

There are, in fact, four Louvre glass pyramids: the grand central pyramid plus the three small echoes of it bordering the large fountain-filled pool surrounding the glass entryway. Consistent with postmodern aesthetics, Pei turned to the past for inspiration, choosing the quintessential emblem of ancient Egypt (FIG. 3-7), an appropriate choice given the Louvre's rich collection of Egyptian art. But Pei transformed his ancient solid stone models (see "Building the Great Pyramids," Chapter 3, page 62) into a transparent "tent," simultaneously permitting an almost uninterrupted view of the wings of the royal palace courtyard and serving as a skylight for the new underground network of ticket booths, offices, shops, restaurants, and conference rooms he also designed.

Environmental and Site-Specific Art

When Robert Smithson created *Spiral Jetty* (FIG. 30-50) in Utah's Great Salt Lake in 1970, he was a trailblazer in the new genre of Environmental Art, or earthworks. In recent decades, earthworks

31-36 IEOH MING PEI, Grand Louvre Pyramide (looking southwest), Musée du Louvre, Paris, France, 1988.

Egyptian stone architecture inspired Pei's postmodern entryway to the Louvre, but his glassand-steel pyramid is a transparent tent serving as a skylight for the underground extension of the old museum.

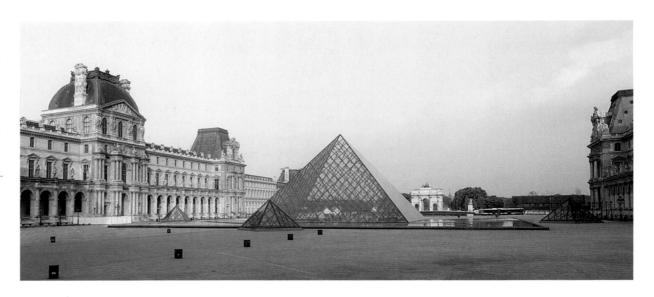

Maya Lin's Vietnam Veterans Memorial

aya Lin's design for the Vietnam Veterans Memorial (FIG. 31-37) is, like Minimalist sculptures (FIGS. 30-17 and 30-18), an unadorned geometric form. Yet the monument, despite its serene simplicity, actively engages viewers in a psychological dialogue, rather than standing mute. This dialogue gives visitors the opportunity to explore their feelings about the Vietnam War and perhaps arrive at some sense of closure.

The history of the Vietnam Veterans Memorial provides dramatic testimony to this monument's power. In 1981, a jury of architects, sculptors, and landscape architects selected Lin's design from among 1,400 entries in a blind competition for a memorial to be placed in Constitution Gardens in

Washington, D.C. Conceivably, the jury not only found her design compelling but also thought its simplicity would be the least likely to provoke controversy. But when the jury made its selection public, heated debate ensued. Even the wall's color came under attack. One veteran charged that black is "the universal color of shame, sorrow and degradation in all races, all societies worldwide."* But the sharpest protests concerned the form and siting of the monument. Because of the stark contrast between the massive white memorials (the Washington Monument and the Lincoln Memorial) bracketing Lin's sunken wall, some people interpreted her Minimalist design as minimizing the Vietnam War and, by extension, the efforts of those who fought in the conflict. Lin herself, however, described the wall as follows:

The Vietnam Veterans Memorial is not an object inserted into the earth but a work formed from the act of cutting open the earth and polishing the earth's surface—dematerializing the stone to pare surface, creating an interface between the world of the light and the quieter world beyond the names.†

Due to the vocal opposition, a compromise was necessary to ensure the memorial's completion. The Commission of Fine Arts, the federal group overseeing the project, commissioned an additional memorial from artist Frederick Hart (1943–1999) in 1983. This larger-than-life-size realistic bronze sculpture of three soldiers,

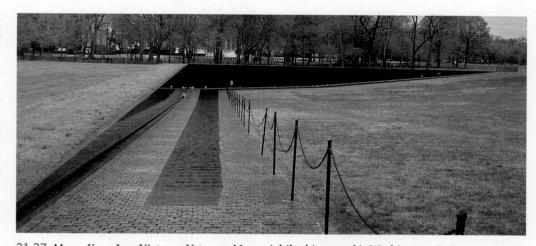

31-37 Maya Ying Lin, Vietnam Veterans Memorial (looking north), Washington, D.C., 1981–1983. Like Minimalist sculpture, Lin's memorial to veterans of the Vietnam War is a simple geometric form.

Its inscribed polished walls actively engage viewers in a psychological dialogue about the war.

armed and uniformed, now stands approximately 120 feet from Lin's wall. Several years later, a group of nurses, organized as the Vietnam Women's Memorial Project, received approval for a sculpture honoring women's service in the Vietnam War. The seven-foot-tall bronze statue by Glenna Goodacre (b. 1939) depicts three female figures, one cradling a wounded soldier in her arms. Unveiled in 1993, the work occupies a site about 300 feet south of the Lin memorial.

Whether celebrated or condemned, Lin's Vietnam Veterans Memorial generates dramatic responses. Commonly, visitors react very emotionally, even those who know none of the soldiers named on the monument. The polished granite surface prompts individual soul-searching—viewers see themselves reflected among the names. Many visitors leave mementos at the foot of the wall in memory of loved ones they lost in the Vietnam War or make rubbings from the incised names. It can be argued that much of this memorial's power derives from its Minimalist simplicity. Like Minimalist sculpture, it does not dictate response and therefore successfully encourages personal exploration.

*Elizabeth Hess, "A Tale of Two Memorials," $Art\ in\ America\ 71,\ no.\ 4$ (April 1983): 122.

[†]Excerpt from an unpublished 1995 lecture, quoted in Kristine Stiles and Peter Selz, *Theories and Documents of Contemporary Art: A Sourcebook of Artists' Writings* (Berkeley and Los Angeles: University of California Press, 1996), 525.

and other site-specific artworks that bridge the gap between architecture and sculpture have become an established mode of artistic expression. As is true of all other media in the postmodern era, these artworks take a dazzling variety of forms—and some of them have engendered heated controversies.

MAYA YING LIN Variously classified as either a work of Minimalist sculpture or architecture is the Vietnam Veterans Memorial (FIG. 31-37) in Washington, D.C., designed in 1981 by MAYA YING LIN

(b. 1959) when she was a 21-year-old student at the Yale School of Architecture. The austere, simple memorial, a V-shaped wall constructed of polished black granite panels, begins at ground level at each end and gradually ascends to a height of 10 feet at the center of the V. Each wing is 246 feet long. Lin set the wall into the landscape, enhancing visitors' awareness of descent as they walk along the wall toward the center. The names of the Vietnam War's 57,939 American casualties (and those missing in action) incised on the memorial's walls, in the order of their deaths, contribute to the monument's dramatic effect.

31-38 RACHEL WHITEREAD, Holocaust Memorial (looking northwest), Judenplatz, Vienna, Austria, 2000.

Whiteread's monument to the 65,000 Austrian Jews who perished in the Holocaust is a tomblike concrete block with doors that cannot be opened and library books seen from behind.

When Lin designed this pristinely simple monument, she gave a great deal of thought to the purpose of war memorials. Her conclusion was a memorial

should be honest about the reality of war and be for the people who gave their lives. . . . [I] didn't want a static object that people would just look at, but something they could relate to as on a journey, or passage, that would bring each to his own conclusions. . . . I wanted to work with the land and not dominate it. I had an impulse to cut open the earth . . . an initial violence that in time would heal. The grass would grow back, but the cut would remain. 6

In light of the tragedy of the war, this unpretentious memorial's allusion to a wound and long-lasting scar contributes to its communicative ability (see "Maya Lin's Vietnam Veterans Memorial," page 965).

RACHEL WHITEREAD Another controversial memorial commissioned for a specific historical setting is the Viennese Holocaust Memorial by British sculptor RACHEL WHITEREAD (b. 1963). In 1996, the city of Vienna chose Whiteread as the winner of the competition to design a commemorative monument to the 65,000 Austrian Jews who perished at the hands of the Nazis during World War II (FIG. 31-38). The decision to focus attention on a past most Austrians wished to forget unleashed a controversy that delayed construction of the monument until 2000. Also controversial was the Minimalist severity of Whiteread's massive block of concrete planted in a Baroque square at the heart of the Austrian capital—as was, at least initially, the understated form of Lin's Vietnam monument (FIG. 31-37) juxtaposed with the Washington and Lincoln Monuments in Washington, D.C.

Whiteread modulated the surface of the Holocaust memorial only slightly by depicting in low relief the shapes of two doors and hundreds of identical books on shelves, with the edges of the covers and the pages rather than the spines facing outward. The book motif was a reference both to Jews as the "People of the Book" and to

the book burnings that accompanied Jewish persecutions throughout the centuries and under the Nazis. Around the base, Whiteread inscribed the names of Nazi concentration camps in German, Hebrew, and English. The setting for the memorial is Judenplatz (Jewish Square), the site of a synagogue destroyed in 1421. The brutality of the tomblike monument—it cannot be entered, and its shape suggests a prison block—was a visual as well as psychological shock in the beautiful Viennese square. Whiteread's purpose, however, was not to please but to create a memorial that met the jury's charge to "combine dignity with reserve and spark an aesthetic dialogue with the past in a place that is replete with history."

Whiteread had gained fame in 1992 for her monument commemorating the demolition of a working-class neighborhood in East London. *House* took the form of a concrete cast of the space inside the last standing Victorian house on the site. She had also made sculptures of "negative spaces," for example, the space beneath a chair or mattress or sink. In Vienna, she represented the space behind the shelves of a library. In drawing viewers' attention to the voids between and inside objects and buildings, Whiteread pursued in a different way the same goal as Pop Art innovator Jasper Johns (FIG. 30-22), who painted things "seen but not looked at."

RICHARD SERRA Also unleashing an emotional public debate, but for different reasons and with a decidedly different outcome, was *Tilted Arc* (FIG. 31-39) by San Franciscan RICHARD SERRA (b. 1939), who worked in steel mills in California before studying art at Yale. He now lives in New York, where he received a commission in 1979 from the General Services Administration (GSA), the federal agency responsible for overseeing the selection and installation of artworks for government buildings, to install a 120-foot-long, 12-foot-high curved wall of Cor-Ten steel in the plaza in front of the Jacob K. Javits Federal Building in lower Manhattan. He completed the project in 1981. Serra wished *Tilted Arc* to "dislocate or alter the decorative function of the plaza and actively

Richard Serra's Tilted Arc

When Richard Serra installed *Tilted Arc* (FIG. 31-39) in the plaza in front of the Javits Federal Building in New York City in 1981, much of the public immediately responded with hostile criticism. Prompting the chorus of complaints was the uncompromising presence of a Minimalist sculpture bisecting the plaza. Many argued *Tilted Arc* was ugly, attracted graffiti, interfered with the view across the plaza, and prevented use of the plaza for performances or concerts. Due to the sustained barrage of protests and petitions demanding the removal of *Tilted Arc*, the General Services Administration, which had commissioned the sculpture, held a series of public hearings. Afterward, the agency decided to remove Serra's sculpture despite its prior approval of the artist's model. This, understandably, infuriated Serra, who had a legally binding contract acknowledging the site-specific nature of *Tilted Arc*. "To remove the work is to destroy the work," the artist stated.*

This episode raised intriguing issues about the nature of public art, including the public reception of experimental art, the artist's responsibilities and rights when executing public commissions, censorship in the arts, and the purpose of public art. If an artwork is on display in a public space outside the relatively private confines of a museum or gallery, do different guidelines apply? As one participant in the *Tilted Arc* saga asked, "Should an artist have the right to impose his values and taste on a public that now rejects his taste and values?" One of the express functions of the historical avant-garde was to challenge convention by rejecting tradition and disrupting

the complacency of the viewer. Will placing experimental art in a public place always cause controversy? From Serra's statements, it is clear he intended the sculpture to challenge the public.

Another issue *Tilted Arc* presented involved the rights of the artist, who in this case accused the GSA of censorship. Serra filed a lawsuit against the federal government for infringement of his First Amendment rights and insisted "the artist's work must be uncensored, respected, and tolerated, although deemed abhorrent, or perceived as challenging, or experienced as threatening." Did removal of the work constitute censorship? A U.S. district court held it did not.

Ultimately, who should decide what artworks are appropriate for the public arena? One artist argued, "We cannot have public art by plebiscite [popular vote]." But to avoid recurrences of the *Tilted Arc* controversy, the GSA changed its procedures and now solicits input from a wide range of civic and neighborhood groups before commissioning public artworks. Despite the removal of *Tilted Arc* (now languishing in storage), the sculpture maintains a powerful presence in all discussions of the aesthetics, politics, and dynamics of public art.

*Grace Glueck, "What Part Should the Public Play in Choosing Public Art?" New York Times, February 3, 1985, 27.

†Calvin Tomkins, "The Art World: Tilted Arc," *New Yorker*, May 20, 1985, 98. †Ibid., 98–99.

§Ibid., 98.

31-39 RICHARD SERRA, *Tilted Arc*, Jacob K. Javits Federal Plaza, New York City, 1981.

Serra intended his Minimalist *Tilted Arc* to alter the character of an existing public space. He succeeded but unleashed a storm of protest that caused the government to remove the work.

bring people into the sculpture's context." In pursuit of that goal, Serra situated the sculpture so that it bisected and consequently significantly altered the space of the open plaza and interrupted the traffic flow across the square. By creating such a monumental pres-

ence in this large public space, Serra succeeded in forcing viewers to reconsider the plaza's physical space as a sculptural form—but only temporarily, because the public forced the sculpture to be removed (see "Richard Serra's *Tilted Arc*," above).

31-40 Christo and Jeanne-Claude, Surrounded Islands, Biscayne Bay, Miami, Florida, 1980–1983. ■◀

Christo and Jeanne-Claude created this Environmental artwork by surrounding 11 small islands with 6.5 million square feet of pink fabric. Characteristically, the work existed for only two weeks.

CHRISTO AND JEANNE-CLAUDE The most famous Environmental artists of the past few decades are Christo (b. 1935) and his deceased spouse Jeanne-Claude (1935–2009). In their works they sought to intensify the viewer's awareness of the space and features of rural and urban sites. However, rather than physically alter the land itself, as Robert Smithson (Fig. 30-50) often did, Christo and Jeanne-Claude prompted this awareness by temporarily modifying the landscape with cloth. Christo studied art in his native Bulgaria and in Austria. After moving from Vienna to Paris, he began to encase objects in clumsy wrappings, thereby appropriating bits of the real world into the mysterious world of the unopened package whose contents can be dimly seen in silhouette under the wrap.

Starting in 1961, Christo and Jeanne-Claude began to collaborate on large-scale projects normally dealing with the environment itself. For example, in 1969 the couple wrapped more than a million square feet of Australian coastline and in 1972 hung a vast curtain across a valley at Rifle Gap, Colorado. Their projects require years of preparation and research, and scores of meetings with local authorities and interested groups of local citizens. These temporary artworks are usually on view for only a few weeks.

Surrounded Islands, Biscayne Bay, Miami, Florida, 1980-1983 (FIG. 31-40), created in Biscayne Bay for two weeks in May 1983, typifies Christo and Jeanne-Claude's work. For this project, they surrounded 11 small artificial islands in the bay (previously created from a dredging project) with 6.5 million square feet of specially fabricated pink polypropylene floating fabric. This Environmental artwork required three years of preparation to obtain the required permits and to assemble the labor force and obtain the \$3.2 million needed to complete the project. The artists raised the money by selling Christo's original preparatory drawings, collages, and models of works he created in the 1950s and 1960s. Huge crowds watched as crews removed accumulated trash from the 11 islands (to assure maximum contrast between their dark colors, the pink of the cloth, and the blue of the bay) and then unfurled the fabric "cocoons" to form magical floating "skirts" around each tiny bit of land. Despite the brevity of its existence, Surrounded Islands lives on in the host of photographs, films, and books documenting the project.

ANDY GOLDSWORTHY The most prominent heir today to the earthworks tradition of Robert Smithson is Environmental artist and photographer ANDY GOLDSWORTHY (b. 1956). Goldsworthy's medium is nature itself—stones, tree roots, leaves, flowers, ice. Because most of his works are ephemeral, the victims of tides, rainstorms, and the changing seasons, he records them in stunning color photographs that are artworks in their own right. Golds-

31-41 ANDY GOLDSWORTHY, Cracked Rock Spiral, St. Abbs, Scotland, 1985.

Goldsworthy's earthworks are "collaborations with nature." At St. Abbs, he split pebbles of different sizes in two, scratched white around the cracks using another stone, and then arranged them in a spiral.

31-42 KEITH HARING, *Tuttomondo*, Sant'Antonio (looking south), Pisa, Italy, 1989.

Haring burst onto the New York art scene as a subway graffito artist and quickly gained an international reputation. His Pisa mural features his signature cartoonlike characters and is a hymn to life.

and displayed a genius for marketing himself and his work. In 1986, he parlayed his popularity into a successful business by opening The Pop Shop in the SoHo (South of Houston Street) gallery district of lower Manhattan, where he sold posters, T-shirts, hats, and buttons featuring his universally appealing schematic human and animal figures, especially his two most popular motifs—a crawling baby surrounded by rays and a barking dog.

Haring's last major work was a commission to paint a huge mural at the church of Saint Anthony in Pisa, Italy, a confirmation of his international reputation. *Tuttomondo* (*Everybody*) encapsulates

Haring's style (FIG. **31-42**)—bright single-color cavorting figures with black outlines against a matte background. The motifs include a winged man, a figure with a television head, a mother cradling a baby, and a dancing dog. It is a hymn to the joy of life (compare FIG. 29-2A). Haring died of AIDS the next year. He was 31 years old.

worthy's international reputation has led to commissions in his native England, Scotland (where he now lives), France, Australia, the United States, and Japan, where his work has much in common with the sculptures of Kimio Tsuchiya (FIG. 31-23). Goldsworthy seeks not to transform the landscape in his art but, in his words, to "collaborate with nature."

One of Goldsworthy's most beautiful "collaborations" is also a tribute to Robert Smithson and *Spiral Jetty* (FIG. 30-50). *Cracked Rock Spiral* (FIG. 31-41), which he created at St. Abbs, Scotland, on June 1, 1985, consists of pebbles Goldsworthy split in two, scratched white around the cracks using another stone, and then arranged in a spiral that grows wider as it coils from its center.

GRAFFITI AND MURAL PAINTING Although generally considered a modern phenomenon, the concept of site-specific art is as old as the history of art. Indeed, the earliest known paintings are those covering the walls and ceilings of Paleolithic caves in southern France and northern Spain (see Chapter 1). A contemporary twist on the venerable art of mural painting is the graffiti and graffiti-inspired art of, among others, Jean-Michel Basquiat (FIG. 31-8) and KEITH HARING (1958-1990). Haring grew up in Kutztown, Pennsylvania, attended the School of Visual Arts in New York, and, as did Basquiat, burst onto the New York art scene as a graffiti artist in the city's subway system. The authorities would constantly remove his chalk figures, which he drew on blank black posters awaiting advertisers, and arrested Haring whenever they spotted him at work. However, Haring quickly gained a wide and appreciative audience for his linear cartoon-inspired fantasies, and began to sell paintings to avid collectors. Haring, like Andy Warhol (FIGS. 30-25 and 30-25A), was thoroughly in tune with pop culture

NEW MEDIA

In addition to taking the ancient arts of painting and sculpture in new directions, contemporary artists have continued to explore the expressive possibilities of the various new media developed in the postwar period, especially digital photography, computer graphics, and video.

ANDREAS GURSKY German photographer Andreas Gursky (b. 1955) grew up in Düsseldorf, where his father was a commercial photographer. Andreas studied photography at Düsseldorf's Kunstakademie (Academy of Art) and since the mid-1990s has used computer and digital technology to produce gigantic color prints in which he combines and manipulates photographs taken with a wide-angle lens, usually from a high vantage point. The size of his photographs, sometimes almost a dozen feet wide, intentionally rivals 19th-century history paintings. But as was true of Gustave Courbet (FIGS. 27-26 and 27-27) in his day, Gursky's subjects come from everyday life. He records the mundane world of the modern global economy—vast industrial plants, major department stores, hotel lobbies, and stock and commodity exchanges and transforms the commonplace into striking, almost abstract, compositions. (Compare the photographs of Edward Burtynsky, FIG. 31-19.)

31-43 Andreas Gursky, Chicago Board of Trade II, 1999. C-print, 6' $9\frac{1}{2}" \times 11'$ $5\frac{5}{8}"$. Matthew Marks Gallery, New York.

Gursky manipulates digital photographs to produce vast tableaus depicting characteristic places of the modern global economy. The size of his prints rivals 19th-century history paintings.

Gursky's enormous 1999 print (FIG. 31-43) documenting the frenzied activity on the main floor of the Chicago Board of Trade is a characteristic example of his work. He took a series of photographs from a gallery, creating a panoramic view of the traders in their brightly colored jackets. He then combined several digital images using commercial photo-editing software to produce a blurred tableau of bodies, desks, computer terminals, and strewn paper in which both mass and color are so evenly distributed as to negate the traditional Renaissance notion of perspective. In using the computer to modify the "objective truth" and spatial recession of "straight photography," Gursky blurs the distinction between painting and photography.

JENNY HOLZER Gallipolis, Ohio, native JENNY HOLZER (b. 1950) studied art at Ohio University and the Rhode Island School of Design. In 1990, she became the first woman to represent the United States at the prestigious Venice Biennale art exhibition. Holzer has won renown for several series of artworks using electronic signs, most involving light-emitting diode (LED) technology, and has created light-projection shows worldwide. In 1989, she assembled a major installation at the Solomon R. Guggenheim Museum in New York that included elements from her previous series and consisted of a large continuous LED display spiraling around the interior ramp (FIG. 31-44) of Frank Lloyd Wright's landmark building (FIG. 30-39). Holzer believes in the communicative power of language, and her installation focused specifically on text. She invented sayings with an authoritative

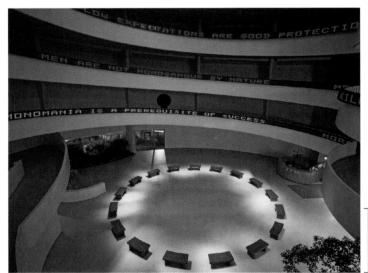

10 ft.

31-44 Jenny Holzer, Untitled (selections from Truisms, Inflammatory Essays, The Living Series, The Survival Series, Under a Rock, Laments, and Child Text), 1989. Extended helical tricolor LED electronic display signboard, $16' \times 162' \times 6'$. Installation at the Solomon R. Guggenheim Museum, New York, December 1989–February 1990 (partial gift of the artist, 1989).

Holzer's 1989 installation consisted of electronic signs created using LED technology. The continuous display of texts wound around the Guggenheim Museum's spiral interior ramp.

tone for her LED displays—for example, "Protect me from what I want," "Abuse of power comes as no surprise," and "Romantic love was invented to manipulate women." The statements, which people could read from a distance, were intentionally vague and, in some cases, contradictory.

ADRIAN PIPER Video artists, like other artists, pursue diverse goals. Adrian Piper (b. 1948) has used video art to effect social change—in particular, to combat pervasive racism. Born in New York City, she studied art at the School of Visual Arts and philosophy at the City College of New York but now lives in Berlin, Germany. Her videos, such as the installation Cornered (FIG. 31-45), are provocative and confrontational. Cornered included a video monitor placed behind an overturned table. Piper appeared on the video monitor, literally cornered behind the table, as she spoke to viewers. Her comments sprang from her experiences as a lightskinned African American woman and from her belief that although overt racism had diminished, subtle and equally damaging forms of bigotry were still rampant. "I'm black," she announces on the 16-minute videotape. "Now let's deal with this social fact and the fact of my stating it together. . . . If you feel that my letting people know that I'm not white is making an unnecessary fuss, you must feel that the right and proper course of action for me to take is to pass for white. Now this kind of thinking presupposes a belief that it's inherently better to be identified as white," she continues. The directness of Piper's art forces viewers to examine their own behaviors and values.

BILL VIOLA For much of his artistic career, BILL VIOLA (b. 1951) has also explored the capabilities of digitized imagery, producing many video installations and single-channel works. Often focusing on sensory perception, the pieces not only heighten viewer awareness of the senses but also suggest an exploration into the spiritual realm. Viola, who majored in art and music at Syracuse University, spent years after graduating seriously studying Buddhist, Chris-

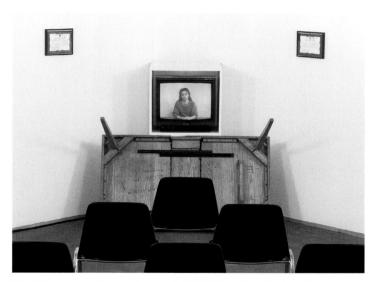

31-45 Adrian Piper, *Cornered*, 1988. Mixed-media installation of variable size; video monitor, table, and birth certificates. Museum of Contemporary Art, Chicago. ■◀

In this installation, Piper, a light-skinned African American, appeared on a video monitor, "cornered" behind an overturned table, and made provocative comments about racism and bigotry.

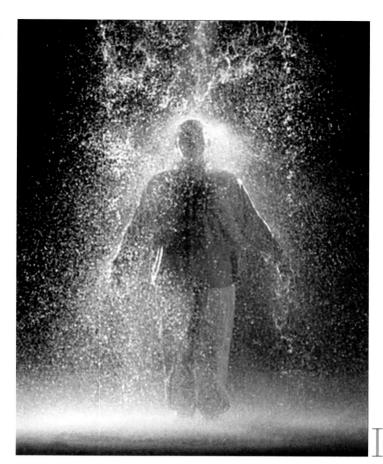

31-46 BILL VIOLA, *The Crossing*, 1996. Video/sound installation with two channels of color video projection onto screens 16' high.

Viola's video projects use extreme slow motion, contrasts in scale, shifts in focus, mirrored reflections, and staccato editing to create dramatic sensory experiences rooted in tangible reality.

tian, Sufi, and Zen mysticism. Because he fervently believes in art's transformative power and in a spiritual view of human nature, Viola designs works encouraging spectator introspection. His video projects have involved using techniques such as extreme slow motion, contrasts in scale, shifts in focus, mirrored reflections, staccato editing, and multiple or layered screens to achieve dramatic effects.

The power of Viola's work is evident in *The Crossing* (FIG. **31-46**), an installation piece involving two color video channels projected on 16-foot-high screens. The artist either shows the two projections on the front and back of the same screen or on two separate screens in the same installation. In these two companion videos, shown simultaneously on the two screens, a man surrounded in darkness appears, moving closer until he fills the screen. On one screen, drops of water fall from above onto the man's head, while on the other screen, a small fire breaks out at the man's feet. Over the next few minutes, the water and fire increase in intensity until the man disappears in a torrent of water on one screen (FIG. 31-46) and flames consume the man on the other screen. The deafening roar of a raging fire and a torrential downpour accompany these visual images. Eventually, everything subsides and fades into darkness. This installation's elemental nature and its presentation in a dark space immerse viewers in a pure sensory experience very much rooted in tangible reality.

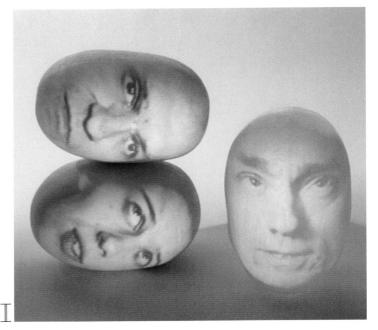

31-47 Tony Oursler, *Mansheshe*, 1997. Ceramic, glass, video player, videocassette, CPJ-200 video projector, sound, $11'' \times 7'' \times 8''$ each. Courtesy of the artist and Metro Pictures, New York.

Video artist Oursler projects his digital images onto sculptural objects, insinuating them into the "real" world. Here, he projected talking heads onto egg-shaped forms suspended from poles.

TONY OURSLER Whereas Viola, Piper, and other artists present video and digital imagery to their audiences on familiar flat screens, thus reproducing the format in which we most often come into contact with electronic images, New Yorker Tony Oursler (b. 1957), who studied art at the California Institute of the Arts, manipulates his images, projecting them onto sculptural objects. This has the effect of taking the images out of the digital world and insinuating them into the "real" world. Accompanied by sound tapes, Oursler's installations, such as *Mansheshe* (FIG. 31-47), not only engage but often challenge the viewer. In this example, Oursler projected talking heads onto egg-shaped forms suspended from poles. Because the projected images of people look directly at the viewer, the statements they make about religious beliefs, sexual identity, and interpersonal relationships cannot be easily dismissed.

MATTHEW BARNEY A major trend in the art world today is the relaxation of the traditional boundaries between artistic media. In fact, many contemporary artists are creating vast and complex multimedia installations combining new and traditional media. One of these artists is MATTHEW BARNEY (b. 1967), who studied art at Yale University. The 2003 installation (FIG. 31-48) of his epic Cremaster cycle (1994-2002) at the Solomon R. Guggenheim Museum in New York typifies the expansive scale of many contemporary works. A multimedia extravaganza involving drawings, photographs, sculptures, videos, films, and performances (presented in videos), the Cremaster cycle is a lengthy narrative set in a self-enclosed universe Barney created. The title of the work refers to the cremaster muscle, which controls testicular contractions in response to external stimuli. Barney uses the development of this muscle in the embryonic process of sexual differentiation as the conceptual springboard for the entire Cremaster project, in

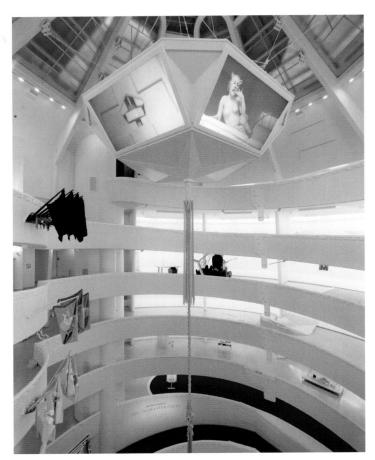

31-48 MATTHEW BARNEY, *Cremaster* cycle, installation at the Solomon R. Guggenheim Museum, New York, 2003.

Barney's vast multimedia installations of drawings, photographs, sculptures, and videos typify the relaxation at the opening of the 21st century of the traditional boundaries among artistic media.

which he explores the notion of creation in expansive and complicated ways. The cycle's narrative, revealed in the five 35-millimeter feature-length films and the artworks, makes reference to, among other things, a musical revue in Boise, Idaho (where San Franciscoborn Barney grew up), the life cycle of bees, the execution of convicted murderer Gary Gilmore, the construction of the Chrysler Building (FIG. 29-47), Celtic mythology, Masonic rituals, a motorcycle race, and a lyric opera set in late-19th-century Budapest. In the installation, Barney tied the artworks together conceptually by a five-channel video piece projected on screens hanging in the Guggenheim's rotunda. Immersion in Barney's constructed world is disorienting and overwhelming and has a force that competes with the immense scale and often frenzied pace of contemporary life.

WHAT NEXT? No one knows what the next years and decades will bring, but given the expansive scope of postmodernism, it is certain no single approach to or style of art will dominate. New technologies will undoubtedly continue to redefine what constitutes a "work of art." The universally expanding presence of computers, digital technology, and the Internet may well erode what few conceptual and geographical boundaries remain, and make art and information about art available to virtually everyone, thereby creating a truly global artistic community. As this chapter has revealed, substantial progress has already been made in that direction.

CONTEMPORARY ART WORLDWIDE

SOCIAL AND POLITICAL ART

- Many contemporary artists use art to address pressing social and political issues and to define their personal identities.
- If Gender and sexuality are central themes in the work of Barbara Kruger, the Guerrilla Girls, David Wojnarowicz, Robert Mapplethorpe, and Shahzia Sikander. Faith Ringgold, Lorna Simpson, Carrie Mae Weems, Melvin Edwards, Jean-Michel Basquiat, and Kehinde Wiley address issues of concern to African Americans. Jaune Quick-to-See Smith focuses on Native American heritage, Chris Ofili and Trigo Piula on their African roots, and Cliff Whiting on traditional Maori themes.
- Other artists have treated political and economic issues: Willie Bester, apartheid in South Africa; David Hammons, racial discrimination; Leon Golub, violence; Shirin Neshat, the challenges facing Muslim women; Krzystof Wodiczko, the plight of the homeless; and Edward Burtynsky, industrial pollution.

Mapplethorpe, Self-Portrait, 1980

Basquiat, Horn Players, 1983

OTHER MOVEMENTS AND THEMES

- Contemporary art encompasses a phenomenal variety of styles ranging from abstraction to brutal realism, both in America and worldwide.
- Leading abstract painters and sculptors include Julian Schnabel and Tara Donovan in the United States, Anselm Kiefer in Germany, Emily Kame Kngwarreye in Australia, and Wu Guanzhong, Song Su-nam, and Kimio Tsuchiya in China, Korea, and Japan, respectively.
- Among today's best-known figural painters and sculptors are Kiki Smith, Jeff Koons, and Venezuelan Marisol in the United States, and expatriate Englishwoman Jenny Saville in Italy.

Smith, Untitled, 1990

ARCHITECTURE AND SITE-SPECIFIC ART

- Postmodern architecture is as diverse as contemporary painting and sculpture. Leading Hi-Tech architects include Norman Foster and Renzo Piano. Among the major champions of Deconstructivism are Günter Behnisch, Frank Gehry, Daniel Libeskind, and Zaha Hadid.
- The monuments designed by Maya Lin, Rachel Whiteread, and Richard Serra bridge the gap between architecture and sculpture, as do the Environmental artworks of Christo and Jean-Claude and of Andy Goldsworthy.

Hadid, Vitra Fire Station, 1989–1993

NEW MEDIA

Many contemporary artists have harnessed new technologies in their artistic production: Andreas Gursky, digital photography; Jenny Holzer, LED displays; Adrian Piper, Bill Viola, and Tony Oursler, video; and Matthew Barney, complex multimedia installations.

Oursler, Mansheshe, 1997

NOTES

Chapter 31

- 1. Quoted in Arlene Hirschfelder, *Artists and Craftspeople* (New York: Facts on File, 1994), 115.
- 2. Quoted in Richard Marshall and Robert Mapplethorpe, 50 New York Artists (San Francisco: Chronicle Books, 1986), 448–449.
- 3. Quoted in Junichi Shiota, *Kimio Tsuchiya*, *Sculpture 1984–1988* (Tokyo: Morris Gallery, 1988), 3.
- Michelle Meagher, "Jenny Saville and a Feminist Aesthetics of Disgust," Hypatia 18.4 (Fall/Winter 2003), 23–41.
- 5. Quoted in Donald Hall, *Corporal Politics* (Cambridge: MIT List Visual Arts Center, 1993), 46.
- 6. Quoted in "Vietnam Memorial: America Remembers," National Geographic 167, no. 5 (May 1985): 557.
- 7. Quoted in Calvin Tomkins, "The Art World: *Tilted Arc*," *New Yorker*, May 20, 1985, 100.

Chapter 33

 Translated by Wang Youfen. Quoted by Wen C. Fong, in Ouyang Zhongshi, Wen C. Fong et al., Chinese Calligraphy (New Haven, Conn.: Yale University Press, 2008), 26.

Chapter 34

1. Jiro Yoshihara, "Gutai Art Manifesto" (1956), translated by Reiko Tomii, in *Japanese Art after 1945: Scream against the Sky* (Yokohama: Yokohama Museum of Art, 1994), 370.

Chapter 35

- 1. Diego de Landa, *Yucatan before and after the Conquest*, translated by William Gates (Mineola, N.Y.: Dover, 1978), 13, 82.
- 2. Bernal Díaz del Castillo, *The Discovery and Conquest of Mexico*. Translated by A. P. Maudslay (New York: Farrar, Straus, Giroux, 1956), 218–219.

GLOSSARY

Note: Text page references are in parentheses. References to bonus image online essays are in blue.

- abhaya—In Buddhist and Hindu iconography, a stylized and symbolic hand gesture. The abhaya (do not fear) mudra, with the right hand up, palm outward, is a gesture of protection or blessing. (984)
- Abstract Expressionism—The first major American avant-garde movement, Abstract Expressionism emerged in New York City in the 1940s. The artists produced abstract paintings that expressed their state of mind and that they hoped would strike emotional chords in viewers. (1046)
- action painting—The kind of *Abstract Expressionism* practiced by Jackson Pollock, in which the emphasis was on the creation process, the artist's gesture in making art. Pollock poured liquid paint in linear webs on his canvases, which he laid out on the floor, thereby physically surrounding himself in the painting during its creation. (1019)
- ahu—A stone platform on which the *moai* of Easter Island stand. Ahu marked burial sites or served ceremonial purposes. (1052)
- 'ahu 'ula—A Hawaiian feather cloak. (1058)
- **akua'ba**—"Akua's child." A Ghanaian image of a young girl. (1071)
- **album leaf**—A painting on a single sheet of paper for a collection stored in an album. (999)
- apse—A recess, usually semicircular, in the wall of a building, commonly found at the east end of a church. (1031)
- **ashlar masonry**—Carefully cut and regularly shaped blocks of stone used in construction, fitted together without mortar. (1031)
- **asye usu**—Baule (Côte d'Ivoire) bush spirits. (1069)
- avatar—A manifestation of a deity incarnated in some visible form in which the deity performs a sacred function on earth. In Hinduism, an incarnation of a god. (981)
- bai—An elaborately painted men's ceremonial house on Belau (formerly Palau) in the Caroline Islands of Micronesia. (1050)
- barge boards—The angled boards that outline the exterior gables of a Maori meetinghouse. (1043)

- barrel vault—See vault. (981)
- **batik**—An Indonesian fabric-dyeing technique using melted wax to form patterns the dye cannot penetrate. (31-22B)
- **Bharat Mata**—Mother India; the female personification of India. (32-10A)
- **bieri**—The wooden *reliquary* guardian figures of the Fang in Gabon and Cameroon. (1064)
- bisj pole—An elaborately carved pole constructed from the trunk of the mangrove tree. The Asmat people of southwestern New Guinea created bisj poles to indicate their intent to avenge a relative's death. (1046)
- **bocio**—A Fon (Republic of Benin) empowerment figure. (1066)
- **byobu**—Japanese painted folding screens. (1010) **calligrapher**—One who practices *calligraphy*. (997)
- **calligraphy**—Greek, "beautiful writing." Handwriting or penmanship, especially elegant writing as a decorative art. (997)
- **cemen**—The winglike openwork projection at the top of an Asmat *bisj pole*. (1046)
- **centaur**—In ancient Greek mythology, a creature with the front or top half of a human and the back or bottom half of a horse. (105)
- chakravartin—In South Asia, the ideal king, the Universal Lord who ruled through goodness. (985)
- Chan-See Zen. (1007)
- characters—In Chinese writing, signs that record spoken words. (997)
- cire perdue—See lost-wax process. (983)
- codex (pl. codices)—Separate pages of vellum or parchment bound together at one side; the predecessor of the modern book. The codex superseded the rotulus. In Mesoamerica, a painted and inscribed book on long sheets of bark paper or deerskin coated with fine white plaster and folded into accordion-like pleats. (1023)
- colophon—An inscription, usually on the last page, giving information about a book's manufacture. In Chinese painting, written texts on attached pieces of paper or silk. (997)
- **course**—In masonry construction, a horizontal row of stone blocks. (1031)

- daguerreotype—A photograph made by an early method on a plate of chemically treated metal; developed by Louis J. M. Daguerre. (983)
- **daimyo**—Local lords who controlled small regions and owed obeisance to the *shogun* in the Japanese *shogunate* system. (1006)
- darbar—The official audience of a *Mughal* emperor. (32-5A)
- deconstruction—An analytical strategy developed in the late 20th century according to which all cultural "constructs" (art, architecture, literature) are "texts." People can read these texts in a variety of ways, but they cannot arrive at fixed or uniform meanings. Any interpretation can be valid, and readings differ from time to time, place to place, and person to person. For those employing this approach, deconstruction means destabilizing established meanings and interpretations while encouraging subjectivity and individual differences. (942)
- **Deconstructivism**—An architectural style using *deconstruction* as an analytical strategy. Deconstructivist architects attempt to disorient the observer by disrupting the conventional categories of architecture. The haphazard presentation of volumes, masses, planes, lighting, and so forth challenges the viewer's assumptions about form as it relates to function. (962)
- Dilukai—A female figure with splayed legs, a common motif over the entrance to a Belau bai, serving as both guardian and fertility symbol. (1052)
- **dome**—A hemispherical *vault*; theoretically, an arch rotated on its vertical axis. In Mycenaean architecture, domes are beehive-shaped. (977)
- dry painting—See sand painting. (1032)
- enamel—A decorative coating, usually colored, fused onto the surface of metal, glass, or ceramics. (992)
- eravo—A ceremonial men's meetinghouse constructed by the Elema people in New Guinea. (1048)
- finial—A crowning ornament. (977)
- **fusuma**—Japanese painted sliding-door panels. (1008)

- garbha griha—Hindi, "womb chamber." In Hindu temples, the holy inner sanctum often housing the god's image or symbol. (977)
- glaze—A vitreous coating applied to pottery to seal and decorate the surface; it may be colored, transparent, or opaque, and glossy or matte. In oil painting, a thin, transparent, or semitransparent layer applied over a color to alter it slightly. (986, 992)
- gopis—South Asian herdswomen. (32-7A)
- **gopuras**—The massive, ornamented entrance gateway towers of southern Indian temple compounds. (981)
- **green architecture**—Ecologically friendly architectural design using clean energy to sustain the natural environment. (961)
- haboku—In Japanese art, a loose and rapidly executed painting style in which the ink seems to have been applied by flinging or splashing it onto the paper. (1008)
- haiku—A 17-syllable Japanese poetic form. (1014)
- handscroll—In Asian art, a horizontal painted scroll that is unrolled right to left, section by section, and often used to present illustrated religious texts or landscapes. (991)
- hanging scroll—In Asian art, a vertical scroll hung on a wall with pictures mounted or painted directly on it. (991)
- heiau—A Hawaiian temple. (1057)
- Hevehe—An elaborate cycle of ceremonial activities performed by the Elema people of the Papuan Gulf region of New Guinea. Also, the large, ornate masks produced for and presented during these ceremonies. (1047)
- High-Tech—A contemporary architectural style calling for buildings that incorporate the latest innovations in engineering and technology and expose the structures' component parts. (961)
- ivi p'o—Hollow, cylindrical bone or ivory ornaments produced in the Marquesas Islands (Polynesia). (1054)
- **karesansui**—Japanese dry-landscape gardening. (1006)
- katsina—An art form of Native Americans of the Southwest, the katsina doll represents benevolent supernatural spirits (katsinas) living in mountains and water sources. (1033)
- **kautaha**—Women's organizations in Tonga (Polynesia) that produce barkcloth. (1053)
- **kente**—Brightly colored patterned cloth woven by Asante men on horizontal looms in long narrow strips sewn together to form toga-like robes. (1070, 1071, 37-13A)
- **khipu**—Andean record-keeping device consisting of numerous knotted strings hanging from a main cord; the strings signified, by position and color, numbers and categories of things. (1030)
- kiva—A square or circular underground structure that is the spiritual and ceremonial center of Pueblo Indian life. (1032)
- **Kogan**—The name of a distinctive type of *Shino* water jar. (1012)

- **koru**—An unrolled spiral design used by the Maori of New Zealand in their *tattoos*. (1055)
- kula—An exchange of white conus-shell arm ornaments and red chama-shell necklaces that takes place among the Trobriand Islanders of Papua New Guinea. (1049)
- **kupesi**—Embroidered design tablets used by Tonga (Polynesia) women in the production of barkcloth. (1053)
- lacquer—A varnishlike substance made from the sap of the Asiatic sumac tree, used to decorate wood and other organic materials. Often colored with mineral pigments, lacquer cures to great hardness and has a lustrous surface.
- **linguist's staff**—In Africa, a staff carried by a person authorized to speak for a king or chief.
- **literati**—In China, talented amateur painters and scholars from the landed gentry. (956, 991, 31-22A, 33-1A)
- lost-wax (cire perdue) process—A bronzecasting method in which a figure is modeled in wax and covered with clay; the whole is fired, melting away the wax (French, *cire perdue*) and hardening the clay, which then becomes a mold for molten metal. (983)
- ma-hevehe—Mythical Oceanic water spirits. The Elema people of New Guinea believed these spirits visited their villages. (1047)
- malanggan—Festivals held in honor of the deceased in New Ireland (Papua New Guinea).

 Also, the carvings and objects produced for these festivals. (1049)
- mana—In Polynesia, spiritual power. (1052)
- manulua—Triangular patterns based on the form of two birds, common in Tongan *tapa* designs. (1054)
- mausoleum—A monumental tomb. The name derives from the mid-fourth-century BCE tomb of Mausolos at Halikarnassos, one of the Seven Wonders of the ancient world. (980)
- mbari—A ceremonial Igbo (Nigeria) house built about every 50 years in honor of the earth goddess Ala. (1070, 1077)
- **mbulu ngulu**—The wood-and-metal *reliquary* guardian figures of the Kota of Gabon. (1064)
- Mesoamerica—The region that comprises Mexico, Guatemala, Belize, Honduras, and the Pacific coast of El Salvador. (1023)
- minaret—A distinctive feature of mosque architecture, a tower from which the faithful are called to worship. (977)
- mingei—A type of modern Japanese folk pottery. (1019)
- miniatures—Small individual Indian paintings intended to be held in the hand and viewed by one or two individuals at one time. (978, 979)
- moai—Large, blocky figural stone sculptures found on Rapa Nui (Easter Island) in Polynesia. (1052)
- modernism—A movement in Western art that developed in the second half of the 19th century and sought to capture the images and sensibilities of the age. Modernist art goes beyond simply dealing with the present and in-

- volves the artist's critical examination of the premises of art itself. (998)
- moko—The form of tattooing practiced by the Maori of New Zealand. (1055)
- mosaic—Patterns or pictures made by embedding small pieces of stone or glass in cement on surfaces such as walls and floors; also, the technique of making such works. (1024)
- Mughal—"Descended from the Mongols." The Muslim rulers of India, 1526–1857. (975)
- Muslim—A believer in Islam. (976)
- **nduen fobara**—A Kalabari Ijaw (Nigeria) ancestral screen in honor of a deceased chief of a trading house. (1060, 1061)
- **ngatu**—Decorated *tapa* made by women in Tonga. (1053, 1054)
- nihonga—A 19th-century Japanese painting style that incorporated some Western techniques in Japanese-style painting, as opposed to *yoga* (Western painting). (1019)
- nishiki-e—Japanese, "brocade pictures." Japanese polychrome woodcut prints valued for their sumptuous colors. (1015)
- nkisi n'kondi—A power figure carved by the Kongo people of the Democratic Republic of Congo. Such images embodied spirits believed to heal and give life or to be capable of inflicting harm or death. (1066)
- Ogoga—A Yoruba king. (1072)
- overglaze—In *porcelain* decoration, the technique of applying mineral colors over the *glaze* after the work has been fired. The overglaze colors, or *enamels*, fuse to the glazed surface in a second firing at a much lower temperature than the main firing. See also *underglaze*. (992)
- **pagoda**—An East Asian tower, usually associated with a Buddhist temple, having a multiplicity of winged eaves; thought to be derived from the Indian *stupa*. (986)
- Performance Art—An American avant-garde art trend of the 1960s that made time an integral element of art. It produced works in which movements, gestures, and sounds of persons communicating with an audience replace physical objects. Documentary photographs are generally the only evidence remaining after these events. (993, 1019)
- **pfemba**—A Yombe (Democratic Republic of Congo) mother-and-child group. (1066)
- **pointed arch**—A narrow arch of pointed profile, in contrast to a semicircular arch. (977)
- porcelain—Extremely fine, hard, white ceramic.
 Unlike stoneware, porcelain is made from a
 fine white clay called kaolin mixed with
 ground petuntse, a type of feldspar. True porcelain is translucent and rings when struck.
 (992)
- pou tokomanawa—A sculpture of an ancestor that supports a ridgepole of a Maori (New Zealand) meetinghouse. (1043)
- pouncing—The method of transferring a sketch onto paper or a wall by tracing, using thin paper or transparent gazelle skin placed on top of the sketch, pricking the contours of the design into the skin or paper with a pin, placing

- the skin or paper on the surface to be painted, and forcing black pigment through the holes. (979, 32-5A)
- **poupou**—A decorated wall panel in a Maori (New Zealand) meetinghouse. (1043, 1055)
- powwow—A traditional Native American ceremony featuring dancing in quilled, beaded, and painted costumes. (1040)
- pueblo—A communal multistoried dwelling made of stone or adobe brick by the Native Americans of the Southwest. Uppercase *Pueblo* refers to various groups that occupied such dwellings. (1032)
- **pukao**—A small red scoria cylinder serving as a topknot or hat on Easter Island *moai*. (1052)
- relics—The body parts, clothing, or objects associated with a holy figure, such as the Buddha or Christ or a Christian saint. (1064)
- **relief**—In sculpture, figures projecting from a background of which they are part. The degree of relief is designated high, low (bas), or sunken. In the last, the artist cuts the design into the surface so that the highest projecting parts of the image are no higher than the surface itself. See also *Rococo*.
- **reliquary**—A container for holding *relics*. (1064) **rocaille**—See *Rococo*. (1043)
- Rococo—A style, primarily of interior design, that appeared in France around 1700. Rococo interiors featured lavish decoration, including small sculptures, ornamental mirrors, easel paintings, tapestries, *reliefs*, wall paintings, and elegant furniture. The term Rococo derived from the French word *rocaille* (pebble) and referred to the small stones and shells used to decorate grotto interiors. (728)
- **rotulus**—The manuscript scroll used by Egyptians, Greeks, Etruscans, and Romans; predecessor of the *codex*. (1023)
- **sabi**—Japanese; the value found in the old and weathered, suggesting the tranquility reached in old age. (1012)
- samurai Medieval Japanese warriors. (1006)
- **sand painting**—A temporary painting technique using sand, varicolored powdered stones, corn

- pollen, and charcoal. Sand paintings, also called dry paintings, are integral parts of sacred Navajo rituals. (1032)
- **Satimbe**—"Sister on the head." A Dogon (Mali) mask representing all women. (1074)
- **seal**—In Asian painting, a stamp affixed to a painting to identify the artist, the *calligrapher*, or the owner. (997)
- shaykh—An Islamic mystic saint. (975)
- Shino—Japanese ceramic wares produced during the late 16th and early 17th centuries in kilns in Mino. (1012)
- shogun—In 12th- through 19th-century Japan, a military governor who managed the country on behalf of a figurehead emperor. (1006)
- **shogunate**—The Japanese military government of the 12th through 19th centuries. (1006)
- splashed-ink painting—See haboku. (1008)
- **stained glass**—Tthe colored glass used for windows. (982)
- **stupa**—A large, mound-shaped Buddhist shrine. (984, 986)
- sultan—A Muslim ruler. (977)
- **superimposition**—In *Mesoamerican* architecture, the erection of a new structure on top of, and incorporating, an earlier structure; the nesting of a series of buildings inside each other. (1026)
- **tapa**—Barkcloth made particularly in Polynesia. Tapa is often dyed, painted, stenciled, and sometimes perfumed. (1053)
- **tatami**—The traditional woven straw mat used for floor covering in Japanese architecture. (1011)
- tatanua—In New Ireland (Papua New Guinea), the spirits of the dead. (1049)
- tatau—See tattoo. (1054)
- tattoo—A permanent design on the skin produced using indelible dyes. The term derives from the Tahitian, Samoan, and Tongan word tatau or tatu. (1054)
- tatu—See tattoo. (1054)
- tiki—A Marquesas Islands (Polynesia) threedimensional carving of an exalted, deified ancestor figure. (1054)

- **togu na**—"House of words." A Dogon (Mali) men's house, where deliberations vital to community welfare take place. (1078)
- **tokonoma**—A shallow alcove in a Japanese room, which is used for decoration, such as a painting or stylized flower arrangement. (1011)
- **tukutuku**—A stitched lattice panel found in a Maori (New Zealand) meetinghouse. (1043)
- **ukiyo-e**—Japanese, "pictures of the floating world." During the Edo period, woodcut prints depicting brothels, popular entertainment, and beautiful women. (1015)
- underglaze—In *porcelain* decoration, the technique of applying mineral colors to the surface before the main firing, followed by an application of clear *glaze*. See also *overglaze*. (986, 992)
- vault (adj. vaulted)—A masonry roof or ceiling constructed on the arch principle, or a concrete roof of the same shape. A barrel (or tunnel) vault, semicylindrical in cross-section, is in effect a deep arch or an uninterrupted series of arches, one behind the other, over an oblong space. A quadrant vault is a half-barrel vault. A groin (or cross) vault is formed at the point at which two barrel vaults intersect at right angles. In a ribbed vault, there is a framework of ribs or arches under the intersections of the vaulting sections. A sexpartite vault is one whose ribs divide the vault into six compartments. A fan vault is a vault characteristic of English Perpendicular Gothic architecture, in which radiating ribs form a fanlike pattern.
- vimana—A pyramidal tower over the garbha griha of a Hindu temple of the southern style. (977)
- wabi—A 16th-century Japanese art style characterized by refined rusticity and an appreciation of simplicity and austerity. (1012)
- waka sran—"People of wood." Baule (Côte d'Ivoire) wooden figural sculptures. (1069)
- Zen—A Japanese Buddhist sect and its doctrine, emphasizing enlightenment through intuition and introspection rather than the study of scripture. In Chinese, Chan. (1007)

BIBLIOGRAPHY

This list of books is very selective but comprehensive enough to satisfy the reading interests of the beginning art history student and general reader. Significantly expanded from the previous edition, the 14th edition bibliography can also serve as the basis for undergraduate research papers. The resources listed range from works that are valuable primarily for their reproductions to those that are scholarly surveys of schools and periods or monographs on individual artists. The emphasis is on recent in-print books and on books likely to be found in college and municipal libraries. No entries for periodical articles appear, but the bibliography begins with a list of some of the major journals that publish art historical scholarship in English.

Selected Periodicals

African Arts American Art American Indian Art American Journal of Archaeology Antiquity Archaeology Archives of American Art Archives of Asian Art Ars Orientalis Art Bulletin Art History Art in America Art Journal Artforum International Artnews Burlington Magazine Gesta History of Photography Journal of Roman Archaeology Journal of the Society of Architectural Historians Journal of the Warburg and Courtauld Institutes Latin American Antiquity October Oxford Art Journal Women's Art Journal

General Studies

- Baxandall, Michael. *Patterns of Intention: On the Historical Explanation of Pictures*. New Haven, Conn.: Yale University Press, 1985.
- Bindman, David, ed. *The Thames & Hudson Encyclopedia of British Art.* London: Thames & Hudson, 1988.
- Boström, Antonia. *The Encyclopedia of Sculpture*. 3 vols. London: Routledge, 2003.
- Broude, Norma, and Mary D. Garrard, eds. *The Expanding Discourse: Feminism and Art History.* New York: Harper Collins, 1992.
- Bryson, Norman. Vision and Painting: The Logic of the Gaze. New Haven, Conn.: Yale University Press, 1983.
- Bryson, Norman, Michael Ann Holly, and Keith Moxey. Visual Theory: Painting and Interpretation. New York: Cambridge University Press, 1991.
- Burden, Ernest. *Illustrated Dictionary of Architecture*. 2d ed. New York: McGraw-Hill, 2002.
- Büttner, Nils. *Landscape Painting: A History.* New York: Abbeville, 2006.

- Carrier, David. A World Art History and Its Objects.
 University Park: Pennsylvania State University
 Press, 2009.
- Chadwick, Whitney. Women, Art, and Society. 4th ed. New York: Thames & Hudson, 2007.
- Cheetham, Mark A., Michael Ann Holly, and Keith Moxey, eds. *The Subjects of Art History: Historical Objects in Contemporary Perspective*. New York: Cambridge University Press, 1998.
- Chilvers, Ian, and Harold Osborne, eds. The Oxford Dictionary of Art. 3d ed. New York: Oxford University Press, 2004.
- Corbin, George A. Native Arts of North America, Africa, and the South Pacific: An Introduction. New York: Harper Collins, 1988.
- Crouch, Dora P., and June G. Johnson. Traditions in Architecture: Africa, America, Asia, and Oceania. New York: Oxford University Press, 2000.
- Curl, James Stevens. Oxford Dictionary of Architecture and Landscape Architecture. 2d ed. New York: Oxford University Press, 2006.
- Duby, Georges, ed. Sculpture: From Antiquity to the Present. 2 vols. Cologne: Taschen, 1999.
- *Encyclopedia of World Art.* 17 vols. New York: McGraw-Hill, 1959–1987.
- Fielding, Mantle. Dictionary of American Painters, Sculptors, and Engravers. 2d ed. Poughkeepsie, N.Y.: Apollo, 1986.
- Fine, Sylvia Honig. Women and Art: A History of Women Painters and Sculptors from the Renaissance to the 20th Century. Rev. ed. Montclair, N.J.: Alanheld & Schram, 1978.
- Fleming, John, Hugh Honour, and Nikolaus Pevsner. The Penguin Dictionary of Architecture and Landscape Architecture. 5th ed. New York: Penguin, 2000.
- Frazier, Nancy. *The Penguin Concise Dictionary of Art History*. New York: Penguin, 2000.
- Freedberg, David. *The Power of Images: Studies in the History and Theory of Response*. Chicago: University of Chicago Press, 1989.
- Gaze, Delia., ed. *Dictionary of Women Artists.* 2 vols. London: Routledge, 1997.
- Hall, James. Hall, James. *Dictionary of Subjects and Symbols in Art.* 2d ed. Boulder, Colo.: Westview, 2008.
- Harris, Anne Sutherland, and Linda Nochlin. Women Artists: 1550–1950. Los Angeles: Los Angeles County Museum of Art; New York: Knopf, 1977.
- Hauser, Arnold. *The Sociology of Art.* Chicago: University of Chicago Press, 1982.

- Hults, Linda C. The Print in the Western World: An Introductory History. Madison: University of Wisconsin Press, 1996.
- Kemp, Martin. *The Science of Art: Optical Themes in Western Art from Brunelleschi to Seurat.* New Haven, Conn.: Yale University Press, 1990.
- Kostof, Spiro, and Gregory Castillo. A History of Architecture: Settings and Rituals. 2d ed. Oxford: Oxford University Press, 1995.
- Kultermann, Udo. *The History of Art History.* New York: Abaris, 1993.
- Lucie-Smith, Edward. The Thames & Hudson Dictionary of Art Terms. 2d ed. New York: Thames & Hudson, 2004.
- Moffett, Marian, Michael Fazio, and Lawrence Wadehouse. *A World History of Architecture*. Boston: McGraw-Hill, 2004.
- Morgan, Anne Lee. Oxford Dictionary of American Art and Artists. New York: Oxford University Press, 2008.
- Murray, Peter, and Linda Murray. A Dictionary of Art and Artists. 7th ed. New York: Penguin, 1998.
- Nelson, Robert S., and Richard Shiff, eds. *Critical Terms for Art History*. Chicago: University of Chicago Press, 1996.
- Pazanelli, Roberta, ed. *The Color of Life: Polychromy in Sculpture from Antiquity to the Present.* Los Angeles: J. Paul Getty Museum, 2008.
- Penny, Nicholas. *The Materials of Sculpture*. New Haven, Conn.: Yale University Press, 1993.
- Pevsner, Nikolaus. *A History of Building Types*. London: Thames & Hudson, 1987. Reprint of 1979 ed.
- ——. An Outline of European Architecture. 8th ed. Baltimore: Penguin, 1974.
- Pierce, James Smith. From Abacus to Zeus: A Handbook of Art History. 7th ed. Upper Saddle River, N.J.: Pearson Prentice Hall, 1998.
- Placzek, Adolf K., ed. *Macmillan Encyclopedia of Architects*. 4 vols. New York: Macmillan, 1982.
- Podro, Michael. *The Critical Historians of Art.* New Haven, Conn.: Yale University Press, 1982.
- Pollock, Griselda. Vision and Difference: Femininity, Feminism, and Histories of Art. London: Routledge, 1988.
- Pregill, Philip, and Nancy Volkman. Landscapes in History Design and Planning in the Eastern and Western Traditions. 2d ed. Hoboken, N.J.: Wiley, 1999.
- Preziosi, Donald, ed. *The Art of Art History: A Critical Anthology*. New York: Oxford University Press, 1998.

- Read, Herbert. The Thames & Hudson Dictionary of Art and Artists. Rev. ed. New York: Thames & Hudson, 1994.
- Reid, Jane D. The Oxford Guide to Classical Mythology in the Arts 1300-1990s. 2 vols. New York: Oxford University Press, 1993.
- Rogers, Elizabeth Barlow. Landscape Design: A Cultural and Architectural History. New York: Abrams,
- Roth, Leland M. Understanding Architecture: Its Elements, History, and Meaning. 2d ed. Boulder, Colo.: Westview, 2006.
- Schama, Simon. The Power of Art. New York: Ecco, 2006
- Slatkin, Wendy. Women Artists in History: From Antiquity to the 20th Century. 4th ed. Upper Saddle River, N.I.: Prentice Hall, 2000.
- Steer, John, and Antony White. Atlas of Western Art History: Artists, Sites, and Monuments from Ancient Greece to the Modern Age. New York: Facts on File, 1994.
- Stratton, Arthur. The Orders of Architecture: Greek, Roman, and Renaissance. London: Studio, 1986.
- Summers, David. Real Spaces: World Art History and the Rise of Western Modernism. London: Phaidon,
- Sutton, Ian. Western Architecture: From Ancient Greece to the Present. New York: Thames & Hudson, 1999.
- Trachtenberg, Marvin, and Isabelle Hyman. Architecture, from Prehistory to Post-Modernism. 2d ed. Upper Saddle River, N.J.: Prentice Hall, 2003.
- Turner, Jane, ed. The Dictionary of Art. 34 vols. New ed. New York: Oxford University Press, 2003.
- Watkin, David. A History of Western Architecture. 4th ed. London: Laurence King, 2010.
- West, Shearer. Portraiture. New York: Oxford University Press, 2004.
- Wittkower, Rudolf. Sculpture Processes and Principles. New York: Harper & Row, 1977.
- Wren, Linnea H., and Janine M. Carter, eds. Perspectives on Western Art: Source Documents and Readings from the Ancient Near East through the Middle Ages. New York: Harper & Row, 1987.
- Zijlmans, Kitty, and Wilfried van Damme, eds. World Art Studies: Exploring Concepts and Approaches. Amsterdam: Valiz, 2008.

Asian Art, General

- Brown, Rebecca M., and Deborah S. Hutton. Asian Art (Blackwell Anthologies in Art History). Malden, Mass.: Blackwell, 2006.
- Clark, John. Modern Asian Art. Honolulu: University of Hawaii Press, 1998.
- McArthur, Meher. The Arts of Asia: Materials, Techniques, Styles. New York: Thames & Hudson, 2005.

Chapter 32: South and Southeast Asia, 1200 to 1980

- Asher, Catherine B. Architecture of Mughal India. New York: Cambridge University Press, 1992.
- Beach, Milo Cleveland. Mughal and Rajput Painting. Cambridge: Cambridge University Press, 1992.
- Blurton, T. Richard. Hindu Art. Cambridge, Mass.: Harvard University Press, 1993.
- Chaturachinda, Gwyneth, Sunanda Krishnamurty, and Pauline W. Tabtiang. Dictionary of South and Southeast Asian Art. Chiang Mai, Thailand: Silkworm Books, 2000.
- Craven, Roy C. Indian Art: A Concise History. Rev. ed. London: Thames & Hudson, 1997.
- Dallapiccola, Anna Libera, ed. Vijayanagara: City and Empire. 2 vols. Stuttgart: Steiner, 1985.
- Dehejia, Vidya. Indian Art. London: Phaidon, 1997.

- Encyclopedia of Indian Temple Architecture. 8 vols. New Delhi: American Institute of Indian Studies; Philadelphia: University of Pennsylvania Press, 1983-1996.
- Girard-Geslan, Maud, ed. Art of Southeast Asia. New York: Abrams, 1998
- Harle, James C. The Art and Architecture of the Indian Subcontinent. 2d ed. New Haven, Conn.: Yale University Press, 1994.
- Huntington, Susan L., and John C. Huntington. The Art of Ancient India: Buddhist, Hindu, Jain. New York: Weatherhill, 1985.
- Lambah, Abha Narian, and Alka Patel, eds. The Architecture of the Indian Sultanates. Mumbai: Marg,
- Michell, George. Architecture and Art of Southern India: Vijayanagara and the Successor States, 1350-1750. Cambridge: Cambridge University Press, 1995.
- . Hindu Art and Architecture. New York: Thames & Hudson, 2000.
- The Hindu Temple: An Introduction to Its Meaning and Forms. Chicago: University of Chicago Press, 1988
- Mitter, Partha. Indian Art. New York: Oxford University Press, 2001.
- Pal, Pratapaditya, ed. Master Artists of the Imperial Mughal Court. Mumbai: Marg, 1991.
- Rawson, Phillip. The Art of Southeast Asia. New York: Thames & Hudson, 1990.
- Schimmel, Annemarie. The Empire of the Great Mughals: History, Art, and Culture. London: Reaktion, 2006.
- Stadtner, Donald M. The Art of Burma: New Studies. Mumbai: Marg, 1999.
- Stevenson, John, and John Guy, eds. Vietnamese Ceramics: A Separate Tradition. Chicago: Art Media Resources, 1997.
- Stierlin, Henri. Hindu India from Khajuraho to the Temple City of Madurai. Cologne: Taschen, 1998.
- Stronge, Susan. Painting for the Mughal Emperor: The Art of the Book, 1560-1660. London: Victoria & Albert Museum, 2002.
- Tingley, Nancy, ed. Arts of Ancient Viet Nam: From River Plain to Open Sea. Houston: Museum of Fine Arts, 2009.
- Verna, Som Prakash. Painting the Mughal Experience. New York: Oxford University Press, 2005.
- Welch, Stuart Cary. Imperial Mughal Painting. New York: Braziller, 1978.
- India: Art and Culture 1300-1900. New York: Metropolitan Museum of Art, 1985.

Chapter 33: China and Korea, 1279 to 1980

- Andrews, Julia Frances, and Kuiyi Shen. A Century in Crisis: Modernity and Tradition in the Art of Twentieth-Century China. New York: Guggenheim Museum, 1998.
- Barnhart, Richard M. Painters of the Great Ming: The Imperial Court and the Zhe School. Dallas: Dallas Museum of Art, 1993
- Cahill, James. The Painter's Practice: How Artists Lived and Worked in Traditional China. New York: Columbia University Press, 1994.
- Clunas, Craig. Art in China. New York: Oxford University Press, 1997.
- . Pictures and Visuality in Early Modern China. Princeton: Princeton University Press, 1997.
- Fahr-Becker, Gabriele, ed. The Art of East Asia. Cologne: Könemann, 1999.
- Fisher, Robert E. Buddhist Art and Architecture. New York: Thames & Hudson, 1993.
- Fong, Wen C., and James C. Y. Watt. Preserving the Past: Treasures from the National Palace Museum, Taipei. New York: Metropolitan Museum of Art, 1996.

- Hearn, Maxwell K. How to Read Chinese Paintings. New York: Metropolitan Museum of Art, 2008.
- Howard, Angela Falco, Li Song, Wu Hong, and Yang Hong. Chinese Sculpture. New Haven, Conn.: Yale University Press, 2006.
- Laing, Ellen Johnston. The Winking Owl: Art in the People's Republic of China. Berkeley: University of California Press, 1989.
- Li, Chu-tsing, ed. Artists and Patrons: Some Social and Economic Aspects of Chinese Painting. Lawrence, Kans.: Kress Department of Art History in cooperation with Indiana University Press, 1989.
- Li, He, and Michael Knight. Power and Glory: Court Arts of China's Ming Dynasty. San Francisco: Asian Art Museum, 2008.
- Marks, Andreas. Japanese Woodblock Prints: Artists, Publishers, and Masterworks: 1680-1900. North Clarendon, Vt.: Tuttle, 2010.
- Nakata, Yujiro, ed. Chinese Calligraphy. New York: Weatherhill, 1983.
- Portal, Jane. Korea: Art and Archaeology. New York: Thames & Hudson, 2000.
- Rawson, Jessica, ed. The British Museum Book of Chinese Art. New York: Thames & Hudson, 1992.
- Sickman, Laurence, and Alexander C. Soper. The Art and Architecture of China. 3d ed. New Haven, Conn.: Yale University Press, 1992.
- Silbergeld, Jerome. Chinese Painting Style: Media, Methods, and Principles of Form. Seattle: University of Washington Press, 1982.
- Steinhardt, Nancy S., ed. Chinese Architecture. New Haven, Conn.: Yale University Press, 2002.
- Sullivan, Michael. Art and Artists of Twentieth-Century China. Berkeley: University of California Press, 1996.
- The Arts of China. 5th ed. Berkeley: University of California Press, 2009.
- Thorp, Robert L. Son of Heaven: Imperial Arts of China. Seattle: Son of Heaven, 1988.
- Thorp, Robert L., and Richard Ellis Vinograd. Chinese Art and Culture. New York: Abrams, 2001.
- Vainker, S. J. Chinese Pottery and Porcelain: From Prehistory to the Present. London: Braziller, 1991.
- Watson, William. The Arts of China 900-1260. New Haven, Conn.: Yale University Press, 2000.
- The Arts of China after 1260. New Haven, Conn.: Yale University Press, 2007.
- Watt, James C. Y., ed. The World of Khubiliai Khan: Chinese Art in the Yuan Dynasty. New York: Metropolitan Museum of Art, 2010.
- Weidner, Marsha, ed. Flowering in the Shadows: Women in the History of Chinese and Japanese Painting. Honolulu: University of Hawaii Press, 1990.
- . Views from Jade Terrace: Chinese Women Artists 1300-1912. Indianapolis: Indianapolis Museum of Art, 1988.
- Xin, Yang, Nie Chongzheng, Lang Shaojun, Richard M. Barnhart, James Cahill, and Wu Hung. Three Thousand Years of Chinese Painting. New Haven, Conn.: Yale University Press, 1997.
- Zhiyan, Li, Virginia L. Bower, and He Li. Chinese Ceramics: From the Paleolithic Period through the Qing Dyansty. New Haven, Conn.: Yale University Press, 2010.
- Zhongshi, Ouyang, Wen C. Fong, et al. Chinese Calligraphy. New Haven, Conn.: Yale University Press, 2008.

Chapter 34: Japan, 1336 to 1980

- Addiss, Stephen. The Art of Zen. New York: Abrams, 1989. Baekeland, Frederick. Imperial Japan: The Art of the Meiji Era (1868-1912). Ithaca, N.Y.: Herbert F. Johnson Museum of Art, 1980.
- Brown, Kendall. The Politics of Reclusion: Painting and Power in Muromachi Japan. Honolulu: University of Hawaii Press, 1997.

- Cahill, James. Scholar Painters of Japan. New York: Asia Society, 1972.
- Calza, Gian Carlo. *Ukiyo-e*. New York: Phaidon, 2005.
- Coaldrake, William H. Architecture and Authority in Japan. London: Routledge, 1996.
- Fontein, Jan, and Money L. Hickman. Zen Painting and Calligraphy. Greenwich, Conn.: New York Graphic Society, 1970.
- Guth, Christine. Art of Edo Japan: The Artist and the City, 1615–1868. New York: Abrams, 1996.
- Hickman, Money L., John T. Carpenter, Bruce A. Coats, Christine Guth, Andrew J. Pekarik, John M. Rosenfield, and Nicole C. Rousmaniere. *Japan's Golden Age: Momoyama*. New Haven, Conn.: Yale University Press, 1996.
- Kawakita, Michiaki. Modern Currents in Japanese Art. Translated by Charles E. Terry. New York: Weatherhill. 1974.
- Kidder, J. Edward, Jr. *The Art of Japan*. New York: Park Lane, 1985.
- Lane, Richard. *Images from the Floating World: The Japanese Print*. New York: Dorset, 1978.
- Mason, Penelope. *History of Japanese Art.* 2d ed. New York: Abrams, 2004.
- Meech, Julia, and Jane Oliver. *Designed for Pleasure: The World of Edo Japan in Prints and Drawings, 1680–1860.* Seattle: University of Washington Press, 2008.
- Munroe, Alexandra. *Japanese Art after 1945: Scream against the Sky.* New York: Abrams, 1994.
- Nishi, Kazuo, and Kazuo Hozumi. What Is Japanese Architecture? Translated by H. Mack Horton. New York: Kodansha International, 1985.
- Ohki, Sadak. *Tea Culture of Japan*. New Haven, Conn.: Yale University Press, 2009.
- Sanford, James H., William R. LaFleur, and Masatoshi Nagatomi. Flowing Traces: Buddhism in the Literary and Visual Arts of Japan. Princeton, N.J.: Princeton University Press, 1992.
- Shimizu, Yoshiaki, ed. *Japan: The Shaping of Daimyo Culture, 1185–1868.* Washington, D.C.: National Gallery of Art, 1988.
- Singer, Robert T. *Edo: Art in Japan 1615–1868*. Washington, D.C.: National Gallery of Art, 1998.
- Stanley-Baker, Joan. *Japanese Art.* Rev. ed. New York: Thames & Hudson, 2000.
- Stewart, David B. The Making of a Modern Japanese Architecture, 1868 to the Present. New York: Kodansha International, 1988.
- Tiampo, Ming. *Gutai: Decentering Modernism.* Chicago: University of Chicago Press, 2011.

Chapter 35: Native Arts of the Americas,

- Bawden, Garth. Moche. Oxford: Blackwell, 1999.
- Berlo, Janet Catherine, ed. *Plains Indian Drawings* 1865–1935. New York: Abrams, 1996.
- Berlo, Janet Catherine, and Ruth B. Phillips. *Native North American Art.* New York: Oxford University Press, 1998.
- Boone, Elizabeth. *The Aztec World*. Washington, D.C.: Smithsonian Institution Press, 1994.
- Bruhns, Karen O. Ancient South America. New York: Cambridge University Press, 1994.
- Burger, Richard L., and Lucy C. Salaza, eds. *Machu Picchu: Unveiling the Mystery of the Incas.* New Haven, Conn.: Yale University Press, 2004.
- Coe, Michael D. *The Maya*. 7th ed. New York: Thames & Hudson, 2005.
- ——. *Mexico: From the Olmecs to the Aztecs.* 5th ed. New York: Thames & Hudson, 2002.
- D'Altroy, Terence N. *The Incas*. New ed. Oxford: Blackwell, 2003.
- Davies, Nigel. The Ancient Kingdoms of Peru. New York: Penguin, 1997.

- Feest, Christian F. *Native Arts of North America*. 2d ed. New York: Thames & Hudson, 1992.
- Fienup-Riordan, Ann. *The Living Tradition of Yup'ik Masks*. Seattle: University of Washington Press, 1996
- Fitzhugh, William W., and Aron Crowell, eds. *Cross-roads of Continents: Cultures of Siberia and Alaska*. Washington, D.C.: Smithsonian Institution Press, 1988.
- Gasparini, Graziano, and Luise Margolies. Inca Architecture. Bloomington: Indiana University Press, 1980
- Hill, Tom, and Richard W. Hill, Sr., eds. Creation's Journey: Native American Identity and Belief. Washington, D.C.: Smithsonian Institution Press, 1994.
- Jonaitis, Aldona. *Art of the Northwest Coast*. Seattle: University of Washington Press, 2006.
- Kubler, George. The Art and Architecture of Ancient America: The Mexican, Maya, and Andean Peoples. 3d ed. New Haven, Conn.: Yale University Press, 1992.
- Malpass, Michael A. *Daily Life in the İnca Empire*. Westport, Conn.: Greenwood, 1996.
- Mathews, Zena, and Aldona Jonaitis, eds. *Native North American Art History*. Palo Alto, Calif.: Peek, 1982.
- Matos, Eduardo M. *The Great Temple of the Aztecs: Treasures of Tenochtitlan.* New York: Thames & Hudson, 1988.
- Maurer, Evan M. Visions of the People: A Pictorial History of Plains Indian Life. Seattle: University of Washington Press, 1992.
- McEwan, Gordon F. *The Incas: New Perspectives*. Santa Barbara, Calif.: ABC-CLIO, 2006.
- Miller, Mary Ellen. *The Art of Mesoamerica, from Olmec to Aztec.* 4th ed. New York: Thames & Hudson, 2006.
- Miller, Mary, and Karl Taube. An Illustrated Dictionary of the Gods and Symbols of Ancient Mexico and the Maya. New York: Thames & Hudson, 1993.
- Minelli, Laura Laurencich. *The Inca World*. Norman: University of Oklahoma Press, 2000.
- Morris, Craig, and Adriana von Hagen. *The Incas*. New York: Thames & Hudson, 2011.
- ——. The Inka Empire and Its Andean Origins. New York: Abbeville, 1993.
- Moseley, Michael E. *The Incas and Their Ancestors: The Archaeology of Peru*. Rev. ed. New York: Thames & Hudson, 2001.
- Nabokov, Peter, and Robert Easton. *Native American Architecture*. New York: Oxford University Press, 1989.
- Pasztory, Esther. Aztec Art. New York: Abrams, 1983.
 ——. Pre-Columbian Art. New York: Cambridge University Press, 1998.
- Penney, David W. North American Indian Art. New York: Thames & Hudson, 2004.
- Phillips, Ruth B. *Trading Identities: The Souvenir in Native North American Art.* Seattle: University of Washington Press, 1998.
- Samuel, Cheryl. The Chilkat Dancing Blanket. Norman: University of Oklahoma Press, 1982.
- Schaafsma, Polly, ed. *Kachinas in the Pueblo World.* Albuquerque: University of New Mexico Press, 1994.
- Silverman, Helaine. *The Nasca*. Oxford: Blackwell, 2002.
 —————, ed. *Andean Archaeology*. Oxford: Blackwell, 2004
- Smith, Michael Ernest. *The Aztecs.* 2d ed. Oxford: Blackwell, 2003.
- Stewart, Hilary. *Looking at Totem Poles*. Seattle: University of Washington Press, 1993.
- Townsend, Richard F. *The Aztecs*. 2d ed. New York: Thames & Hudson, 2000.
- Von Hagen, Adriana, and Craig Morris. The Cities of the Ancient Andes. New York: Thames & Hudson, 1998.

- Wardwell, Allen. *Tangible Visions: Northwest Coast Indian Shamanism and Its Art.* New York: Monacelli, 1996.
- Washburn, Dorothy. *Living in Balance: The Universe of the Hopi, Zuni, Navajo, and Apache.* Philadelphia: University Museum, 1995.
- Weaver, Muriel Porter. *The Aztecs, Mayas, and Their Predecessors.* 3d ed. San Diego: Academic, 1993.
- Wright, Robin K. *Northern Haida Master Carvers*. Seattle: University of Washington Press, 2001.
- Wyman, Leland C. Southwest Indian Drypainting. Albuquerque: University of New Mexico Press, 1983.

Chapter 36: Oceania before 1980

- Caruana, Wally. *Aboriginal Art.* 2d ed. New York: Thames & Hudson, 2003.
- Cox, J. Halley, and William H. Davenport. *Hawaiian Sculpture*. Rev. ed. Honolulu: University of Hawaii Press, 1988.
- D'Alleva, Anne. *Arts of the Pacific Islands*. New York: Abrams, 1998.
- Ellis, Juniper. *Tattooing the World. Pacific Designs in Print & Skin.* New York: Columbia University Press, 2008.
- Feldman, Jerome, and Donald H. Rubinstein. *The Art of Micronesia*. Honolulu: University of Hawaii Art Gallery, 1986.
- Greub, Suzanne, ed. Authority and Ornament: Art of the Sepik River, Papua New Guinea. Basel: Tribal Art Centre, 1985.
- Hanson, Allan, and Louise Hanson, eds. *Art and Identity in Oceania*. Honolulu: University of Hawaii Press, 1990.
- Kaeppler, Adrienne L., Christian Kaufmann, and Douglas Newton. *Oceanic Art.* New York: Abrams, 1997
- Kjellgren, Eric. Oceania: Art of the Pacific Islands in the Metropolitan Museum of Art. New York: Metropolitan Museum of Art, 2007.
- Kjellgren, Eric, and Carol Ivory. Adorning the World: Art of the Marquesas Islands. New York: Metropolitan Museum of Art, 2005.
- Kooijman, Simon. *Tapa in Polynesia*. Honolulu: Bishop Museum Press, 1972.
- Lilley, Ian, ed. Archaeology of Oceania: Australia and the Pacific Islands. Malden, Mass: Blackwell, 2006.
- Mead, Sidney Moko, ed. *Te Maori: Maori Art from New Zealand Collections*. New York: Abrams in association with the American Federation of Arts, 1984.
- Morphy, Howard. Aboriginal Art. London: Phaidon, 1998.
- Rainbird, Paul. *The Archaeology of Micronesia*. New York: Cambridge University Press, 2004.
- Sayers, Andrew. Australian Art. New York: Oxford University Press, 2001.
- Schneebaum, Tobias. *Embodied Spirits: Ritual Carvings of the Asmat.* Salem, Mass.: Peabody Museum of Salem, 1990.
- Smidt, Dirk, ed. Asmat Art: Woodcarvings of Southwest New Guinea. New York: Braziller in association with Rijksmuseum voor Volkenkunde, Leiden, 1993.
- Starzecka, Dorota, ed. *Maori Art and Culture*. Chicago: Art Media Resources, 1996.
- Sutton, Peter, ed. *Dreamings: The Art of Aboriginal Australia*. New York: Braziller in association with the Asia Society Galleries, 1988.
- Thomas, Nicholas. *Oceanic Art.* London: Thames & Hudson, 1995.

Chapter 37: Africa, 1800 to 1980

Abiodun, Roland, Henry J. Drewal, and John Pemberton III, eds. *The Yoruba Artist: New Theoretical Perspectives on African Arts*. Washington, D.C.: Smithsonian Institution Press, 1994.

- Bassani, Ezio. Arts of Africa: 7,000 Years of African Art. Milan: Skira, 2005.
- Binkley, David A., and Patricia Darish. *Kuba*. Milan: 5 Continents, 2009.
- Blier, Suzanne P. *The Royal Arts of Africa*. New York: Abrams, 1998.
- Boyer, Alain-Michel. *Baule*. Milan: 5 Continents, 2007. Cole, Herbert M. *Icons: Ideals and Power in the Art of Africa*. Washington, D.C.: National Museum of African Art, Smithsonian Institution, 1989.
- ——, ed. I Am Not Myself: The Art of African Masquerade. Los Angeles: UCLA Fowler Museum of Cultural History, 1985.
- Cole, Herbert M., and Chike C. Aniakor. *Igbo Art:*Community and Cosmos. Los Angeles: UCLA
 Fowler Museum of Cultural History, 1984.
- Fraser, Douglas F., and Herbert M. Cole, eds. African Art and Leadership. Madison: University of Wisconsin Press, 1972.
- Geary, Christraud M. Bamum. Milan: 5 Continents, 2011.
- Things of the Palace: A Catalogue of the Bamum Palace Museum in Foumban (Cameroon). Weisbaden: Franz Steiner Verlag, 1983.
- Glaze, Anita J. Art and Death in a Senufo Village. Bloomington: Indiana University Press, 1981.
- Kasfir, Sidney L. Contemporary African Art. London: Thames & Hudson, 1999.
- -----. West African Masks and Cultural Systems. Tervuren: Musée Royal de l'Afrique Centrale, 1988.
- Magnin, Andre, with Jacques Soulillou. *Contemporary Art of Africa*. New York: Abrams, 1996.
- Nooter, Mary H. Secrecy: African Art That Conceals and Reveals. New York: Museum for African Art, 1993.
- Oguibe, Olu, and Okwui Enwezor, eds. Reading the Contemporary: African Art from Theory to the Marketplace. London: Institute of International Visual Arts, 1999.
- Perani, Judith, and Fred T. Smith. The Visual Arts of Africa: Gender, Power, and Life Cycle Rituals. Upper Saddle River, N.J.: Prentice Hall, 1998.
- Perrois, Louis. Fang. Milan: 5 Continents, 2008.
- Phillips, Ruth B. Representing Women: Sande Masquerades of the Mende of Sierra Leone. Los Angeles: UCLA Fowler Museum of Cultural History, 1995.
- Plankensteiner, Barbara. Benin. Milan: 5 Continents, 2010.
- Sieber, Roy, and Roslyn A. Walker. *African Art in the Cycle of Life.* Washington, D.C.: Smithsonian Institution Press, 1987.
- Stepan, Peter. Spirits Speak: A Celebration of African Masks. Munich: Prestel, 2005.

- Thompson, Robert F., and Joseph Cornet. *The Four Moments of the Sun: Kongo Art in Two Worlds.* Washington, D.C.: National Gallery of Art, 1981.
- Vinnicombe, Patricia. People of the Eland: Rock Paintings of the Drakensberg Bushmen as a Reflection of Their Life and Thought. Pietermaritzburg: University of Natal Press, 1976.
- Visonà, Monica B., ed. A History of Art in Africa. 2d ed. Englewood Cliffs, N.J.: Prentice Hall, 2007.
- Vogel, Susan M. Baule: African Art, Western Eyes. New Haven, Conn.: Yale University Press, 1997.
- ——, ed. Africa Explores: Twentieth-Century African
 Art. New York: Te Neues, 1990.
- Walker, Roslyn A. Olowe of Ise: A Yoruba Sculptor to Kings. Washington, D.C.: National Museum of African Art, 1998.
- Wastiau, Boris. Chokwe. Milan: 5 Continents, 2008.

Chapter 31: Contemporary Art Worldwide

- Buchhart, Dieter, et al., Jean-Michel Basquiat. Ostfildern: Hatje Cantz, 2010.
- Butler, Cornelia H., and Lisa Gabrielle Mark. WACK!:

 Art and the Feminist Revolution. Cambridge,
 Mass.: MIT Press, 2007.
- Celent, Germano. Anselm Kiefer. Milan: Skira, 2007.
- Chilvers, Ian, and John Glaves-Smith. Oxford Dictionary of Modern and Contemporary Art. 2d ed. New York: Oxford University Press, 2009.
- Cook, Peter. New Spirit in Architecture. New York: Rizzoli, 1990.
- Cummings, P. Dictionary of Contemporary American Artists. 6th ed. New York: St. Martin's, 1994.
- Deepwell, K., ed. *New Feminist Art.* Manchester: Manchester University Press, 1994.
- Enwezor, Okwui, and Chika Okeke-Agulu. *Contemporary African Art since 1980*. Bologna: Damiani, 2009.
- Ferguson, Russell, ed. *Discourses: Conversations in Postmodern Art and Culture.* Cambridge, Mass.: MIT Press, 1990.
- Fineberg, Jonathan. Art since 1940: Strategies of Being. 2d ed. Upper Saddle River, N.J.: Prentice Hall, 2000.
- Galassi, Peter. *Andreas Gursky*. New York: Museum of Modern Art, 2001.
- Ghirardo, Diane. Architecture after Modernism. New York: Thames & Hudson, 1996.
- Goldsworthy, Andy. Andy Goldsworthy: A Collaboration with Nature. New York: Abrams, 1990.
- Heartney, Eleanor, Helaine Posner, Nancy Princenthal, and Sue Scott. *After the Revolution: Women Who Transformed Contemporary Art.* New York: Prestel, 2007
- Hertz, Richard, ed. *Theories of Contemporary Art.* 2d ed. Upper Saddle River, N.J.: Prentice Hall, 1993.

- Hopkins, David. *After Modern Art, 1945–2000.* New York: Oxford University Press, 2000.
- Jencks, Charles. The New Paradigm in Architecture: The Language of Post-Modernism. New Haven, Conn.: Yale University Press, 2002.
- Jodidio, Philip. *100 Contemporary Architects*. Cologne: Taschen, 2008.
- Kasfir, Sidney Littlefield. Contemporary African Art. New York: Thames & Hudson, 1999.
- Kolossa, Alexandra. Keith Haring 1958–1990: A Life for Art. Cologne: Taschen, 2009.
- Kotz, Mary Lunn. *Rauschenberg: Art and Life.* New York: Abrams, 2004.
- Lippard, Lucy R. Mixed Blessings: New Art in a Multicultural America. New York: Pantheon, 1990.
- Mullins, Charlotte. *Painting People: Figure Painting Today.* New York: Thames & Hudson, 2008.
- Nesbitt, Judith, ed. Chris Ofili. London: Tate, 2010.
- Norris, Christopher, and Andrew Benjamin. What Is Deconstruction? New York: St. Martin's, 1988.
- Paul, Christiane. *Digital Art.* 2d ed. New York: Thames & Hudson, 2008.
- Pauli, Lori, ed. *Manufactured Landscapes: The Photo*graphs of Edward Burtynsky. New Haven, Conn.: Yale University Press, 2003.
- Perry, Gill, and Paul Wood. *Themes in Contemporary Art.* New Haven, Conn.: Yale University Press, 2004.
- Raskin, David. *Donald Judd*. New Haven, Conn.: Yale University Press, 2010.
- Risatti, Howard, ed. *Postmodern Perspectives: Issues in Contemporary Art.* Upper Saddle River, N.J.: Prentice Hall, 1990.
- Sandler, Irving. *Art of the Postmodern Era*. New York: Harper Collins, 1996.
- Smith, Terry. What Is Contemporary Art? Chicago: University of Chicago Press, 2009.
- Sollins, Susan, ed. Art: 21 (Art in the Twenty-first Century). 5 vols. New York: Abrams, 2001–2009.
- Stiles, Kristine, and Peter Selz. Theories and Documents of Contemporary Art: A Sourcebook of Artists' Writings. Berkeley and Los Angeles: University of California Press, 1996.
- Taylor, Brendon. *Contemporary Art: Art since 1970.* Upper Saddle River, N.J.: Prentice Hall, 2005.
- Terraroli, Valerio, ed. Art of the Twentieth Century, 1969–1999: Neo-avant-gardes, Postmodern and Global Art. Milan: Skira, 2009.
- Wands, Bruce. Art of the Digital Age. New York: Thames & Hudson, 2007.
- Warren, Lynne. *Jeff Koons*. New Haven, Conn.: Yale University Press, 2008.
- Wines, James. Green Architecture. Cologne: Taschen, 2008

CREDITS

Chapter 31—Opener: Courtesy of Jaune Quick-to-See Smith (An Enrolled Salish, member of the Salish and Kootenai Nation Montana) Photo: © Chrysler Museum of Art, Norfolk, VA, Museum Purchase, 93.2; (timeline) Courtesy of Jaune Quick-to-See Smith (An enrolled Salish, member of the Salish and Kootemai Nation Montana) Photo © Chrysler Museum of Art, Norfolk, VA, Museum Purchase, 93.2; 31-2: "COPYRIGHT: BARBARA KRUGER. COURTESY: MARY BOONE GALLERY, NEW YORK."; 31-3: Courtesy of the Estate of David Wojnarowicz and P.P.O.W. Gallery, NY; 31-2A: Copyright © 1988 Guerrilla Girls, courtesy www.guerrillagirls.com; 31-4: Self-Portrait, 1980 © Copyright The Robert Mapplethorpe Foundation. Courtesy Art + Commerce; 31-5: © Shahzia Sikander. Photograph: Sheldan C. Collins, courtesy Whitney Museum of American Art; 31-6: © 1983 Faith Ringgold; 31-6A: © Lorna Simpson; 31-6B: Art: Courtesy of the artist and Jack Shainman Gallery, NY. Photo: Brooklyn Museum of Art, New York, USA/Caroline A.L. Pratt Fund/The Bridgeman Art Library International; 31-7: © Smithsonian American Art Museum, Washington, DC/Art Resource, NY; 31-8: © 2011 Estate of Jean-Michel Basquiat/ADAGP, Paris/Artists Rights Society (ARS), New York. Photography: Douglas M. Parker Studio, Los Angeles. Image courtesy of The Broad Art Foundation, Santa Monica; 31-9: © Kehinde Wiley. Brooklyn Museum photograph, 2010; 31-10A: Trigo Piula; 31-10: © Chris Ofili, courtesy Chris Ofili-Afroco and Victoria Miro Gallery, photo by Stephen White; 31-11: Meteorological Service of New Zealand Ltd. Collection, Wellington.; 31-12: © Willie Bester; 31-13: Photo Scott Frances © Esto, All rights reserved, © David Hammons; 31-14: Art © Estate of Leon Golub/Licensed by VAGA, New York, NY Courtesy Ronald Feldman Gallery; 31-15: © Shirin Neshat. Photo © The Bridgeman Art Library International; 31-16: © Krzysztof Wodcizko Courtesy Galerie Lelong, New York; 31-17: © 2011 Hans Haacke. Licensed by Artists Rights Society (ARS), NY/VG Bild-Kunst, Bonn. Photo: © CNAC/MNAM/Dist. © Réunion des Musées Nationaux/Art Resource, NY; 31-18: Copyright © Xu Bing, courtesy Chazen Museum of Art (formerly Elvehjem Museum of Art), University of Wisconsin; 31-19: © Edward Burtynsky, courtesy Nicholas Metivier, Toronto/Howard Greenberg & Bryce Wolkowitz, New York; 31-20: Photo courtesy Broad Art Foundation and the Pace Gallery, NY, © Julian Schnabel; 31-21: © Anselm Kiefer. Courtesy Gagosian Gallery. Photography by Robert McKeever. © Philadelphia Museum of Art, 1985-5-1; 31-22: Collection of National Heritage Board, Singpore Art Museum; 31-22A: Heritage Images, © The British Museum; 31-22B: © DACS/Mollie Gowing Acquisition Fund for Contemporary Aboriginal Art 1992/The Bridgeman Art Library; 31-23: Association de la Jeune Sculpture 1987/2 photo © Serge Goldberg; 31-24: © Tara Donovan. Ace Gallery, Los Angeles; 31-25: Artwork © Jenny Saville; 31-26: Photo © Whitney Museum of American Art, © Kiki Smith; 31-27: Museum of Contemporary Art, Chicago © Jeff Koons; 31-27A: Art © Estate of Robert Arneson/Licensed by VAGA, NY Photo: San Francisco Museum of Modern Art: 31-27A: Art © Estate of Robert Arneson/Licensed by VAGA, New York, NY. Photo: San Francisco Museum of Modern Art; 31-28: Art @ Marisol Escobar/ Licensed by VAGA, New York, NY; 31-29: © Johan Gerrits; 31-28A: Mark Tansey, courtesy Gagosian Gallery, NY; 31-30: © Martin Jones; Ecoscene/CORBIS; 31-31a: © John Gollings/Arcaid/Corbis; 31-31b: © John Gollings/Arcaid/Corbis; 31-32: Photo Saskia Cultural Documentation; 31-33: © Santiago Yaniz/Photolibrary; 31-34: © Jacques Pavlovsky/Sygma/CORBIS; 31-34A: Arcaid.co.uk; 31-35: akg-images/ Hilbich; 31-36: © Jonathan Poore/Cengage Learning; 31-36: The Denver Art Museum; 31-37: Kokyat Choong/The Image Works; 31-38: Robert O'Dea/akg-images; 31-39: © 2011 Richard Serra/Artists Rights Society (ARS), NY. Photo © Burt Roberts, courtesy of Harriet Senie; 31-40: Wolfgang Volz ©1983 Christo; 31-41: © Andy Goldsworthy Courtesy Galerie Lelong, New York; 31-42: © Jonathan Poore/Cengage Learning; 31-43: © 2011 ANDREAS GURSKY. Licensed by Artist's Rights Society (ARS) New York.; 31-44: © 2011 Jenny Holzer/Artists Rights Society (ARS), NY. photograph by David Heald © The Solomon R. Guggenheim Foundation; 31-45: Adrian Piper Research Archive; 31-46: Bill Viola, photo: Kira Perov; 31-47: Tony Oursler, courtesy of the artist and Metro Pictures, NY.; 31-48: Photograph by David Heald © The Solomon R. Guggenheim Foundation, NY; UNF 31-01: Self-Portrait, 1980 © Copyright The Robert Mapplethorpe Foundation. Courtesy Art + Commerce; UNF 31-2: © 2011 Estate of Jean-Michel Basquiat/ADAGP, Paris/Artists Rights Society (ARS), New York.

Photography: Douglas M. Parker Studio, Los Angeles. Image courtesy of The Broad Art Foundation, Santa Monica; **UNF 31-3:** Photo © Whitney Museum of American Art, © Kiki Smith; **UNF 31-4:** akg-images/Hilbich; **UNF 31-5:** Tony Oursler, courtesy of the artist and Metro Pictures, NY.

Chapter 32—Opener: Freer Gallery of Art, Smithsonian Institution, Washington, D.C., Purchase, F1942.15a; Map 32-1: © Cengage Learning; timeline: Freer Gallery of Art, Smithsonian Institution, Washington, D.C., Purchase, F1942.15a; 32-2: © Robert Harding/Photolibrary; 32-3: © V Muthuraman/India Picture RM/Photolibrary; 32-4: © Victoria & Albert Museum, London/Art Resource, NY; 32-5: © Victoria & Albert Museum, London/Art Resource, NY; 32-5A: Photograph © 2011 Museum of Fine Arts, Boston.14.654; 32-6: © Kevin R. Morris/Documentary Value/Corbis; 32-7: National Museum, New Delhi; 32-7A: Courtesy of the Trustees of the Chhatrapati Shivaji Maharaj Vastu Sangrahalaya formerly Prince of Wales Museum of Western India, Mumbai. Not to be reproduced without prior permission of the Trustees; 32-8: © ml-foto ml-foto/Photolibrary; 32-9: © Tony Waltham/Robert Harding Picture Library; 32-10: The Brooklyn Museum of Art, 87.234.6; 32-11: © Dr. Ronald V. Wiedenhoeft/Saskia, Ltd; 32-12: © Stuart Westmorland; 32-13: © Luca Tettoni Photography; 32-14: © Ladislav Janicek/Bridge/Corbis; 32-15: Pacific Asia Museum Collection, gift of Hon. and Mrs. Jack Lydman, Museum No. 1991.47.34; UNF 32-01: © Robert Harding/Photolibrary; UNF 32-2: © V Muthuraman/India Picture RM/Photolibrary; UNF 32-3: Freer Gallery of Art, Smithsonian Institution, Washington, D.C., Purchase, F1942.15a; UNF 32-4: © Stuart Westmorland; UNF 32-5: © Tony Waltham/Robert Harding Picture Library.

Chapter 33—Opener: © photos12.com/Panorama Stock; (detail 1): © Best View Stock/Photolibrary; (detail 2): © View Stock/Photolibrary; (detail 3): © Best View Stock/Photolibrary; (detail 4): © Alfred Ko/CORBIS; 33-01A: Freer Gallery of Art, Smithsonian Institution, Washington, D.C.; 33-2: Collection of the National Palace Museum, Taiwan, Republic of China; timeline: © photos12.com/Panorama Stock; 33-3: Collection of the National Palace Museum, Taiwan, Republic of China; 33-4: Collection of the National Palace Museum, Taiwan, Republic of China; 33-5: Percival David Foundation of Chinese Art, B614; 33-4A: Collection of the National Palace Museum, Taiwan, Republic of China; Map 33-1: © Cengage Learning; 33-6: © Best View Stock/Photolibrary; 33-7: © Alfred Ko/CORBIS; 33-8: © Victoria & Albert Museum/Art Resource, NY; 33-9: Cultural Relics Publishing House, Beijing; 33-10: © Michael DeFreitas/Robert Harding Travel/Photolibrary; 33-11: © Mauritius/Photolibrary; 33-12: Collection of the National Palace Museum, Taiwan, Republic of China; 33-12A: Nelson-Atkins Museum of Art, Kansas City; 33-13: Photo copyright © Cleveland Museum of Art, Cleveland; 33-14: Gift of Mr. Robert Allerton, 1957 (236.1), photo copyright © Honolulu Academy of Arts; 33-15: John Taylor Photography, C. C. Wang Family Collection, NY; 33-16: Cultural Relics Publishing House, Beijing; 33-17: Percival David Foundation of Chinese Art, A821; 33-18: @ Audrey R. Topping; 33-19: © JTB Photo/Photolibrary; 33-20: Hoam Art Museum, Kyunggi-Do; UNF 33-01: Percival David Foundation of Chinese Art, B614; UNF 33-2: © Best View Stock/Photolibrary; UNF 33-3: John Taylor Photography, C. C. Wang Family Collection, NY; UNF 33-4: @ Audrey R.Topping; UNF 33-5: @ JTB Photo/Photolibrary.

Chapter 34—Opener: Museum photograph © 206 The Brooklyn Museum.

30.1478.30; Map 34-1: © Cengage Learning; timeline: Museum photograph © 206 The Brooklyn Museum. 30.1478.30; 34-2: Patricia J. Graham; 34-2A: © Michael S. Yamashita/Documentary Value/Corbis; 34-3: TNM Image Archives, Source: http://TNMArchives.jp/; 34-4: TNM Image Archives, Source: http://TNMArchives.jp/; 34-5: © Sakamoto Photo Research Laboratory/Corbis; 34-4A: © Steve Vidler/SuperStock; 34-6: TNM Image Archives, Source: http://TNMArchives.jp/; 34-7: Photograph by Oyamazaki Town Office. Haga Library/Lebrecht Music and Arts Photo Library; 34-8: The Hatakeyama Memorial Museum of Fine Art, Tokyo; 34-9: Lebrecht Music and Arts Photo Library; 34-9A: Smithsonian Freer Gallery of Art and Arthur M. Sackler Gallery; 34-10: TNM Image Archives, Source: http://TNMArchives.jp/; 34-11: Photocopyright © Hiraki Ukiyo-e Museum, Yokohama; 34-12: Photography © The Art Institute of Chicago1925.243; 34-12A: © Erich Lessing/Art Resource, NY; 34-13: Photograph © 2011 Museum of Fine Arts, Boston 11.17652; 34-14: Tokyo National

University of Fine Arts and Music; **34-15:** Freer Gallery of Art, Smithsonian Institution, Washington, D.C., Purchase, F192.225; **34-16:** © Hamada Shoji, Mashiko Reference Collection. Photo: © National Museum of Modern Art, Kyoto; **34-17:** Copyright: Fujiko Shiraga and the former members of the Gutai Art Association Courtesy: Ashiya City Museum of Art and History; **34-18:** © AP Photo/Kyodo News; **UNF 34-01:** TNM Image Archives, Source: http://TNMArchives.jp/; **UNF 34-2:** © Sakamoto Photo Research Laboratory/Corbis; **UNF 34-3:** Lebrecht Music and Arts Photo Library; **UNF 34-4:** 1925.243, Photography © The Art Institute of Chicago; **UNF 34-5:** © AP Photo/Kyodo News.

Chapter 35—Opener: The Bodleian Libraries, University of Oxford. Shelfmark: MS. Arch. Selden. A.1, fol. 2r; Map 35-1: © Cengage Learning; timeline: The Bodleian Libraries, University of Oxford. Shelfmark: MS. Arch. Selden. A.1, fol. 2r; 35-2: Private Collection/Jean-Pierre Courau/The Bridgeman Art Library International; 35-3: adapted from an image by Ned Seidler/National Geographic Society; 35-4: @ Gianni Dagli Orti/CORBIS; **35-5:** © Ronaldo Schemidt/AFP/Getty Images; **35-6:** © Gianni Dagli Orti/The Picture Desk Limited/Corbis; Map 35-2: © Cengage Learning; 35-7: © G. Dagli Orti/De Agostini Picture Library/Learning Pictures; 35-8: left © Michael Freeman/Encyclopedia/CORBIS; 35-8: right @ Milton Keiles; 35-8A: @ American Museum of Natural History, New York, USA/The Bridgeman Art Library; Map 35-3: © Cengage Learning; **35-9:** © Ira Block/National Geographic/Getty Images; **35-10:** Arizona State Museum, University of Arizona, photo W. McLennan; 35-11: Photo © National Museum of Women in the Arts; 35-12a: American Museum of Natural History, New York; 35-12b: American Museum of Natural History, New York.; 35-13: Photo © American Museum of Natural History, NY; 35-14: Museum of Anthropology at the University of British Columbia, photo W. McLennan; 35-14A: The Art Archive/ Neil Setchfield/Picture Desk; 35-15: Southwest Museum of the American Indian Collection, Autry National Center; 761.G.33; 35-16: © The Metropolitan Museum of Art/Art Resource, NY; 35-16A: Peabody Museum of Archaeology, Harvard University, Cambridge.; 35-17: he Art Archive/Gift of Clara S Peck/Buffalo Bill Historical Center, Cody, Wyoming/21.69.37/Picture Desk; 35-18: Collection of Mr. and Mrs. Charles Diker; UNF 35-01: Private Collection/Jean-Pierre Courau/The Bridgeman Art Library International; UNF 35-2: © Gianni Dagli Orti/The Picture Desk Limited/Corbis; UNF 35-3: © G. Dagli Orti/De Agostini Picture Library/Learning Pictures; UNF 35-4: © Ira Block/National Geographic/Getty Images; UNF 35-5: American Museum of Natural History, New York.

Chapter 36—Opener (bottom): © Werner Forman/Art Resource, NY; (detail 1): © Werner Forman/Art Resource, NY; (detail 2): © Tara Hunt; (detail 3): © Werner Forman/Art Resource, NY; (detail 4): © Werner Forman/Art Resource, NY; Map 36-1: © Cengage Learning; timeline: © Werner Forman/Art Resource, NY; 36-01A: © Werner Forman/Art Resource, NY; 36-2: Reproduced courtesy Museum of Victoria; 36-3: © Yoko Aziz/Alamy; 36-4: © NHPA/Photoshot; 36-7: Copyright © Otago Museum, Dunedin, New Zealand, D45.179; 36-5: AA353/3/22 Vyse Collection. F. E. Williams, photographer, South Australian Museum Archives; 36-6: abm-Archives Barbier-Mueller, photographer Wolfgang Pulfer; 36-8: © Scala/Art Resource, NY;

36-9: © Trustees of the British Museum/Art Resource, NY; 36-10: © Bildarchiv Preussischer Kulturbesitz/Art Resource, NY; 36-11: © The Metropolitan Museum of Art/Art Resource, NY; 36-12: © Wolfgang Kaehler/CORBIS; 36-13: Adrienne Kaeppler; 36-14: Photo © University of Pennsylvania Museum/153195; 36-15A: Reproduced by permission of the University of Cambridge Museum of Archaeology & Anthropology, E 1895.158; 36-15: akg-images; 36-16: © The Trustees of the British Museum/Art Resource, NY; 36-17: © Heritage Images/The British Museum; 36-18: © The Trustees of the British Museum/Art Resource, NY; 36-19: Photo Bishop Museum, Honolulu; 36-19A: Copyright © Otago Museum, Dunedin, New Zealand; UNF 36-2: Otago Museum, Dunedin, New Zealand; UNF 36-3: © The Metropolitan Museum of Art/Art Resource, NY; UNF 36-4: Werner Forman/Value Art/Corbis; UNF 36-5: Photo Bishop Museum, Honolulu.

Chapter 37—Opener: © The Trustees of the British Museum/Art Resource, NY; Map 37-1: © Cengage Learning; timeline: © The Trustees of the British Museum/Art Resource, NY; 37-2: Natal Museum, Pietermaritzburg, South Africa; 37-3: Natal Museum, Pietermaritzburg, South Africa; 37-4: @ Art Resource, NY; 37-5: abm-Archives Barbier-Mueller; 37-6: © Bildarchiv Preussischer Kulturbesitz/Art Resource, NY; 37-7: © Musee du Quai Branly/© Scala/Art Resource, NY; 37-8: Photograph by Franko Khoury. National Museum of African Art, Smithsonian Institution; 37-9: Detroit Institute of Arts, USA/Founders Society Purchase Eleanor Clay Ford Fund for African Art/The Bridgeman Art Library International; 37-10: © Werner Forman/Art Resource, NY; 37-11: © The Metropolitan Museum of Art/Art Resource, NY; 37-12: The Metropolitan Museum of Art/Art Resource, NY; 37-13: Photo by Eliot Elisofon, 1970. Image no. EEPA EECL 7590. Eliot Elisofon Photographic Archives. National Museum of African Art, Smithsonian Institution; 37-13A: © Owen Franken/Encyclopedia/Corbis; 37-14: Photograph by Franko Khoury. National Museum of African Art, Smithsonian Institution"; 37-15: © Herbert M. Cole; 37-16: © Trustees of the British Museum, London; 37-16A: Denver Art Museum Collection: Funds from 1996 Collectors' Choice and partial gift of Valerie Franklin; 37-17: © Fulvio Roiter/Corbis; 37-17A: Photograph by Franko Khoury. National Museum of African Art, Smithsonian Institution; 37-18: Musée Barbier-Mueller, Geneva.; 37-19: © Charles & Josette Lenars/ CORBIS; 37-20: Fowler Museum at UCLA, photo: Don Cole; 37-21: © Otto Lang/ CORBIS; 37-22: 2011 Peabody Museum, Harvard University 17-41-50/B198 T762.1; 37-23: Photograph by Eliot Elisofon, 1971, EEPA EECL 2139, Eliot Elisofon Photographic Archives, National Museum of African Art, Smithsonian Institution; 37-24: © Herbert M. Cole; 37-25: © Herbert M. Cole; 37-26: photograph by Philip L. Ravenhill, 1989, EEPA 1989-6346, Eliot Elisofon Photographic Archives, National Museum of African Art, Smithsonian Institution; UNF 37-01: @ Bildarchiv Preussischer Kulturbesitz/Art Resource, NY; UNF 37-2: © Detroit Institute of Arts, USA/The Bridgeman Art Library International; UNF 37-3: Photo by Eliot Elisofon, 1970. Image no. EEPA EECL 7590. Eliot Elisofon Photographic Archives. National Museum of African Art, Smithsonian Institution; UNF 37-4: © Herbert M. Cole; UNF 37-5: Fowler Museum at UCLA, photo: Don Cole.

MUSEUM INDEX

Note: Figure numbers in blue indicate bonus images.

Adelaide (Australia): South Australian Museum: Auuenau, Western Arnhem Land (bark painting), 1045

Bangkok (Thailand): Wat Behamabopit: Walking Buddha, Sukhothai, 985 Beijing (China)

Palace Museum

Auspicious Objects (Castiglione), 1000 Guan Yu Captures General Pang De (Shang Xi), 995

Berlin (Germany)

Staatliche Museen zu Berlin men's ceremonial house, Belau, 1050 throne and footstool of King Nsangu, Bamum, 1065

Boston, Massachusetts (U.S.A.)

Museum of Fine Arts

Darbar of Jahangir, Tuzuk-i Jahangiri (Memoirs of Jahangir) (Abul Hasan and Manohar),

The Great Wave off Kanogawa, Thirty-six Views of Mount Fuji series (Hokusai), 1017

Brooklyn, New York (U.S.A.)

Brooklyn Museum

Maharaja Jaswant Singh of Marwar,

Napoleon Leading the Army Over the Alps (Wiley), 948

Plum Estate, Kameido, One Hundred Famous Views of Edo series (Hiroshige), 1004

Untitled (Man Smoking/Malcolm X), Kitchen Table series (Weems),

C

Cambridge, Massachusetts (U.S.A.) Peabody Museum of Archaeology and Ethnology, Harvard University buffalo-hide robe with battle scene, Mandan, 35-16A

Ngady Amwaash mask, Kuba, 1076 Canberra (Australia): National Gallery of Australia: Ambum Stone (composite animal-human figurine), Papua New Guinea, 36-1A Chicago, Illinois (U.S.A.)

Art Institute of Chicago: Evening Bell at the Clock, Eight Views of the Parlor series (Harunobu), 1016

Museum of Contemporary Art Cornered (Piper), 971 Pink Panther (Koons), 958

Cleveland, Ohio (U.S.A.): Cleveland Museum of Art: Dwelling in the Qingbian Mountains (Dong Qichang), 998

Cody, Wyoming (U.S.A.): Buffalo Bill Historical Center: Hidatsa Warrior Pehriska-Ruhpa (Two Ravens) (Bodmer) (engraving), 1039

Denver, Colorado (U.S.A.): Denver Art Museum: veranda post, Akure (sculpture) (Olowe of Ise), 37-16A

Detroit, Michigan (U.S.A.): Detroit Institute of Arts: nail figure (nkisi n'kondi), Kongo (sculpture), 1067

Dunedin (New Zealand): Otago Museum: tatuana mask, New Ireland, 1049

Fort Worth, Texas (U.S.A.): Kimbell Art Museum: Chibinda Ilunga, Chokwe (sculpture), 1068

Geneva (Switzerland) Musée Barbier-Mueller Abelam yam mask, Maprik district,

"Beautiful Lady" dance mask, Senufo,

reliquary guardian figure (mbulu ngulu), Kota, 1064

Honolulu, Hawaii (U.S.A.) Bishop Pauahi Museum: feather cloak, Hawaii, 1058

Honolulu Academy of Arts: Carnations and Garden Rock (Wen Shu), 999

Jerusalem: Israel Museum: Allegiance and Wakefulness (Neshat), 952

Kansas City, Missouri (U.S.A.): Nelson-Atkins Museum of Art: Poet on a Mountaintop (Shen Zhou), 33-12A

Kolkata (India): Rabindra Bharati Society: Bharat Mata (Mother India) (Tagore),

Kyoto (Japan): National Museum of Modern Art: large bowl, Showa period (Hamada), 1019

Kyunggi-Do (Korea): Hoam Art Museum: Geumgangsan Mountains (Jeong Seon), 1002

London (England) British Museum A'a, Rurutu (sculpture), 1056 ancestral screen (nduen fobara), Kalabari Ijaw, 1060

canoe prow ornament, Chuuk, 1050 head of Lono, Hawaii, 1057 Kuka'ilimoku, Hawaii (sculpture), 1056 Ohisa of the Takashima Tea Shop (Utamaro), 34-12

shrine of the king's head, royal palace, Ikere (Olowe of Ise), 1072 Summer Trees (Song), 31-22.

Percival David Foundation of Chinese Art: dish with lobed rim, Qing dynasty,

Saatchi Collection Branded (Saville), 957 The Holy Virgin Mary (Ofili), 949

Victoria & Albert Museum Akbar and the Elephant Hawai, Akbarnama (Basawan and Chatar

Shah Tahmasp Meditating (Banu), 979 table with drawers, Ming dynasty (Orchard Factory), 995

Los Angeles, California (U.S.A.)

the Ace Gallery: Untitled (Donovan), 957 Fowler Museum of Cultural History, University of California: female mask, Mende, 1075

Southwest Museum of the American Indian: Chilkat blanket with stylized animal motifs, Tlingit, 1038

Madison, Wisconsin (U.S.A.): Chazen Museum of Art, University of Wisconsin: A Book from the Sky (Xu),

Mexico City (Mexico) Museo del Templo Mayor Coyolxauhqui, Great Temple of Tenochtitlán (relief sculpture), 1027 Tlaltecuhtli, Great Temple of Tenochtitlán (relief sculpture), 1028

Museo Nacional de Antropología: Coatlicue, Tenochtitlán (sculpture),

Mumbai (India): Chhatrapati Shivaji Maharaj Museum: Krishna and the Gopis, 32-7A

New Delhi (India)

Maurya Sheraton Hotel: Ashoka at Kalinga (Mukherjee), 984

National Museum: Krishna and Radha in a Pavilion (Pahari School), 980

New York, New York (U.S.A.)

American Museum of Natural History eagle transformation mask, Kwakiutl,

llama, alpace, and woman, near Lake Titicaca (sculptures), 35 war helmet mask, Tlingit, 1037

Broad Art Foundation and the Pace Gallery: The Walk Home (Schnabel),

C.C. Wang Collection: Man in a House beneath a Cliff (Shitao), 999

Gagosian Gallery: A Short History of Modernist Painting (Tansey), 31-28A

Mary Boone Gallery: Untitled (Your Gaze Hits the Side of My Face) (Kruger),

Matthew Marks Gallery: Chicago Board of Trade II (Gursky), 970

Metropolitan Museum of Art Dilukai, Belau, 1051

male and female figures, probably bush spirits (asye usu), Baule, 1069 mask, Yupik Eskimo, 1039

seated couple, Dogon, 1068 Self-Portrait Looking at the Last Supper (Marisol), 959

Museum of Modern Art: Public Enemy (Hammons), 951

Robert Mapplethorpe Foundation: Self-Portrait (Mapplethorpe), 944

Ronald Feldman Fine Arts: Mercenaries IV (Golub), 951

Sean Kelly Gallery: Stereo Styles (Simpson), 31-6A

Solomon R. Guggenheim Museum: Untitled (Holzer), 970

Whitney Museum of American Art Perilous Order (Sikander), 945 Untitled (Smith), 958

Norfolk, Virginia (U.S.A.): Chrysler Museum of Art: Trade (Gifts for Trading Land with White People) (Smith), 940

Omaha, Nebraska (U.S.A.): Joslyn Art Museum: Hidatsa Warrior Pehriska-Ruhpa (Two Ravens) (Bodmer), 1039

Ottawa (Canada): National Gallery of Canada: Densified Scrap Metal #3A, Toronto, Ontario (Burtynsky), 954

Oxford (England): Bodleian Library, Oxford University: Codex Mendoza, 1022

Paris (France)

Musée du quai Branly canoe prow and splashboard, Trobriand Islands, 1049 warrior figure (Gu?) (Kendo), 1066

Musée National d'Art Moderne, Centre Georges Pompidou: MetroMobiltan (Haacke), 953

Pasadena, California (U.S.A.): Pacific Asia Museum: dish with two mynah birds on flowering branch, Vietnam, 986

Philadelphia, Pennsylania (U.S.A.) Philadelphia Museum of Art *Nigredo* (Kiefer), 955 reliquary guardian figure (bieri), Fang,

1064

University of Pennsylvania Museum of Archaeology and Anthropology: hair ornaments, Marquesas Islands, 1054

Pietermartizburg (South Africa): Natal Museum: San rock painting, Bamboo Mountain, 1063

R

Rome (Italy): Biblioteca Apostolica Vaticana: Borgia Codex (facsimile), 1025

S

San Francisco, California (U.S.A.): San Francisco Museum of Modern Art: California Artist (Arneson), 31-27A

Santa Fe (New Mexico): Museum of New Mexico: kiva mural, Kuaua Pueblo, 1033

Santa Monica, California (U.S.A.): Broad Foundation: *Horn Players* (Basquiat), Singapore: Singapore Art Museum: Wild Vines with Flowers Like Pearls (Wu), 956

Sydney, Australia: Art Gallery of New South Wales: *Untitled* (Kngwarreye),

T

Taibei (Taiwan)

National Palace Museum

Bamboo Groves in Mist and Rain (Guan
Daosheng), 990

Dwelling in the Fuchin Mountains (Huang Gongwang), 991 Lofty Mount Lu (Shen Zhou), 997 Rongxi Studio (Ni Zan), 33-4A Stalks of Bamboo by a Rock (Wu Zhen),

Tokyo (Japan)

hatakeyama Memorial Museum: Kogan (tea-ceremony water jar), Momoyama period, 1012

Museum of the Imperial Collections: *Chinese Lions* (Eitoku), 1010 Tokyo National Museum

Boat Bridge (writing box) (Koetsu), 1014 Pine Forest (Tohaku), 1011 splashed-ink (haboku) landscape (hanging scroll) (Sesshu Toyo), 1008

Zen Patriarch Xiangyen Zhixian Sweeping with a Broom (Motonobu), 1009

Tokyo National University of Fine Arts and Music: *Oiran (Grand Courtesan)* (Takahashi), 1018

Tucson, Arizona (U.S.A.): Arizona State Museum, University of Arizona: katsina figure (Pentewa), 1034

17

Vancouver (Canada): Museum of Anthropology, University of British Columbia: *The Raven and the First* Men (Reid), 35-14A

W

Washington, D.C. (U.S.A.)
Freer Gallery of Art
Bodhisattva Kannon (Kano), 1018
Jahangir Preferring a Sufi Shaykh to
Kings (Bichitr), 974
Sheep and Goat (Zhao), 33-1A

Waves at Matsushima (Tawaraya Sotatsu), 34-9A

National Museum of African Art Akua'ba (sculpture) (Bonsu), 1071 Ancient Mother figure, Senufo, 37-17A Ta Tele (Piula), 31-10A Yombe mother and child (pfemba) (sculpture), 1067

National Museum of American Art: Tambo, Lynch Fragments series (Edwards), 947

National Museum of Women in the Arts: jar (Martínez), 1035

Wellington (New Zealand)

Meterological Service of New Zealand: Tawhiri-Matea (God of the Winds) (Whiting), 949

National Museum of New Zealand: Te Hau-ki-Turanga meetinghouse, Poverty Bay (Rukupo and others) (reconstruction), 1042

v

Yokohama (Japan): Hiraki Ukiyo-e Museum: *Cuckoo Flying over New Verdure* (Buson), 1015

SUBJECT INDEX

Notes:

- · Page numbers in italics indicate illustrations.
- Page numbers in italics followed by b indicate bonus images in the text.
 - · Page numbers in italics followed by map indicate maps.
 - Figure numbers in blue indicate bonus images.

Numbers

20th century art African, 1069-1078, 1079 Chinese, 1001 Japanese, 1019-1020, 1021 Native North American, 1035, 35-14A See also late 20th century European and American art; Modernism

A'a, Rurutu (sculpture), 1056, 1056 Abelam yam mask, Maprik district, 1048,

abhaya mudra (do not fear mudra), 984 Abstract Expressionism

contemporary art and, 941, 947, 954, 955,

and Oceanic art, 1046, 31-22B

Rothenberg, 954 abstraction

in contemporary art, 954-957, 973,

See also Abstract Expressionism

Abul Fazl, 978 Abul Hasan: Darbar of Jahangir, 979b, 32-5A

action painting, 1019 The Advantages of Being a Woman Artist (Guerrilla Girls), 943b, 31-2A

African Americans

contemporary social art, 945-948 and kente cloth, 37-13.

See also specific African Americans African art, 1060-1079, 1062map

Asante, 1071-1072, 37-13A

Bamum, 1065

Baule, 1069

Benin. See Benin art Chokwe, 1067-1068

contemporary, 959-960, 1078, 31-10A

Dogon, 1068-1069, 1073, 1074-1075, 1078

Fang, 1061, 1064

Fon, 1066 Igbo, 1070, 1077-1078

Kalabari, 1060, 1061

Kongo, 1066-1067

Kota, 1061, 1064-1065

Kuba, 1076 Mende, 1073, 1075

Samburu, 1076-1077

San, 1063

Senufo, 1073-1074, 37-17A

societal contexts, 1061, 1066, 1068

timelines, 1062

Western fascination with. See primitivism Yoruba, 1072-1073, 37-16A

African sculpture

Asante, 1071-1072

Baule, 1069

Chokwe, 1068 Dogon, 1068-1069

Fang, 1064

Fon, 1066

Igbo, 1077-1078

Kalabari, 1060, 1061

Kongo, 1066-1067

Kota, 1064-1065 Senufo, 1073, 1074, 37-17A

Yoruba, 1072-1073, 37-16A

Agra (India): Taj Mahal, 980, 980

'ahu 'ula, 1058

Ahuitzotl (Aztec emperor), 1028

AIDS, 943-944

airplane and cow coffins (Joe), 960, 960 Akbar and the Elephant Hawai, Akbarnama

(Basawan and Chatar Muni), 978, 978 Akbar the Great (Mughal emperor), 978 Akbarnama (History of Akbar) (Abul Fazl),

978, 978 akua'ba, 1071-1072

Akua'ba (sculpture) (Bonsu), 1071–1072, 1071 Ala and Amadioha, mbari house, Umugote

Orishaeze, 1078, 1078 Alai Darvaza, Delhi, 977, 977

Alaska Native art, 1034, 1036, 1037, 1038,

1039

album leaves, 999, 33-12A

alchemy, 955

Allegiance and Wakefulness, Women of Allah

series (Neshat), 952, 952 Altes Museum, Berlin (Schinkel), 31-34A

Ambum Stone (composite animal-human figurine), Papua New Guinea, 1045b,

American art (U.S. art). See late 20th century European and American art;

Native North American art

Anasazi art. See Ancestral Puebloan art anatomy. See human figure Ancestral Puebloan art, 1032

ancestral screen (nduen fobara), Kalabari Ijaw, 1060, 1061

Ancient Mother figure, Senufo, 1073b, 37-17A Andean South American art, 1029map, 1041

Inka, 1029-1031, 35-8A societal contexts, 1029-1030

in African art, 1063

in Andean South American art, 35-8A

in Chinese art, 33-1A

in Japanese art, 1010

in Native North American art, 35-16A

in Oceanic art, 1046

See also composite animal-human figures antiapartheid movement, 950

Apanui, Wepiha: Mataatua meetinghouse,

Whakatane, 1058, 1058b, 36apprenticeship, 1071 apses: in Spanish art in the Americas, 1031 Arbus, Diane: Kruger and, 942

arches. See pointed arches architecture

African, 1078

Andean South American, 1030-1031 Chinese. See Chinese architecture contemporary, 960-964, 965-966, 973,

Japanese. See Japanese architecture Korean, 1002

Mesoamerican, 1026

Native North American, 1037 Oceanic, 1042, 1043, 1047, 1050, 1052, 1058, 36-19A

postmodern, 961, 962-963, 964, 31-34A South Asian. See South Asian

architecture Southeast Asian, 986

Arneson, Robert, 959

California Artist, 959b, 31-27A Art and Society boxes

African apprentices, 1071

African masquerades, 1073

gender roles in African art, 1070 gender roles in Native American art, 1035

Japanese tea ceremony, 1012 Mende female masqueraders, 1075

public funding, 944 tattoo in Polynesia, 1055

Tilted Arc, 967

Vietnam Veterans Memorial, 965 women's roles in Oceania, 1051

art as a political tool

in China, 989

in Japan, 1011

in Korea, 1002

in Mesoamerica, 1028

in Native North America, 1036-1037

See also contemporary art

art brut, 947

Art Deco. 1035

art market

and printmaking, 1015, 1016, 1017 See also patronage

artists, recognition of: in Africa, 1066, 1071, 1072

Artists on Art boxes: Gehry, 963

Asante art, 1071-1072, 37-1

Ashikaga shogunate, 1006, 1009 ashlar masonry, 1031

Ashoka at Kalinga (Mukherjee), 984, 984 Asmat bisj poles, Buepis village, 1046, 1046 Assassins series (Golub), 951

asye usu, 1069 AT&T Building (Sony Building), New York (Johnson and Burgee, with Simmons

Architects), 961

Atawalpa (Inka emperor), 1031 atrium/atria, 963

Aurangzeb (Mughal emperor), 945

painting), 1045, 1045 avatars, 981

Auspicious Objects (Castiglione), 1000, 1000 Australian art, 1045–1046, 1059, 31-22B Auuenau, Western Arnhem Land (bark

Beuys, Joseph, 954 bhakti, 981

Bichitr: Jahangir Preferring a Sufi Shaykh to Kings, 974, 975

bieri, 1064

Bihzad, 978

Bilbao (Spain): Guggenheim Bilbao Museum (Gehry), 962–963, 962, 963, 31-34B

Bilderbuch für Kinder (Bertuch), 1055 Bingham, Hiram, 1030

Ayuthaya kingdom (Thailand), 984

Bamboo Groves in Mist and Rain (Guan

Bamboo Mountain San rock painting, 1063,

Bangkok (Thailand): Emerald Temple, 985,

Banu, Sahifa: Shah Tahmasp Meditating, 978–979, 979

Barney, Matthew: Cremaster cycle, 972, 972

barrel vaults (tunnel vaults): in South Asian

Basawan: Akbar and the Elephant Hawai,

Beaubourg (Centre Georges Pompidou),

Olympic Park, Munich, 962

993-994, 994, 1002

Benin art, 1061, 1069-1071

Bertuch, Carl, 1055

Beijing (China): Forbidden City, 988, 989,

Belau (Caroline Islands), 1050, 1051, 1052

Benin City (Nigeria): royal ancestral altar of

Berlin (Germany): Altes Museum (Schinkel),

Bester, Willie: Homage to Steve Biko, 950, 950

King Eweka II, 1069–1071, 1070

Paris (Rogers and Piano), 964
"Beautiful Lady" dance mask, Senufo, 1074,

Hysolar Institute, University of Stuttgart, Stuttgart, 962, 962

barkcloth, 1047, 1051, 1053-1054

architecture, 981

Basquiat, Jean-Michel, 969

Horn Players, 947, 947

Akbarnama, 978, 978

Daosheng), 990, 991, 997

Aztec art, 1022, 1023, 1025-1029

Babur (Mughal emperor), 978

bai, 1050, 1052

1063

Bamum art, 1065

barge boards, 1043

bark painting, 1045

Barrie, Dennis, 944

Bastar art, 983–984

batik, 31-22E

Baule art, 1069

beadwork, 1040

1074

Behnisch, Günter

bisj pole, 1046

Boat Bridge (writing box) (Koetsu), 1014, 1014

bocio, 1066

Bodhisattva Kannon (Kano), 1018, 1019 Chilkat blanket with stylized animal motifs, South Asian, 945, 983 E Tlingit, 1038, 1038 eagle transformation mask, Kwakiutl, 1036, Southeast Asian, 986 bodhisattvas, 1018, 1019 Chinese architecture: Ming dynasty, 988, timeline, 942 Bodmer, Karl: Hidatsa Warrior 1036 989, 993-994, 996 controversial contemporary art, 944, 949, Pehriska-Ruhpa (Two Ravens), 1039, earthworks, 964-965, 968-969 Chinese art, 988-1002, 993map 965-967 1039 East India Company, 982 contemporary, 953, 956, 1001 Ming dynasty, 988, 989, 993–999, 1003, Cook, James, 1057 body adornment, 1076-1077 East Sepik (Papua New Guinea): Iatmul Cornered (Piper), 971, 971 See also tattoo ceremonial men's house, 1047, 1047 Bonsu Osei Cortés, Hernán, 1023, 1024, 1026, 1029 Easter Island (Rapa Nui): moai (sculptures), People's Republic, 1001, 1003 Akua'ba (sculpture), 1071-1072, 1071 costume, African, 1076, 1077 1045, 1052-1053, 1052 Qing dynasty, 999–1000, 1003 timelines, 990 two men sitting at a table of food (linguist's staff) (sculpture), 1072, Edo period Japanese art, 1004, 1005, 1012–1017, 1021, 34-9A, 34-12A Courbet, Gustave: Gursky and, 969 courses (in masonry), 1031 Coyolxauhqui (Aztec deity), 1026–1028 Coyolxauhqui, Great Temple of Tenochtitlán Yuan dynasty, 990-993, 1003, 33-1A, Edwards, Melvin: Tambo, Lynch Fragments 1072 A Book from the Sky (Xu), 953, 953 series, 946-947, 947 See also Chinese painting (relief sculpture), 1026–1028, 1027 books, illustrated, 978 Egyptian art: and postmodern architecture, Chinese Lions (Eitoku), 1010, 1010 Cracked Rock Spiral, St. Abbs (Goldsworthy), See also illustrated manuscripts Borgia Codex, 1025, 1025 Bourke-White, Margaret, 954 Eight Views of the Parlor series (Suzuki Chinese painting 968, 969 Ming dynasty, 994, 995, 996–999, 33-12A Cranmer, Doug: Haida village re-creation, Harunobu), 1016, 1017 Branded (Saville), 957, 957 Qing dynasty, 999, 1000 Yuan dynasty, 990–993, 33-1A, 33-4A Queen Charlotte Island, 1037, 1037 Eitoku: Chinese Lions, 1010, 1010 Elema art, 1047–1048 Cremaster cycle (Barney), 972, 972 bronze casting Chokwe art, 1067–1068 South Asian, 983-984 critical theory, 942 Elizabeth I (queen of England), 982 cross vaults. See groin vaults Southeast Asian, 984-985 Christianity Emerald Buddha, Emerald Temple, Brunelleschi, Filippo: San Lorenzo, Florence, in Andean South America, 1031 The Crossing (Viola), 971, 971 Bangkok, 985, 985 in China, 1000 Crucifixion: in contemporary art, 944 Emerald Temple, Bangkok, 985, 985 Buddhism in Mesoamerica, 1024, 1028-1029 Crystal Palace, London (Paxton), 961 emotionalism: in South Asian art, 32-7A Chan/Zen, 999, 1007 in Oceania, 1054, 36-14. Cubism: contemporary art and, 950 enamel 992 Christo: Surrounded Islands, Biscayne Bay, Esoteric, 1006 Cuckoo Flying over New Verdure (Buson), Environmental Art, 964-965, 968-969 in Southeast Asia, 984 1014-1015, 1015 Miami, Florida, 1980-1983, 968, 968 Era of Warring States (Japan), 1009 Theravada, 984 Chuuk (Caroline Islands), 1050 Cuzco (Peru), 1031 eravo, 1048 See also Pure Land Buddhism in Japan cire perdue. See lost-wax process Santo Domingo, 1031, 1031 eroticism Buddhist art city planning. See urban planning Temple of the Sun, 1031, 1031 in contemporary art, 944, 945 Southeast Asian, 984-985, 986 classical influences on later art: postmodern in Japanese art, 1017 See also Japanese Buddhist art architecture, 31-3 in South Asian art, 980, 981 Cliff Palace, Mesa Verde National Park, 1032 Escobar, Marisol. See Marisol buffalo-hide robe with battle scene, da Vinci, Leonardo. See Leonardo da Vinci Mandan, 1039, 1039b, 35-16A Coatlicue (Aztec deity), 1026, 1027, 1028, 1029 daguerreotypes, 983 Eskimo art, 1035, 1038 Coatlicue, Tenochtitlán (sculpture), 1028, burials. See funerary customs daimyo, 1006 Esoteric Buddhism, 1006 Evening Bell at the Clock, Eight Views of the Parlor series (Harunobu), 1016, 1017 Burtynsky, Edward 1029 Darbar of Jahangir (Abul Hasan and Densified Scrap Metal #3A, Toronto, Codex Mendoza, 1022, 1023, 1024, 1025 Manohar), Tuzuk-i Jahangiri (Memoirs Ontario, 954, 954 codex/codices, 1023 of Jahangir), 979b, 32-5A Expressionism Gursky and, 969 Borgia Codex, 1025, 1025 darbars, 32-5A Neo-Expressionism, 954–956 bush spirits (asye usu), 1069 See also Codex Mendoza David, Jacques-Louis: Napoleon Crossing the See also Abstract Expressionism Buson (Yosa Buson): Cuckoo Flying over New Saint-Bernard Pass, 948 colonialism Verdure, 1014-1015, 1015 in Africa, 1066, 37-16A Dayi (China): Rent Collection Courtyard (Ye F Bwoom masquerader, Kuda (photograph), in the Americas, 1024, 1028-1029, 1031 Yushan and others), 1001, 1001 face. See human face 1076, 1076 de Kooning, Willem in Oceania, 1045 Fan Kuan, 998 byobu, 1010 in South Asia, 982-983 contemporary art and, 941 fan paintings, 998-999 Schnabel and, 954 colophons, 997 Fang art, 1061, 1064 color death feather cloak, Hawaii, 1058, 1058 California Artist (Arneson), 959b, 31-27A in African art, 1075 in African art, 1066 feather heads, 1057 in Chinese art, 992, 994 female mask, Mende, 1075, 1075 in contemporary art, 950 in Mesoamerican art, 1025, 1028 Chinese, 990-991, 996, 997, 33-1A, 33-12A in contemporary art, 955, 965 feminist art in Japanese art, 1009, 1013, 1016, 1017 South Asian, 979 See also funerary customs contemporary, 942-943, 957, 973, 31-2A, deconstruction theory, 942 canoe prow and splashboard, Trobriand in Native North American art, 35-16A Islands, 1049-1050, 1049 in South Asian art, 32-7 Deconstructivism, 962-963, 31-34B and race, 945-946, 31-6A canoe prow ornament, Chuuk, 1050, 1050 compose. See composition deities. See religion and mythology Fenollosa, Ernest, 1018-1019 Carnations and Garden Rock (Wen Shu), 998–999, 999 composite animal-human figures: in Delhi (India) fiber arts. See textiles Alai Darvaza, 977, 977 Oceanic art, 36-1 Fifty-three Stations of the Tokaido Highway Caroline Islands art, 1050, 1052 composite view: in South Asian art, 32-7A Qutb Minar, 977, 977 (Hokusai), 1005 finials, 977 Castiglione, Giuseppe (Lang Shining): composition Quwwat al-Islam Mosque, 977 Auspicious Objects, 1000, 1000 in Chinese art, 999 Delhi sultanate, 976-977, 987 Finley, Karen, 944 casting. See bronze casting in Japanese art, 1005, 1017, 1019, 34-2A, Densified Scrap Metal #3A, Toronto, Ontario Fleck, John, 944 cemen, 1046 (Burtynsky), 954, 954 Florence (Italy): San Lorenzo, 31-32A Centre Georges Pompidou (Beaubourg), in Mesoamerican art, 1028 Denver Art Museum (Libeskind), 963, 963b, Fon art, 1066 Paris (Rogers and Piano), 964 Centzon Huitznahua (Aztec deities), 1027 in South Asian art, 978, 979, 32-5A computer graphics, 969–970 Forbidden City, Beijing, 988, 989, 993-994, Díaz del Castillo, Bernal, 1026 994, 1002 conceptual representation: in South Asian ceramics digital photography, 969-970 foreshortening: in contemporary art, 957 Chinese, 992, 993, 1000 Dilukai, 1051, 1052 art, 32 formalism, 31contemporary, 31-27/ Japanese, 1012, 1019 Confucianism, 1012 Dilukai, Belau, 1051 Foster, Norman: Hong Kong and Shanghai congregational mosques. See great mosques dish with lobed rim, Qing dynasty, 1000, 1000 Bank, Hong Kong, 960, 961 Native North American, 1034, 1035 conquistadores, 1024 dish with two mynah birds on flowering Freer, Charles Lang, 1019 Southeast Asian, 986 contemporary art, 940-973 branch, Vietnam, 986, 986 Freud, Lucian, 957 abstract, 954–957, 973, 31-22A, 31-22B See also sculpture do not fear mudra (abhaya mudra), 984 Friday mosques. See great mosques African, 959–960, 1078, 31-10A Chaco Canyon, New Mexico (U.S.A.): Pueblo documentary photography, 954 (congregational mosques) Bonito, 1032 architecture, 960-964, 965-966, 973, Dogon art, 1068-1069, 1073, 1074-1075, 1078 Frohnmayer, John, 944 chakravartin, 985 31-34A 31-34B domes: in South Asian architecture, 977, 980 funerary customs Chinese, 953, 956, 1001 Chan Buddhism, 999, 1006, 1007 Dong Qichang: Dwelling in the Qingbian Africa, 1074 characters, Chinese, 997 feminist, 942-943, 957, 973, 31-2A, 31-6A Oceanic, 1049, 1054 Mountains, 998, 998 Chatar Muni: Akbar and the Elephant Donovan, Tara: Untitled, 957, 957 and homosexuality, 943-945 South Asia, 980 Hawai, Akbarnama, 978, 978 human figure in, 951, 957-960, 973, 31-27A Douglas Camp, Sokari, 1070 fusuma, 1008 Chevenne art, 1035 Japanese, 956-957, 1020 dragons: in Chinese art, 992, 993, 994, 995 Chhatrapati Shivaji Terminus (Victoria Korean, 1002, 31 drawings: contemporary, 956, 31-22A Terminus), Mumbai (Stevens), 982, 982 and national identity, 945, 948-949, 973, Dreamings (Aboriginal), 1045 Gandhi, Mahatma, 983 chiaroscuro: in Japanese art, 1018-1019 dry painting. See sand painting garbha griha, 977 Chibinda Ilunga, 1067-1068 Native American, 940, 941, 1038, 1040 dry-landscape gardens. See karesansui Garden of the Master of the Fishing Nets Chibinda Ilunga, Chokwe (sculpture), 1068, Neo-Expressionist, 954-956 Dubuffet, Jean: Basquiat and, 947 (Wangshi Yuan), Suzhou, 996, 996 1068 new media, 969-972, 973 Duchamp, Marcel: Koons and, 958-959 gardens Chicago, Illinois (U.S.A.): Willis Tower Oceanic, 949, 1058, 31-22B Dumont, Jules Sébastien César, 1044 Chinese, 996, 998 (Sears Tower) (Skidmore, Owings, and political, 950-954, 973 Dwelling in the Fuchin Mountains (Huang Japanese, 1006, 1007, 1008, 1009, 1012, Merrill), 961 and race, 945-948, 950, 971, 973, 31-6A, Gongwang), 991-993, 991

Dwelling in the Qingbian Mountains (Dong

Qichang), 998, 998

gay/lesbian artists, 943-945

See also specific artists

Chichén Itzá (Mexico), 1024

Chicago Board of Trade II (Gursky), 970, 970

site-specific, 964-969, 973

Gehry, Frank Ming dynasty Chinese, 996, 997, 998 Ikere (Nigeria): royal palace, 1072-1073, 1072 karesansui, 1006, 1008, 1009, 1012, 34-2A on architectural design and materials, 963 Muromachi period Japanese, 1008 illustrated books, 978 Karesansui (dry-landscape) garden, Ryoanji Guggenheim Bilbao Museum, 962-963, Yuan dynasty Chinese, 991 illustrated manuscripts temple, Kyoto, 1008, 1008b, 34-2 **962, 963,** 31-34B Harihara (Vijayanagar king), 977 Mesoamerican, 1022, 1023, 1024-1025 katsina figure (Pentewa), 1034, 1034 Gehry Talks (Gehry), 963 Haring, Keith: Tuttomondo, Sant'Antonio, South Asian, 978, 3 katsinas, 1033, 1033-1034 Genghis Khan, 990 Pisa, 969, 969 Iltutmish (sultan of Delhi), 976 Katsura Imperial Villa, Kyoto, 1013, 1013 gestural abstraction, 954 harmony. See proportion Hart, Frederick, 965 imperialism. See colonialism Katsushigka Hokusai. See Hokusai Geumgangsan Mountains (Jeong Seon), India. See South Asian art Katsushika Oi, 1016 1002, 1002 Harunobu, 1015 Inka art, 1029-1031, 35-8A kautaha, 1053 installations, 950–951, 953, 956–957, 970–971, 972 Ghorids, 976 Evening Bell at the Clock, Eight Views of Kendo, Akati Akpele, 1071 Gita Govinda (Song of the Cowherd), 981, the Parlor series, 1016, 1017 warrior figure (Gu?), 1066, 1066 Hasegawa Tohaku. See Tohaku Inuit art, 1038 kente cloth, 1070, 1071, 1071b, 37-13A Hawaiian art, 1056-1058 Giuliani, Rudolph, 944 Islam khipu, 1030 glazes (in ceramics), 986, 992 head of Lono, Hawaii, 1057, 1057 in South Asia, 976 Kiefer, Anselm: Nigredo, 954–955, 955 Glele (Fon king), 1066 headhunting, 1046 in Southeast Asia, 984 Kitagawa Utamaro. See Utamaro gods/goddesses. See religion and mythology heiau, 1057 Kitchen Table series (Weems), 946b, 31-6B See also Islamic art Goldsworthy, Andy, 968–969 Hevehe, 1047–1048, 1051 Islamic art: South Asian, 977, 980 kiva mural, Kuaua Pueblo, 1032, 1033 ivi p'o, 1054 Cracked Rock Spiral, St. Abbs, 968, 969 hevehe masks, Elema, 1047-1048, 1048 kivas, 1032 Kngwarreye, Emily Kame, 956, 1046 Untitled, 956b, 31-22B Golub, Leon Hidatsa art, 1039 Assassins series, 951 Hidatsa Warrior Pehriska-Ruhpa (Two Mercenaries IV, 951, 951 Jahan (Shah), 980, 32-5A Koetsu, 1013-1014, 34-9A Ravens) (Bodmer), 1039, 1039 Goodacre, Glenna, 965 hierarchy of scale: in African art, 1060, 1061, Jahangir (Mughal emperor), 974, 975, 980, Boat Bridge (writing box), 1014, 1014 gopis, 32 Kogan, 1012 Jahangir Preferring a Sufi Shaykh to Kings (Bichitr), 974, 975 gopuras, 981 hieroglyphics: Mesoamerican, 1023 Kogan (tea-ceremony water jar), Momoyama period, 1012, *1012* Goryeo dynasty (Korea), 1001 High-Tech architecture, 961, 31-34A Govardhan Chand (raja of Guler), 981 Himeji (Japan): White Heron Castle James I (king of England), 974, 975 Kongo art, 1066-1067 Koons, Jeff, 958-959 graffiti, 947, 969 Japanese architecture (Shirasagi), 1010, 1010b, 34-5A Grand Louvre Pyramide, Musée de Louvre, Hindu art Edo period, 1013 Pink Panther, 958, 959 Paris (Pei), 964, 964 Momoyama period, 1009-1010, 1011, and British colonial rule, 32-10A Koran: architectural inscriptions, 980 graphic arts. See printmaking Rajput kingdoms, 980-981, 32-7A Korean art, 993map, 1001-1002, 1003 graves. See funerary customs Hiroshige Ando, 1017 contemporary, 1002, 31-22A Showa period, 1020, 1021 great mosques (congregational mosques): Plum Estate, Kameido, One Hundred Japanese art, 1004-1021, 1006map timelines, 990 Quwwat al-Islam Mosque, Delhi, 977 Famous Views of Edo series, 1004, 20th century, 1019-1020 Korin, 1013, 34-9A Great Plains Native American art, 1035, 1005, 1016 contemporary, 956-957, 1020 koru, 1055 1038-1040, 35 Edo period, 1004, 1005, 1012-1017, 1021, hokkyo, 34 Kot a-Mbweeky III (Kuba king), 1076, 1077 Great Salt Lake, Utah (U.S.A.): Spiral Jetty Hokusai (Katsushigka Hokusai), 1005 Kota art, 1061, 1064-1065 (Smithson), 964 The Great Wave off Kanogawa, Thirty-six Meiji period, 1018-1019, 1021 Kramer, Hilton, 31-Great Temple, Madurai, 981-982, 981 Views of Mount Fuji series, 1016, 1017, Momoyama period, 1009-1012, 1021, Krishna (Hindu deity), 981, 32-7A Great Temple, Tenochtitlán (Templo Mayor), Krishna and Radha in a Pavilion (Pahari 1022, 1023, 1026-1028, 1026, 1027, 1028 Holocaust, 955, 966 Muromachi period, 1006, 1008-1009, School), 980, 981 The Great Wave off Kanogawa, Thirty-six Holocaust Memorial, Vienna (Whiteread), Krishna and the Gopis, 981, 981b, 32-7A Views of Mount Fuji series (Hokusai), Showa period, 1019-1020, 1021 Krishnadevaraya (Vijayanagar king), 977 1016, 1017, 1017 The Holy Virgin Mary (Ofili), 948-949, 949 Kruger, Barbara, 944, 946, 31-6A societal contexts. See societal contexts of Greek art. See classical influences on later art Holzer, Jenny: Untitled, 970-971, 970 Untitled (Your Gaze Hits the Side of My Japanese art green architecture, 961 Homage to Steve Biko (Bester), 950, 950 Face), 942-943, 943 timelines, 1006 Greenberg, Clement, 942 The Homeless Projection (Wodiczko), 952, 952 See also Japanese Buddhist art; Japanese Kuaua Pueblo, New Mexico, 1032, 1033 groin vaults (cross vaults): in South Asian homosexuality, 943-945 painting Kuba art, 1076 architecture, 982 Honami Koetsu. See Koetsu Japanese Buddhist art Kuba king Kot a-Mbweeky III during a Guan Daosheng, 990-991 Hong Kong and Shanghai Bank, Hong Kong 20th century, 1019 display (photograph), 1076, 107. Bamboo Groves in Mist and Rain, 990, (Foster), 960, 961 Muromachi period, 1006, 1007, 1008, Kublai Khan (Chinese emperor), 990 991, 997 Hongwu (Chinese emperor), 989 Kuka'ilimoku (Hawaiian deity), 1057 Guan Yu Captures General Pang De (Shang honoring song at painted tipi, Julian Scott Japanese painting Kuka'ilimoku, Hawaii (sculpture), 1056, 1057 Edo period, 1013, 1014-1015, 34-9A, Xi), 994, 995 ledger, Kiowa, 1040, 1040 kula, 1049-1050 Guanyin (Kannon), 1018, 1019 Hopi art, 1033-1034 kupesi, 1053 Meiji period, 1018-1019 Guerrilla Girls, 943, 944 Horn Players (Basquiat), 947, 947 Kwakiutl art, 1034, 1036 The Advantages of Being a Woman Artist, Hosokawa Katsumoto, 3 Momoyama period, 1010 Kwei, Kane, 959-960 943b, 31-House (Whiteread), 966 Muromachi period, 1008-1009 Kyoto (Japan) Katsura Imperial Villa, 1013, 1013 Guezo (Fon king), 1066 Huang Gongwang Japonaiserie: Flowering Plum Tree (van Dwelling in the Fuchin Mountains, Gogh), 1005 Guggenheim Bilbao Museum (Gehry), Ryoanji temple, 1008, 1008b, 34-2A 991-993, 991 Japonisme, 1016, 34-12A 962-963, 962, 963, 31-341 Saihoji temple gardens, 1006, 1007, 1008, Secrets of Landscape Painting, 992-993 jar (Martínez), 1034, 1035 Gursky, Andreas, 969 Chicago Board of Trade II, 970, 970 Taian teahouse, Myokian temple (Sen no Huetocalli. See Templo Mayor jazz, 947 Gutai Art Manifesto (Yoshihara), 1020 Hughes, Holly, 944 Jeanne-Claude: Surrounded Islands, Biscayne Rikyu), 1011, 1011, 1013 Huitzilopochtli (Aztec deity), 1023, 1026, Bay, Miami, Florida, 1980-1983, 968, H 1027 lacquer, 994, 995, 1013, 1014 Haacke, Hans, 952 Jeanneret, Charles-Edouard. See Le Corbusier human face MetroMobiltan, 953, 953 in African art, 1067, 1075 Jeong Seon: Geumgangsan Mountains, 1002 Lahori, Abd al-Hamid, 980 haboku landscape (hanging scroll) (Sesshu in Japanese art, 1018, 34-12A Jesuit order (Society of Jesus), 1000 Landa, Diego de, 1024 landscape painting Chinese, 990–993, 996, 997, 998, 999, Toyo), 1008, 1008 in Native North American art, 1036 Jingdezhen ceramics, 993, 994 haboku painting, 1008 in Oceanic art, 1052, 1057 Jodo. See Pure Land Buddhism in Japan Hadid, Zaha: Vitra Fire Station, Joe, Paa: airplane and cow coffins, 960, 960 33-4A, 33-12A contemporary, 955, 31-22A Weil-am-Rhein, 964, 964 in African art, 1068, 1069, 37-16A, 37-17A Johns, Jasper: and Whiteread, 966 Haida art, 1036-1037, 35-14A in contemporary art, 951, 957-960, 973, Johnson, Philip Japanese, 1004, 1005 Seagram Building, New York, 961 Haida village re-creation, Queen Charlotte Lang Shining. See Castiglione, Giuseppe Island (Reid and Cranmer), 1037, 1037 in Native North American art, 35-16A Sony Building (AT&T Building), New large bowl, Showa period (Hamada), 1019, in Oceanic art, 1045, 1046 York, 961 1019 hair ornaments, Marquesas Islands, 1054, in South Asian art, 978, 983, 32-5A Joseon dynasty (Korea), 1001 Last Supper: in contemporary art, 959 in Southeast Asian art, 984 Judd, Donald, 962 Last Supper (Leonardo da Vinci), 959 Hall of Supreme Harmony, Forbidden City, human sacrifice in Mesoamerica, late 20th century European and American

Beijing, 994, 994

1019, 1019

Hamzanama, 978

handscrolls, 991

hanging scrolls

halos: in South Asian art, 975

Hamada-Leach aesthetic, 1019

Hamada Shoji: large bowl, Showa period,

Hammons, David: Public Enemy, 950-951,

Meiji period Japanese, 1018, 1019

1025-1026, 1027

humanism. See classical influences on later

Humayun (Mughal emperor), 978, 979

Hysolar Institute, University of Stuttgart,

Iatmul ceremonial men's house, East Sepik,

1047, 1047, 1051, 1052

Igbo art, 1070, 1077-1078

Stuttgart (Behnisch), 962, 962

Kalabari art, 1060, 1061
Kamehameha I (king of Hawaii), 1056–1057
Kamehameha III (king of Hawaii), 1058
Kangxi (Chinese emperor), 999
Kannon, 1018, 1019
Kano Eitoku. See Eitoku
Kano Hogai: Bodhisattva Kannon, 1018, 1019
Kano Motonobu. See Motonobu
Kano School of Japanese painting, 1008–1009, 1014

Pop Art, 959, 960

Leach, Bernard, 1019

ledger paintings, 1040

LED technology, 970-971

Post-Painterly Abstraction, 31-22A

See also Abstract Expressionism

Pehriska-Ruhpa (Two Ravens)

(Bodmer) (engraving), 1039

Le Corbusier: Tange and, 1020

Legrand, Paul: Hidatsa Warrior

New Zealand art, 949, 1042, 1043, 1058 Leonardo da Vinci: Last Supper and Madonna Marquesas Islands art, 1054 mudras: abhaya mudra, 984 Mughal Empire art, 974, 975, 978-980, 981, and Child with Saint Anne, 959 Martínez, Julian, 1034, 1035 Ngady Amwaash mask, Kuba, 1076, 1076 ngatu, 1053, 1054 Lewis and Clark expedition, 35-16A Martínez, María Montoya: jar, 1034, 1035 987, 32-5A Liang Kai: Sixth Chan Patriarch Chopping Marxism, 1001 contemporary evocation, 945 See also barkcloth ngatu with manulua designs (Sitani), 1053, Bamboo, 1009 Mary (mother of Jesus). See Virgin Mary Muhammad of Ghor, 976 Mukherjee, Meera, 983-984 Libeskind, Daniel mask, Yupik Eskimo, 1038, 1039 1054 Ni Zan: Rongxi Studio, 993, 993b, 33-4A Denver Art Museum, 963, 963b, 31-34B Ashoka at Kalinga, 984, 984 Nigredo (Kiefer), 954-955, 955 World Trade Center reconstruction African, 1073-1076 Mumbai (India): Victoria Terminus Native North American, 1034, 1036, 1037, (Chhatrapati Shivaji Terminus) nihonga, 1018-1019 proposal, 31-34B nimbus. See halos Lin, Maya Ying: Vietnam Veterans Memorial, 1038 (Stevens), 982, 982 Washington, D.C., 965-966, 965 Oceanic, 1047-1048, 1049 Munich (Germany): Olympic Park nishiki-e, 1015, 1017 Lingering Garden (Liu Yuan), Suzhou, 996, masquerades, African, 1070, 1073-1076 (Behnisch), 962 nkisi n'kondi, 1066, 1067 Mataatua meetinghouse, Whakatane mural painting Nkrumah, Kwame, 37-13A North American Native art. See Native linguist's staff, 1072 (Apanui), 1058, 1058b, 36-19A contemporary, 969 Native North American, 1032, 1033 North American art Materials and Techniques boxes Northwest Coast Native American art, 1034, and contemporary art, 956, 31-22A Chinese porcelain, 992 Muromachi period Japanese art, 1006, 1036-1038, 35-14 Edo period Japanese, 1014-1015 Indian miniature painting, 979 1008-1009, 1021 Noumea (New Caledonia): Tjibaou Cultural Ming dynasty Chinese, 996, 998, 33-12A Inka technology, 1030 music: and contemporary art, 947 Centre (Piano), 961 Qing dynasty Chinese, 999, 1000 inscriptions on Chinese paintings, 997 Muslims, 976 Nsangu (Bamum king), 1065 Yuan dynasty Chinese, 991-993, 33-1A, Japanese woodblock prints, 1016 See also Islam; Islamic art lacquered wood, 995 Mwashamboy masks, 1076 nudity Myanmar art (Burmese art), 986 in contemporary art, 944, 945, 957, 958 literature Tongan barkcloth, 1053 Myokian temple, Kyoto (Sen no Rikyu), 1011, in South Asian art, 980, 981 and Chinese art, 994, 997, 33-12A Matsushima Screens (Tawaraya Sotatsu), and Japanese art, 34-9 1013, 1013b, 34-9A 1011 0 mythology. See religion and mythology and South Asian art, 981 mausoleum, 980 Oceanic art, 1042-1059, 1044map Maya art: Postclassic period, 1024-1025 See also books Australian, 1045-1046, 1059, 31-22B mbari, 1070, 1077-1078 Liu Yuan (Lingering Garden), Suzhou, 996, contemporary, 949, 1058, 31-22B Micronesia, 1050, 1052, 1059 nail figure (nkisi n'kondi), Kongo mbari house, Umugote Orishaeze, 1078, 1078 mbulu ngulu, 1064-1065 (sculpture), 1066-1067, 1067 llama, alpaca, and woman, near Lake New Guinean, 1045, 1046-1048, 1051, Namdaemun, Seoul, 1002, 1002 Titicaca (sculptures), 1031, 1031b, 35-8A Meagher, Michelle, 957 Napoleon Crossing the Saint-Bernard Pass 36-1A Lofty Mount Lu (Shen Zhou), 996, 997, 997, medieval art: Postclassic Mesoamerican art, New Ireland, 1049 (David), 948 998, 33-12/ 1024-1025 Napoleon Leading the Army over the Alps New Zealand, 949, 1042, 1043, 1058 Lono (Hawaiian deity), 1057 Meiji period Japanese art, 1018–1019, 1021 Polynesian, 1052-1058, 1059, 36-14 lost-wax process (cire perdue), 983–984, Melanesian art, 1046-1050, 1059, 36-17 (Wiley), 948, 948 societal contexts, 1042, 1044-1045, 1046, men's ceremonial house, Belau, 1050, 1050, narrative art 1047, 1050, 1052, 1054, 1055 African, 1073 Lotus Mahal, Vijayanagara, 977, 977 1052 tattoo, 1043, 1054, 1055 Mende art, 1073, 1075 contemporary, 946 Louis, Morris, 31-22A Mercenaries IV (Golub), 951, 951 Native North American, 35-16A timeline, 1044 luxury arts Chinese, 994, 995 Mercer, Kobena, 31-6A South Asian, 978 Trobriand Islands, 1049-1050, 1051 Mesoamerican art, 1023, 1024-1029, National Endowment for the Arts (NEA) Western fascination with. See primitivism Japanese, 1014 (U.S.A.), 944, 945 Oceanic, 1054 1024map, 1041 Aztec, 1022, 1023, 1025–1029 Oceanic sculpture New Guinean, 1045, 1046, 1047, 36-1A national identity in contemporary art, 945, See also ceramics; metalwork 948-949, 973, 31-10A Lynch Fragments series (Edwards), 946–947, Postclassic, 1024-1025 New Zealand, 1042, 1043 societal contexts, 1024, 1025-1026 Native American art, 1022-1041 Polynesian, 1052-1053, 1054, 1056, 1057, 947 contemporary, 940, 941, 1038, 1040 metalwork M African, 1064-1065, 1066 Mesoamerica. See Mesoamerican art Trobriand Islands, 1049-1050 ma-hevehe, 1047 Andean South American, 35-8A North America. See Native North Oda Nobunaga (shogun), 1009, 34-5A Machu Picchu (Peru), 1030-1031, 1030 contemporary, 946-947 Ofili, Chris: The Holy Virgin Mary, 948-949, American art South America. See Andean South Madonna and Child with Saint Anne Japanese, 1014 949 See also bronze casting Ogata Korin. See Korin (Leonardo da Vinci), 959 American art Madurai (India): Great Temple, 981-982, 981 MetroMobiltan (Haacke), 953, 953 timelines, 1024 ogoga, 1072 Maharaja Jaswant Singh of Marwar, 983, Native American Graves Protection and Ohisa of the Takashima Tea Shop (Utamaro), Mexica. See Aztec art Micronesian art, 1050, 1052, 1059 Repatriation Act (NAGPRA), 1033 1017b, 34-12A 983, 32-10A Making a Work with His Own Body Mictlantecuhtli (Aztec deity), 1027 Native North American art, 1032-1040, oil painting in Japan, 1018 (Shiraga), 1020, 1020 Mies van der Rohe, Ludwig: Seagram 1032map, 1041 malanggan, 1049 Building, New York, 961 20th century, 1035, 35-14A See also painting Miller, Tim, 944 Alaska, 1034, 1036, 1037, 1038, 1039 Oiran (Grand Courtesan) (Takahashi), 1018, male and female figures, probably bush spirits (asye usu), Baule, 1069, 1069 minarets, 977, 980 contemporary, 940, 941, 1038, 1040 male gaze, 942-943, 31-6A Ming dynasty Chinese art, 988, 989, Great Plains, 1035, 1038-1040, 35-16A Okakura Kakuzo, 1019 Malevich, Kazimir: Hadid and, 964 993-999, 1003, 33-12A Northwest Coast, 1034, 1036-1038, 35-14A Oldenburg, Claes, 962 Man in a House beneath a Cliff (Shitao), 999, mingei, 1019 Southwest, 1032-1034 Olowe of Ise, 1071 999 miniatures, 978-979, 980, 981, 32-5A, 32-7A, Woodlands, 1035 doors, shrine of the king's head, royal mana, 1052 naturalism/realism palace, Ikere (relief sculpture), Manchu dynasty. See Qing dynasty Chinese Minimalism, 965, 966 in African art, 1067 1072-1073, 1072 minor arts. See luxury arts in Chinese art, 1001 veranda post, Akure (sculpture), 1072b, Mandan art, 1039, 35-16A mixed media: contemporary, 940, 941, in Native North American art, 1039 mandapas, 981 948-949, 950, 951, 954-955 Navajo art, 1032-1033 Olympic Park, Munich (Behnisch), 962 Mangaia art, 1054 Mixteca-Puebla art, 1025 Nayak dynasty art, 981–982 Olympic stadiums, Tokyo (Tange), 1020, Manifest Destiny, 1039 moai, Rapa Nui (Easter Island) (sculptures), Nazi Germany, 954-955, 966 1020 Manohar: Darbar of Jahangir, 979b, 32-5A 1045, 1052-1053, 1052 nduen fobara, 1060, 1061 One Hundred Famous Views of Edo series Mansheshe (Oursler), 972, 972 Moctezuma II (Aztec emperor), 1024, 1029 Neo-Expressionism, 954-956 (Hiroshige), 1004, 1005 manulua, 1053, 1054 modeling. See chiaroscuro Neshat, Shirin: Allegiance and Wakefulness, Orchard Factory: table with drawers, Ming manuscripts, illustrated. See illustrated Modernism Women of Allah series, 952, 952 dynasty, 994, 995, 995 Chinese, 998 Neue Staatsgalerie, Stuttgart (Stirling), 963, Oursler, Tony: Mansheshe, 972, 972 manuscripts overglazes, 992 Maori art. See New Zealand art See also Cubism 963b, 31-34A Mapplethorpe, Robert, 944-945 moko, 1055 New Guinean art, 1045, 1046-1048, 1051, The Perfect Moment, 944, 945 moko tattoo, 1043 P Self-Portrait, 944, 945 Momoyama period Japanese art, 1009-1012, New Ireland art, 1049 pagodas, 986 maps 1021, 34-5A new media, 969-972, 973 Pahari School: Krishna and Radha in a Africa, 1062 monastic orders: Jesuit, 1000 New York, New York (U.S.A.) Pavilion, 980, 981 China/Korea, 993 Mongols, 990 Seagram Building (Mies van der Rohe painting Japan, 1006 monoliths, 1053 action, 1019 and Johnson), 961 Mesoamerica, 1024 Monte Albán (Mexico), 1024 bark, 1045 Solomon R. Guggenheim Museum Native North American sites, 1032 Moorish art. See Islamic art (Wright), 970 Chinese. See Chinese painting Oceania, 1044 mosaics: Mesoamerican, 1024 Sony Building (AT&T Building) (Johnson contemporary, 945, 951, 31-10A, 31-22B South American Native sites, 1029 mosques: Quwwat al-Islam Mosque, Delhi, and Burgee, with Simmons haboku, 1008 South Asia, 976 Architects), 961 Japanese. See Japanese painting Marco Polo, 990 Motonobu: Zen Patriarch Xiangyen Tilted Arc (Serra), 944, 966-967, 967 Korean, 1002 Marisol: Self-Portrait Looking at the Last Zhixian Sweeping with a Broom, 1007, New York School. See Abstract landscapes. See landscape painting Supper, 959, 959 1008-1009, 1009 murals. See mural painting Expressionism

primitivism, 1045, 1066 Native North American, 1032-1033, Rothenberg, Susan, 954 Shen Zhou printmaking 1040, 35-16 rotulus/rotuli, 1023 Lofty Mount Lu, 996, 997, 997, 998, 33-12A Oceanic, 1045, 31-22B Native North American, 1035 rotundas, 31-3 Poet on a Mountaintop, 998, 998b, 33-12A royal ancestral altar of King Eweka II, Benin oil. See oil painting See also woodblock prints Sherman, Cindy, 942, 31-6A Post-Painterly Abstraction, 31-22A propaganda. See art as a political tool City, 1069-1071, 1070 Shino, 1012 Royal Polyglot Bible, 978 sand, 1032-1033 proportion Shinto, 956, 957, 1005 South Asian, 974, 975, 978-979, 980, 981, in South Asian architecture, 980 Rukupo, Raharuhi: Te Hau-ki-Turanga Shiraga, Kazuo: Making a Work with His 983, 32-5A, 32-7A, 32-10A See also hierarchy of scale public art, 965–967 meetinghouse, Poverty Bay, 1042, 1043 Own Body, 1020, 1020 splashed-ink, 1008 Rurutu art, 1054, 1056 Shirasagi (White Heron Castle), Himeji, techniques. See painting techniques Public Enemy (Hammons), 950-951, 951 Ryoanji temple, Kyoto, 1008, 1008b, 34-2A 1010, 1010b, 34-5A Pueblo art, 1033-1034 true view, 1002 Shitao (Daoji) Man in a House beneath a Cliff, 999, 999 See also illustrated manuscripts Pueblo Bonito, Chaco Canyon, 1032 painting techniques pueblos, 1032 sabi, 1012 Sayings on Painting from Monk Bitter Safavid dynasty, 978-979 Chinese, 997 pukao, 1052 Gourd, 999 Japanese, 1008 Pure Land Buddhism in Japan, 1006 Saihoji temple gardens, Kyoto, 1006, 1007, shogunate, 1006 South Asian, 979 putti, 948 1008, 34-2 shoguns, 1006 Samburu art, 1076-1077 Palau. See Belau A Short History of Modernist Painting Papua New Guinea. See New Guinean art samurai, 1006 (Tansey), 959B, 31-28A Qing dynasty Chinese art, 999–1000, 1003 San art, 1063 Showa period Japanese art, 1019-1020, 1021 Paris (France) Centre Georges Pompidou (Beaubourg) San Ildefonso Pueblo, 1034, 1035 Queen Charlotte Island (Canada): Haida shrine of the king's head, royal palace, Ikere (Rogers and Piano), 964 village re-creation (Reid and Cranmer), San Lorenzo, Florence (Brunelleschi), (Olowe of Ise), 1072-1073, 1072 Grand Louvre Pyramide, Musée de Louvre (Pei), 964, 964 Sikander, Shahzia, 32-10A Perilous Order, 945, 945 1037, 1037 Quetzalcoatl (Aztec deity), 1025, 1027 San rock painting, Bamboo Mountain, 1063, patronage: African art, 1066, 37-16A Paxton, Joseph: Crystal Palace, London, 961 Pei, Ieoh Ming: Grand Louvre Pyramide, quillworking, 1035 Qutb al-Din Aybak (sultan of Delhi), 976, 977 silver. See metalwork Simpson, Lorna, 946 1063 sand painting, 1032-1033 Qutb Minar, Delhi, 977, 977 Quwwat al-Islam Mosque, Delhi, 977 Stereo Styles, 946b, 31-6A Sant'Antonio, Pisa, 969, 969 Santo Domingo, Cuzco, 1031, *1031* Satimbe, 1074–1075 Musée de Louvre, Paris, 964, 964 Singh, Jaswant (ruler of Jodhpur), 983 Pentewa, Otto: katsina figure, 1034, 1034 Sitani, Mele: ngatu with manulua designs, People's Republic of China art, 1001, 1003 Satimbe masquerader, Dogon (photograph), 1053, 1054 racial issues in contemporary art, 945–948, 950, 971, 973, 31-6A, 31-6B The Perfect Moment (Mapplethorpe), 944, 945 site-specific art, 964-969, 973 Performance Art: Japanese, 1019–1020 Perilous Order (Sikander), 945, 945 Saville, Jenny: Branded, 957, 957 Sixth Chan Patriarch Chopping Bamboo Radha (Hindu deity), 981 Sayings on Painting from Monk Bitter Gourd (Liang Kai), 1009 Persian art: and Mughal Empire art, 975, Rajput kingdoms art, 980-981, 32-7A Skidmore, Owings, and Merrill (SOM): Willis (Shitao), 999 Rangoon (Yangon) (Myanmar): Schwedagon Pagoda, 986, 986 Tower (Sears Tower), Chicago, 961 slide projections, 952 978-979 Schiele, Egon, 957 Schinkel, Karl Friedrich: Altes Museum, perspective in contemporary art, 955, 959 Rapa Nui (Easter Island): moai (sculptures), Smith, Jaune Quick-to-See, 1040 Berlin, 31-3 Schnabel, Julian: The Walk Home, 954, 955 Trade (Gifts for Trading Land with White in Japanese art, 1017, 1018–1019 1045, 1052–1053, 1052 Rarotonga art, 1054, 36-14A People), 940, 941 twisted. See composite view Schneemann, Carolee, 1020 See also foreshortening Schwedagon Pagoda, Rangoon (Yangon), Smith, Kiki: Untitled, 958, 958 The Raven and the First Men (Reid), 1037, pfemba, 1066, 1067 986, 986 1037B, 35-14A Smithson, Robert, 968 readymades, 958-959 science: and Mesoamerican art, 1031 Spiral Jetty, Great Salt Lake, Utah, 964 photography contemporary, 942–945, 952, 954, 969–970, 31-6A, 31-6B societal contexts of art realism. See naturalism/realism sculpture Reid, Bill African. See African sculpture Africa, 1061, 1066, 1068 South Asian, 983 Haida village re-creation, Queen Andean South American, 1031, 35-8A Andean South America, 1029-1030 contemporary, 946-947, 949, 956-957, Charlotte Island, 1037, 1037 China. See societal contexts of Chinese art Piano, Renzo Centre Georges Pompidou (Beaubourg), The Raven and the First Men, 1037, 1037B, 959-960, 966-967, 31contemporary art, 941, 943, 945, 950, Mesoamerican, 1026-1028 Paris, 964 Tjibaou Cultural Centre, Noumea, 961, 961 relics Native North American, 1033-1034, 1035, Japan. See societal contexts of Japanese art Picasso, Pablo: Basquiat and, 947 African, 1064 1036-1037, 35-14A Korea, 1001, 1002 Buddhist, 984, 986 Oceanic. See Oceanic sculpture Mesoamerica, 1024, 1025-1026 Pine Forest (Tohaku), 1010, 1011 Southeast Asia, 984 People's Republic of China, 1001 Oceania, 1042, 1044-1045, 1046, 1047, Pink Panther (Koons), 958, 959 relief. See relief sculpture 1050, 1052, 1054, 1055, 1056-1057 Piper, Adrian: Cornered, 971, 971 relief sculpture Pisa (Italy): Sant'Antonio, 969, 969 African, 1072 Southeast Asian, 984-985 South Asia, 976, 978, 980-981, 982, 983, Piss Christ (Serrano), 944 Native North American, 1036-1037 techniques. See sculpture techniques Piula, Trigo, 948 Oceanic, 1042, 1043, 1046, 1052 sculpture techniques Southeast Asia, 984, 986 Ta Tele, 948b, 31-10A religion and mythology lost-wax process, 983-984, 35-8A See also religion and mythology Pizarro, Francisco, 1031, 35-8A in Africa, 1066-1067, 1069, 1073, 37-17A South Asia, 983-984 societal contexts of Chinese art plans (urban). See urban planning Buddhism. See Buddhism; Buddhist art Seagram Building, New York (Mies van der Qing dynasty, 999, 1000 Plum Estate, Kameido, One Hundred Famous Christianity. See Christianity Rohe and Johnson), 961 Yuan dynasty, 990 Views of Edo series (Hiroshige), 1004, Hinduism. See Hindu art seals, Chinese, 997 societal contexts of Japanese art in Japan, 1005, 1006, 1007 Sears Tower (Willis Tower), Chicago Edo period, 1012 1005, 1016 Poet on a Mountaintop (Shen Zhou), 998, in Mesoamerica, 1025, 1026, 1027 (Skidmore, Owings, and Merrill), 961 Meiji period, 1018, 1019 in Native North America, 1032-1034, 1036 seated couple, Dogon, 1068-1069, 1068 Momoyama period, 1009-1010, 34-5A 998b, 33-12A pointed arches: in South Asian architecture, in Oceania, 1045, 1046, 1047-1048, 1049 Secrets of Landscape Painting (Huang Muromachi period, 1006 in South Asia, 981, 983, 32-Gongwang), 992-993 Society of Jesus (Jesuit order), 1000 Religion and Mythology boxes Self-Portrait (Mapplethorpe), 944, 945 Solomon R. Guggenheim Museum, New political contemporary art, 950-954, 973 Self-Portrait (Te Pehi Kupe), 1055 York (Wright), 970 Pollock, Jackson Aztecs, 1027 Self-Portrait Looking at the Last Supper Song Su-Nam, 956, 1002 Performance Art and, 1019 Zen Buddhism, 1007 Schnabel and, 954 (Marisol), 959, 959 Summer Trees, 956b, 31-22A reliquaries: African, 1064 reliquary guardian figure (bieri), Fang, self-portraits Sony Building (AT&T Building), New York Wu and, 956 Polynesian art, 1052-1058, 1059, 36-14A 1064, 1064 contemporary, 944, 945, 957, 31-27A (Johnson and Burgee, with Simmons Pop Art, 959, 960 reliquary guardian figure (mbulu ngulu), in South Asian art, 974, 975 Architects), 961 porcelain, 992, 993, 1000 Kota, 1064-1065, 1064 Sen no Rikyu, 1012 South American Native art. See Andean Rent Collection Courtyard, Dayi (Ye Yushan Taian teahouse, Myokian temple, Kyoto, South American art portraiture 1011, 1011, 1013 South Asian architecture in Chinese art, 994 and others), 1001, 1001 Senufo art, 1073-1074, 37-17A and British colonial rule, 982 in Japanese art, 1018 reservation period Native North American in South Asian art, 974, 975, 983, 32-5A Seoul (South Korea): Namdaemun, 1002, Delhi sultanate, 977 art, 1040 Mughal Empire, 980 Postclassic Mesoamerican art, 1024-1025 ridgepole, 1043 Nayak dynasty, 981–982 postmodernism Ringgold, Faith, 945-946 Serra, Richard: Tilted Arc, New York, 944, architecture, 961, 962-963, 964, 31-34A Who's Afraid of Aunt Jemima?, 946, 946 966-967, 967 Vijayanagar Empire, 977 See also contemporary art Rinpa School of Japanese painting, 1013, Serrano, Andres: Piss Christ, 944 South Asian art, 975-984, 976map, 987 Post-Painterly Abstraction, 31-22A pottery. See ceramics 20th century, 983-984 Sesshu Toyo: splashed-ink (haboku) and British colonial rule, 982-983, 987, rock art, African, 1063 landscape (hanging scroll), 1008, 1008 Rogers, Richard, 960 pou tokomanawa, 1043 sexuality. See eroticism pouncing, 979, 32-5 poupou, 1043, 1055 Shah Tahmasp Meditating (Banu), 978-979, Buddhist art, 984 Centre Georges Pompidou (Beaubourg), contemporary, 945, 983 Paris, 964 Shang Xi: Guan Yu Captures General Pang Hindu Rajput, 980-981, 32-7A Poverty Bay (New Zealand): Te Roman art. See classical influences on later Hau-ki-Turanga meetinghouse, Poverty Bay (Rukupo and others), 1042, 1043 De, 994, 995 Mughal. See Mughal Empire art The Romance of the Three Kingdoms, 994 shaykhs, 975 Nayak dynasty, 981-982 Sheep and Goat (Zhao), 990b, 33-1A sculpture, 981, 983-984 powwows, 1040 Rongxi Studio (Ni Zan), 993, 993b, 33-4A

South Asian art (continued) Te Hau-ki-Turanga meetinghouse, U societal contexts, 976, 978, 980-981, 982, Poverty Bay (Rukupo and others), U.S. art. See late 20th century European and 983. 984 1042, 1043 American art; Native North American Sultanate of Delhi, 976-977 Te Pehi Kupe: Self-Portrait, 1055 timeline, 976 Te Whanau-A-Apanui. See Whiting, Cliff ukiyo-e, 1015, 1016, 1017, 1018, 34-12A Vijayanagar Empire, 977, 987 tea ceremony, 1007, 1010-1011, 1012 Umugote Orishaeze (Nigeria): mbari house, Southeast Asian art, 976map, 984-986, 987 Temple of the Sun, Cuzco, 1031, 1031 societal contexts, 984, 986 Templo Mayor (Great Temple), Tenochtitlán, underglazes, 986, 992 timelines, 976 1022, 1023, 1026-1028, 1026, 1027, 1028 Untitled (Donovan), 957, 957 Southwest Native American art, 1032-1034 Tenochtitlán (Mexico), 1022, 1024, 1025 Untitled (Holzer), 970-971, 970 Sowie masks, 1075 Coatlicue (sculpture), 1028, 1029 Untitled (Kngwarreye), 956b, 31-22B Spanish art: in the Americas, 1031 Coyolxauhqui (relief sculpture), Untitled (Smith), 958, 958 Spiral Jetty (Smithson), Great Salt Lake, 1026-1028, 1027 Untitled (Man Smoking/Malcolm X), Kitchen Templo Mayor (Great Temple), 1022, Utah, 964 Table series (Weems), 946b, 31-6B splashed-ink landscape (hanging scroll) 1023, 1026-1028, 1026, 1027, 1028 Untitled (Your Gaze Hits the Side of My Face) Tlaltecuhtli (relief sculpture), 1028, (Sesshu Toyo), 1008, 1008 (Kruger), 942-943, 943 splashed-ink painting, 1008 urban planning 1028 St. Abbs (Scotland): Cracked Rock Spiral Teotihuacán (Mexico) China, 989 Aztecs and, 1026 (Goldsworthy), 968-969, 968 Mesoamerica, 1026 staff god (Tangaroa?), Rarotonga, 1054b, destruction of, 1024 urbanization, 1015 textiles Utamaro, 1017 stained-glass windows: in South Asian African, 1070, 1071, 37-13A Ohisa of the Takashima Tea Shop, 1017b, Andean South American, 1029-1030 architecture, 982 contemporary, 945–946 Native North American, 1033 Stalks of Bamboo by a Rock (Wu Zhen), 991, Utzon, Joern: Sydney Opera House, 1020 991 Oceanic, 1042, 1043, 1047, 1051, 1053–1054, 1058 Stereo Styles (Simpson), 946b, 31-6A Stevens, Frederick W.: Victoria Terminus van Gogh, Vincent Thai art. 984-985 (Chhatrapati Shivaji Terminus), Japonaiserie: Flowering Plum Tree, 1005 Mumbai, 982, 982 Theravada Buddhism, 984 and Japonisme, 1005 Stirling, James: Neue Staatsgalerie, Thirty-six Views of Mount Fuji series vaults. See barrel vaults; groin vaults Stuttgart, 963, 963b, 31-34A (Hokusai), 1016, 1017, 1017 veranda post, Akure (sculpture) (Olowe of stoneware, 992 throne and footstool of King Nsangu, Ise), 1072b, 37 Bamum, 1065, 1065 story quilts, 946 Victoria (queen of England), 982 storytelling. See narrative art stupas, 984, 986 tiki, 1054 Victoria Terminus (Chhatrapati Shivaji tilework, 34-5A Terminus), Mumbai (Stevens), 982, 982 Tilted Arc, New York (Serra), 944, 966-967, Stuttgart (Germany) video, 971-972 Hysolar Institute, University of Stuttgart 967 Vienna (Austria): Holocaust Memorial (Behnisch), 962, 962 timelines (Whiteread), 966, 966 Neue Staatsgalerie (Stirling), 963, 963b, African art, 1062 Vietnam Veterans Memorial, Washington, Chinese/Korean art, 990 D.C. (Lin), 965-966, 965 Sukhothai (Thailand) contemporary art, 942 Vietnam War, 965-966 Walking Buddha (sculpture), 984-985, Japanese art, 1006 Vietnamese art, 986 Native American art, 1024 Vijayanagar (India): Lotus Mahal, 977, 977 Wat Mahathat, 984 Oceanic art, 1044 Vijayanagar Empire, 977, 987 Sultanate of Delhi, 976-977, 987 South Asian art, 976 vimanas, 977 Viola, Bill: The Crossing, 971, 971 sultans, 977 Timur (Tamerlane), 975 Summer Trees (Song), 956b, 31-22A Tjibaou Cultural Centre, Noumea (Piano), Virgin and Child: Madonna and Child with superimposition, 1026 961, 961 Saint Anne (Leonardo da Vinci), 959 Surrounded Islands, Biscayne Bay, Miami, Tlaloc (Aztec deity), 1026, 1027 Virgin Mary Tlaltecuhtli (Aztec deity), 1027, 1028 Florida, 1980-1983 (Christo and in contemporary art, 944, 948-949 Jeanne-Claude), 968, 968 Tlaltecuhtli, Great Temple of Tenochtitlán See also Virgin and Child Suzhou (China) (relief sculpture), 1028, 1028 Vitra Fire Station, Weil-am-Rhein (Hadid), Liu Yuan (Lingering Garden), 996, 996 Tlingit art, 1036, 1037, 1038 964, 964 Wangshi Yuan (Garden of the Master of togu na, 1078 the Fishing Nets), 996, 996 Tohaku: Pine Forest, 1010, 1011 Suzuki Harunobu. See Harunobu tokonoma, 1011 wabi, 1012 Sydney Opera House (Utzon), 1020 Tokugawa Ieyasu (shogun), 1009, 1012, waka sran, 1069 Yanagi Soetsu, 1019 Symptom (Tsuchiya), 956-957, 956 The Walk Home (Schnabel), 954, 955 Tokugawa shogunate. See Edo period Walking Buddha, Sukhothai (sculpture), Japanese art Ta Tele (Piula), 948b, 31-10A Tokyo (Japan): Olympic stadiums (Tange), Wang Meng, 993 table with drawers, Ming dynasty (Orchard Factory), 994, 995, 995 1020, 1020 Wangshi Yuan (Garden of the Master of the Toltecs, 1024, 1025 Fishing Nets), Suzhou, 996, 996 Tagore, Abanindranath, 983, 32-10A tombs. See funerary customs war helmet mask, Tlingit, 1036, 1037 Tahmasp (Savafid shah), 978-979 Tongan art, 1053-1054 Warhol, Andy: Haring and, 969 warrior figure (Gu?) (Kendo) (sculpture),

Taj Mahal, Agra, 980, 980 Takahashi Yuichi: Oiran (Grand Courtesan), 1018, 1018 Tales of Ise, 34-9A Tambo, Lynch Fragments series (Edwards), 946-947, 947 Tangaroa (Polynesian deity), 36-14A Tange, Kenzo: Olympic stadiums, Tokyo, 1020, 1020 Tansey, Mark, 959 A Short History of Modernist Painting, 959b, 31-28A Tansey, Richard, 31-28A tapa, 1053-1054 See also barkcloth tatami, 1011 tatanua, 1049 tattoed warrior with war club, Nukahiva (engraving), 1054, 1055 tattoo (tatu/tatau), 1043, 1054, 1055 tatuana mask, New Ireland, 1049, 1049 Tawaraya Sotatsu: Waves at Matsushima, 1013, 1013b, 34-9 Tawhiri-Matea (God of the Winds)

totem poles, 1036-1037 Toyotomi Hideyoshi (shogun), 1009, Trade (Gifts for Trading Land with White People) (Smith), 940, 941 Trobriand Islands art, 1049-1050, 1051 true view painting, 1002 Tsuchiya, Kimio, 1020 Symptom, 956-957, 956 Tsutaya Juzaboro, 34-12A tukutuku, 1043 Tula (Mexico), 1024, 1025 tunnel vaults. See barrel vaults Tupou IV (king of Tonga), 1054 Tuttomondo, Sant'Antonio, Pisa (Haring), 969, 969 Tuzuk-i Jahangiri (Memoirs of Jahangir), twentieth century art. See 20th century art twisted perspective. See composite view two Asante noblemen wearing kente cloth robes, Kumasi (photograph), 1071b,

two men sitting at a table of food (linguist's

staff) (Bonsu), 1072, 1072

1066, 1066 Wat Mahathat, Sukhothai, 984 Waves at Matsushima, Matsushima Screens (Tawaraya Sotatsu), 1013, 1013b, 34-9A weaving. See textiles Weems, Carrie Mae, 946 Untitled (Man Smoking/Malcolm X), Kitchen Table series, 946b, 31-6B Weil-am-Rhein (Germany): Vitra Fire Station (Hadid), 964, 964 Wen Shu: Carnations and Garden Rock, 998-999, 999 Weston, Edward, 945 Whakatane (New Zealand): Mataatua meetinghouse (Apanui), 1058, 1058b, When I Put My Hands on Your Body (Wojnarowicz), 943-944, 943 White, Minor, 954 White Heron Castle (Shirasagi), Himeji, 1010, 1010b, 34-5A Whiteread, Rachel Holocaust Memorial, Vienna, 966, 966 House, 966

Whiting, Cliff (Te Whanau-A-Apanui), 1058 Tawhiri-Matea (God of the Winds), 949, Who's Afraid of Aunt Jemima? (Ringgold), 946, 946 Wild Vines with Flowers Like Pearls (Wu), 956, 956 Wildmon, Donald, 944 Wiley, Kehinde, 947-948 Napoleon Leading the Army over the Alps, 948. 948 Willis Tower (Sears Tower), Chicago (Skidmore, Owings, and Merrill), 961 windows. See stained-glass windows Wodiczko, Krzysztof: The Homeless Projection, 952, 952 Wojnarowicz, David, 945, 946 When I Put My Hands on Your Body, 943-944. 943 Women of Allah series (Neshat), 952, 952 women's roles in society Africa, 1070, 1074, 1075 and contemporary art, 942-943, 31-2A Japan, 1014 Native North America, 1035 Oceania, 1042, 1043, 1050, 1051, 1053 South Asia, 979 See also feminist art; specific women woodblock prints Chinese, 1000 Japanese, 1004, 1005, 1015, 1016, 1017, Woodlands Native American art, 1035 World Trade Center reconstruction proposal (Libeskind), 31-34B World War II, 955, 1019 Wright, Frank Lloyd: Solomon R. Guggenheim Museum, New York, 970 writing Chinese, 997 See also calligraphy writing boxes, 1014 Wu Guanzhong, 1001 Wild Vines with Flowers Like Pearls, 956, Wu School of Chinese painting, 996, 997, 998 Wu Zhen: Stalks of Bamboo by a Rock, 991, 991 X X-ray style, 1045

Xiangyen Zhiaxian, 1008-1009 Xipe Totec (Mesoamerican deity), 1027 Xu Bing, 956, 1001 A Book from the Sky, 953, 953

Yangon. See Rangoon Ye Yushan: Rent Collection Courtyard, 1001, Yi Seonggye, 1001 yoga (Western painting), 1019 Yombe mother and child (pfemba) (sculpture), 1066, 1067, 1067 Yongle (Chinese emperor), 989 Yongzheng (Chinese emperor), 1000 Yoruba art, 1072-1073, 37-16A Yosa Buson. See Buson Yoshihara, Jiro, 1019 Gutai Art Manifesto, 1020 Yuan dynasty art, 990-993, 1003, 33-1A, Yuan dynasty Chinese art, 990-993, 1003, 33-1A, 33-4A Yupik art, 1038, 1039

Z Zapotecs, 1024 Zen Buddhism, 1006, 1007, 1008, 1012, 1019, Zen Patriarch Xiangyen Zhixian Sweeping with a Broom (Motonobu), 1007, 1008-1009, 1009 Zhao Mengfu, 990 Sheep and Goat, 990b, 33-1A zoomorphic forms. See animals

(Whiting), 949, 949

*				